# THE ARTS
# OF THE
# ITALIAN
# RENAISSANCE

*Painting · Sculpture · Architecture*

# THE ARTS OF THE ITALIAN RENAISSANCE

## Painting · Sculpture · Architecture

WALTER PAATZ

Prentice-Hall, Inc., Englewood Cliffs, N.J.
and Harry N. Abrams, Inc., New York

**Library of Congress Cataloging in Publication Data**
Paatz, Walter, 1902–
  The arts of the Italian Renaissance:
painting, sculpture, architecture
    1. Art, Renaissance—Italy.  2. Art, Italian.
I. Title.
N6915.P15  1974b    709'.45    73–21965
ISBN 0-13-047316-2

Library of Congress Catalogue Card Number: 73–21965

# CONTENTS

# THE ARTS
# OF THE
# ITALIAN
# RENAISSANCE

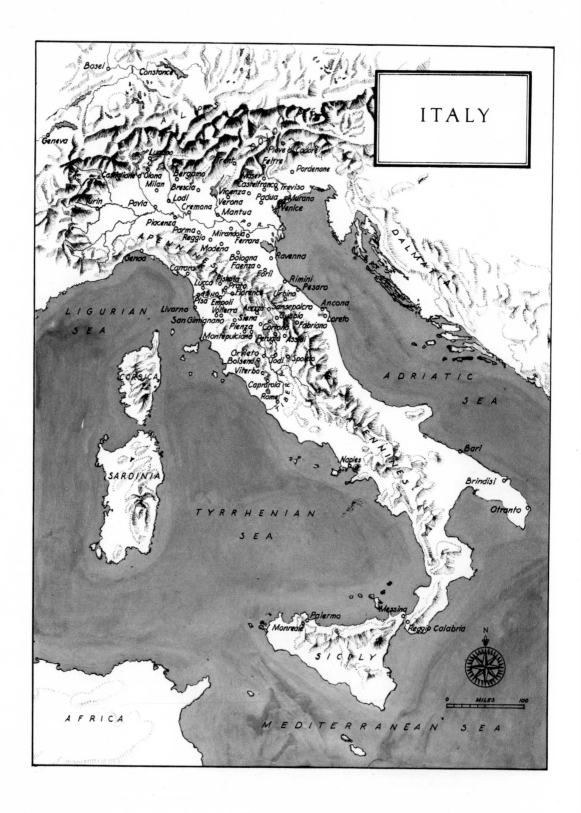

ITALY

# CHAPTER ONE

# RENAISSANCE: WORD AND IDEA

## The word

The word "Renaissance," in its best translation, means "rebirth."[1] German scholars adopted the word from the French, no earlier than 1840, to define a specific phenomenon of Occidental culture—the beginning of what can be called modern times. The French themselves had borrowed it from the Italian *rinascità*, which was first used in this sense in Vasari's *Lives of the Painters* in its earliest printing (1550) and again in the second and enlarged edition (1568). It is this work which initiated the modern conception of art history.

The true meaning of the word can best be determined if we allow the spokesmen of the Renaissance themselves to define it for us.[2] Contemporary sources show us what the word meant when it was first used to proclaim in trumpet tones the self-awareness and the ambitions of what men were certain was to be a new era in culture.

## The doctrine of historical periods

Vasari distinguished three periods of varying importance in the history of art: (1) the magnificent epoch of Greco-Roman antiquity, (2) an intervening dark age of decadence, which we call "medieval," and (3) the revival or "rebirth" of the arts that began about 1250.[3]

Vasari's notion was based not on objective historical knowledge but on something quite different—a passionate, partisan attempt to justify the basic premises and orientation of a contemporary way of thinking. Thus Vasari writes[4]: "And with her [Rome] were likewise utterly ruined the most excellent craftsmen, sculptors, painters and architects, leaving the arts and their own selves buried and submerged among the miserable massacres and ruins of that most famous city." Or again,[5] "We come at last to another sort of work called German [Teutonic]. . . . Nor is it adopted now by the best architects but is avoided by them as monstrous and barbarous. . . . This manner was the invention of the Goths, for, after they had ruined the ancient buildings and killed the architects in the wars, those who were left constructed the buildings in this style. . . . May God protect every country from such ideas and style of buildings!" (" . . . that damned way of building," he says elsewhere.)

Of Tuscan architects, sculptors, and painters of the second half of the thirteenth century, such as Arnolfo di Cambio ("di Lapo"), Nicola Pisano, Cimabue, and Giotto, Vasari says,[6] "In the darkest days, they traced for the masters who came after them the way which leads to perfection." And he finds this perfection—through which finally even the great achievements of antiquity were to be surpassed—in the works of his own century, the sixteenth, and above all in those of Michelangelo.

This doctrine of the notable periods in art history can be found even earlier than Vasari's formulation. Before 1528, Albrecht Dürer, for one, had expounded it most impressively in his theoretical writings. And about 1470 or 1480 the author of the anonymous biography of Brunelleschi (perhaps Antonio di Tuccio Manetti) had linked this notion to a universal history of art: art had proceeded from its most primitive begin-

nings through the cultures of ancient Egypt and the Orient to the Greeks and Romans and thereafter, one might say, had "passed over" the Middle Ages to come to fruition at last in the fifteenth century. Intimations of this new historical conception appeared between 1435 and 1460 in the treatises of Alberti, Ghiberti, and Filarete. Elsewhere I have attempted to show that it can be traced even further back, into the fourteenth century, to Filippo Villani and Cennino Cennini and, indeed, to Petrarch, Boccaccio, and Giovanni Villani. Especially characteristic is a sentence in the fifth tale of the sixth day in Boccaccio's *Decameron* (c. 1350). Concerning Giotto, the great Florentine painter of the late thirteenth and early fourteenth centuries, Boccaccio says that he had "brought to light that art which for many centuries had lain buried."

## The doctrine of the nature of Renaissance art

From these writings of the fourteenth to the sixteenth centuries we learn also what their authors conceived to be the nature of the third epoch of the arts, their own, the period of "rebirth." These heralds of the Renaissance merit our closest attention, for they were themselves artists, most of them of real importance. They were highly qualified to speak of what was their own major concern and to define the basic concepts that underlay their endeavors. These firsthand views of their epoch furnish an invaluable and authentic source of evidence.

*The New Relationship to Antiquity and to Nature.* As early as Boccaccio, the basic lines of this historical attitude were sketched out. In his notion of the arts as being reawakened from a centuries-long sleep, there is already implied a retroactive relationship of the reviving arts to antiquity. Indeed, he says of Giotto that it was he who, singlehanded,

brought the arts back to nature[7]: "Giotto, whose genius was of such excellence that with his art and brush or crayon he painted anything in Nature, the mother and mover of all things under the perpetual turning of the heavens, and painted them so like that they seemed not so much likenesses as things themselves; whereby it often happened that men's visual sense was deceived, and they thought that to be real which was only painted."

This motif of an artifice deceptively true to nature was probably borrowed by Boccaccio from classical Greek and Latin literature, where it often appears in the aesthetic theories of such philosophers as Aristotle and in anecdotes about artists told by historians such as Pliny. To be sure, Boccaccio does not mean this to apply to an outward imitation, which is pleasing only to the senses, but rather to an idealized transcription of the essence of natural phenomena, similar to the Platonic notion of mimesis.

Boccaccio's conception of the nature of art must have been a general belief of his time. Even earlier, about 1340, Giovanni Villani[8] had written (significantly enough, also about Giotto), "He draws every figure and every action most like unto nature." At the end of the fourteenth century, Giovanni's nephew, Filippo Villani, said of the Florentine painter Cimabue, "He began to lead painting back to truth"; and about Giotto, "Not only that his own splendid fame should equal that of the ancient painters, but rather to outstrip them in art and ingenuity did he restore painting to its former worth and high repute. . . . His figures were drawn so much in accord with the lines of nature that to the beholder it seemed as if they lived and breathed, even to accomplish typical acts and gestures, and so truly that one really saw them speak and weep and rejoice and so forth."

A half century later, Lorenzo Ghiberti[9] did not hesitate to state flatly that it was Giotto who "introduced the new art that is true to nature." Dürer, some half century after Ghiberti, insisted that art must pattern itself after nature with ever-increasing expressiveness and all sorts of wondrous transformations,[10] "For art standeth firmly fixed in nature, and whosoever can rend her forth thence, he only possesseth her." Or again[11]: "The more closely thy work abideth by life in its form, so much the better will it appear." And he urges[12] the artist not to omit "even the tiniest wrinkles and details . . . though it is useless to overdo and overload a thing." Vasari, finally, stated flatly: "I know that our art is nothing more than the imitation of nature." The belief that it should and must be so was, as we have seen, one of the basic premises of the Renaissance development from as far back as the mid-fourteenth century.

A second guiding principle was faith in classical antiquity.[13] This recourse to ancient culture was closely associated with the insistence on truth to nature. To the heralds of the Renaissance previously singled out, these attitudes seem to have been inseparable —and with good reason, for Aristotle himself had demanded that art be true to nature. Thus ancient art could serve as a worthy model for Renaissance artists, a guide for their own still vague comprehension of just what "nature" was. The most impressive evidence of this conviction is perhaps the oldest record: an account by Ristoro d'Arezzo, written in 1282, of how potsherds of antique vases were found in Arezzo.[14] As a historian, he gives a graphic report of the reaction of the Arezzo artists to this discovery. Sculptors and draftsmen and other "experts" were of the opinion that these fragments must have lain buried for more than a thousand years: "When they saw them, they were quite literally carried away by emotion, as if transported, and they all began to murmur at once and were as if struck dumb." The figures painted on these

ancient vases impressed them as so natural and so subtle that these objects could only be accounted for as something holy: " . . . they could but marvel that human nature could produce such subtlety and such artistic perfection." Those present at the event are said to have exclaimed: "Such artists must have been like gods, or these vases must have fallen from heaven itself, for otherwise there is no way of explaining how they could have achieved such perfection in form, in color, and especially in artistic lifelikeness."

Hardly ever again was there to be such a spontaneous emotional response to the antique as occurred at this first reported instance. In the course of the fourteenth century, ancient art began to take on the character of an absolute norm, although more perhaps for the Humanist writers and scholars (for example, the commentator of Dante, Benvenuto Rambaldi da Imola) than for the artists themselves. From that time on, opinion was divided as to how slavishly the models of antiquity should be followed. Certain doctrinaire theorists, especially in the sixteenth century, regarded classical antiquity as an absolute ideal, unconditionally obligatory, and they judged any deviation from this norm as artistic error. But there were other theorists who, like the leading artists of the time, advocated a more flexible emulation of ancient art and of nature. This standard was true even of Boccaccio, but no one stated it more clearly than Leon Battista Alberti: "We should not simply take over into our work the formulas of the Ancients and thereby remain chained by ancient rules; rather, we should let ourselves be stimulated by Antiquity to discover our true selves and to make the effort not just to equal the ancient masters but, where it is still possible, even to surpass them." Vasari found this challenge fulfilled in the work of Michelangelo.

*The Controversy over the Ideal of Beauty.* In their striving, through both theory and practice, to arrive at a new definition of the relationship of art to nature and to antiquity, Renaissance artists faced many special problems. One of these was of the greatest importance—the question of the nature of beauty, yet another question which dated back as far as the fourteenth century. Again, in the fifth tale of the sixth day of the *Decameron* Boccaccio, speaking of the long dormant interval of the arts before the Renaissance (that is, the Middle Ages), says that this hiatus resulted from "the false path taken by painters who cared more about pleasing the eyes of the ignorant than about edifying the spirit and the intelligence of the learned." In this, the writer revealed his belief in the idea that beneath the sensuous appearances of things lie innate spiritual values.

In other writers and in fourteenth-century records (even as early as 1282 in the above-noted passage from Ristoro d'Arezzo), we repeatedly find the theme of an opposition between "connoisseurs" and a public that was ignorant of the arts. From this, I believe, we can deduce that there already existed a specific ideal of beauty. About 1400, Filippo Villani wrote that Giotto made painting "pleasing and precious" (*preciosam placidamque*). Ghiberti, a half century later, formulated this underlying idea even more clearly; he praised Giotto not only for having brought art back to nature but also for having given to it the quality of "sweetness" (*gentilezza*), by which he meant that Giotto respected the true proportions of things.

Shortly before, in 1442, Angiolo Galli had almost succeeded in defining perfectly the Renaissance ideal of beauty in this short sentence about the painter Pisanello[15]: "Arte, mesura, aere et desegno, manera, prospectiva et natura e gli ha dato el celo per mirabil dono." That this formula in-

cludes very nearly everything that the Renaissance masters conceived to be the essence of their new art will be shown more fully in the following chapters; for now, a brief explanation of the individual concepts implied in this definition will suffice.

*Arte*: art, an all-embracing term, but laden with new value, significantly comes first. *Mesura*: measure, meaning grace and proportion combined, the same dual quality that Filippo Villani and Ghiberti praised. *Aere*: aerial perspective (the *sfumato* of Leonardo da Vinci), applied especially perhaps to the art of spatial design in painting. *Desegno*: a concept that, as we shall see further on, Vasari explains more fully. *Manera*: presumably this means facility in execution. *Prospectiva*: linear perspective in drawing. *Naturale*: truth to nature. And all of this Galli, characteristically, esteems as a "gift from heaven."

Further explanations of the ideal of beauty, that concern which was both the despair and the salvation of the Renaissance masters, were attempted by Albrecht Dürer, who in his writings[16] speaks of people "as they really are, as they ought to be, and as they might be." This makes perfectly clear what had been implied by Boccaccio and the fourteenth-century Italians: the opposition between the accidental form that is realized in matter and the eternal, necessary, law-determined original design—the Idea—that matter must always imitate. To grasp this Idea, Dürer drove himself tirelessly through all sorts of investigations and experiments, as is known from his drawings, especially relating to questions of measurement that involved studies of ideal proportion by means of geometric constructions and arithmetic calculations (pls. 1, 2): "Howbeit if a man prove his theory by geometry and manifest forth its fundamental truth, him must all the world believe, for so is one compelled."[17] Later he admitted that his

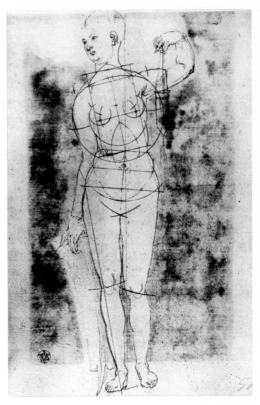

1. ALBRECHT DÜRER. Construction of a Nude Woman Holding a Shield and Lamp. *c. 1500. Pen with sepia wash, 12⅛ × 8¼". Staatliche Museen, Berlin*

efforts had been unsuccessful and had produced no sure results. "I hold Nature for master in such matters and the fancy of man for delusion."[18] "Wherefore, nevermore imagine that thou either canst or shalt make anything better than God hath given power to his creatures to do. For thy power is weakness compared to God's creating hand." And finally: "What beauty is I know not, though it dependeth upon many things."[19] Such sentences are impressive testimony of Dürer's own modesty, of the humility of a great artist, among the most illustrious of all the Renaissance geniuses; however, these phrases do not deny the fruitfulness of his previous efforts to achieve idealization of natural form.

It was invariably the outstanding figures

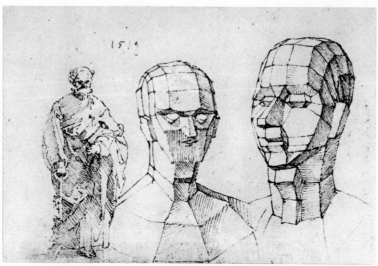

2.   ALBRECHT DÜRER. St. Peter; Two Heads Divided
in Facets. *1519. Pen. Formerly Sächsische Landesbib-
liothek, Dresden*

among Renaissance artists who worried
about the laws of beauty, who pondered
over them in theoretical writings and tested
them in their art. One need only recall
Leonardo da Vinci, in whom theory and
practice were indissolubly linked, or such a
great "practical" artist as Raphael. The at-
tempt to learn eternal laws by studying liv-
ing creatures, the effort to embody in a work
of art the fundamental principle behind all
creation—such a struggle is in the highest
degree characteristic of the spirit and will of
the Renaissance masters.

Vasari illuminates the problem in his own
special way, by presenting intellectual con-
cepts as allegorical figures. In his biography
of Donatello, he says that Nature had caused
that artist to be born because she revolted
against having always before her eyes the
caricature of herself presented in the un-
natural sculpture of the Middle Ages.[20]
Donatello, he goes on to say, developed the
principle of *disegno* and thereby overcame
the "scandalous disorder" of medieval art. In
the foreword to his book he explains what is
meant by this principle. For him it is far
more than mere "drawing," in the literal

meaning of the word. At the root of the
Italian lies the Latin *signum* (sign), and from
this it should be understood that drawing is
a sign or symbol of a deeper truth.

Vasari seems to have discovered this him-
self. *Disegno*, according to him, is above all
a fundamental principle, a basic configura-
tion, of Renaissance art[21]:

*Seeing that Design, the parent of our three arts,
Architecture, Sculpture, and Painting, having
its origins in the intellect, draws out from many
single things a general judgment, it is like a form
or idea of all the objects in nature, most marvelous
in what it compasses, for not only in the bodies of
men and of animals but also in plants, in build-
ings, in sculpture and in painting, design is
cognizant of the proportion of the whole to the
parts and of the parts to each other and to the
whole. Seeing too that from this knowledge there
arises a certain conception and judgment, so that
there is formed in the mind that something which
afterwards, when expressed by the hands, is
called design, we may conclude that design is not
other than a visible expression and declaration of
our inner conception and of that which others
have imagined and given form to in their idea.*

These sentences imply—and this must be understood—that embodiment of the Idea in a work of art can be accomplished only by a fully aware artistic mind which, through its intuition of nature, draws the Idea out of nature.

This represents a profound departure from [the artistic] concepts of the Middle Ages, which

[handwritten marginal note: The Arts of the Italian Renaissance) New York; Random House, c. 1975; Paatz, Walter]

n-
li-
vas
nd
the
ects
tain
bly
on-
ieve
r of
and
ool-
owl-
with
er to
an to

enais-
, to be
n and
o, for
dedi-
to the

. From
for the

men of the Renaissance, ... ...ented a value in and of itself. Both their thought and their actions were profoundly imbued with this idea. Art is one of the highest achievements of mankind, and for the men of the fifteenth and sixteenth centuries this was as unconditionally self-evident as it is for us today, and as it had been for the men of Greco-Roman antiquity. In the Middle Ages, however, this apparent truism was, to say the least, anything but self-evident;

nonetheless, some such high evaluation of art must have been acknowledged in that period also, for only if we assume the unconscious existence of that kind of motivating force can we comprehend the mighty creative achievements of Byzantine, Romanesque, and Gothic art. However, it seems that no one expressed consciously and aloud what many undoubtedly knew was being done in practice. Ever since the Church Fathers had relegated the visual arts to the category of manual arts—that is, to the status of mechanical crafts good for nothing more than to alleviate the want and misery which had come into the world with the Fall of Man—those arts had been deemed to have no more than the most elementary kind of value. And yet some slight dignity was accorded them because every art of representation could play the role of *ancilla theologiae,* a handmaiden in the teaching of the Holy Word. Architecture built houses for God, and the other visual arts could convey the sacred truths to the many who could not read; this was the line of reasoning which arose from the patristic "book of the unlearned" justification.

One of the greatest achievements of the Renaissance was to overcome this medieval state of mind. Beginning with the fourteenth century, the arts were restored to the high and independent position they had once known. This change was also expressed in the rise of an independent literature on art which treated the visual arts as an autonomous domain with three kinds of value: aesthetic-formal, craftsmanly-technical, and historical. In the new Renaissance literature on art, the question of the relationship of these values to religious principles played at best an auxiliary role. Religious principles entered into this development only in terms of the reversal of the medieval relationships. Autonomy of the visual arts had existed to some degree in the Middle Ages, even though it may have been deliberately ig-

nored by religious writers, but it became a principal theme in Renaissance literature. Conversely, what had formerly been the only concern of medieval thinkers and writers—the relationship of the visual arts to religion—was virtually relegated by Renaissance artists and thinkers to the realm of the unconscious, although it must be said that it remained intensely operative there. Because of this "psychologizing" of what had once been objectively and unquestioningly accepted, the old relationship, viewed in retrospect, took on a power of imagery of the greatest impact. An understanding of this point is essential if we are to grasp the nature of Renaissance religious art.

To all intents and purposes, nothing was said or written explicitly on this subject through the fifteenth century except for a few highly significant observations of Alberti. It was Dürer who finally formulated the problem and proposed a solution. The Nürnberg of 1500 in which he lived was still medieval; for this reason, the question that pressed on him was what compromise or reconciliation could be found between the medieval insistence on art as handmaiden to religion and the new Renaissance claim that art must be autonomous and serve only truth and beauty. Dürer himself believed some such compromise to be possible and necessary [23]: "For, even as the ancients used the fairest figure of a man to represent their false god Apollo, we will employ the same for Christ the Lord, who is the fairest of all the earth; and as they figured Venus as the loveliest of women, so will we in like manner set down the same beauteous form for the most pure Virgin Mary, the mother of God." What Dürer proclaims here in theory, the artists of the Renaissance carried out in practice. By and large, it must be said that the greatest impact of the Renaissance movement lay in the application of its new principles to the old, rejected Christian functions of art. That the new tasks it set for

itself also attained great significance will be demonstrated below.

*Chronological Separation from the Late Gothic.* From the nineteenth century on, repeated efforts have been made, especially by French scholars, to incorporate into the Renaissance development certain significant phenomena of French and Netherlandish art of the fourteenth and fifteenth centuries. To my mind, this is an error, for the Italian Renaissance is distinguished from such Late Gothic phenomena by the very nature of its basic principles. Only the Italians sought and were able to find a rational, scientific, mathematical foundation for their attempts to relate artistic representation to nature; only they recognized and revealed in nature not only the unique and accidental but also the eternal laws. The French and the Netherlanders did not go beyond appearances, beyond what was perceptible by the senses. Only the Italians made classical antiquity the norm for their strivings to comprehend nature. They alone completely rejected the Gothic repertory of forms and Gothic standards of beauty. Until well into the sixteenth century, all art north of the Alps (including German, even when it had come into contact with the Italians) remained unmistakably and basically Late Gothic.

## Chronological limits

Any attempt to set time limits for the Renaissance runs into difficulties. The fifteenth century is generally taken to be the starting point, but some of the writers and artists already cited as representative of the new development belong to the fourteenth century. Moreover, the term "renaissance" is often applied to still earlier, incontestably medieval, periods.

*The Medieval "Renaissances."* In scholarly literature we read of the "Carolingian Renaissance" of the eighth and ninth centuries, the "proto-Renaissance" (the first or

pre-Renaissance) in Tuscany and southern France during the eleventh, twelfth, and thirteenth centuries, or of the "south Italian Renaissance" (c. 1230–50) in the cultural circles around the last Hohenstaufen emperor, Frederick II, and so on. All these movements, without exception, belong to the medieval world.[24] Their strong regard for antiquity is responsible for the application of the term "renaissance" to them. In my opinion, however, these are more correctly summed up by the word *renovatio,* that is to say, "renewal."

This term appears in certain medieval sources, especially in instances where the relationship of the Middle Ages to antiquity is under consideration. But this earlier relationship is fundamentally different from that which the Italian Renaissance had to antiquity. There is certainly an aesthetic impetus in each of these medieval "renewals," but what always remains in the foreground is the religious impetus. The antiquity to which these periods are related is the Early Christian period of late antiquity. Literary and political historians have long understood the special significance and pertinence of the concept of *renovatio*; unfortunately, art history has made very little use of it. In this book the use of the term "renaissance" will be limited to that world which invented the idea and through practice brought it into being—Italy at the dawn of the modern era.

*Trecento, Quattrocento, and Cinquecento.* These Italian terms for the fourteenth, fifteenth, and sixteenth centuries, respectively, refer also to three specific historical styles. If we ask how all three fit into the single style called "Renaissance," new problems arise. As we have already seen, the movement characterized as the Renaissance can be traced continuously from the fourteenth to the sixteenth centuries, from the trecento to the cinquecento. Its program was developed in theoretical writings on art from Boccaccio in the trecento to Vasari in the cinquecento,

with impressive consistency, and all these writers are unanimous in considering that the break between the Middle Ages and modern times had already taken place in the second half of the duecento, the thirteenth century, with the appearance of the great Tuscan painters, sculptors, and architects: Cimabue, Giotto, Nicola Pisano, Giovanni Pisano, and Arnolfo di Cambio. In the face of this firsthand evidence from the leading writers of the Renaissance—sources that certainly are not to be taken lightly—modern art history has nevertheless persisted in treating the duecento and trecento as part of the medieval era. This attitude requires reconsideration, at least up to a certain point; but all in all, since the Renaissance development remained imbued with still-vital medieval tendencies until well into the fifteenth century, I too prefer to limit the use of the term proper to the quattrocento and the cinquecento.

In any event, what we are interested in here is not so much the origins of the movement as its essential character, and this is seen most clearly in the fully mature forms of the fifteenth and sixteenth centuries. Moreover, we shall be concerned with only the first third of the cinquecento, not considering for our context the period after approximately 1530. As recently as a generation ago, this later period was still considered part of the Renaissance and given the specific name "Late Renaissance." However, for some thirty years now, historians have recognized more and more clearly that the years between 1530 and 1590 or 1600 were marked by a new style quite different from that of the Renaissance, a style to which they have given the name "Mannerism."

# CHAPTER TWO

# CULTURAL AND HISTORICAL FACTORS

Renaissance art was a direct outgrowth of historical circumstance. As a creation of fifteenth- and sixteenth-century Italian culture, it expresses many traits characteristic of this phenomenon, at least in its essentials. This "historical locus" must therefore be defined, insofar as it is indispensable to an understanding of the art of the time.

## The political units

The question of chronological limits, which has already been raised, appears in a special light when one recognizes that the period of Italian history with which we are concerned (1400–1530) is commonly considered by historians not as a precise entity but as part of a larger epoch beginning with the year 1250.[1] As a matter of fact, the characteristic features of the age are distinguished most comprehensively within the years 1250 to 1525 or 1530.

With the death in 1250 of Frederick II, the last Holy Roman Emperor of the German house of Hohenstaufen, the political subdivisions of Italy began to assume the forms they were to maintain until about 1530. It was in 1250 that the authority of the German-controlled Imperium Romanum collapsed, and two new factors in Italian politics gained importance simultaneously. On the one hand, there were many Italian states, all more or less independent but quite

different in size and strength. Five of these became increasingly powerful as political centers of gravity: Milan, Venice, Florence, the Papal State, and Naples (together with Sicily), each seeking to bring all of Italy under its hegemony. On the other hand, there was a counterweight in various foreign powers that claimed the right to incorporate Italy into their own spheres of authority. Among these were subsequent Holy Roman emperors belonging to various German houses, especially that of the Austrian Hapsburgs. There were also the French kings—in particular, those of the house of Anjou, one line of whom ruled Naples from 1268 to 1435, and those of the house of Valois, who from 1494 on tried to assert their claims to Milan and Naples through wars on Italian soil. Finally, there was the Spanish ruling house of Aragon, which governed Sicily from 1282 to 1295 and ruled in Naples from about 1435 to 1504.

The struggle for power between these Italian and foreign governments provides the leitmotiv of Italian history between 1250 and 1525–30. The resolution of this conflict occurred only about 1525–30 with the Battle of Pavia, the defeat and sack of Rome, and the seizure of Florence. The Hapsburg emperor Charles V—who wore the Holy Roman crown and ruled over the hereditary Hapsburg possessions in Germany, the Netherlands, and Burgundy, and was at the same time king of Spain—successfully opposed the French king's claims to Italy with the combined power of his Spanish, Netherlandish, and German forces. As a result, an entirely new pattern of Italian political organization came into being, and the chapter in Italian history with which this book is concerned was brought to a close. The dream of a united Italy under Italian leadership was thus interrupted, to be realized more than three centuries later, in the years from 1860 to 1870. Even within the individual Italian states, the year 1530 marked a dividing point. The victory of Charles V brought about a change from the old Italian political organization in which each state had a unique form of government to the henceforth dominant form of principalities with an ever-increasing tendency toward absolutism.

*The Influence of Foreign Political Relations.* To understand Renaissance art it is necessary to appreciate the weighty consequences of these political events. The national consciousness of the Italians, who had longed for a unified nation under Italian leadership, had been grievously weakened by the repeated triumphs of foreign powers. While any political future was denied the Italian Peninsula, however, it sought and found a compensating fulfillment in the realm of the spirit, and especially in art. The energy that was frustrated in the sphere of politics found new release in philosophy, poetry, the sciences, and the visual arts; it was this creative vitality which resulted in the marvelous revival known as the Renaissance.

The return to antiquity, so important for Renaissance art, was not affected by the defeat of nationalistic strivings but, in fact, became even stronger. Its continued vitality can only be understood as a manifestation of profound instincts involving man's entire being, instincts that sought their outlet in artistic expression. The Italian populace, many centuries later, considered the ancient Roman culture as its birthright. By proclaiming the superiority of that culture, it proclaimed its own spiritual ascendancy over the German, French, and Spanish "barbarians" who had triumphed in the realm of politics. This confident Italian proclamation of the classical heritage was so effective that it gave rise to important and long-lasting consequences. Throughout the sixteenth and seventeenth centuries and well into the eighteenth, the art and culture of the victorious nations remained under the banner of the Renaissance. And, though these nations

in the course of time contributed their own admirable achievements, such accomplishments were touched off, and their direction was partly determined, by contact with the art of the Italian trecento, quattrocento, and cinquecento.

For yet another reason it is important for our study to understand the Italian political pattern between 1250 and 1530. The powers that held sway politically influenced the very structure of the artistic process; foreign political alliances gave rise to corresponding interrelationships in the domain of art. As an example, while Naples and Sicily were under the rule of the Spanish house of Aragon, painting (that of Antonello da Messina, for instance) took the Netherlandish style as a model, just as was being done in Spain itself. Or, when the island state of Venice, hard-pressed by the Levantine Turks, was forced to seek a new basis for power on the mainland, it was obliged to cooperate with Florence. At precisely that historical moment, about 1400, Venetian art finally freed itself of Byzantine characteristics and, ever more resolutely, joined with the Italian Renaissance movement that had been created in Florence. Only with this new orientation of Venetian politics did there come into being what we recognize as Venetian Renaissance art—that is, the particular stylistic unity within the Italian Renaissance which prevailed as a significant creative factor throughout all the northern Italian territory, from the Friuli region on the east to Lake Como on the west, from Trent on the north to Padua on the south.

*The Influence of the Dynasties.* The influence of the Italian ruling houses had an even more marked effect on artistic activity than did the political factors. The contribution of such dynasties to the rise of the Renaissance development can scarcely be evaluated too highly. The house of Medici, for one, played an immensely important part in the unfolding of the Renaissance in Florence. For a half century its heads, who spurned princely titles the better to govern the Florentine republic, spared neither effort nor expense to further the aims of the Renaissance. Cosimo the Elder helped his artist friends Brunelleschi, Donatello, and Michelozzo to realize their great potential by commissioning ambitious works from them. Cosimo's grandson, Lorenzo the Magnificent, encouraged Botticelli, Signorelli, and Leonardo, among others, and his personal interest in the young Michelangelo's talent was one of the earliest steps in the great artist's solitary path. Lorenzo's son, Pope Leo X, and the second Medici pope, Clement VII, were slavish patrons of the mature Michelangelo and of Raphael.

Still other bonds linked artists with those who held power. At Urbino, in the middle of the fifteenth century, Duke Federigo da Montefeltro made his imposing palace a center for the new artistic currents, attracting to it masters such as the Dalmatian architect Luciano Laurana, the Sienese architect, decorator, sculptor, and painter Francesco di Giorgio, and the Tuscan painter Piero della Francesca. The despot of Rimini, Sigismondo Malatesta, transformed the medieval church of the mendicant order of St. Francis into the "Tempio Malatestiano," a veritable jewel of the new art (pl. 3). He gave employment to the prince of painters of his time, Piero della Francesca, and to the inspired Florentine architect Leon Battista Alberti.

The dukes of Ferrara, of the house of Este, converted their seat into a model of the new style, with everything in it planned according to rational urban organization. The dukes of Mantua, the Gonzaga, bedecked their city with masterworks of the new architecture and painting. The Visconti and the Sforza dukes made Milan into a Renaissance metropolis. Finally, papal undertakings attracted the finest artists from all over Italy to eternal Rome. What these great powers of the period accomplished on a large

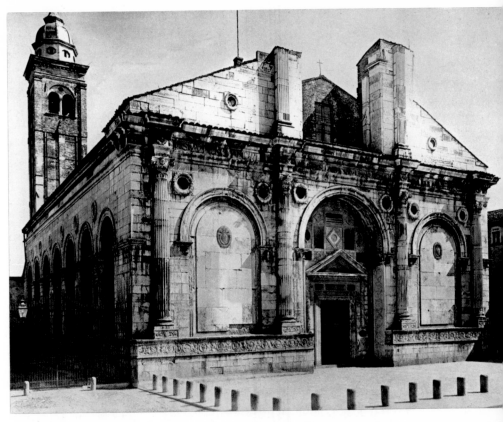

3.   LEON BATTISTA ALBERTI. *S. Francesco ("Tempio Malatestiano"), Rimini. 1446–50*

scale was emulated on a more modest scale by ruling houses throughout the land, even the smallest among them.

*The Influence of the City-Republics.* Side by side with the great autocratic dynasties, vigorous city-republics continued to flourish throughout the fifteenth century and well into the sixteenth; they, too, profoundly affected the arts of the Renaissance. In the great communes such as Florence, Siena, Perugia, Bologna, and Venice, the distinctive qualities of their art reflected a correspondingly distinct political structure, the prevailing concept of the republican city-state.

In Florence, the great dome of Brunelleschi was intended as a monumental crown for the principal and official church of the city, the Cathedral of Santa Maria del Fiore (Colorplate 1)—an especially significant example. The name Santa Maria del Fiore was given by the city authorities to the new cathedral begun about 1300 to replace an older church, Santa Reparata. Stern decrees were required to impose the new name on a stubborn populace, which continued to employ the old name. The city fathers persisted because the new name was intended to echo that of the city itself—Fiorenza (Firenze), the city of flowers—and also to proclaim the Mother of God as patroness of both city and state, a symbolic gesture reminiscent of the tutelary gods of ancient Greece and Rome.[2]

Another major work of the Renaissance reveals a similar political association: the

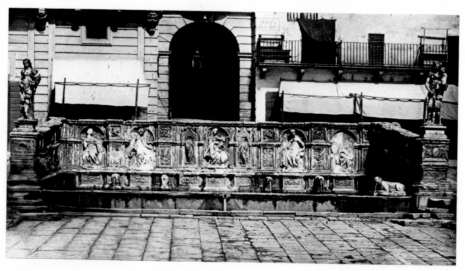

4. JACOPO DELLA QUERCIA. *Fonte Gaia, Siena. 1409–28*

series of statues in niches around the exterior walls of the Florentine church of Orsanmichele (pl. 91), the first examples of the new monumental sculpture. These were commissioned by the guilds (on which the power of the republican government rested) to surround the miracle-working images of the Madonna with marble and bronze statues of their various patron saints, thereby symbolically placing the guild members and the government under the protection of the Mother of God.[3]

Siena, the neighbor and rival of Florence, did likewise. At the same time that the statues were being placed around the Madonna of Orsanmichele, the Sienese were erecting the monumental fountain of Jacopo della Quercia (pls. 4, 5) in the principal square of their city, just opposite the Palazzo Pubblico.[4] Not only is this first great masterpiece of Sienese Renaissance sculpture a remarkably decorative monument to one of the most progressive institutions of municipal government (it was the principal outlet of the city's water supply), but also the figures carved on it are symbolic of the Sienese political principle and its connection with the Mother of God, under whose protection

the Sienese government had placed itself. ("Sena vetus civitas virginis" is inscribed on one of the city gates and on coins.) The Sienese policy is expressed in yet another way in the choice of figures for this fountain. They proclaim the legendary origins of the city from ancient Rome and assert symbolically that the good and righteous government inherited from Rome has remained the fundamental principle of Sienese civic life.

The architectonic character and propagandistic purpose of such Renaissance works, and even certain stylistic traits, are closely related to historical and political fact. Only when such historico-cultural relationships are understood do these works reveal their full meaning. The influence of such factors from civic life and of historical circumstance on every aspect of Renaissance art is far more pervasive than is commonly thought. The art historical significance of a work such as Donatello's statue of St. Mark for Orsanmichele (pl. 137) is generally considered without reference to the statue's role in the entire cycle of figures and without taking into account the political and religious overtones of the cycle. In so neglecting the

relevant historical factors, an essential part of a thoroughgoing appreciation of the art work is lost, for such influences were of great importance in its creation and had the utmost meaning for the patron, the artist, and the citizens of the republic.

## Society

Such considerations lead to yet another that cannot be overlooked—the social structure of the Renaissance. This aspect, essentially a historical condition, is intimately linked with the political life. Here we can only point out the most influential of these factors and sketch them roughly.[5]

*The New Social Structure.* The basis of medieval social structure was aristocratic. Birth dictated social position, and it was

5. JACOPO DELLA QUERCIA. Acca Larentia, *from the Fonte Gaia. 1409–28. Marble, height of entire figure 65″. Palazzo Pubblico, Siena*

exceptional for anyone to rise above the class into which he was born. This organization was bequeathed to the Renaissance, and it continued to function even while gradually disintegrating. Indeed, what is absolutely characteristic of the Renaissance period is the initiation and affirmation of a new social order. From about 1250 on, the individual managed more and more often to loosen the bonds of his preordained social straitjacket. Rank in society began to depend not solely on the station to which one was born and to a greater degree on personal achievement. Such accomplishments might be of various kinds— political, military, and commercial, but also intellectual or artistic. More and more, social status depended on one's personal capabilities.

The most successful men in all these fields joined together in a new elite in which social origins were irrelevant. This new aristocracy included statesmen, whether they came to power legitimately or illegitimately, whether they were heirs of long-established feudal dynasties, such as Alfonso V of Aragon in Naples (Colorplate 29), or victorious mercenaries (*condottieri*) such as Francesco Sforza, Duke of Milan from 1450, or merely plebeian heads of powerful banking houses, such as the Medici of Florence. It also included learned men and artists such as the mathematician Antonio Manetti, the architect Brunelleschi, and the sculptor Donatello, all of whom belonged to the circle of friends gathered around Cosimo de' Medici. The circle that the young Lorenzo de' Medici later assembled for himself included men of low birth such as the painter Botticelli and the poet Angelo Poliziano, as well as the philosopher Pico della Mirandola, scion of a long line of counts.

Artists and art in the Renaissance took on a very special character through this transformation of the social structure. Occasionally, it even happened that painters were raised to noble rank. In the early fourteenth

century, for example, the Sienese Simone Martini was ennobled at the royal court of Naples, and in the second half of the fifteenth century Andrea Mantegna was honored by his patron, the Duke of Mantua, with the title of count. The Venetian Gentile Bellini was given the title Bey by the Sultan of Constantinople in 1479. At about the same time, Carlo Crivelli (who had been expelled from his native Venice on an adultery charge) was ennobled by the King of Naples, and in 1496 King Charles VIII of France granted a title to Guido Mazzoni, a sculptor from Modena called to the French court in 1494. There can be no doubt that artistic achievement was rewarded by social favor in the Renaissance.[6]

*The Influence of the New Social Status.* Through the incorporation of the artist into the new "aristocracy of the capable," the very essence of art was transformed. When architects, sculptors, and painters came to live on intimate terms with the leading personalities in politics, the military, commerce, and intellectual life, they reoriented their work toward those common interests which unified the new aristocracy. Botticelli's *Primavera* and *Birth of Venus* (pls. 148, 169), along with many other of his paintings, were produced at the suggestion of the court circle of Lorenzo the Magnificent. This coterie had an ardent appreciation of masterpieces of ancient and modern literature, and their passion for the verse of Horace, Virgil, Lucretius, and their contemporary Angelo Poliziano profoundly stimulated Botticelli's thought and work. In essence, the gigantic creative achievements of Michelangelo also derive from this erudite circle. His Medici tombs in the New Sacristy of San Lorenzo in Florence (pl. 84, Colorplate 18) are a triumph of imagination, skillfully embodied in a most complex structure. In their figures are expressed, in diverse ways, a multiplicity of abstruse concepts drawn from religion, philosophy, astrology, and politics.

Especially significant for the Renaissance development was the link between the arts and the sciences. With the fifteenth century there began in Italy an interplay of the artistic imagination and the scientific or erudite spirit, and these were destined to combine into a higher unity. The "discovery" of linear perspective illuminated this connection as if by a sudden, brilliant light; indeed, it may be said that we owe this discovery to the fact that mathematicians and artists were brought together in the circle around Cosimo de' Medici. Brunelleschi is reputed to have been the first to work out the laws of scientific perspective, in cooperation with Antonio Manetti, and full exploitation of the theory resulted from the joint labors of the painter Piero della Francesca and the mathematician Luca Pacioli working at the ducal court of Urbino.

To justify the importance assigned to this joint achievement of artists and scientists, it should suffice to mention Leonardo da Vinci. His art is an astounding, virtually universal phenomenon. It became this because Leonardo was deeply involved in that incredibly rich complex which was the total culture of the Renaissance. Leonardo is the embodiment of the ideal man of the Renaissance, the universal genius. His personality and work are the most exemplary proof that this human ideal was directed toward a specific goal. Whether Leonardo painted or modeled statues, designed monumental structures or utilitarian objects, whether he functioned as researcher in technology or as anatomist, wrote theoretical treatises or solved practical problems, ultimately all these were one and the same activity for him—the exploration and demonstration of the universal laws of nature which also govern man.

*The Spiritualization of Creative Activity.*
The association of art with the new learning
was not confined exclusively to the sphere
of the concrete, that is, to techniques and
subject matter as such. The introduction of
the artist into the world of scientists and
philosophers had a much more profound
result—art was elevated from craftsmanship,
from a manual activity, to a spiritual pur-
suit. What is meant by this new phenome-
non, and how it transformed the very essence
of the work of art, is clearly revealed in
Vasari's exposition of the principle of *disegno*.

The nature of this transformation becomes
even clearer if we consider painting itself. It
is as if creative activity had been transported
to an entirely different plane. With a work
of medieval art, to understand what the
artist's hand had made is to comprehend all,
because the aesthetic idea embodied in a
medieval work is inseparable from what
has been made. It is completely bound up
in its material realization, in the stuff the
artist worked with; furthermore, it is com-
pletely tied to the here and now. Traditions
and influences were usually transmitted
directly. In the Gothic guilds, personal
instruction in the craft, the occupational
travels of journeymen and apprentices, and
to some extent study of existing works of
art were the accepted ways to learn. (The
illuminators of manuscripts profited also
from books received from foreign centers.)

In the Renaissance, however, aesthetic
ideas could be, and commonly were, dis-
seminated in another way, with a fundamen-
tally different attitude. What had hitherto
been tangible and practical gradually be-
came, as it were, spiritualized. The highest
value was no longer attributed to the actual
art object, something whose worth was in-
separable from its material realization, but
primarily to the *idea* contained in the object.
This essential idea was already present in the
rough sketches prepared by the artist. These
revealed not only the artist's "handwriting"
—his personal trademark, as it were—but
also his striving to embody a given theme.
The subjective nature of the sketch differ-
entiates Renaissance work at its very source
from the objectivity of medieval working
projects. During the Renaissance, a sketch
was prepared at the behest of the patron who
wished to commission the work, and this
sketch was most important to him. Once
the sought-after genius had consented to
submit his rough draft, either the artist him-
self or other masters were required to ex-
ecute it: it was in no way a simple matter of
realizing a finished product from a detailed
working model as had been the case in the
Middle Ages.

This separation of the artistic act from
mere craftsmanship was already apparent in
the second half of the thirteenth century,
and it is hinted at in the work of Nicola
Pisano. With Arnolfo di Cambio, the obvi-
ous difference between his work in Rome
and his work in Florence is best explained if
we presume that, while in Florence, he sent
on to Rome rough drafts for his commissions
there, which were to be executed by sub-
ordinates. Also, certain inconsistencies in the
work of Giotto (hitherto sometimes ex-
plained by denying Giotto's authorship)
could be understood by supposing that he
followed the same procedure. About 1330,
Giotto was called *protomagister* and *proto-
pictor* ("first master" and "first painter") at
the royal court of Naples. These well-docu-
mented, authentic designations seem to
refer to some such preparatory division of
labor undertaken for that court. Many and
better-documented instances of this are
found in the fifteenth and sixteenth cen-
turies. Brunelleschi's great churches in Flor-
ence were mostly constructed after his death,
on the basis of his models and drawings.
Michelangelo, working in Rome, used this
method to carry out architectural and sculp-

tural projects in Florence such as the Medici Chapel and the Laurentian Library. Explicit references in his letters and his drawings prove this. A great many of Raphael's works also were completed in this fashion.

## Religion and learning

*The Influence of Religion.*[7] The Catholic Church had been the great cultural leader of the Middle Ages, achieving a synthesis of the still-vital values contained in a tradition founded in over three thousand years of development of the human mind and soul. Everything that had been accomplished in the intellectual and spiritual realms by Egypt, the ancient Middle East, the Hebrews, and the Greeks and Romans, plus the contribution of medieval Christendom, the Church assembled into a vast unity designed to satisfy all inquiring intellects. To the simple in heart, the common folk, the Church offered the passionate conviction of the Gospels, the legends of the saints, and a few uncomplicated and unequivocal moral precepts. For the more fastidious, there was the inexhaustible variety and profundity of the accumulated thought of the East, of classical antiquity, and of Christianity itself, on which basis Scholasticism had erected a system of learning of overwhelming richness and impressive consistency and universality.

The world of the medieval Catholic Church continued to stir the imagination of Renaissance patrons and artists profoundly. The extent and intensity of this survival into the new age has never been made sufficiently clear. But it is art above all which reveals, beyond the shadow of a doubt, that the specifically modern impulses of the Renaissance in Italy were not yet able to break away from the framework of traditional medieval Christian culture.

The great achievements of the duecento and trecento, although deriving from medieval art, remained by and large the unquestioned foundation for everything to which the quattrocento and cinquecento aspired. The models and standards for these later centuries included churches and cloisters, sculptured façades, pulpits, baldachins, baptismal fonts, bas-reliefs on the bronze portals of churches, fresco cycles and mosaics, altarpieces with marble or carved or painted decorations: the imagery on all of these depicted the doctrines inherited from many centuries of intellectual effort on the part of Christian theologians.

In the duecento the native genius of the Italian people seized upon the varied elements of the medieval tradition—Byzantine, Romanesque, Gothic, Early Christian, and even pagan Classical—and synthesized these in one great process of amalgamation. At the same time, the creative imagination of the era stamped this older rediscovered raw material with the mark of its own prodigious groping toward something different—a world that was new, distinctly Italian, and increasingly modern. The great bulk of Renaissance art belongs to this continuous tradition. Moreover, this is true of the entire hierarchy of the arts, from the most modest folk handicrafts to the artistic revelations of the most refined spirituality, from the pilgrim amulets stamped with a holy picture (used as small change) all the way up to Raphael's *Sistine Madonna* and the great frescoes Michelangelo conceived for the Sistine Chapel.

All the well-known iconography of medieval Christian art lived on into the Renaissance, though subject to the rule of continued change and progress, as are all living things at all times: the Mother of God, or the Madonna, with her look of a woman of the people; the scenes from the life of Mary and from the Passion that had stirred the faithful for so many centuries; the saints and their legends, inexhaustibly rich in pictorial suggestion, endowed with religious

feeling and so powerful in arousing such feeling in others; and finally the great, carefully programed cycles illustrating doctrinal, moralistic, and allegorical concepts, the very reflection of Scholastic schematization of belief. All these pictorial concepts survived into the Renaissance in the same archetypal forms the duecento and trecento had evolved for them. The mighty stream of religious and artistic tradition with its source in medieval Christendom flowed calmly on, and the artists of the Renaissance bathed in it, from the humblest craftsmen to veritable titans of the spirit such as Michelangelo. What the Renaissance did change was the *manner* of expressing these older concepts and the *form* of their presentation.

*The Influence of Learning.* It was left to Humanism to infuse the sciences and learning in general with new impulses. From the fourteenth century on, owing mainly to the study of antiquity, the conception of man took on a new character. In the Middle Ages, Christian theology had been the sole determinant of this conception, and to Scholastic thinkers the literary and artistic remains of antiquity seemed of value only insofar as these could be incorporated into the system of Catholic dogma. To the Humanists, however, the classical heritage was considered valuable in and for itself, its relics being priceless signposts through which mankind could achieve self-realization in harmony with nature. In Italy, as early as the fourteenth century the barriers between the scholarly Humanists and the artists began to disappear. Both groups belonged to the circles around the great political leaders of the time, and the artists—especially the greatest of them, those whose work pointed to the future—joined with the scientists and philosophers as exponents of Humanism.[8]

Involvement with the new learning had two effects on Renaissance art: it brought a predilection for antique themes,[9] both mythological and historical (at least to the extent that the predominantly Christian cultural nexus permitted), and it stimulated artists to seek an appropriately "Classical" style for subjects drawn from antiquity. The stages of this progress can be summed up in a short list of masterpieces of the period: Donatello's "*Atys-Amorino*" (pl. 126); Verrocchio's *Putto with Dolphin* (pl. 97); Botticelli's *Birth of Venus* (pl. 169)[10]; Signorelli's *School of Pan* (pl. 170)[11]; Michelangelo's *Battle of Lapiths and Centaurs* (Colorplate 25); Leonardo's *Leda* (pl. 135); Raphael's *Cupid and Psyche* fresco cycle in the Villa Farnesina in Rome (pl. 174); and finally, Titian's *Venus and Danaë* (pls. 172, 173).

This side stream of Classicism, fed from Humanist sources, existed concurrently with the diversified mainstream of Christian art and gained increasingly in power. Like the mainstream, it split into many branches as time went on. One result of the intensive study of antiquity was the rediscovery of late-antique Middle Eastern culture, which had been fostered and developed by the Islamic Arabs throughout the Middle Ages and in which astrology played so important a part. This offered artists still another kind of subject matter, of which the fresco cycle executed by Francesco del Cossa and others in the Palazzo Schifanoia in Ferrara is the most striking example (pl. 175).[12] Even the greatest artists were unable to resist the seductive magic of this mysterious portentous, fatalistic realm of thought, as is evidenced in Dürer's engraving *Melencolia I* (pl. 179) and in many details of Michelangelo's Medici Chapel. Its influence is perceptible in other masterworks of the Renaissance such as the enigmatic themes of Giorgione and Titian's *Sacred and Profane Love* (pls. 166, 149), inspired perhaps by Humanist imaginative writings of an antiquizing character such as the *Hypnerotomachia Poliphili* by Francesco Colonna. Still another derivative of the antique and astrological subject matter is seen in the several

arts of ornamentation, comprising a wonderfully attractive, seemingly inexhaustible world of forms.

The peculiar parallel course of the classicizing and the Christian currents is perhaps most clearly demonstrated in the Ducal Palace of Urbino, where beneath the small library (the *studiolo* of Federigo da Montefeltro) two chapels were built—one dedicated to the Holy Ghost, the other to the Muses. That the two currents sometimes merged has already been noted in Dürer's wish to appropriate the sensual beauty of Apollo and Venus for the purposes of Christianity. The attempt to lend greater dignity to Christian subject matter by profiting from the truth and beauty of antique forms is one of the main features of the Renaissance, and this reconciliation of two apparently opposite traditions lies at the root of the highest achievements of its greatest architects, sculptors, and painters.

*Artists and the Public.* The Humanist world of poets, scholars, and philosophers remained, it is true, within the confines of Christian culture; yet within that context it constituted a foreign body, for it was marked by an inclination toward independent, often empirical inquiry. Ever since the appearance of Humanism in the fourteenth century, this inquiring spirit tended to drive a wedge between Humanist circles and those social strata which persisted in clinging to traditional Christian principles. For those artists who were also Humanists, there resulted an open conflict with the mass of the public. In the late thirteenth century, there had already been such opposition between the progressive intellectual class in Italy and the general populace. We have already quoted Ristoro d'Arezzo's account (c. 1282), which offers very early and interesting evidence of this. He stresses the clash of opinion between the uninformed masses and the "connoisseurs." The latter prove worthy of their title in that they alone appreciated the true beauty of the

antique vase fragments discovered. As early as the year 1311, in the verse inscription he set into the pulpit of the Cathedral of Pisa, the sculptor Giovanni Pisano cried out against the uncomprehending public: "I foresaw it all badly; while I pointed out the way to many things, I also endured many blows and insults. . . . He who is worthy of the crown proves himself unworthy if he revile it; he honors him whom he insults, for in so doing he himself has been put in the wrong." Such plaints from unappreciated geniuses were to be heard more and more often, and they were to become even more pathetic.

Later in the fourteenth century, the great Humanist poets Petrarch and Boccaccio both wrote of the conflict between connoisseurs and laymen in matters of art, especially in terms of a conflict between the educated and the uneducated. Virtually no great Renaissance artist was spared some part in this conflict, which in our times is still a significant factor in the relationship between artist and public. Conflict was inevitable as artists began to liberate themselves from the constrictions of a uniform culture, that is, when the world of the spirit prepared to seek its own destiny, no longer bound by the accepted standards of the masses.

# CHAPTER THREE

# ARCHITECTURE *The formal vocabulary*

*Origins and History.* Architecture[1] is often considered the "mother of the arts." For Renaissance art, this notion proves particularly valid—at least to the extent that one can say that Renaissance style, growing out of medieval styles, achieved greater independence in architecture than in any other form of art. One might ask, indeed, whether Italian painting and sculpture from about 1400 on do not simply represent a stage in the development of a formal vocabulary that had already been in use for a hundred and fifty years, somewhat like the development of the English language from Chaucer to the Elizabethans.

Such a continuation cannot be discerned in architecture. Beginning with the mature style of Filippo Brunelleschi, about 1419, a quite different architectonic language made its appearance, the personal creation of that unparalleled genius.[2] This style was the fruit of a perfectly conscious individual act of will, and through this revolutionary act, many other Florentine and Italian artists, previously unable to express adequately what they felt, were enabled to find their voices. What they desired especially was a "rebirth" of the formal vocabulary of Greco-Roman antiquity; in fact, an immediate continuation of the Classical style of the ancients seemed perfectly feasible to these artists. In their time the treasure house

of Italy still possessed many more antique monuments than exist today—and it remains incomparably richer than any other country. Brunelleschi was the first to recognize with utmost clarity that this ancient legacy was a treasure from which one could mint new coin far surpassing the current architectural tender, which he felt had been debased by its outworn medieval character.

The transition from will to deed ensued, apparently, in that methodical fashion which was especially characteristic of the Renaissance. Brunelleschi and his friend Donatello set out to study, analyze, and measure the ancient ruins of Rome. This we learn from Vasari,[3] who with his usual relish for anecdote tells us how suspiciously the Romans viewed the actions of the two Florentines, whom they took to be grave robbers. (This same reaction harried the first archaeological expeditions of the nineteenth century in the Near East.)

It is possible that this "study at the source" was a later stage in Brunelleschi's development and that he first sought, vainly, his new style in the pseudo-antique buildings of the so-called Florentine proto-Renaissance of the eleventh to thirteenth centuries.[4] Actually, however, the question of priority is irrelevant, for sooner or later he would have arrived at the same conclusions. Although Brunelleschi's notebooks with his drawings of ancient monuments have been lost, we can get some idea of what they must have looked like from the sketchbooks of Giuliano da Sangallo preserved in the Vatican Library and in Siena (pl. 212).[5]

Brunelleschi's findings were epoch-making. Succeeding generations of architects continued to study and investigate the material that he was the first to explore, and during the fifteenth and sixteenth centuries they worked out a classicizing vocabulary of forms for the new architecture of the Renaissance.[6] There is, however, one extremely significant factor that must always be kept in mind. The vocabulary they developed was merely classicistic, and it could never be genuinely antique for two reasons: first, the structures to which it was applied were, of course, contemporary and not antique; second, in many cases medieval methods of construction were still being used. We must now consider the characteristic elements of this classicizing language of forms.

*The Classical Orders.* Instead of medieval supporting piers, Renaissance architects preferred true columns based on the four Classical orders: Corinthian (pl. 6), Composite, and, less often, the Ionic and Doric.[7] Most often these were based on the old Roman versions of the orders; thus, the column shafts were usually smooth, without the Greek fluting, and the Doric order was used

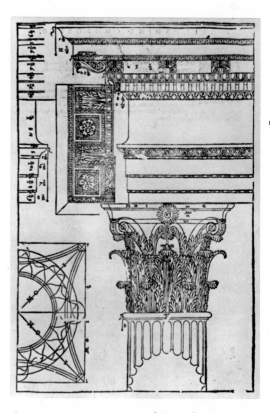

6.  ANDREA PALLADIO. Corinthian Column, *woodcut illustration in* I quattro libri dell'architettura, *Venice, 1570*

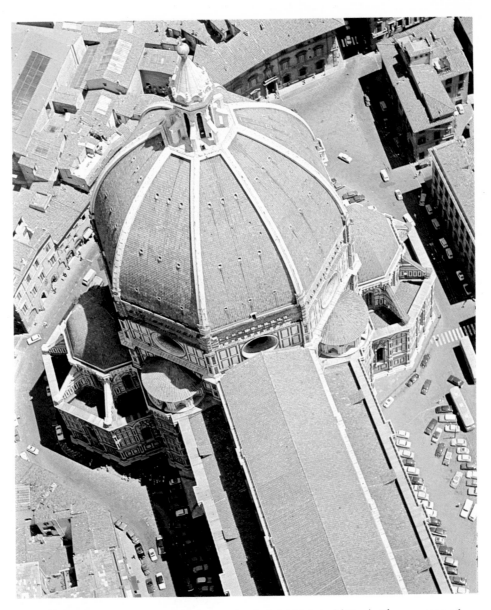

Colorplate I.   FILIPPO BRUNELLESCHI. *Dome of Cathedral (S. Maria del Fiore), Florence. 1420–36*

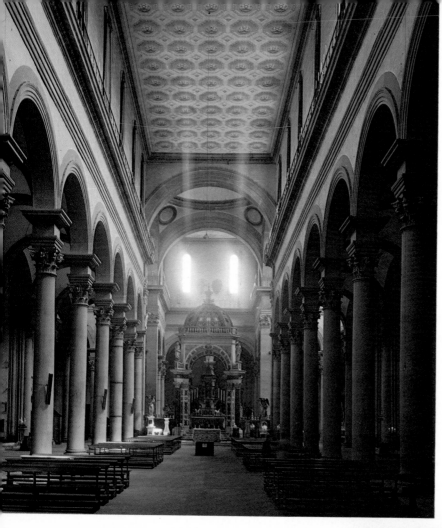

Colorplate 2. FILIPPO BRUNELLESCHI. *Interior, S. Spirito, Florence. Begun 1434*

Colorplate 3. FILIPPO BRUNELLESCHI. *Interior, Old Sacristy, S. Lorenzo, Florence. 1419–28. (Sculptural decoration by* DONATELLO, *c. 1435–43)*

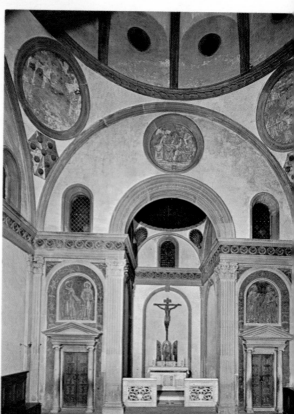

almost exclusively in its Italian (i.e., Tuscan) variant, which was derived from Etruscan practice.[8]

In general, this relationship to ancient models remained completely free. Therefore we must not consider it an offense against Classical principles that, for instance, instead of the conventional ancient entablature (architrave, frieze, and cornice), round arches spring directly from the capitals of the columns. This form had been used in ancient Rome and also very frequently in the Early Christian era.[9] (True, Alberti rejected the idea of setting arches directly on capitals and held out for the use of entablatures.) When the Renaissance did make use of the entablature, moreover, it was seldom differentiated according to the regular Classical orders; what mattered was only that the architecture had an over-all Classical appearance.

This approach holds true for the capital also. In ancient buildings the capitals generally are all of the same order, either throughout the structure or at least throughout an entire section of a structure. In a Renaissance building, instead, the orders are freely mixed. The obvious pleasure in such diversity is like that attitude which led to the great variety of capitals and columns in medieval buildings.

Freestanding columns are usually echoed by engaged columns or pilasters, either smooth or fluted, which act structurally as piers—though like columns in the round these are composed of base, shaft, and capital for aesthetic purposes. Freestanding pillars in interiors (for structural reasons, indispensable at points of stress) were made to approximate columns as much as possible, either through superimposing on them the typical articulations of Classical supports or by making their proportions similar to those of columns; in any event, everything possible was done to avoid resemblance to medieval composite piers.

*Walls, Windows, and Portals.* In the Gothic style of the late Middle Ages the ideal conception was of a nearly transparent wall reduced to thin supporting members, or at least delicately articulated with a series of differentiated levels and projections.[10] Even in the Middle Ages, however, this Gothic ideal never found so much favor in Italy as it had north of the Alps. The southern world preferred solidly enclosed spaces, with the walls left as smooth as possible; the feeling for massive, solid structure bequeathed by the Romans was apparently still strong.[11] Even during the Gothic period proper, the northern Gothic was considered in Italy as something unnatural, an aesthetic that smacked of revolt against the eternal laws of nature. With the emergence of the Renaissance, this Italian attitude gained in conviction. Wall surfaces remained unbroken; thus, with few apertures and small window area, the walls became the true bearers of the weight of the superstructure, with no recourse to auxiliary weight-bearing members. The complicated Gothic system of support, which aspired ever higher as it piled up flying buttresses and distributed weight through added pinnacles, was progressively rejected and abandoned.

Both Filarete and Vasari eloquently expressed the general dislike—indeed, hatred—of this "unnatural" formal machinery. In varied ways, the Renaissance style sought to counter Gothic complexity by a delight in the beauty of finely proportioned, unbroken wall surfaces adorned only by the use of rich materials. If the wall could not be constructed entirely of costly marble, at least it could be covered with a thin marble veneer, for which precedent can be found in the inlay technique used during the medieval proto-Renaissance in various Italian art centers. Overlaying with colored marbles resulted in a decorative style that transformed the flat surface of a wall into a delightful play of line and color.[12] Even

7.   *Biforium window forms*

8.   *Aedicula window form*

9.   *Early Renaissance portal*

interior floors were brought into the decorative scheme by the use of mosaic pavement.[13]

Openings in walls were restricted to the dimensions demanded by their function. Windows of the quattrocento maintained the narrow, round-arched form inherited from the medieval Romanesque. In the Early Renaissance the round-arched window was frequently subdivided by a small central column, which gave rise to two smaller round arches—again a Romanesque and Gothic motif (pl. 7). Even the use of Gothic tracery was continued in some places. Only toward the end of the fifteenth century and, finally, in the sixteenth was this holdover from medieval tradition supplanted by the antique-inspired "tabernacle" or "aedicula" window, in which two half columns or pilasters are set at the sides of the aperture and are crowned by a pediment (pl. 8). Especially popular was the alternation of triangular and half-arched gables across a wall front, a harmonious pattern permitted by the two possible forms of these windows.

Portals underwent a similar development. Typical of the Early Renaissance portal was a right-angled frame with a Classical profile, to which was often added a semicircular relieving arch springing from the vertical supports, a motif that had been frequent in Romanesque portal design (pl. 9). In the High Renaissance, the ideal portal form was the monumental aedicula with half columns and pediment.

*Ceiling and Vault Forms.* The vault was the principal method of covering an interior space during the Gothic period. By contrast, the Renaissance favored the flat wooden ceiling, usually with antiquizing coffered paneling for decoration; this roofing form was employed not only for civil architecture but also, and especially, for religious edifices.[14,15] In multi-aisled churches in which both vaults and flat ceilings were used, the latter form usually had the place of honor over the central nave. Ceilings having ex-

posed timberwork with painted decoration
had been very popular in Italian religious
architecture from Classical times through
the Romanesque and Gothic periods and on
into the trecento. In the quattrocento, how-
ever, this form was considered insufficiently
monumental and impressive, and therefore
its use was relegated to less important
structures.

Vaulting remained in use during the
Renaissance, but the Gothic forms disap-
peared and were replaced by new forms
inspired, as might be expected, by those of
antiquity (pl. 10). Thus, the cross-ribbed
vault was abandoned for the ribless groined
vault, a Roman type that had also been used
in Romanesque architecture. Just as frequent
was the incidence of the barrel vault, like-
wise a Roman and Romanesque type. For
large halls, mirror vaulting became com-
mon. This form arose, apparently, toward
the end of the trecento in Tuscany as a varia-
tion on Late Gothic web vaulting, as seen in
the Chapter House of Santa Felicita in
Florence (pl. 11).[16]

For large central-plan structures, the
cupola supported on pendentives was bor-
rowed from Byzantine architecture (pl.
12a). The crowning lantern, also of Byzan-
tine origin, was patterned after those of the
Tuscan proto-Renaissance of the twelfth
century, which were themselves for the most
part derived from Roman round temples.
To achieve a smooth transition between
lantern and cupola, volutes were introduced
into the design. These spiral scroll-shaped
forms had been used in antiquity as decora-
tion, especially as bracket consoles (small
stone elements designed to support project-
ing cornices), and they seem to have evolved
from a minor, decorative architectural use
in the trecento to a much more significant,
and structural, function in the monumental
buildings of the Renaissance.[17]

Domes and cupolas had two principal
forms. Either they were simple hemispheres

10. *Vault forms:*

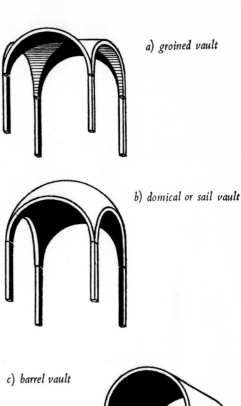

a) *groined vault*

b) *domical or sail vault*

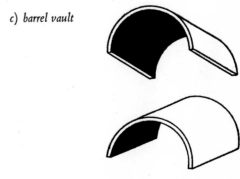

c) *barrel vault*

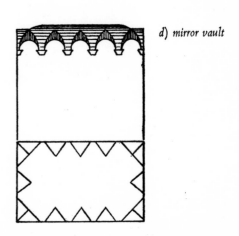

d) *mirror vault*

("calotte"), as had been used in Roman times, or they were segmented like a parasol or melon, in a free adaptation of the antique or Byzantine design (pl. 12b).[18] Especially popular was the "sail vault" (pl. 10b), a combination of cube and hemisphere, which was frequently used in series over side aisles or loggias in place of the cross vault.

## Structural principles

As must now be evident, Renaissance architects were not free to invent the individual elements of their structures but were tied to the forms of older styles, especially to those of classical antiquity. However, in dealing with the over-all structure or main body of the building, they enjoyed some degree of freedom. Each building demanded its own organization, an individual solution. But even in the general conception there were certain guiding principles imposed by medieval tradition or by the rediscovery of antiquity. Renaissance architects followed such principles to a certain point, as will become clearer when the different types of buildings are examined. In spite of these limitations, they enjoyed appreciable liberty, for the imposed standards applied only to the broad characteristics of the forms used.

It is quite obvious that the formal ideal of the Renaissance—especially in its opposition to everything Gothic—had greatest influence in the conception of the structure as a whole. The Gothic structure aimed always to transcend its material limits, to attain infinity, not only through spatial extension but equally through immense diversity of individual details and the way in which these relate to one another, with each detail com-

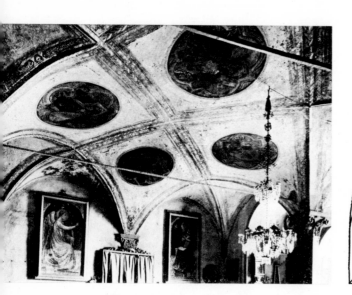

11.   *Renaissance web vaulting. Chapter House of S. Felicita, Florence. 1387*

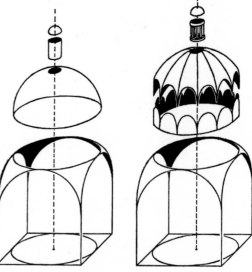

12.   *a) Dome of central-plan church; b) "Parasol" dome of central-plan church*

plementing and rendering more significant the others. In these highly articulated shells of stone, there are no strongly discernible spatial or structural barriers. In contrast, the Renaissance building is finite, unambiguous, and complete in itself, frankly revealing all; its construction rejects the transparent, bewildering kaleidoscope of soaring Gothic vaults, pinnacles, and fretworked gables, along with their many-faceted refractive character. The Renaissance building, instead, is locked into a compact unity that derives from simple stereometric forms such as cubes, cylinders, cones, and hemispheres, and its beauty results precisely from the purity of these primary components.

These simple forms are the architectural expression of that fundamental feeling for the essential orderliness of nature of which the theorists of the time speak so often and with such insistence. From the writings of Alberti and of Humanist philosophers such as Nicholas of Cusa and Marsilio Ficino, it is clear that a religious significance, a kind of spiritual revelation, was attributed to numerical ratios and geometric figures: the essence of God and the divine harmony of the universe were to be found in the mathematical symbol.[19]

Confronted with the stereometric character of Renaissance architecture, one is often reminded of the Romanesque; yet there is a fundamental distinction that should not be underestimated. In Romanesque art the effort to mold clearer, more compact stereometric shapes was restrained by the hand of tradition, by religious convention. A church was designed for liturgical use; this determined its structure and components, and that is why Romanesque churches everywhere conform to a standardized pattern. These bonds of tradition were broken in the Renaissance by the desire for perfect embodiment of an ideal form. The striving for beauty—and for beauty as a revelation

of divine truth—became an autonomous end; at least this was how the Renaissance artist conceived it and willed it to be.

Perhaps the clearest manifestation of this quest for ideal, symbolic beauty is the central-plan church. This type of structure, equally impressive from all sides, allows full play for a design in which stereometric elements (cubes, cylinders, hemispheres, and the like) are combined in their purest aspect and with absolute symmetry. Symmetry itself was a quintessential factor in the Renaissance ideal of beauty in architecture, as in all the arts.[20]

If we agree that the creative drive of Renaissance architecture found fulfillment in the development of stereometric structures, then one may well ask how such free creation could be reconciled with the Classical formal vocabulary which, as we have seen, constitutes another main condition of Renaissance architecture. The answer is not difficult. The antiquizing elements are completely assimilated into and in harmony with the essential structure. They are Classical—that is, in that they are conventionalized and formal—and, at the same time, they are an expression of one of the laws of nature in its application to art. Within the over-all design they assume the function of showing that the same attitude which imprinted such rigorous form on the total structure can also produce something quite different, the casual grace of purely decorative elements. In a mysterious way, then, two worlds are linked together (worlds that, according to the firm conviction of the Renaissance masters, are essentially in harmony): the world of pure stereometric forms and the world of organic natural forms; or to express it another way, ideas in their pure, abstract, and mathematical form and ideas in material form. Whether created by nature or by art, both employ natural forms and both are fashioned after them.

## The conception of space

The conception of interior space corresponds exactly to the conception of outward structure. When this simple relation is understood, lengthy theoretical explanations become superfluous. Renaissance architects envisaged and designed interior space as something solid and tangible, a physical property, as if a structure were made of *space* rather than of stone. (That medieval architecture was based on a similar conception would seem highly dubious.) As a consequence, the interior of a Renaissance building was designed to correspond perfectly to its exterior. In all carefully worked out buildings of the period, spatial organization and solid structure follow the same laws. Individual units of interior space, like the elements of exterior construction, are based on abstract geometric concepts and are clearly related to the structural whole.

The beauty of such spaces lies precisely in the clarity of their stereometric design. Their effectiveness can be seen, for instance, in the distinctly cubic volume of a flat-ceilinged nave (pl. 18), or in the pleasing self-contained shape of a hemispheric dome. The effect of the inner space differs from that of the outer solid structure only insofar as the latter is intended to impress the viewer from a distance, whereas the interior has a more immediate impact since the viewer is himself enclosed with it. This involves a psychological distinction which has nothing to do with the architecture as such, but only with the beholder.

The fact that the Renaissance consciously calculated such distinctions in effects is one of its most striking characteristics. As will be shown later, another discovery of the period, linear perspective (making use of the central-projection method), introduced new possibilities for similar distinctions in effect in painting and reliefs.

Architects, fully aware of this problem of viewpoint, never considered a building as a thing in itself, without reference to its eventual effect on the beholder. Instead, they quite plainly considered such relationships and planned their designs accordingly. This is most evident in the especially characteristic development of the double-shell dome, which confirms that the interior was conceived and designed as a spatial construct relating the external, containing structure to the true body of the building. The earliest examples of such double-shell domes are that over the crossing in the Church of Santo Spirito in Florence, designed in 1479–82 by Salvi d'Andrea, and that over the sacristy in the same church, erected between 1488 and 1496 by Giuliano da Sangallo and Antonio del Pollaiuolo (pl. 13). In buildings of the High Renaissance, the dome is normally composed of two separate shells, one set within the other. The inner, smaller shell is conceived as a crown for the interior space, the larger outer one as a climax to the exterior mass. This division into two more or less concentric layers, without precedent in medieval and ancient architecture, can only be explained in terms of the effect it was intended to have on the viewer. Seen from

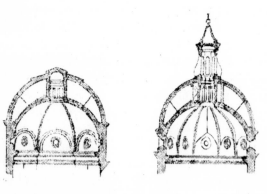

13.  *Double-shelled domes. Church and Sacristy of S. Spirito, Florence. Completed late 15th century*

outside, from a distance, the dome can achieve its full impact only if its contour is substantially enlarged and emphasized, if it is raised above the surrounding parts, and if, thereby, optical foreshortening is counteracted. In the single-shell dome, this was possible only if the shell was thickened and its profile altered. However, since the interior of the dome is affected by quite different factors—and obviously should not be altered in form for exterior considerations—the remedy was found in enclosing it in an outer shell of more imposing dimensions and with a somewhat different, steeper contour.

## Proportions and composition

It should be readily apparent that in such architecture the science of proportion assumes a central place. Where clarity is sought above all, the ultimate and highest task will, of necessity, be to clarify the rhythmical relationships between the container and that which is contained, between outer structure and inner space. Alberti revived interest in the writings of the Roman architect and engineer Vitruvius (1st century B.C.), and Renaissance architects embraced the idea of the ancient theorist that individual parts of a structure should be inseparably related to each other and to the whole. This organic relation should be so tightly composed, they maintained, that even the most minor parts could not be altered without disrupting the harmony of the whole.[21]

Vasari's pronouncements on proportion are, of course, concerned with the representation of the human body in sculpture and painting. But they are equally illuminating for architecture because the aesthetic idea, as understood in the Renaissance, was thought to be a fundamental natural law made visible in a material embodiment. The architect, thus, should govern the relationship of the parts so that the structure becomes a convincing whole, an architectonic body which functions organically and which expresses—exactly as do human beings, animals, plants, and every physical embodiment —the ultimate sense of things and thereby reveals their essence, the natural order of all phenomena in creation.

It is precisely this grounding in nature which explains the special character of the Renaissance art of perspective. Particularly significant in this connection are many drawings to be found in treatises on architecture, especially in a treatise of Francesco di Giorgio, where a drawing of a human body is superimposed on the ground plan of a basilica to demonstrate the analogy between the architectural conception and organic reality (pl. 14). In the architect's first sketches, when the structure is still in the initial stages of conception, the building is projected in the form of a human body. Although it may be only a fleeting sketch, the work is conceived of a priori as something consistent, as an idea clothed in matter. In such rough sketches (those of Leonardo da Vinci, for example), the stereometric basis is indicated with such purity and emphasis that we understand to what extent it was the abiding principle—the ideal, primordial image of the corporeal realization (pl. 15).

Because stereometric archetypes coincided with total structure for the Renaissance architect, he could bypass what had been the point of departure for his Gothic predecessor—the planimetric aids to construction offered by triangulation and related methods of determining proportions (that is, the use of triangles, squares, and so forth, to ascertain the mass and relationships of ground plan and elevation).[22] In Gothic architecture, geometry was employed for the most part as a two-dimensional linear science, even when working with an overall mass; in its Renaissance applications, it became chiefly a three-dimensional science of volumetric bodies. The efforts of Renaissance masters gave the mathematically

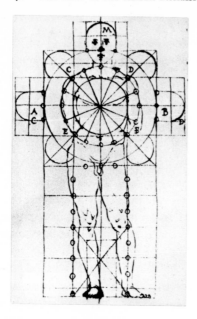

14. FRANCESCO DI GIORGIO. *Anthropomorphic Der-*
*ivations of Church Plan. Pen drawing from* Trattato
*(fol. 43v). c. 1490–95. Biblioteca Nazionale, Florence*

15. LEONARDO DA VINCI. *Drawing of Central-Plan*
Church *(Ms. B, fol. 25v). Bibliothèque de l'Institut*
*de France, Paris*

calculated figure new significance by return-
ing the structure to its simplest form, to its
ideal archetype. The Renaissance architect
operated by induction; the Gothic builder,
by deduction.

In our attempt to grasp the Renaissance
doctrine of proportion, the recognition that
the same ideal proportions govern both
architecture and figure drawing carries us
one step further. As revealed in many draw-
ings, including those of Leonardo and
Dürer, Renaissance painters and sculptors
derived planimetric figures primarily from
the natural organic appearance of men,
horses, and other living creatures. The con-
verse approach—basing the representation
of nature on abstract geometric forms—was
followed by Gothic artists such as Villard de
Honnecourt. In parallel efforts, therefore,
architects, painters, and sculptors of the
Renaissance threw light on universally bind-
ing laws of their respective arts and arrived
at identical results; in one and the same
geometric figure they found revealed the
occult unity within the manifold, the eternal
law within the accidental phenomenon. For
architects, thus, antiquity proved to be the
best guide. The architectural treatise of
Vitruvius (the Bible, so to speak, of the many
Renaissance architects who swore by an-
tiquity) contained early speculations of this
sort, and later editions of it were illustrated
with drawings demonstrating the essential
similarity of the human body and pure
geometric figures (pl. 16).

The Classical orders had also translated
the organic into the architectonic, and the
recondite analogy between the column and
the human body was now discovered or,
rather, rediscovered. This is revealed in such
architectural terms as "capital," derived
from the Latin *caput,* meaning "head." This
human analogy was insisted upon in both
the text and illustrations of the theoretical
writings of Antonio Filarete and Francesco
di Giorgio.[23]

Just as the proportions of the human body presented a problem to be solved by the Renaissance artists and theorists, so also did those of the column. One important conclusion was arrived at: the column was also recognized as a natural phenomenon, with a structure and proportions that were, by and large, given and unalterable. These could only be accepted as they were and, in essence at least, respected. The attitude had been quite different in the Middle Ages, when the proportions of columns were varied at will according to their special function in the architectural plan. Contrary to this, the Renaissance was obedient to an entirely different principle, namely, the recognition of the authority and immutability of primordial forms derived from nature. According to this new aesthetic, then, all medieval notions of proportion were judged unnatural and arbitrary.

The column is that element of the Renaissance building which, by its very nature, was regarded as closest to organic—and therefore, correct—proportions. In association with this single element, all other elements were treated correspondingly wherever possible, and the entire architectural structure was subjected to the same rule of proportion. An absolutely fundamental and new science of proportion was worked out, as the systematic demonstration of an objective, natural law. In this manner, each element of the structure was proportioned according to its inherent nature, as if it were a part of a human body and formed in strictest relationship to other parts and to the whole. From these characteristic parts, also, there grew an organism of equally distinctive character.

Nothing could be more alien to medieval and Gothic procedure, in which the unity of the whole derived from a single basic form (for example, an arcade of pointed arches) repeated throughout a structure, although this might be varied in innumerable ways.

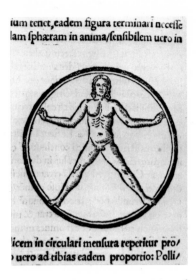

16. FRANCESCO GIORGI. Vitruvian Man, *from* De harmonia mundi totius, *Venice, 1525*

For the Renaissance, unity resulted from sensitive integration of individualized components and was based on carefully manipulated contrast, not on recurring similarity. Highly varied, even contradictory forms were systematically developed, juxtaposed, and played off against each other, so that finally there ensued an equilibrium of diverse forces, a harmony that arose out of contrast.

In architecture, instances of such formal interplay are seen in flat wall surfaces opposed to curved, in cubes played off against cylindrical shapes, in cylinders countered by hemispheres (Colorplate 4, pl. 39). For this new law of composition, the Renaissance theorists used the expression *contrapposto*. The concept was derived from their study of the masterworks of antiquity, and there was a marked similarity between antiquity and the Renaissance in their predilection for playing contrasting forms against one another. Deeply immersed in studying the secrets of proportion contained in old Roman buildings, the Renaissance architect developed, in addition, certain principles for regulation of specific relationships, such as the "golden section," which governed the

ratio of height to width of a wall surface and similar relations.[24]

By and large, whatever its original contribution, the Renaissance drew its understanding of proportion and composition from the ancient Romans. It exploited more clearly and fundamentally, however, the possibilities of constructing according to universal principles and, intentionally or unconsciously, gave purer expression to the ideal nature of the mathematical archetype. The Renaissance movement desired above all to free itself from the mystical, otherworldly orientation of the Middle Ages; and this it achieved, although it could never be completely denied that the Middle Ages had been a precondition for realization of the Renaissance development.

## Religious architecture

The relationship between religious and civil architecture remained in the Renaissance what it had been in the Middle Ages: the former continued to enjoy priority and to satisfy the highest strivings of the epoch. The following types of church buildings became standard.

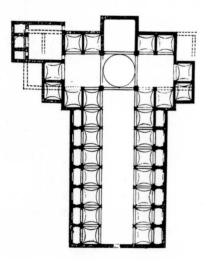

17.  FILIPPO BRUNELLESCHI. *Plan, S. Lorenzo, Florence. 1420–69*

18.  FILIPPO BRUNELLESCHI. *Nave, S. Lorenzo, Florence. 1420–69* ▶

*The Basilica.* The basilica[25] is a church oriented along its longitudinal axis: an oblong with three or sometimes with five aisles, the central one (the nave) being broader and higher than those on the sides. Usually the elongated-rectangle plan is completed at one end by the transept, which cuts across the aisles, and by the choir area extending beyond it—the whole ensemble forming a Latin cross. This form, which had been valued most highly in the Middle Ages, remained the most popular in the Renaissance.[26] When Brunelleschi conceived the idea of ridding church architecture of Gothic "distortion" and returning to the original Classical structure, he took as a point of departure the basilicas of the eleventh- and twelfth-century Tuscan proto-Renaissance, which impressed him and his contemporaries as monuments of antique beauty that had somehow survived. According to Vasari, he took as a model the Florentine church of Santi Apostoli; but recent studies seem to point instead to two churches in Pisa, the Cathedral and San Paolo a Ripa d'Arno.

Like all these Romanesque structures, Brunelleschi's Florentine churches, San Lorenzo (begun 1420) and Santo Spirito (begun 1434), make use of the basilica plan with columns and round-arched arcades (pls. 17–19, Colorplate 2). Like Pisa Cathedral, they have a dome over the crossing or, more exactly, a dome on pendentives as in San Paolo a Ripa d'Arno. Also similar to Pisa Cathedral, the Santo Spirito transept is tripartite and developed in basilican style.[27] Brunelleschi's own innovations were the flat ceiling of the nave,[28] the domical vaults over the side aisles, and antiquizing decorative elements such as pilasters and half columns placed against the side walls to echo the

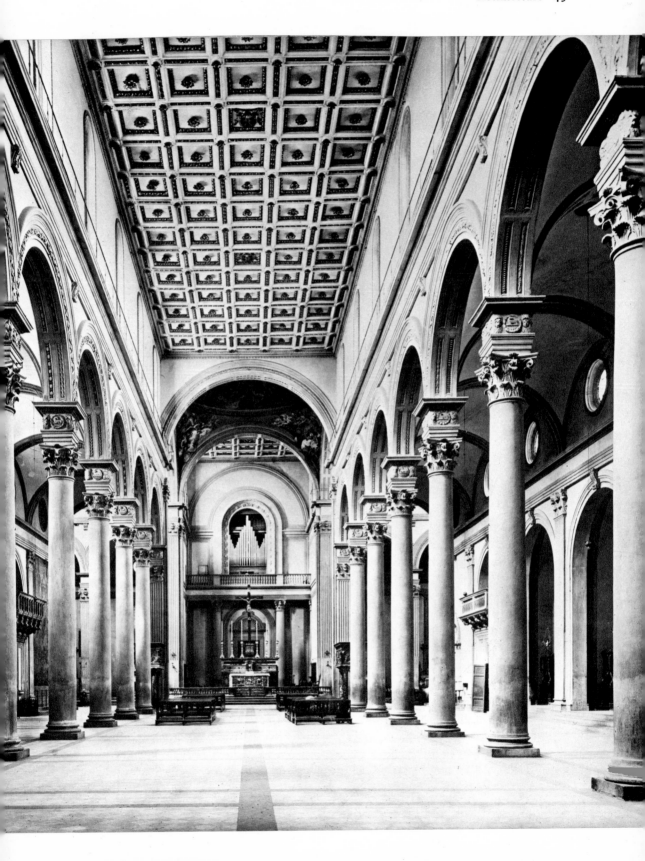

freestanding columns of the nave directly opposite. The wide bands of molding over the half columns and pilasters of the side walls and over the columns of the nave arcade are also Brunelleschi's contributions.

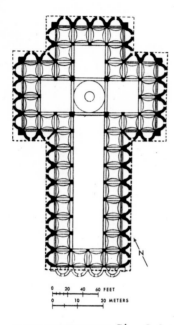

19.   FILIPPO BRUNELLESCHI. *Plan, S. Spirito, Florence.* *Begun 1434*

In San Lorenzo, Brunelleschi's invention was cramped by the fact that he was obliged to use for the transept an older, Gothic plan already under way. This involved square chapels for the apse, a design which was frequently employed by the Gothic builders of Florence in the thirteenth and fourteenth centuries and which was derived from the Cistercian style of the High Middle Ages.

In planning Santo Spirito, however, Brunelleschi was free to do what he wished. His plan was to continue the side aisles around the entire building, a device that also provided a new solution for the transept and the choir. The result was a homogeneous design that attained the Renaissance ideal of logical consistency and concentration. Having extended the side aisle all around the

transept and around the entire choir, he also intended to continue it along the inner wall of the façade, in order to form a kind of entrance hall leading to the nave and thereby completely surround the basilica. However, this radical conception, in marked contrast to the traditional ground plan, was only partially carried through after Brunelleschi's death, and the idea of such an entrance hall was abandoned. Nevertheless, in its completed form, with the side aisle running around nearly the entire building, the architectural conception of Santo Spirito represents the ideal of the basilica toward which Renaissance architects strove unremittingly.

Among the many more or less free imitations of this great model, certain particularly distinctive variations deserve notice. Over the nave, a tunnel vault, usually still with coffered paneling, was often substituted for the flat ceiling, as in the lovely Church of San Sisto (1499–1511) in Piacenza, the work of Alessio Tramello (pl. 20).[29] Another variant involved great bays with cloister vaults or cross-groining. To provide better support, two concessions were necessary. Either pillars (with pilasters) were added to the rows of columns to bear some of the downward thrust—a device reminiscent of the medieval bundle pier, which was used in the Cathedral of Faenza (1474–86; pl. 21), the major work of Brunelleschi's Florentine follower Giuliano da Maiano[30]—or pillars were used almost exclusively, as in Santa Maria del Popolo in Rome (1471–77; pl. 22).[31]

A third variety is the domed basilica, whose prototype is that masterpiece of Byzantine art on Italian soil, San Marco in Venice. The main aisles of domed basilicas are vaulted over with domes resting on pendentives; their side aisles are defined by great tunnel-vaulted niches rising from massive piers that serve as substructure for the domes. Alessio Tramello developed this type at San Sepolcro in Piacenza (begun

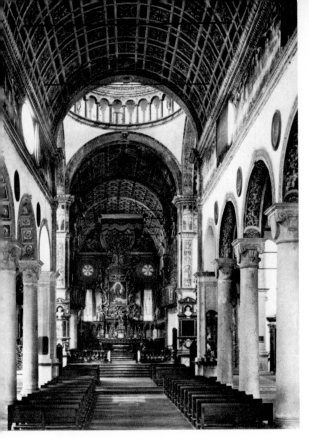

20. ALESSIO TRAMELLO. *Interior, S. Sisto, Piacenza.*
*1499–1511*

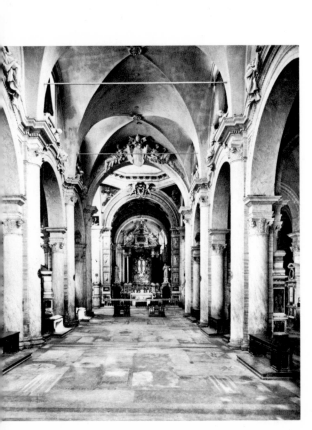

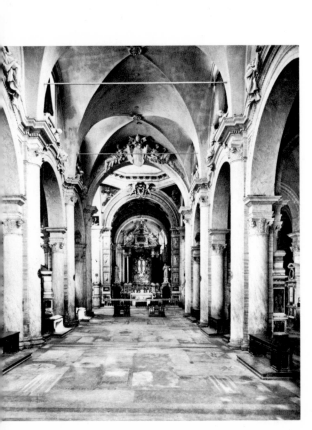

21. GIULIANO DA MAIANO. *Nave, Cathedral,*
*Faenza. 1474–86*

22. *Interior, S. Maria del Popolo, Rome. 1471–77*

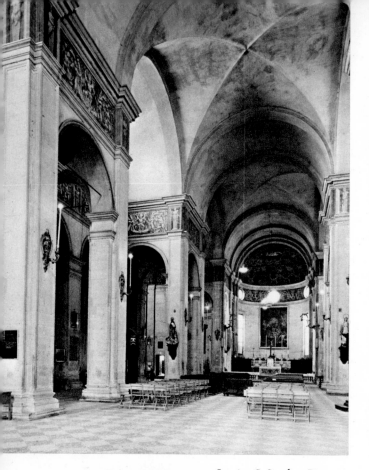

23. ALESSIO TRAMELLO. *Interior, S. Sepolcro, Piacenza. Begun 1488*

1488; pl. 23).[32] In San Salvatore in Venice (1506–34), Giorgio Spavento resolved the pier masses into groups of four slender pilasters arranged in a rectangle (pl. 24), a plan that also derives from San Marco.[33] It was from such variations of the principal types that there arose the almost incalculable diversity of forms assumed by the Renaissance basilica.

*The Central-Plan Church.* The basilica represented the classic type of Christian church in Western Europe; therefore, throughout the Renaissance it remained the ideal of most of the ecclesiastical authorities. The ideal of the architects, however, was the central-plan church,[34] a building developed equilaterally around bisecting central axes. In the hierarchy of values attributed to various types of churches in the treatises of Leon Battista Alberti and Francesco di Giorgio, for religious reasons the central-plan church

was given first place. Because of the perfection and symbolism of its form, the philosopher Nicholas of Cusa considered the cross to be the geometric image of God. Alberti likewise declared that the cruciform, as the most perfect of forms, occupied the highest rank in the cosmos, that is to say, in the whole universe as well as in terrestrial nature. He writes, characteristically[35]: "Nature—and that means God—is reflected principally in this mathematical figure; therefore the cruciform central plan appears the most worthy and the most appropriate for religious edifices." This type had been used concurrently with the basilica since Christian late antiquity and throughout the early Middle Ages (though relatively rare), but in the Gothic period it had become almost extinct. Because it corresponded most closely to the religious sentiment and ideal of beauty of the Renaissance, however, it was the form most likely to excite the imagination of creative artists of that epoch and to elicit their wholehearted enthusiasm.

Once again it was Brunelleschi in Florence

24. GIORGIO SPAVENTO. *Plan, S. Salvatore, Venice. 1506–34*

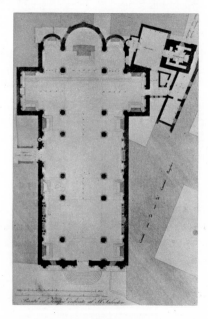

who took the first and decisive step. The earliest central-plan structures of the Renaissance are the Old Sacristy in San Lorenzo (1419–28; Colorplate 3) and the Pazzi Chapel, the chapter hall in the Franciscan cloister of Santa Croce (begun 1429; pls. 25, 26).[36] The point of departure for Brunelleschi's creative achievement was, interestingly, a medieval design, the type of trecento Gothic chapter hall represented by the Spanish Chapel in the Dominican cloister of Santa Maria Novella, a great rectangular room with a cross-ribbed vault, behind which was a somewhat similarly designed choir and family chapel (1350–55). Brunelleschi took over this late medieval design and worked out the central-plan idea which was, as it were, concealed within it. In the Old Sacristy, he substituted a pendentive dome for the Gothic cross-ribbed vault. He used a smaller hemispheric dome over the altar area and a great "melon" shape for the main hall —both of these being personal innovations in this period, though apparently suggested by ancient and Byzantine prototypes.

There resulted spatial structures of truly elemental clarity. The lower part of the main hall (including the zone of the pendentives) forms a cube, and the dome becomes a modified hemisphere, conceived as an image of the vault of Heaven.[37] The proportions and organization of the walls are such as to contribute to the clear presentation of the simple stereometric design. Exactly halfway up the sides of the cubic volume a molding separates the principal hall into two horizontal zones of equal height, and these great horizontals are forcefully opposed by the perpendiculars of the pilasters in the four corners and at the entrance to the apsidal chapel. Combined with these *contrapposto* elements of verticals and horizontals is the cross shape, with four large medallions in the pendentives and many small openings for light in the individual segments of the dome. Cross, vertical supports, horizontal

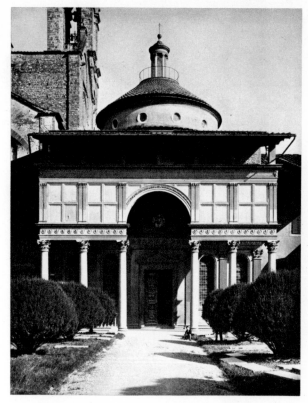

25.  FILIPPO BRUNELLESCHI. *Pazzi Chapel, adjoining S. Croce, Florence. Begun 1429*

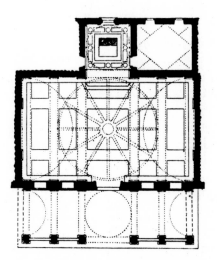

26.  *Plan, Pazzi Chapel, Florence*

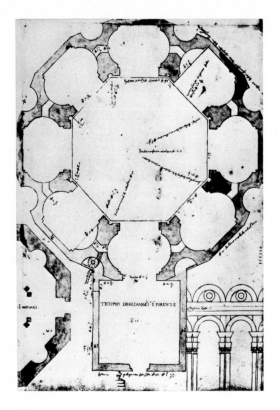

*27.* FILIPPO BRUNELLESCHI. *Plan, S. Maria degli Angeli, Florence. Begun 1434. (Anonymous drawing after Brunelleschi's design)*

bands, cube, and hemisphere—already in these earliest Renaissance central-plan buildings the artistic effect depends entirely on precise selection of these basic elements and on the establishment of relationships between them that are both pleasing and immediately comprehensible. To this is added the charm of organic elements or, more aptly, of Classical elements patterned after organic forms—shells on the chapel pendentives, fluted Corinthian pilasters, *putti* heads (winged angel heads, like Classical cupids) on the sculptured medallions of the molding band, stucco reliefs in the various other medallions—and the use of touches of bright color. However, in this structure the central plan is not fully carried out, qualified as it is by remnants of the medieval chapter hall scheme; in the chapel appended to the main hall, there remains some trace of the older longitudinal plan.

Brunelleschi himself was destined to purge the evolving central plan completely of all such medieval vestiges. This he did by returning to ancient sources. The Pantheon in Rome, a cylinder and a hemisphere combined to form a cubic volume, is the oldest and most radical monumental embodiment of the central plan, an achievement never to be surpassed. In innumerable old Roman tombs, baths, and palaces, there were also heretofore unexploited treasures of central-plan structures, perfect in themselves, wonderfully logical, and of great diversity. Brunelleschi must have been acquainted with these, and he profited from their lesson. Built for the *condottiere* Pippo Spano, his

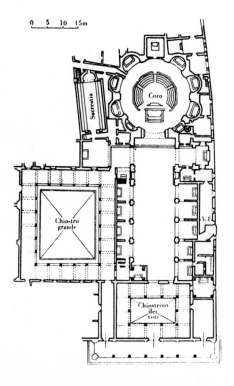

*28.* MICHELOZZO. *Plan, SS. Annunziata, Florence. Begun 1444*

Colorplate 4. ANTONIO DA SANGALLO THE ELDER. *S. Biagio, Montepulciano. 1518–45*

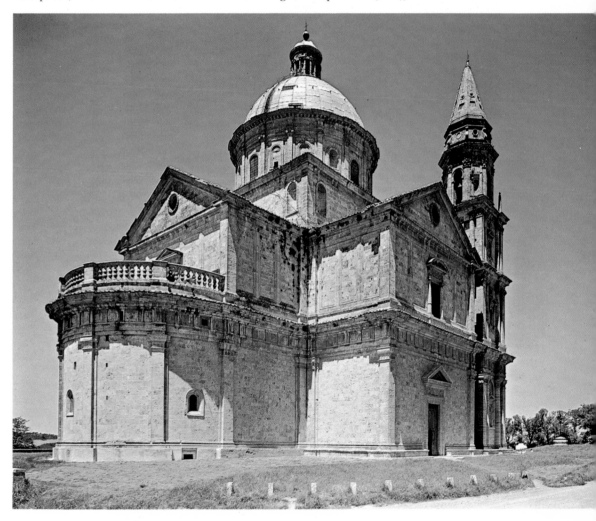

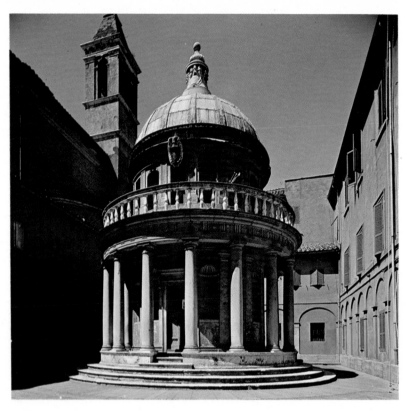

Colorplate 5. DONATO BRAMANTE. *"Tempietto," S. Pietro in Montorio, Rome. 1502–4*

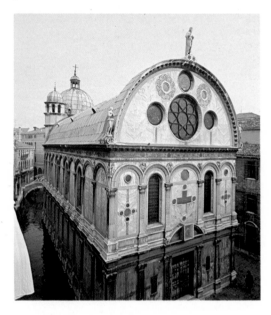

Colorplate 6. PIETRO LOMBARDO. *S. Maria dei Miracoli, Venice. 1481–89.*

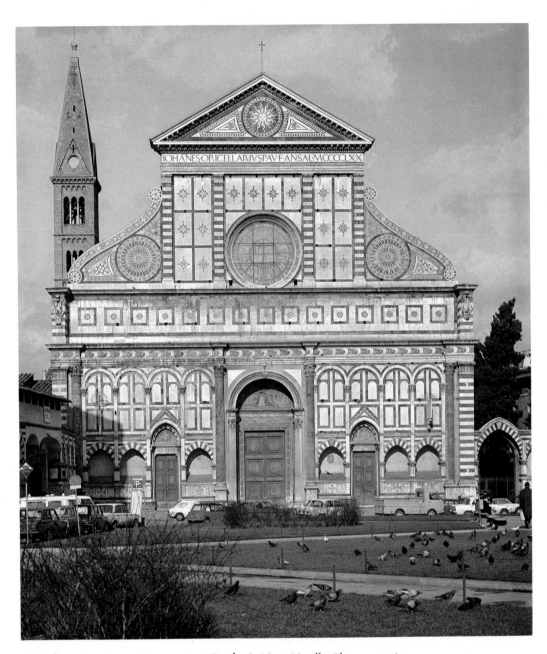

Colorplate 7.   LEON BATTISTA ALBERTI. *Façade, S. Maria Novella, Florence. 1456–70*

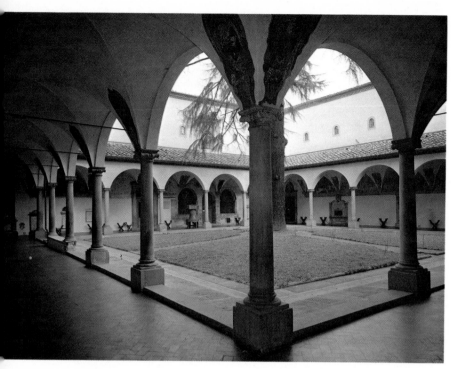

Colorplate 8.   MICHELOZZO. *Cloister, Convent of S. Marco, Florence. 1437–52*

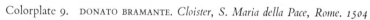

Colorplate 9.   DONATO BRAMANTE. *Cloister, S. Maria della Pace, Rome. 1504*

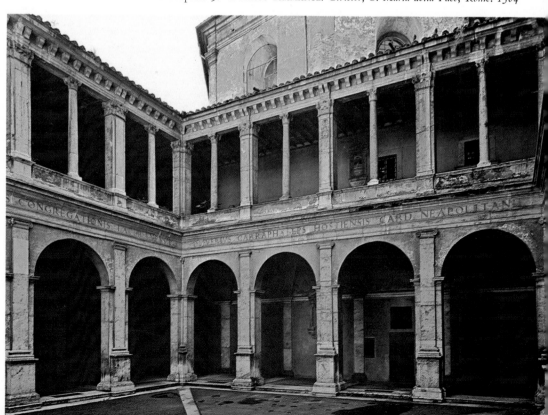

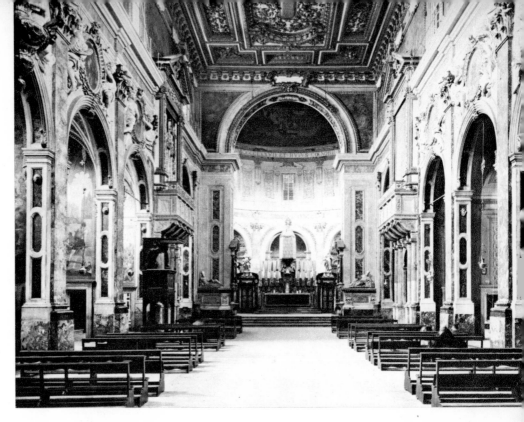

29. MICHELOZZO. *Interior, SS. Annunziata, Florence*

Church of Santa Maria degli Angeli in Florence (pl. 27) was begun in 1434 but then left unfinished and completed only in our time.[38] It is the oldest Classicizing structure of the Renaissance and the first to be designed on an unqualified central plan. An octagonal chamber with an octagonal cloister-vaulted dome, it is surrounded by eight roughly elliptical chapels. Apparently this chapel was inspired by old Roman buildings such as the so-called Temple of Minerva Medica, and within modest dimensions it gives an impression of monumentality by its use of the Roman technique of massive structure based on pillars.

The architectural path that Brunelleschi opened was to be followed by many. The same fusion of cylinder and hemisphere —the Pantheon motif—was adopted by Michelozzo in the original plan for the monumental choir chapel of the Florentine Servite Church of Santissima Annunziata (pls. 28, 29), begun in 1444.[39] Very soon

thereafter, this Classical design was proposed by Alberti for the choir (never executed) in the "Tempio Malatestiano" (San Francesco) in Rimini.[40] In both cases, the particular formulation, including a ring of apsidal chapels, was inspired by the ancient Roman Temple of Minerva Medica. The Greek cross (four equal arms), another and very popular variant of the antique central plan, was used by Alberti for the ground plan of San Sebastiano in Mantua, begun in 1460. The square central space of this building is covered with a cross-groined vault, and each of the arms has a barrel vault—a plan recalling old Roman baths and palaces.[41]

In the truly great Renaissance development of the central-plan principle, not only those forces already indicated were involved (mere suggestions from trecento and ancient pagan architecture) but also other, quite different motivations. The old Roman centralized structure had survived into the Christian era, and three other artistic styles

had contributed markedly and imaginatively to its further development: the late-antique Early Christian, the Byzantine, and the Romanesque. Northern Italy especially was full of impressive central-plan buildings from those Christian periods: San Lorenzo in Milan, San Marco in Venice, and many pre-Romanesque and Romanesque baptisteries scattered throughout the region. Such

Formosa (1492)[43] the Byzantine design of the eleventh- to thirteenth-century Basilica of San Marco, a Greek cross with pendentive domes over the crossing and the arms of the cross. In all these cases the architects abandoned the original medieval builders' use of enchanting colored marble inlay and mosaics in order to expose more clearly the structural force of their Classical organization.

The great diversity of form found in the Lombard central-plan churches in and around Milan is too broad a subject to be entered into here.[44] However, this much should be said: in that region the influence of the monumental Early Christian central-plan Church of San Lorenzo and of the Romanesque baptisteries did not prevent a loosening of the basic rigid, round structure

31.  DONATO BRAMANTE. *Sacristy of S. Maria presso S. Satiro, Milan. Begun 1482*

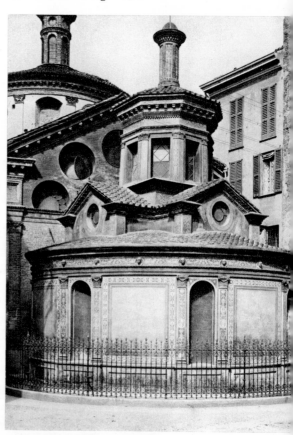

30.  GIULIANO DA SANGALLO. *Interior, Sacristy of S. Spirito, Florence. 1488–96*

edifices were studied by Renaissance architects, and from these sources there arose a magnificent diversity of conceptions, which can only be indicated briefly here.

In Florence, the baptistery plan—an octagonal space with an octagonal cloister-vaulted dome—that had been developed in the eleventh and twelfth centuries was adopted by Giuliano da Sangallo for the sacristy of Santo Spirito (1488–96; pl. 30).[42] In Venice, Mauro Coducci took as his point of departure for San Giovanni Crisostomo (1497–1504, and Santa Maria

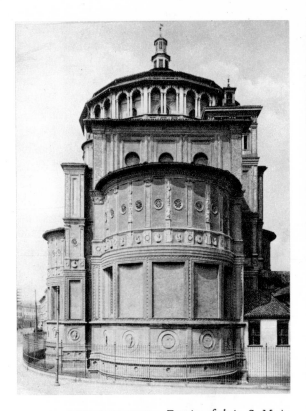

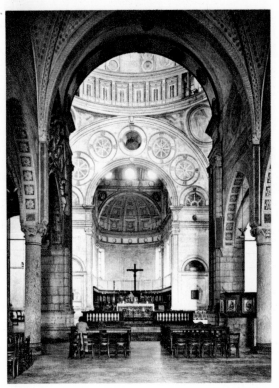

32.   DONATO BRAMANTE. *Exterior of choir, S. Maria delle Grazie, Milan. 1492–98*

33.   DONATO BRAMANTE. *Interior, S. Maria delle Grazie, Milan*

into a group of subsidiary structures clustered around the main core. Along with these more complicated plans, there was a naïve delight in embellishment, a taste for brilliant decoration of a figurative and, especially, of an ornamental character.

This indigenous Lombard style was perfected and raised to genuine significance when an inspired genius left Urbino to settle in Milan—the young Donato Bramante.[45] His principal achievements there are the octagonal sacristy of Santa Maria presso San Satiro (begun 1482; pl. 31) and the superb choir of Santa Maria delle Grazie (1492–98; pls. 32, 33), a splendid free variation on Brunelleschi's design for the Old Sacristy of San Lorenzo. Among the many works of other masters of this circle, at least

two deserve mention: the lovely Church of the Incoronata in Lodi, the work of Giovanni Battagio (1488–94; pl. 34), and the choir of the Cathedral of Pavia (begun 1488; pl. 35), in whose design both Bramante and Leonardo da Vinci were involved.

The ultimate perfection of the central plan arose from still another source. In his Pazzi Chapel, a reworking of the design of the Old Sacristy, Brunelleschi had extended the principal interior space by joining to it two secondary arms covered by barrel vaults. For Santa Maria delle Carceri in Prato (1485–91; pls. 36–38), one of his Florentine followers, Giuliano da Sangallo, developed a Greek cross out of this motif, replacing the apsidal chapel by a third equal arm and then adding a fourth to balance it.[46] His brother

34. GIOVANNI BATTAGIO. *Interior, Church of the Incoronata, Lodi. 1488–94*

Antonio da Sangallo the Elder repeated this design in the pilgrimage church of San Biagio, outside the gates of Montepulciano (1518–45; Colorplate 4).[47] He achieved here unquestionably the finest central-plan church of the Renaissance. Its monumental effect, due to a new formal language based on a revival of the Doric style, arises from the sensitive combination of a Greek-cross design with a square-based dome. Everything that characterizes Renaissance architecture is here brought to perfection: clarity of the solid-void relationships, carefully stabilized *contrapposto* composition that is subordinated to an over-all harmony, nobility of proportion, expressive power of the Classical orders, and a subtly relaxed symmetry that gives an impression of vital energy rather than of rigid and inert structure.

A counterpart of this masterpiece, and itself an impressive composition, is found in Santa Maria della Consolazione, outside the gates of Todi in Umbria (begun 1508; pls. 39–41).[48] Here, Lombard architects from the circle of Bramante cooperated with his

Roman students to produce an architectural conception of Classical harmony. The central space forms a tall, square prism that is crowned by the raised cylinder of the drum, capped in turn by the hemisphere of the dome. From each of the four sides of the central prism there extends a polygonal apse resembling a domed half cylinder. All these compositional elements are combined with the most perfect symmetry. The generally severe structure, beautifully plain and clear in its modeling, is given a restrained animation through the use of slightly projecting plane-surfaced elements that are placed in subtle relationship to one another; these include pilasters, moldings, aedicula windows, Roman-arched niches, and other devices. The rhythmic animation thus obtained is further accentuated by the rhythm of effectively placed horizontals circling the entire structure—the sharply profiled mold-

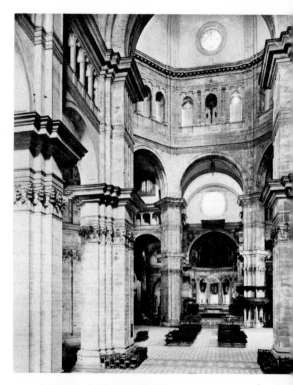

35. DONATO BRAMANTE, LEONARDO DA VINCI, *and others. Interior, Cathedral, Pavia. Begun 1488*

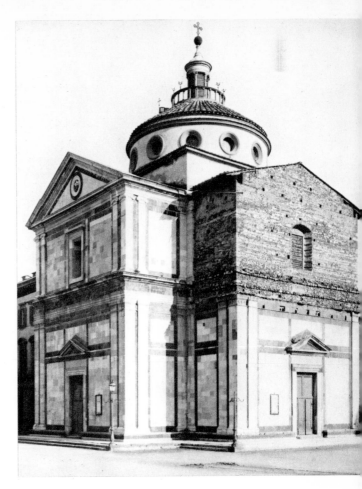

36. GIULIANO DA SANGALLO. *Plan,*
*S. Maria delle Carceri, Prato. 1485–91*

37. GIULIANO DA SANGALLO. *S. Maria delle Carceri,*
*Prato*

38. Interior, *S. Maria delle Carceri, Prato*

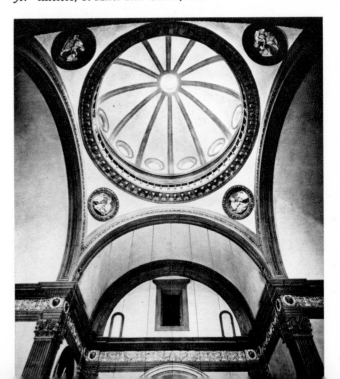

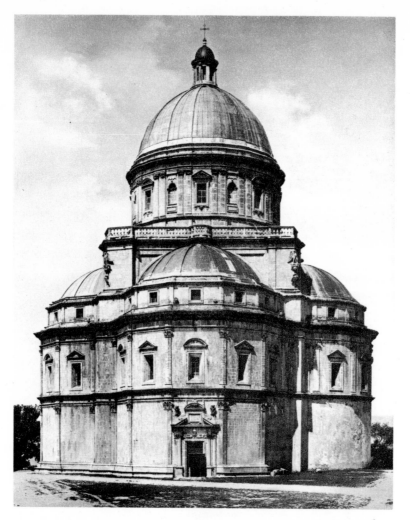

39.   SCHOOL OF BRAMANTE. *S. Maria della Consolazione, Todi. Begun 1508*

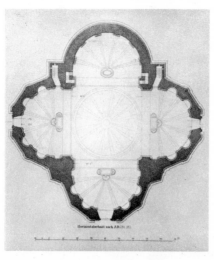

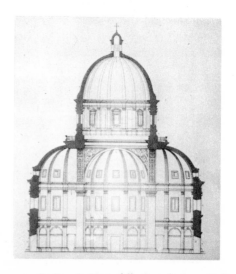

40.   *Plan, S. Maria della Consolazione, Todi*      41.   *Section, S. Maria della Consolazione, Todi*

ing halfway up the apses, the strongly projecting cornice at the upper limit of the apse walls, the "mezzanine" (half story) at the base of the semidomes of the apses, the balustrade crowning the walls of the central prism, and the various strong bands of molding at the base of the drum, the main dome, and the lantern.

The Classical masterworks at Montepulciano and Todi had their counterparts in Rome. In 1499 Bramante left Milan to settle in Rome, where, in fruitful contact with the works of antiquity, he refined his style to a Classical perfection. His so-called "Tempietto" in the courtyard of San Pietro in Montorio[49] (1502-4; Colorplate 5, pl. 42) is a characteristic creation of the High Renaissance Classical style. Erected over one of Christendom's holy sites (where the Apostle Peter was martyred), its Christian purpose of commemoration and dedication is fulfilled in the guise of a pagan round temple. Its aesthetic form is at once simple and rich. The core of the building is a cylinder with a hemispherical dome, to which is added, around the entire lower half, a ring of columns obviously derived from those on old Roman round temples. Its noble articulation gives this simple structural conception a wonderful expressive richness. Horizontals and verticals are played off against one another in *contrapposto* relationships with manifold variations. In recurrent forms, the horizontals revolve first around the plinth, rising in three steps; then around the stylobate supporting the columns; still higher, in the strongly emphasized entablature and the balustraded parapet surmounting it; and finally, in the two circular profiles at the top—the powerful ring at the base of the dome and the more delicate ring of the lantern above. In similar fashion, the vertical accents strive upward in many and varied forms. First there are the smooth shafts of the columns; then the triglyphs of the frieze (a Tuscan variant on

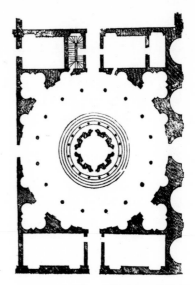

42. BRUNELLESCHI. *Plan, "Tempietto," S. Pietro in Montorio, Rome. 1502-4*

the Doric); then the more plastic shapes of the balusters of the parapet; still higher, the pilasters and niches of the drum, above which are the delicately raised stripes of the dome; and in the peak of the lantern, the highest extension of all. Opposites are resolved into a felicitous harmony—straight lines and curves, plane surfaces and rounded ones, the severe Doric style and an almost Baroque play of forms in the lantern. All these directional forces, in opposition and yet held in equilibrium, combine here to realize to perfection exactly what is meant by "Classical."

This same feat was to be repeated in St. Peter's, but on the most sublime scale.[50] For the burial place of the Apostle, the holiest site of Catholic Christendom, the goal was a structure composed of the most perfect and, at the same time, the most grandiose of forms. A steady procession of outstanding representatives from the most influential Italian schools of architecture worked toward this goal. First, from 1503 to 1514, there was Bramante, creator of the most important central-plan buildings of both Lombardy and Rome. From 1514 to 1520, Raphael took over the task. Like

Bramante, Raphael was born in Urbino, and in addition to being the greatest painter of the Roman High Renaissance he was also a great architect. Working in cooperation with Raphael was Giuliano da Sangallo, builder of Santa Maria delle Carceri in Prato, the most magnificent Tuscan central-plan church of the early years of the High Renaissance. Later, from 1520 on, the Sienese architect and painter Baldassare Peruzzi took charge. He was joined by Antonio da Sangallo the Younger, nephew of Giuliano and son of the older Antonio—who in San Biagio at Montepulciano had erected the most monumental central-plan structure of the mature Florentine-Roman High Renaissance. Finally Michelangelo, the greatest Renaissance genius of both Florence and Rome, worked on the building from 1546 on.

The competition over St. Peter's between the outstanding schools and masters also involved a struggle between the two foremost ideals of Renaissance church design—the central plan and the basilica. The drama of this conflict between such impressive forces, all concerned with the ideal conception of the most important architectural task of the time, offers an incomparable spectacle. The many vicissitudes can only be sketched here, especially in view of the fact that until 1530 all these assembled efforts had managed to arrive at little more than a beginning. The major activity began only when Michelangelo took over, and thus it lies on the other side of the boundary between the Renaissance and Mannerism. That part of the dramatic unfolding of the final scheme which concerns us here must therefore depend for its documentation not on the completed building but on sketches and models.

From the very beginning, with Bramante's participation, the central plan was proposed, a design to be modeled after the ancient Roman monumental structure incorporating massive pillar groupings (pls. 43, 44). A good idea of Bramante's initial conception can be gained from a sketch of a central-plan church by his Milanese associate Leonardo (pl. 15). The basic motif is a Greek cross, with four equal arms and with a dome over the crossing. Over the four groups of pillars at the corners of the square central

43.  DONATO BRAMANTE. *Original Plan for St. Peter's, Rome. 1506*

44.  CARADOSSO. *Medal showing Bramante's design for St. Peter's, Rome. 1506. British Museum, London*

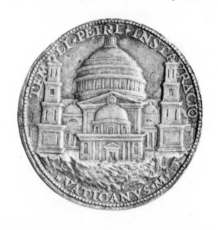

hall, there was to be a hemispherical dome set on a cylindrical drum. Each of the four arms of the cruciform structure was to be covered with a mighty barrel vault and was to end in a colossal apse. In the angles of the cross there were to be sacristies and other minor rooms. The entire plan, complex but clearly and thoroughly organized, was to form a closed square block. From this immense cube, four projections were to stand out a little, from the middle of each of the four sides, and these were to accommodate the four main apsidal chapels. Over these interior spaces the tremendous principal dome, with its four smaller satellite cupolas, was to rise. But of this plan, only the core—that is, the four pillar masses of the crossing—was actually executed.

Had this whole project been carried through, St. Peter's would surely have been the most sublime central-plan church of the Renaissance. However, especially after the death of Bramante in 1514, the central plan could not hold its own against the time-honored basilica idea. Raphael envisaged the new building as a basilica with a centrally placed choir. His successor Peruzzi reverted to the central plan, but a new turn was taken with the large wooden model in basilica form that the younger Antonio da Sangallo prepared. Finally, Michelangelo contrived to reinstate the central-plan idea; using Bramante's conception only as a point of departure, he gave it a new character in keeping with his own Mannerist style. The major part of the project was then carried through according to his design. Nevertheless, there were to be new upsets, and when Carlo Maderna took charge in 1607, he again imposed the basilica scheme, this time definitively. The reasons for this triumph of the basilica design are rooted in both the theology and the artistic theory of the time.[51] As a consequence of the Council of Trent (1545–63), at which the principles of the Counter Reformation were laid down, there

was a general return to the basilica as the ideal form. However, the presbytery (the area around the high altar) continued to be designed in accordance with the "Classical" central plan of the High Renaissance.

Thus it happened that in the most important church of Western Catholicism the central-plan ideal of the Renaissance was realized only imperfectly. This was in no way accidental, and must be understood in a wider context. For artists and architects, the central plan was always the most highly valued form, but the Papacy was obliged to satisfy more than that small group. It was responsible to the entire Christian community of believers, and for them the traditional basilica form remained the time-consecrated symbol of their faith.

*The Hall Church.* In addition to basilicas and central-plan churches, the single-aisled hall church[52] was popular in Italy from the Early Christian period until the trecento. This simple structure corresponded in a high degree to the Renaissance ideal of beauty. The quattrocento and cinquecento stressed the monumental possibilities of this design, and the Florentine school of architects was especially active in its elaboration.

By adroit rebuilding, Michelozzo, from 1444 on, transformed the trecento basilica of Santissima Annunziata in Florence (pls. 28, 29) into a unified hall with two flanking rows of chapels.[53] By this means, with three adjacent interlocked aisles of equal importance, a single cohesive space was created in which each member stands out clearly, yet in a manner that a marked over-all order emerges. The great nave produces the impression that the sequence of chapels along its flanks is definitely subordinate to the central hall. A similar feat was accomplished by Giuliano da Sangallo for Santa Maria Maddalena dei Pazzi in Florence (pl. 45). Beginning about 1480, he added two flanking rows of chapels to its trecento hall-nave.[54]

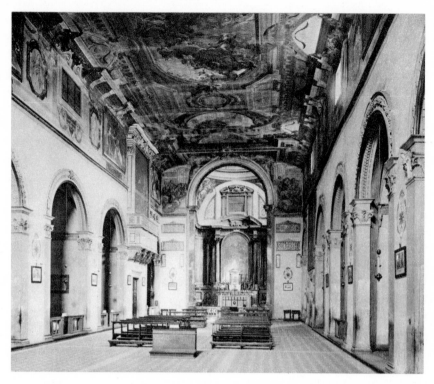

*45.*   GIULIANO DA SANGALLO. *Interior, S. Maria Maddalena dei Pazzi, Florence. 1480–92*

*46.*   IL CRONACA (SIMONE DEL POLLAIUOLO). *Interior, S. Salvatore al Monte, Florence. 1487–1504*

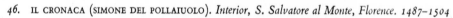

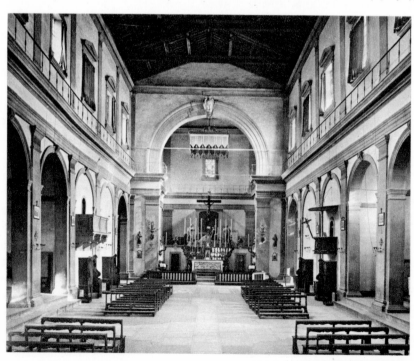

The pearl among Florentine hall churches is San Salvatore al Monte, (1487–1504; pl. 46), the masterpiece of Il Cronaca.[55] The general design of the structure corresponds to that of the two churches cited above, but since this was an entirely new building, the proportions could be freely planned to yield satisfying and perfectly balanced harmony. Furthermore, for the first time here a sort of decorative but architectonic screen was superimposed upon the walls to give them a new animation, which in its organic, Classicizing way underscores the equilibrium of the entire spatial construct. The nave is encircled halfway up by an imposing cornice, which divides the walls into two stories. On the lower level, the round-arched chapel openings at the sides resemble two arcaded interior "façades," with the individual bays closely linked by a row of pilasters and the surmounting cornice. A sequence of pilasters on the upper story corresponds to those on the lower story and continues the vertical emphasis. Between these are wall surfaces of noble proportions, into which are set with great sensitivity the lovely forms of Classical aedicula windows. The rows of windows are rhythmically ·varied by alternating gabled and half-round pediments. All these details are carried out in tooled brownish stone, which stands out smoothly against the flat whitewashed wall surfaces. The strength of Doric pilasters acquires a delightful grace through the deliberate fineness of the carving. It is said that Michelangelo took great joy in this building and called it a "bella villanella." Indeed, with its chaste charm, this church reminds one of the fresh beauty of a peasant girl, and there is particular significance in the fact that one can so characterize one of the noblest buildings of the Renaissance.

Even before this early Classical work, the genius of Leon Battista Alberti, the great forerunner of the High Renaissance, had completely transformed the Florentine hall church scheme in the spirit of Roman antiquity, thereby creating one of the greatest church styles of the entire Renaissance. In 1472, the huge Church of Sant'Andrea (pls. 47–49) was begun in Mantua after his designs.[56] A mighty tunnel vault gives the hall-nave a wonderful spatial monumentality, and the supporting wall masses are correspondingly monumental. In the manner of colossal ancient Roman structures (the Basilica of Maxentius, for example), the chapel arches are so widely separated from each other and are opened so broadly that the wall surfaces between them become enormous, creating a ponderous rhythm of alternating wall masses and chapel spaces. By means of a broad cornice above the round-arched chapel openings and by paired pilasters on the surfaces between these openings, the chapel entrances and the side walls of the nave gained a monumentality similar to that of antique triumphal arches. A final touch was the insertion of transepts and a choir conceived of as three arms of a Greek cross, with a pendentive dome over the crossing. In doing so, Alberti believed he was reviving the plan of ancient Etruscan temples—an erroneous idea that was to be of some creative importance.

This monumental type of hall church, which owed its overwhelming majesty to exploitation of ancient Roman principles and forms, was to have a great future. It became the foremost type of the Mannerist and Baroque periods from the time that Vignola adopted it for his Jesuit mother church, the Gesù in Rome.

Other schools of architecture invested the hall church with their own special characteristics. The profusion of variations exceeds the narrow limits of this study, especially since, to further complicate the picture, there were (chiefly in the schools of Siena and Rome) a vast number of combined forms with centralized choirs. A single example may suffice to show the astounding

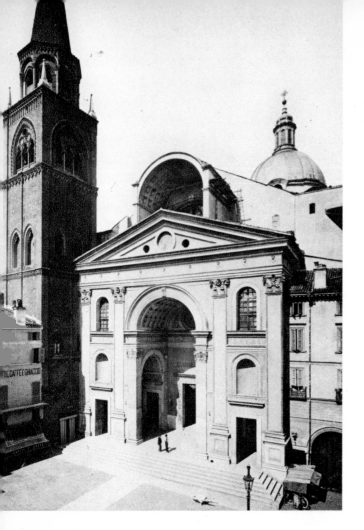

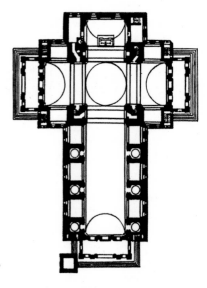

47. LEON BATTISTA ALBERTI. *Façade, S. Andrea, Mantua. Begun 1472*

48. *Plan, S. Andrea, Mantua*

49. *Interior, S. Andrea, Mantua*

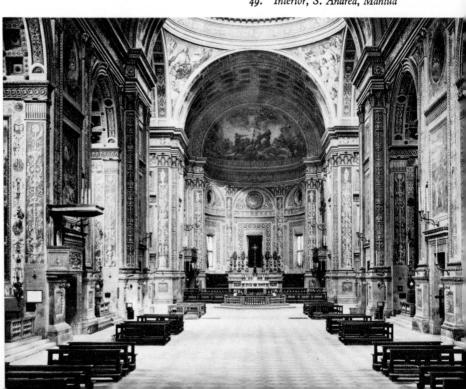

range of possibilities. In his hall church Santa Maria dei Miracoli (1481–89; Colorplate 6) in Venice, Pietro Lombardo abandoned the effort toward monumentality. The domed choir, however, was conceived in the manner of Brunelleschi's Old Sacristy in San Lorenzo or some similar central-plan structure and was raised above ground level, with a high flight of stairs leading up to it. The enchanting beauty of this jewel casket of a church lies in the bright interplay of color and form in its variegated marble inlay, in the finely carved balustrade of the sanctuary, in the figured reliefs, and in the wonderful over-all richness of ornamentation.[57]

*Façades.* Church façades[58] called forth all the architectonic imagination of the Renaissance. Often they are nothing more than a cross section of the interior structure they conceal, although somewhat enriched in details, of course. At times they became independent display pieces; but on the whole, this tendency was seldom more than hinted at. The ultimate liberation of the contour and organization of the façade from the structure behind it did not occur until Michelangelo's never-executed plans for San Lorenzo in Florence (1516–20). This liberation was characteristic of Mannerism and the Baroque rather than of Renaissance style, which, as a rule, made of the façade a Classical plane surface whose lines faithfully reflected the basilica, central-plan, or hall layout behind it.

For Santa Maria Novella in Florence (1456–70; Colorplate 7, pl. 50), Alberti succeeded in giving a monumental character to a marble façade that, since it was in an essentially trecento style, was overendowed with small, encrusted elements.[59] This he achieved by introducing a few large Classical motifs. Reflecting the design of the three basilican aisles behind it, the broad ground story of the façade is organized like a triumphal arch, with flanking half columns, a central round-arched portal niche, a cornice, and an attic. Above this, the central portion of the upper story resembles a kind of temple front, with pilasters, entablature, and pediment. In the right angles formed between the two stories of unequal breadth, two great volutes (spiral scrolls) further a smooth

50.  *Diagrams of façade of S. Maria Novella, Florence*

vertical transition, as is accomplished in the similar buttresslike forms on the lantern of Brunelleschi's dome for Florence Cathedral (Colorplate 1)—a motif that was to reappear often in façade design into the Baroque. The triumphal arch plan is seen in even purer form in Alberti's façade for the "Tempio Malatestiano" in Rimini (pl. 3), which likewise took inspiration from ancient Roman portals.[60] The most mature Classical designs are to be found among the fine sketches made by Giuliano da Sangallo for the façade of San Lorenzo in Florence (pl. 51) in 1515.[61]

As might be expected, the individual schools had their numerous variants, often of great decorative beauty. Added interest was obtained by adapting a basilica façade to the cross section of a central-plan or a hall church. Above all, however, the prime effect was consistently achieved by the beautiful intrinsic forms and relations of plane surfaces, right angles, triangular gables, and volutes and by the *contrapposto* force of

*51.* GIULIANO DA SANGALLO. Sketch for Façade of S. Lorenzo. *1515. Pen and wash.*
*Gabinetto dei Disegni e Stampe, Uffizi, Florence*

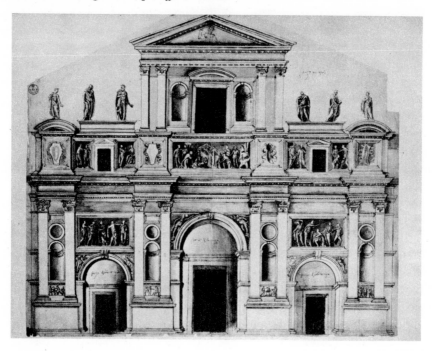

Classical relief elements such as pilasters, half columns, and round arches.

*Cloisters.* The medieval type of cloister design remained the standard for the Renaissance.[62] Its central feature was still the rectangular ambulatory, closed off by the vaulted halls of the refectory and the chapter house and topped by a second story that served as a dormitory. Only the forms changed. In the arcades of the ambulatory, instead of Gothic octagonal piers there were usually columns; instead of Gothic pointed segmental arches, there were semicircular arches. These innovations drawn from ancient sources resulted in a more pleasant, transparent ensemble, which often impresses one as brighter and more cheerful. Instead of Gothic cross-ribbed vaulting, there were, more commonly, Classical groined vaults over the bays of the ambulatory, and over the halls was found the newly devised "mirror" vaulting (cf. pl. 10). The open

space in the center was generally enhanced by tall trees, cedars usually, and nature was considered much more carefully in the architectural planning. The new Renaissance sense of truth and beauty was clearly expressed in these cloisters.

San Marco (Colorplate 8), Florentine monastery of the Dominican Observants, a reformed branch of the great mendicant order, can serve as a typical example of Early Renaissance monastic architecture.[63] Michelozzo built it (1437–52) as one of Cosimo de' Medici's pious donations. The characteristics of the Renaissance cloister already noted made their first appearance here, but there were other innovations, which reveal a determined striving toward appropriateness based on function: the newly invented type of stairwell with barrel vaulting; two rows of cells along the dormitory corridors; a new kind of library hall arranged as a small three-aisled basilica with columns, in which

the side aisles served to contain reading desks and the central aisle was left unencumbered, to provide a passageway. Even those elements taken over from the trecento—the infirmary, the pharmacy, the shelters for strangers and pilgrims—were reorganized with a keen feeling for their function. Moreover, the purpose of each room was illustrated and emphasized by the fine frescoes of Fra Angelico.

In the Renaissance cloister, the ambulatory corresponds to the atrium, that is, the forecourt or covered portico, of a church. This is an Early Christian motif that was rarely employed after the Renaissance. In Michelozzo's Servite Church of Santissima Annunziata in Florence (begun 1444; pl. 52) is seen the outstanding example of such a portico.[64] In the atrium of the Florentine cloister church of Santa Maria Maddalena dei Pazzi (1480–92; pl. 53), as rebuilt by Giuliano da Sangallo, architraves were introduced to replace the commonly used arches, which were still employed by Michelozzo. These consisted of lintels resting directly upon the abacus of the capitals—an idea taken from Roman imitations of Greek architecture.

Beginning with the early cinquecento, the tendency toward Classicism became more and more pronounced. The architrave was used more and more, and rectilinear pillars began to appear along with columns in cloisters. In Bramante's cloister for Santa Maria della Pace in Rome (1504; Colorplate 9), pillars are found with arches on the ground floor, and alternating pillars and columns capped with an architrave are on the second story.[65] The contrasting, clearly individualized forms work together in sensitive *contrapposto,* and all details are harmonized in a wonderfully organic whole. The ground floor and second floor are further characterized as bearers of different static and aesthetic functions. The round arches of the first story call for vaulting; the

*52.* MICHELOZZO. *Portico of SS. Annunziata, Florence. Begun 1444*

*53.* GIULIANO DA SANGALLO. *Cloister and façade, S. Maria Maddalena dei Pazzi, Florence. 1480–92*

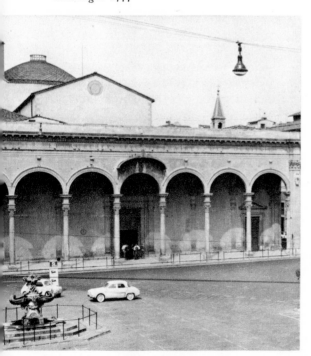

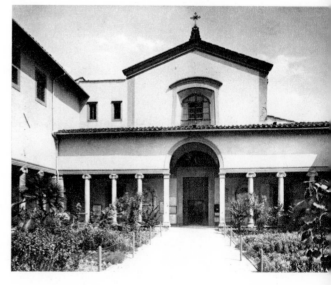

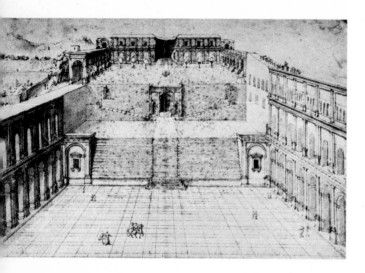

54. DONATO BRAMANTE. *Belvedere Court, Vatican, Rome. Begun 1503. (Anonymous 16th-century drawing, Collection Edmonde Fatio, Geneva)*

ancient amphitheaters. This is not the last of such subtleties, all of which express a superb capacity to temper austerity with grace, to build great structures that remain nonetheless discreet, to achieve both clarity and richness, and to invent freely within ordered limits.

In the Vatican, the great courtyards were laid out in a much more monumental spirit. These imposing spaces were executed, in the course of many decades, according to the plans of Bramante (pl. 54). In his designs, wall structure supplanted freestanding pillars in such a way that the traditional archways were still present but were engaged, forming blind arcades against the wall surfaces. Between the blind arches stand pairs of pilasters, disposed in a free variation of the ancient triumphal arch. Also new were the greatly extended dimensions of the court, as well as the idea of creating focal points in such tremendous open spaces by careful placement of decorative display pieces, such as the great apselike semicircular niche at one end of the area.

*Hospitals.* As in the Middle Ages, hospitals were still connected with monasteries in the

architrave of the second story, for a raftered ceiling. The second story is somewhat lower than the ground floor in height. The capitals below are Ionic, while those above are Composite. On the ground floor, also, the pilasters of the arcade are raised on pedestals in contrast to the lower, floor-level pilasters set against the walls, in order to harmonize arches and architrave according to the "theater" motif—that is, in line with the favorite Classical plan exemplified in the ground floor of the Colosseum and other

55. FILIPPO BRUNELLESCHI. *Ospedale degli Innocenti (Foundling Hospital), Florence. Designed 1419*

Colorplate 10. MICHELOZZO. *Courtyard, Palazzo Medici-Riccardi, Florence*. Begun 1444

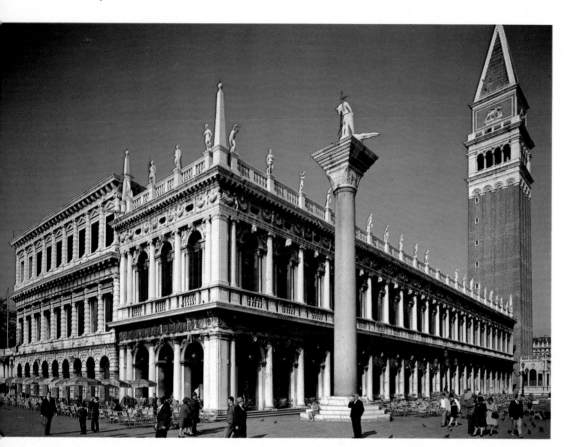

Colorplate 11. JACOPO SANSOVINO. *Library of S. Marco, Venice. Begun 1536*

Colorplate 12. GIULIANO DA SANGALLO. *Villa Medici, Poggio a Caiano. Begun 1*

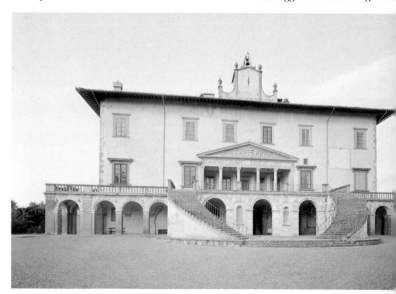

Colorplate 13. DESIDERIO DA SETTIGNANO. Altar of the Sacrament. *1461*.
*Marble. S. Lorenzo, Florence*

Colorplate 15. JACOPO DELLA QUERCIA. Tomb of Ilaria del Carretto. *c. 1406. Marble, length of sarcophagus 7′ 8″. S.Martino, Lucca*

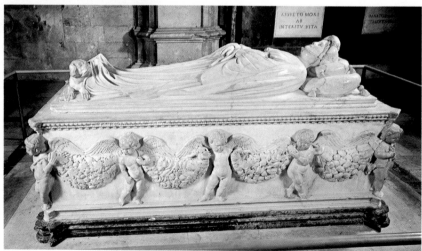

56. ANDREA DELLA ROBBIA. Foundling. *1463–66.*
*Glazed terra cotta, diameter 39⅜". Ospedale degli In-*
*nocenti, Florence*

Renaissance, since care of the sick continued to be the responsibility of religious orders.[66] Therefore, hospital design corresponded in a general way to monastery design, but one slight difference peculiar to hospitals deserves mention. Ever since the Middle Ages, it had been customary to design hospital façades in the form of a loggia; this open hall with pillars or columns along the street front presumably served as shelter for ambulatory patients. In Florence as elsewhere, from the eleventh to the fourteenth century, this fine architectural conception, which was both functional and beautiful, had proved its value.[67] And from the time that Brunelleschi, in his design for the Ospedale degli Innocenti in Florence (1419; pl. 55), had oriented the formal vocabulary toward precisely this type of open loggia, such porticoes remained popular with Renaissance architects.[68] Characteristic of the period's highly developed sense of the functional and appropriate are the medallions

with infants in swaddling clothes that decorate the spandrels of the loggia arcades (pl. 56). These masterpieces of the Della Robbia workshop serve to inform all passers-by of the purpose of the building.

An attempt was also made to establish a specific design for hospitals, and this ideal solution is represented by the imposing, complex, but entirely functional layout of the Ospedale Maggiore, the principal hospital of Milan (pl. 57). This edifice is the work of the Florentine architect and theorist Antonio Filarete and his followers (1451–65).

## Secular architecture

Secular architecture became increasingly important in the Renaissance under the pressure of powerful forces whose beginnings date back to the late Middle Ages. North of the Alps, Gothic secular buildings had gone through an impressive development, and soon in Italy, in the duecento and trecento, such buildings were erected in great number, among them many of high artistic value. In the Renaissance, the cultural forces that called them forth were to find even freer scope for development.

*Palaces.* The foremost task of secular architecture was the palace[69] (*palazzo*), especially the urban family residence of the nobles and wealthy bourgeois. Their most usual form was a multistory cube enclosing a courtyard, which was surrounded by a columned loggia somewhat in the manner of a cloister. This scheme was already fixed about 1300, particularly in Florence, but with rectilinear pillars instead of columns in the courtyard, as in the Palazzo Vecchio.

The Renaissance continued this pattern but infused it with a new feeling. First, it rethought this essentially architectonic design into an organic structure. In the Renaissance, the basic design of these palaces remained the same in its chief characteristics, but Renaissance architects broke with the

57.   ANTONIO FILARETE. *Façade, Ospedale Maggiore, Milan. 1451–65*

medieval trecento use of towers, wings, and similar secondary additions to the basic palace design. Instead, the simple stereometric plan was allowed to function unaided and in all its purity; the excellence of the basic form was itself enough to satisfy the aesthetic requirement. The achievement of the Renaissance architect lay in his ability to make something individual of every element of the traditional design and, then, to mold all these elements into a single organic structure.

In these qualities, the pioneer was the Florentine Michelozzo (di Bartolommeo or Michelozzi). His Palazzo Medici-Riccardi in Florence (beg. 1444; pl. 58) differed from its model the Palazzo Vecchio in only one way, but by that single difference it achieved something quite different and essentially contemporary. A generously overhanging cornice supported on Classical bracket consoles gives the blocklike edifice a decisive terminal element. The exterior expresses

most artistically the natural laws of statics. The three stories lead convincingly upward: the ground floor, which bears the main weight, is made of "rusticated" blocks whose surfaces are left unpolished to give a greater effect of power and solidity;[70] the second story, in contrast, uses smooth stones with pronounced edges; the upper story is composed of even smoother blocks that seem to fuse into a single mass. In its formal, aesthetic aspect, this exterior recalls the rough-hewn stonework of medieval defense works in Italy and Germany, especially those built for the Hohenstaufen emperors, and it preserves something of their protective feudal ruggedness.

The inner court, however, is a carefully calculated, aesthetically oriented contradiction to the external appearance of the palace (Colorplate 10), elegantly proportioned and richly organized throughout. Its fine, graceful ornamentation lends to the whole structure an aura of serenity quite unknown previously. There are medallions in relief above the arcades and between the windows, and in the center of the court there may have once stood a fountain with a bronze figure by Donatello.

This early scheme was to be adapted again and again throughout the quattrocento in Florence and Tuscany, with ever-increasing elegance, beauty, and diversity. In the circle of Alberti, it became the practice to use Classical pillars in order to lend grace to rusticated façades, as in his Palazzo Rucellai in Florence (pl. 59), the Palazzo della Cancelleria in Rome (pl. 60), and the palaces by Bernardo Rossellino in Pienza and Siena, among others.

With the High Renaissance, the tendency toward Classical stylization reached its zenith. Bramante took the decisive step in the palace he built for himself in Rome. We can get some idea of this building, which unfortunately was destroyed, from the Palazzo Vidoni-Caffarelli in Rome (pl. 61),

58. MICHELOZZO. *Palazzo Medici-Riccardi, Florence. Begun 1444*

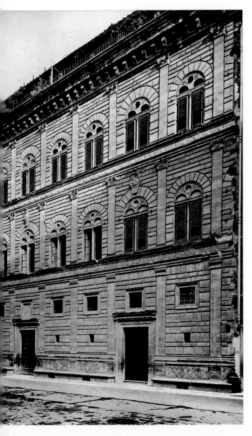

9. LEON BATTISTA ALBERTI. *Palazzo Rucellai, Flor-ce. c. 1445–51*

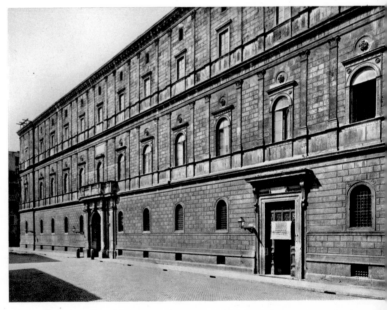

60. SCHOOL OF ALBERTI. *Palazzo della Cancelleria, Rome. Late 15th century*

built by Raphael in 1515, and from the Palazzo Uguccioni in Florence (pl. 62), also by Raphael. The ground floor is of rough-hewn stone; above it, raised on high plinths connected by a balustrade, are smooth paired columns of the Doric-Tuscan order, with an aedicula window set between each two pairs. The Classical concept of the façade is here elevated to a truly monumental level.

Equally impressive is the masterpiece of the younger Antonio da Sangallo, the Palazzo Farnese in Rome, which he worked on variously from about 1515–20 until his death in 1546 (pl. 63). The divisions of the block structure are forcefully emphasized by projecting moldings, rough-hewn quoins at the corners, and the powerful crowning cornice that was added by Michelangelo in 1547. Another salient projection is provided in the middle of the ground floor of the

principal façade by the portal, similarly rough-textured. There are subtle relationships between the three stories, in the moldings separating them, and, above all, in the aedicula windows. In an earlier building, Raphael's Palazzo Pandolfini in Florence (pl. 64), executed by Giovan Francesco and Aristotile da Sangallo beginning about 1520, the effectiveness of the façade already depended on the alternation of triangular and half-round pedimented aedicula windows. In the Palazzo Farnese, the aedicula windows of the ground floor (which is itself treated rather like a pedestal or plinth for the entire building) have only a horizontal architrave, without pediment; whereas the second story alternates triangular and half-round pediments, as in Raphael's palace, and the top story has triangular ones exclusively, but over a round-arched, tabernacle-like

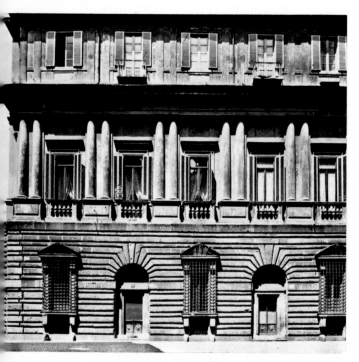

61. RAPHAEL. *Palazzo Vidoni-Caffarelli, Rome. 1515* (*third story added later*)

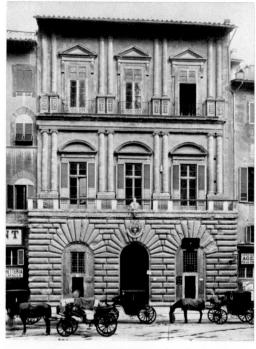

62. RAPHAEL (*design of*). *Palazzo Uguccioni, Florence.* *Built 1550*

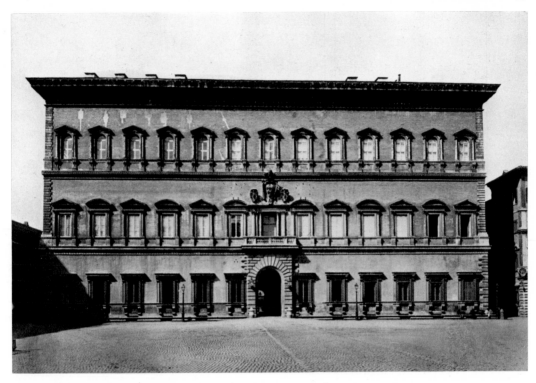

*63.* ANTONIO DA SANGALLO THE YOUNGER *and* MICHELANGELO. *Palazzo Farnese, Rome. c. 1515–47*

window opening. On each floor, the aedicula window frames are supported by scroll consoles. Because each of the lower moldings between stories is echoed by another at the level of the window bases, and because both moldings seem linked to each other and to the wall through the volutes, each story begins with a kind of horizontal, pedestal-like band that seems to lift it clear of the underlying story. The total impression is both monumental and elegant, compact and rich; in short, it is a work of Classical perfection.

The inner court is also a masterpiece (pl. 65). Instead of the columns so frequently employed in the arcades of quattrocento palaces, pillars are used here. The ground-floor loggia employs the "theater motif" of the Colosseum. On the front of each square pillar a half column is applied, and these bear an entablature which is continuous around the court. This monumental system is carried out in the noblest and strictest Doric-Tuscan style. On the façades of the two closed stories over the loggia, the design used in the loggia is repeated; here, however, it is transformed and made less weighty by the use of blind arcades. Into these blind arcades are set, on the second story, aedicula windows with triangular pediments, flanked by Ionic half columns. The pattern is repeated on the top story, but the windows have half-round gables and flanking half columns of the Corinthian order. The overwhelming proportions of the upper story, designed by Michelangelo, broke with the austere, harmonious pattern of Antonio da Sangallo's composition. In Michelangelo's additions the style of the High Renaissance has gone over into Mannerism.[71]

In his magnificent Library of San Marco in Venice (begun 1536; Colorplate 11), Jacopo Sansovino of Florence employed

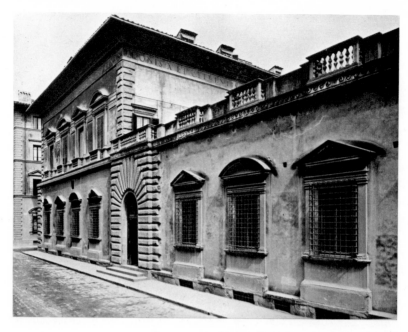

64. RAPHAEL *(design of)*. *Palazzo Pandolfini, Florence (executed c. 1520–27, by* GIOVAN FRANCESCO *and* ARISTOTILE DA SANGALLO*)*

65. ANTONIO DA SANGALLO THE YOUNGER *and* MICHELANGELO. *Courtyard, Palazzo Farnese, Rome*

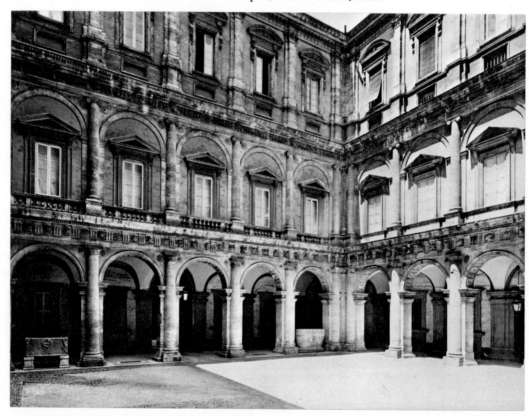

means similar to those of Sangallo, but he raised the Classical style to a new decorative splendor. The ancient amphitheater motif was applied to the outer façade and further developed by deepening the openings, so that both stories were converted into loggias. On the ground floor, over the Doric-Tuscan columns, there is a triglyph frieze with metopes in relief, an ancient motif that must have had a special appeal for Sansovino, who was both architect and sculptor. On the upper story, a horizontal line is powerfully emphasized by the balustrade linking the pedestals of the columns. Again, as in the Palazzo Farnese, the columns of the second story are Ionic. Their frieze is laden with sculptured garlands of fruit, cherubs, and similar decorative motifs. At the very top, another balustrade crowns the building, with its line rhythmically punctuated by pedestals bearing statues and terminated by taller obelisks at each corner of the building. The upper story was finished after 1582 under Vincenzo Scamozzi, who also added the part of the building toward the Molo, but still according to Sansovino's plan.

These examples demonstrate the diverse possibilities inherent in Renaissance palace design. Variations on these principal types resulted in a great number of delightful forms. In this, as always, the differences between regional or local schools or architecture played a significant role, as did the disparate requirements of the patrons who commissioned the buildings. These factors explain the differences in such edifices as episcopal palaces, governmental palaces in the city-republics, and the urban castles of the ruling dynasties such as those of Urbino and Mantua. For the latter category, the Renaissance concept of ideal beauty was somewhat tempered. The medieval practice of adding to the main structure all sorts of towers, wings, and outbuildings persisted, often giving rise to constructions of great

visual charm, especially in the Ducal Palace of Urbino.

Typical of the Renaissance palace, in Tuscany at least, is the separate, freestanding loggia, generally situated on the piazza facing the palace. This "ceremonial loggia" provided a monumental setting for festive occasions, which the Italians loved then as now. In private palaces they were used for weddings and other solemn ceremonies; in official palaces, for the reception of foreign legations and ambassadors and for other public events. As early as the trecento, such buildings were common. The finest examples from the Renaissance period are the loggia across from the Palazzo Rucellai in Florence and the loggia of the Piccolomini in Siena (pls. 66, 67).

*Villas.* The most characteristic type of country house, the villa, was one of the finest achievements of Renaissance architecture.[72] The ancient Romans had been fond of this kind of dwelling outside the city walls; but when the barbarian invasion began, landed proprietors no longer felt secure on their outlying estates without armed protection. For this reason, until the late Middle Ages, the country houses of the nobility and the wealthy bourgeois were generally constructed as strongholds or fortified castles. During the fourteenth century, there was relative calm in Italy as well as north of the Alps, and with the quattrocento a general change in the design of such residences became possible. The open countryside was no longer menaced, and once again the spacious, unfortified villa returned to favor.

As in Roman antiquity, Renaissance villas were especially designed to provide for the utmost enjoyment of country life. Used as models were both the urban palaces of the owners and the older castles scattered about the countryside. Typical features of these medieval castles, such as towers, were taken over for the villa. In this way, what had

originally been conceived in terms of defense came to be appreciated for its aesthetic value; the tower not only emphasized the protective and rustic character of the building but was enjoyed for its beautiful form as well. The over-all structure of the Renaissance villa is therefore generally more relaxed than the austere block of the city palace. Often it has a single tower with a crowning pinnacle, or there are towers at each corner (pl. 68). Frequently, loggias are opened on the façades, either at ground level, to provide an architectural link with the gardens, or on an upper floor, from which the surrounding landscape can be admired.

The whims of the patron and the imagination of the architect were both allowed free play, and as a result one cannot begin to count the many variations on the basic design. One of these, however, deserves special notice. Usually, the relationship of the villa to the charms of the surrounding countryside was taken into account, and nature became a factor in architectural planning—an innovation that was stressed by Alberti in his treatise. With the sixteenth century, there was again a marked tendency to treat the villa in the more strict Classical style of the city palace. An earlier example is Poggio a Caiano near Florence (Colorplate 12), begun in 1485 by Giuliano da Sangallo for Lorenzo de' Medici.[73]

*Gardens.* With the new attitude toward nature, it was inevitable that gardens should once again assume the artistic importance they had enjoyed in Roman times and continued to enjoy throughout the Middle Ages in the East.[74] The Christian Middle Ages had, for the most part, cultivated the garden for its utility only, first in cloisters and later also in castles and bourgeois dwellings. The Norman gardens in Sicily were an exception, but these were imitated from Arabian examples. Beginning with the quattrocento, purely decorative gardens again came to be appreciated, especially in villas.

Almost nothing has survived to help identify the types of gardens then in favor;

**66.** LEON BATTISTA ALBERTI. *Loggia opposite Palazzo Rucellai, Florence. c. 1445–51*

**67.** ANTONIO FEDERIGHI. *Loggia of the Piccolomini (Loggia del Papa), Siena. 1462*

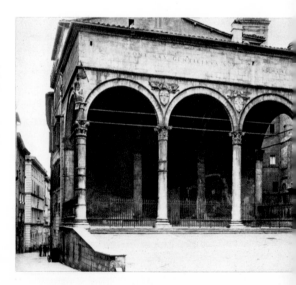

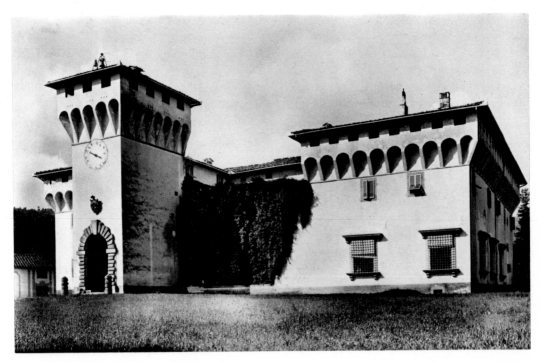

68. MICHELOZZO. *Villa Medici, Cafaggiolo. 1451*

but we have significant literary evidence of the contemporary joy in nature, especially in the charming letters of Enea Silvio Piccolomini, the Humanist scholar who occupied the papal throne from 1458 to 1464 under the name of Pius II. He gives a very lively account of his enjoyment of life in the open on his estates at Monte Amiata in southern Tuscany.[75]

Apparently, Renaissance gardens were small flat areas with flower beds separated by walks. As far as we can judge, their beauty lay in the subordination of natural elements to the strictly formal design of planimetric figures, so much appreciated at the time. Such figures—squares, circles, crosses, and the like—were as predominant in landscape architecture as in monumental building and were to continue in favor well into the eighteenth century. The great period for gardens, marked by their conversion into extensive parks, did not begin until the Mannerist period.

*Urbanism.* All the many achievements of Renaissance architecture were taken into account in the new art of city planning.[76] It is typical of the systematic thinking of Renaissance artists that they should decide that an entire city could and should be conceived as an organic unity, so designed that every detail fulfills its special function with utmost efficiency, and that, moreover, from the cooperation of all elements there should emerge an organism of ideal perfection. Some medieval builders had made some efforts toward such rational planning and design on a larger scale, as is shown by the cities founded in France during the twelfth and thirteenth centuries, by the German colonies established in the Slavic regions in the thirteenth and fourteenth centuries, and in Italy by the city of Florence in the period about 1300.[77] But none of these beginnings was ever fully carried through. In general, throughout the Middle Ages and as late as the trecento in Italy, it was customary to

allow cities to take shape as they might, taking advantage of the accidental features of the terrain, of roads, river courses, and hills, as well as of buildings already situated at some particular spot as a result of individual initiative or historical circumstance. It is the old, the casual, the meandering and picturesque which constitute the charm of medieval towns.

In opposition to this general indifference to organization, the Renaissance introduced the idea of city planning, which gradually became a fully rational science. Certain goals were aimed at. In the Middle Ages such principles had played no more than a subordinate role, but in the Italy of the duecento and trecento they emerged as genuinely significant factors. Some of these goals were practical, others aesthetic. In the realm of the practical, there was a new consideration for such hygienic necessities as water and sewerage systems and for easy circulation of traffic inside the towns. Over and beyond these, it was felt that a city should be, and could be, aesthetically pleasing.

Plans for such an "ideal city" have survived from the Renaissance. On the basis of his experience in Milan during the plague year 1484–85, Leonardo da Vinci drew up plans for an ideal city to be constructed on two levels. The lower city, through which were to run conduits and canals, was to be devoted to practical necessities, to work activities and to traffic; the upper city, reached by ramps and winding staircases, was to be a place of pleasure and enjoyment.[78] Naturally, the rationalistic imagination of the city-planning artist tempted him into some quite unfeasible flights of fancy: four hundred years later, we are still very far from realizing anything even vaguely like Leonardo's ideal.

His contemporaries, however, confined themselves by and large to what was workable, as is seen, for instance, in the little town of Pienza in southern Tuscany.[79] Enea Silvio

Piccolomini was born there when it was a village called Corsignano. As Pope Pius II, he converted the village into a town to which he gave his own name, Pienza (the city of Pius), and commissioned the Florentine Bernardo Rossellino to draw up and carry through a city plan based on rational principles. All the buildings necessary to communal life—cathedral, bishop's palace, papal palace, town hall, and the like—were grouped around a central square, with such artfully calculated perspective that they present themselves to greatest advantage. In this instance, the aim of the plan was not only functionalism but also beauty. The central square plays an important role, and the buildings are conceived as artistic monuments. Nevertheless, some vestige of medieval informality was retained in the general outline of the square and in the layout of the streets.

Basically, however, already the aim of all city planners was a more rigorously regulated urban design. Just as buildings were deemed beautiful because they were based on elementary stereometric figures, so also cities were to be made aesthetically satisfying by basing them on elementary planimetric figures. The fundamental pattern was a cross or a square, with a star-shaped or rectangular network of streets. The center was to be distinguished by a main square with imposing buildings around it. In practice, however, the execution of such projects usually entailed substantial concessions to topographical and other site limitations. This is what happened with the projected network of streets in the plan for enlarging and reorganizing Ferrara under Duke Ercole I (1471–1505). Nonetheless, a public park—one of the earliest examples known—was included in the design. It remained for later times to achieve full realization of such ideal urban schemes, that is, to the Mannerist and Baroque epochs and to the nineteenth and twentieth centuries. In this respect, architec-

*69.   Piazza della SS. Annunziata, Florence*

ture in our day still carries out the urban ideals of the Renaissance.

This holds true also for the design of public squares.[80] In the city planning of the fifteenth and sixteenth centuries, they had a special significance. Above all, the city square had to be beautiful. What was meant by this requirement can be judged from the Piazza della Santissima Annunziata in Florence (pl. 69). About 1500, it was merely a commons, bordered on the right by the loggia of Brunelleschi's foundling hospital, at the rear by the dingy walls of the Church of the Annunziata, and on the other two sides by gardens. To correct this accidental arrangement, in 1516 Antonio da Sangallo the Elder, the inspired creator of the central-plan Church of San Biagio in Montepulciano, set out to make of it a carefully designed, symmetrical and harmonious square. The surface was laid out as a rec-

tangle. Facing the loggia of the foundling hospital, another loggia was built to echo it symmetrically. Perhaps also, at that time, a third loggia was intended for the back of the square, to conceal the unattractive façade of the atrium of the church, but this was not built until 1601–4. Many such Renaissance plans for public squares were not carried out until the Mannerist and Baroque periods. However, their fundamental principles— symmetry and harmony—were the spiritual and creative contribution of the Renaissance masters.

Understandably, within the framework of Renaissance city planning, or at least in that same spirit, there was also a rational and aesthetically satisfying character imposed upon various smaller constructions devoted to public use, such as market halls, bridges, city gates, and other utilitarian or defensive structures.[81]

# CHAPTER FOUR

# MONUMENTAL DECORATION

The Italian churches, palaces, gardens, and public squares would seem like theaters without actors were there no figured decoration, and the Renaissance created a wealth of such decoration. While this world of forms unites in itself the varied expressive means of architecture, sculpture, and painting, it is valuable to treat it as a separate domain of art whose special character is determined by its decorative function. One cannot even begin to discuss the basic characteristics of sculpture and painting as independent arts unless it is made clear just how they were integrated into an architectural whole. To grasp the essence of a style, its underlying formal concepts must not be viewed within too narrow a context. As significant as the aesthetic, or formal, traits of a statue or a painting is the way in which the artist sought to fulfill the functional requirements imposed on him by a specific commission.

Thus, Gothic statues were usually conceived with relation to some architectural element: a column, a niche, a tabernacle, or a tympanum over a portal. Virtually always they form part of some architectonic structural grouping—statues around a portal or on buttresses, eaves, pillars, altarpieces, tombs, and the like—and this is of utmost importance in determining their style.[1] Similarly, in pinpointing the characteristics of Renaissance style, we are obliged to ask how statues, reliefs, and paintings were

related to the structure or space for which they were designed. This question permits us to establish a scheme of categories which are best designated as "formal types." The Renaissance inherited a great number of these types or consciously borrowed them, intact, from older styles, and from these it evolved new types. In this connection, it is expedient to distinguish between religious and secular types.

## Religious types

The special character of the Renaissance is revealed with particular clarity in the way that it gave new meaning to the formal types it had inherited from the Middle Ages. In the trecento, each of these types continued to be essentially Gothic in execution, but qualities that were characteristically Italian were already emerging. In the Early Renaissance, the existing Italian versions of architectural schemes were, by and large, retained and developed further, with Gothic details gradually being supplanted by Classical elements. Only in the High Renaissance did the growing enthusiasm for antiquity finally affect the fundamental architectural design; no longer merely to be endowed with a veneer of Classicism, medieval plans became obsolete, and new Classical conceptions took their place. This process can be traced in a number of types of decoration.

*The Altar.* The point of departure for Renaissance altar design was the retable of the trecento,[2] in particular the polyptych, an architectonic ensemble made up of separate elements integrated around a painting, a relief, or one or more freestanding statues. The Early Renaissance gave a new compactness to these attractive ensembles, which until then had dominated the altar area with their Gothic gables and pinnacles. The framework took on the same aedicula shape that was used for windows, or was at least patterned after that simpler shape,

70. LORENZO GHIBERTI *and* FRA ANGELICO. Linaiuoli Altar. *1434. Museo di S. Marco, Florence*

using half columns or pilasters surmounted by an architrave and a triangular or arched pediment, with or without volutes. Such Classical constructions were designed to display a single painting or relief: for instance, Ghiberti's framework for the Linaiuoli altar (1434; pl. 70) or Donatello's Cavalcanti tabernacle, with a relief depicting the Annunciation (Colorplate 33).[3]

The most imposing work of this sort is Donatello's high altar in the Basilica of Sant'Antonio in Padua (1447–53; pl. 71). In its original design (it was rearranged in 1895), seven freestanding statues and several bas-reliefs were held together within an aedicula framework.[4] Donatello's concep-

tion was very soon adapted by Niccolò Pizzoli to display bas-reliefs only. His retable for the Ovetari Chapel in the Church of the Eremitani in Padua (1448–53; pl. 72), which was almost totally destroyed in World War II, included only figured and scenic reliefs.[5] Inspired by these, Andrea Mantegna devised something similar for his impressive painted altarpiece for San Zeno in Verona (1457–59; pl. 73), the panels of which are now divided among churches and collections in Verona, Paris, and Tours.[6]

In the High Renaissance a more Classical design, patterned after the Roman triumphal arch, gained favor. The oldest example is the high altar of Santissima Annunziata in Florence (1504), which unfortunately is lost; it may be that Leonardo da Vinci was involved in designing this work (pl. 74).[7] A similar conception was used by Giuliano da Sangallo for the altar wall of the Gondi Chapel in Santa Maria Novella in Florence (1503–8; pl. 75). From that time on, this antiquizing monumental type of retable remained the outstanding design until Vasari's new plan was introduced.[8]

Ever since the Early Renaissance, the new architectonic format called for correspondingly new forms for the painting, relief, or statuary contained within the altar framework. Three themes inherited from the Middle Ages continued to enjoy the highest favor—the figures of Christ, the Virgin Mary, and the local patron saint. These subjects had been used frequently for the sculptured decoration on the façades of Gothic churches and for sculptured or painted altarpieces during the trecento, but now the manner of presenting these familiar motifs changed. The principal panel no longer consisted of a number of separate figures or scenes, as was found in the trecento, but was instead confined to a unified group of figures, in the form known as the *sacra conversazione,* a "sacred conversation" in which the Madonna and Child sit en-

throned and flanked by two or more saints. The new formal concept, initiated by the painter Fra Angelico in his high altar for San Marco in Florence (1437–41), was probably suggested by the *Maestà,* a compositional scheme that had been invented by the Sienese painters of the trecento, in which the Madonna is enthroned amid an assemblage of saints and angels. As a subject, the *sacra conversazione* was not limited to painting but was also used for relief and freestanding sculpture, as in the Pizzoli and Donatello altarpieces in Padua. It was destined to become one of the most popular of all Renaissance themes and compositional devices.

Despite this transformation of the overall altar form, the base of the altarpiece, called the predella, continued to be divided into small separate panels, each of which was more or less self-contained and generally bore scenes from the life of the saint depicted in the main panel. In this respect there was no change from medieval practice.

*Sacramental Shrines.* In the Middle Ages, the ritual of the church provided for a receptacle in which the Sacrament was to be kept when not in use at the altar. In the trecento, such receptacles took the form of a coffer kept in a Gothic-style wall niche. Inevitably, in much the same way as were altarpieces and wall tombs, these tabernacle niches were redesigned during the Renaissance. With the quattrocento, the ogival Gothic framework was supplanted by the Classical aedicula, as in the impressive tabernacle by Desiderio da Settignano in San Lorenzo in Florence (1461; Colorplate 13).[9] This, in turn, was replaced in the High Renaissance by the triumphal-arch motif in the pioneering design that Andrea Sansovino made about 1490 for the tabernacle of Santo Spirito in Florence (pl. 76).[10]

The subjects used to embellish these wall tabernacles included the Trinity on the pediment or on the doors of the receptacle

71. DONATELLO. *High altar. S. Antonio, Padua.*
*1447–53*

72. NICCOLÒ PIZZOLI. Altarpiece of the Madonna
and Saints. 1448–53. Terra cotta. Ovetari Chapel,
Church of the Eremitani, Padua

72. NICCOLÒ PIZZOLI. Altarpiece of the Madonna
and Saints. *1448–53. Terra cotta. Ovetari Chapel,*
*Church of the Eremitani, Padua*

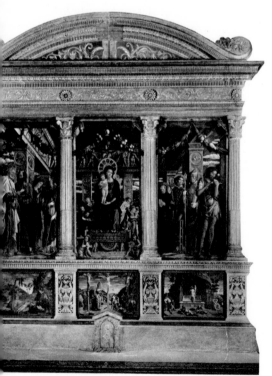

73. ANDREA MANTEGNA. San Zeno Altarpiece.
*1457–59. Panel, height 86⅝″. S. Zeno, Verona*

74. LEONARDO DA VINCI. *Design for a Triumphal Arch. 1480–1500. Codex Atlanticus, Biblioteca Ambrosiana, Milan*

75. GIULIANO DA SANGALLO. *Gondi Chapel. 1503–8. S. Maria Novella, Florence*

and, on the plinth, the lamentation over the dead Christ or, quite often also, a small image of the naked Christ Child with his hand raised in benediction—this latter motif being a typical Renaissance innovation.[11] Such beautiful ornamental tabernacles soon became coveted treasures for private patrons as well as for churches.

A monumental variation of the sacramental tabernacle is a freestanding structure, usually set on the high altar, crowned by a receptacle for the Sacrament in the form of a monstrance. In such constructions, the Classical vocabulary of Renaissance style appears at its most splendid. Among the earliest examples, Desiderio da Settignano built such a receptacle in marble for the Church of San Piero Maggiore (destroyed) in Florence.[12] Then, beginning in 1467, Lorenzo Vecchietta cast a monumental bronze ciborium in this style for the high altar of the Cathedral of Siena (pl. 77), to which were later added freestanding bronze

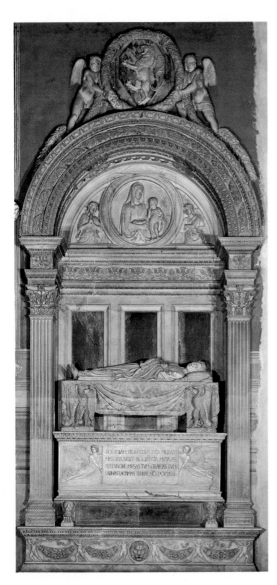

Colorplate 16. BERNARDO ROSSELLINO. Tomb of Leonardo Bruni. *c. 1445. Marble, height (to top of arch) 20'. S. Croce, Florence*

Colorplate 17. DESIDERIO DA SETTIGNANO. Monument of Carlo Marsuppini. *1455–56. Marble. S. Croce, Florence*

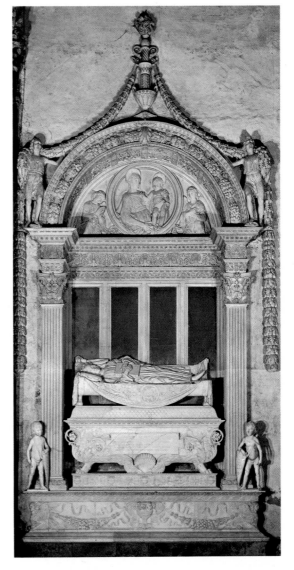

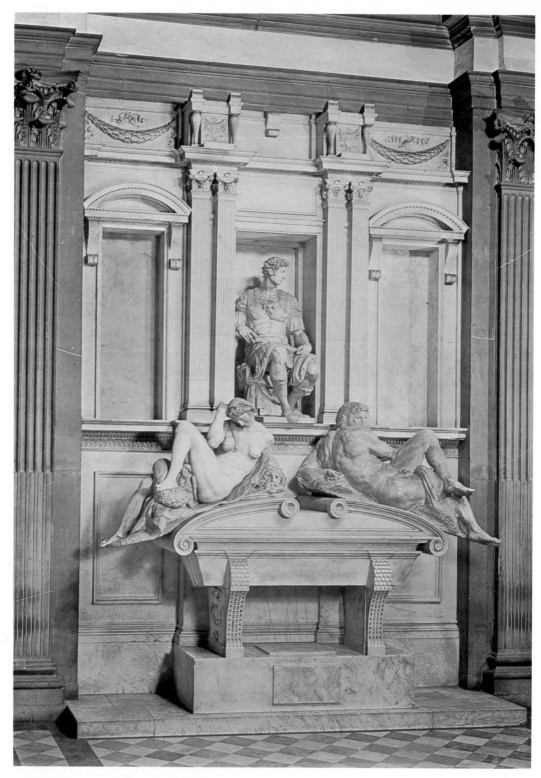

Colorplate 18. MICHELANGELO. Tomb of Giuliano
de' Medici. *1520–34. Marble, height of Giuliano 71".*
*New Sacristy, S. Lorenzo, Florence*

Colorplate 19. DONATELLO. *Choir gallery* (cantoria). *1433–39. Marble and mosaic, 11′ 5″ × 18′ 8″. Museo dell'Opera del Duomo, Florence*

Colorplate 20. LUCA DELLA ROBBIA. Madonna and Angels, *lunette from Via dell'Agnolo. Mid–15th century. Glazed terra cotta, 63 × 87½″. Museo Nazionale, Florence*

76. ANDREA SANSOVINO. *Tabernacle. c. 1490. Marble.*
*S. Spirito, Florence*

statues of angels. Equally noteworthy is the beautiful marble ciborium made by the Florentine sculptor Benedetto da Maiano for San Domenico in Siena about 1475 (pl. 78). As a young man, Andrea Sansovino planned a similar work.

*Altar Canopies.* From Early Christian times, the idea of erecting some kind of superstructure above the altar table had found favor. Originally it consisted merely of four columns that supported lintels forming an architrave, which was sometimes spanned by a roof. The duecento and trecento enriched the primitive structure with Gothic fretworked gables, pinnacles, cupolas, and so forth. Characteristically, the Renaissance purified the altar canopy of these medieval accretions and returned to the original notion, as can be seen in examples by the Florentine architect and sculptor Michelozzo in Santissima Annunziata and San Miniato in Florence (1448) and in Santa Maria at Impruneta (Colorplate 14, pls. 79, 80). For the latter, he commissioned the Della Robbia workshop to make a baldachin of glazed terra cotta with a design of pine branches and cones to symbolize the name of the village, thought to mean "in the pine forest."

*Figured Sarcophagi.* The sarcophagus with a recumbent effigy of the deceased on the lid and with reliefs on its sides, a type that had been very popular in the Gothic period, continued to appear in the Renaissance but was comparatively rare. About 1406, at the very outset of the Renaissance development, a superb example was produced by the Sienese sculptor Jacopo della Quercia, in his tomb for Ilaria del Carretto in the Cathedral of San Martino in Lucca (Colorplate 15). A

77. LORENZO VECCHIETTA. *Ciborium. 1467–72.*
*Bronze. Cathedral, Siena*

78. BENEDETTO DA MAIANO. *Ciborium. c. 1475.*
*Marble. S. Domenico, Siena*

later example, a work of 1504, is the bronze tomb of Cardinal Giovanni Battista Zen by the Venetian Paolo Savin, in the Basilica of San Marco in Venice (pl. 81).

The High Renaissance revived the quite rare Gothic type that comprised a monumental baldachin on supports, with vaulting over the sarcophagus. To be sure, the Classical form it now assumed was markedly different from the Gothic prototype; moreover, an entirely new repertory of illustrative subject matter was introduced into the decoration. About 1505, the baldachin form was used by Benedetto da Rovezzano for the funeral monument of St. Giovanni Gualberto in the Church of Santa Trinita in Florence (pl. 82).[13]

Michelangelo sought to confer an unprecedented monumentality on this type of tomb.[14] As his sketches reveal, had the tomb for Pope Julius II been carried out according

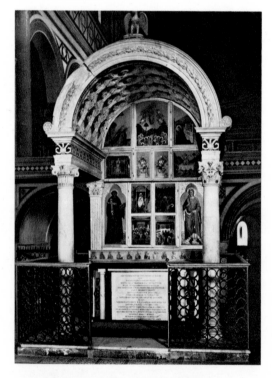

79. MICHELOZZO. *Altar canopy. Chapel of the Crucifixion, S. Miniato al Monte, Florence. 1448*

80. MICHELOZZO. *Altar canopy. Chapel of the Madonna, Church of S. Maria, Impruneta. c. 1460*

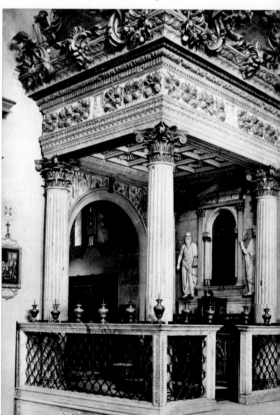

to Michelangelo's original design, it would have been the greatest baldachin-covered funerary monument in all Christian art, as much for sheer size as for its architectural power—to say nothing of the richness of the illustrative themes intended for statues and reliefs to adorn it.

*Wall Tombs.* In duecento and trecento churches, tombs began to be designed in the form of wall niches, with a Gothic ogival frame surrounding the recess.[15] Within the niche a sculptured effigy of the deceased, portrayed as he appeared at the time of his death, lay on a sarcophagus or a simulated bier. The Virgin, angels, saints, and deacons of the church were frequently included as accessory figures in the sculptural group.

The Early Renaissance transformed the Gothic niche by giving it a Classical aedicula frame and a deeper recess. To the conventional accessory figures were added *putti*, cherubs of pagan inspiration who held the coat of arms of the deceased.[16] The inventors of this new type were Bernardo Rossellino and Desiderio da Settignano—the former with the tomb of the Florentine secretary of state Leonardo Bruni in Santa Croce (c. 1445; Colorplate 16), the latter artist with that of another Florentine secretary of state, Carlo Marsuppini, in the same church (1455–56; Colorplate 17).[17] This Early Renaissance innovation was then taken up and used, with variations, throughout Italy.

In the High Renaissance, the wall tomb underwent the same fundamental transformation that affected the altarpiece, tabernacle, and church façade: the Classical triumphal-arch scheme replaced the aedicula. The Florentine sculptor Andrea Sansovino took the decisive step in his cardinals' tombs in Santa Maria del Popolo in Rome (1505–7; pl. 83). Allegorical figures were added to depict the virtues of the deceased. The triumphal-arch motif for wall tombs persisted as long as the corresponding design for altarpieces.

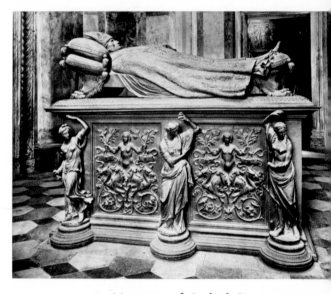

81. PAOLO SAVIN. Monument of Cardinal Giovanni Battista Zen. *Designed 1504. Bronze. S. Marco, Venice*

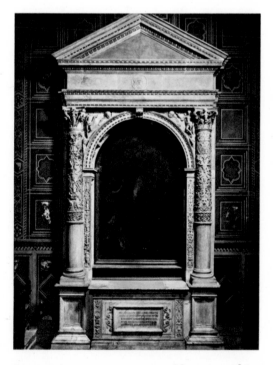

82. BENEDETTO DA ROVEZZANO. Monument of St. Giovanni Gualberto. *c. 1505. Marble. S. Trinita, Florence*

An exception to this generally adopted plan is found in Michelangelo's Medici tombs in the New Sacristy of San Lorenzo in Florence (pl. 84, Colorplate 18).[18] The solitary genius of the greatest sculptor of the Renaissance created something unique here. From tradition he took only the idea of recessing the figured tomb in the wall—everything else was his own, new contribution. The two tombs are housed in a separate structure, an immense chapel annex also designed by Michelangelo. The sarcophagi themselves are placed against an architectonic wall area; the statues of the two princes are set in shallow niches in the zone above the sarcophagi. The Medici are not presented as recumbent, realistic deceased persons but rather as seated, idealized heroic figures that symbolize not only their princely rank on earth but also two diverse astrological temperaments: that is, specific historical personages have become veritable human prototypes.

The accessory figures, the Virgin enthroned and the two patron saints of the Medici (Cosmas and Damian), occupy an entire wall between the tombs of the princes and, moreover, are of unprecedented, monumental proportions. On the sarcophagi themselves, neither conventional cherubs nor Virtues are depicted, but instead two huge nude figures recline atop each coffin. These present an allegory of the passage of time, and therefore of the fundamental law that governs earthly life. Eternity, the converse of their temporality, is symbolized in a carefully calculated *contrapposto* by the figure of the Mother of God. It may be that the allegorical significance of the nude figures was in truth an afterthought, since it appears that two—the Dawn and Twilight —were not originally intended for the lid of the sarcophagus but for the base, where along with six other reclining nudes, never executed, they were to represent mountain and river gods as an allegory of the territories governed by the Medici.

*Pulpits.* The pulpit had been a standard part of church furnishings since the Early Christian era. It took on a truly monumental aspect in the duecento and trecento, when Nicola Pisano and his son Giovanni made of it a freestanding structure adorned with reliefs representing various episodes of Christian teaching. This type of illustrative ornament previously had been confined to sculpture groups on Gothic church façades.[19] The magnificent Pisano pulpits can be seen in Pisa, Pistoia, and Siena.

The Renaissance, however, completely rejected this kind of freestanding monumental construction. In the quattrocento

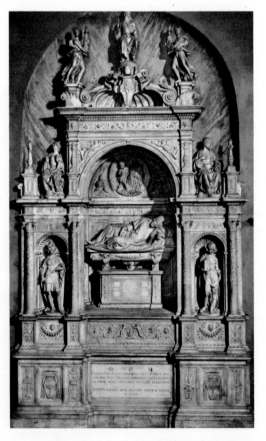

83.   ANDREA SANSOVINO. Monument of Girolamo Basso della Rovere. *c. 1505–7. Marble. S. Maria del Popolo, Rome*

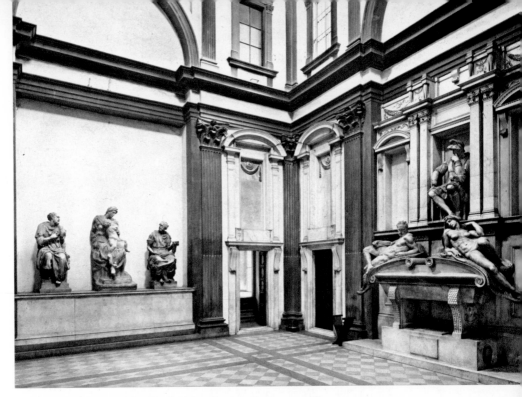

84. MICHELANGELO. *Medici Tombs, New Sacristy, S. Lorenzo, Florence. 1520–34*

the pulpit assumed a form that may have had a precedent in the wooden pulpits of the Middle Ages and the trecento: suspended from a pillar inside the church or, outside, on a corner of the façade, this type of pulpit resembled a stone or wooden basket of circular or polygonal shape. About 1435, Donatello built such a pulpit into the façade of the Cathedral of Prato (pl. 85). It was apparently used on feast days in displaying the most famous relic of the Cathedral, the sacred girdle of the Madonna.[20] On a pillar of the nave of Santa Croce in Florence, about 1474–75 Benedetto da Maiano erected a similar pulpit (pl. 86), but this was undoubtedly a true pulpit designed to be used for sermons.[21]

As might be anticipated, the form of the Renaissance pulpit is generally Classical. The repertory of images used in its decoration included many innovations. For the Prato pulpit, Donatello carved a row of dancing *putti,* a Classical motif that was intended, however, to convey a Christian meaning—

the jubilation of the angels over the healing powers of the precious relic of the Virgin. For his pulpit in Santa Croce, among other seated figures Benedetto da Maiano introduced the Virtues, a motif already employed by Nicola and Giovanni Pisano on their pulpits; moreover, since Santa Croce was a Franciscan church, Benedetto depicted the legend of the patron saint in a series of small-scale figured reliefs.

Various Early Christian churches in Italy had contained ambos, twin pulpits at either side of the chancel for the reading of the Gospel and the Epistle. This late-antique element was revived by at least one Renaissance sculptor. Donatello's two bronze pulpits in San Lorenzo in Florence (pl. 87), begun about 1460, most probably were originally disposed as ambos in front of the canon's choir. Their imagery is new, however; the large reliefs depict the Passion, but the frame around them is made up entirely of friezes with motifs that one might think inappropriate to a Christian context, themes

85. DONATELLO and MICHELOZZO. Outdoor pulpit. c. 1435. Marble, mosaic, and bronze, each relief 29 × 31". Cathedral, Prato

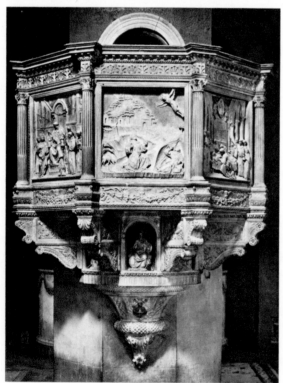

86. BENEDETTO DA MAIANO. Pulpit. c. 1474–75. Marble, each panel 28 × 26¾". S. Croce, Florence

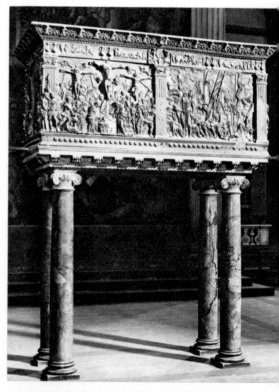

87. DONATELLO. North pulpit. Begun c. 1460. Bronze, height 9' 2". S. Lorenzo, Florence

taken over *in toto* from pagan antiquity.[22]

*Choir Galleries.* Separate galleries for the choir came into use during the Middle Ages and the trecento, but since these were constructed of impermanent materials such as wood, no significant examples have survived. Donatello seems to have been the first to build such choir galleries of marble and to give them impressive dimensions. His singers' gallery, or *cantoria,* for Florence Cathedral (Colorplate 19) takes advantage of all the richness of architectural and ornamental forms that the Early Renaissance had borrowed from antiquity. Like that of the Prato pulpit, the balustrade of this gallery, built between 1433 and 1439, is decorated with *putti* dancing inside a colonnade. The medieval motif of angels rejoicing among the heavenly hosts in the presence of the Mother of God, patroness of the Cathedral, is here converted into a Dionysiac celebration.[23] For his reliefs on the second singers' gallery of the Cathedral, Luca della Robbia adopted the same motif, with angels and children singing and playing instruments (pl. 88), an illustration of the Psalm text appropriate to the purpose of this architectural feature.[24]

*Baptismal Fonts.* In the trecento, the baptismal font was generally a small, hollowed-out polygonal basin decorated with reliefs of the legend of John the Baptist, as in the font of the Baptistery of Florence (1371). The form was redesigned during the quattrocento in keeping with the new Classical style, and the repertory of relief imagery was extended to other subject matter. One of the most impressive examples is the monumental font in the Baptistery of Siena (pl. 89), a great six-sided marble basin with a bronze relief depicting an episode from the life of John the Baptist on each side (pl. 90) and with tabernacle niches at the six angles, each of which holds a bronze allegory of a Virtue.[25] From the center of the great basin rises a short clustered pillar supporting a

88.  LUCA DELLA ROBBIA. Singing Angels (*portion of cantoria*). 1451–38. Marble, 38 × 24″. Museo dell'Opera del Duomo, Florence

89.  JACOPO DELLA QUERCIA, LORENZO GHIBERTI, DONATELLO, *and others.* Baptismal font. 1416–29. Marble, enamel, and gilt bronze. Baptistery, Siena

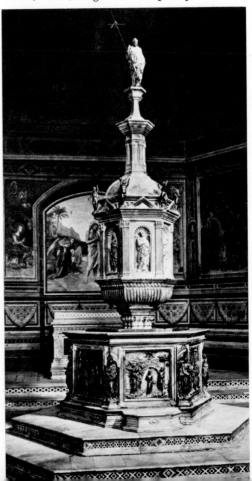

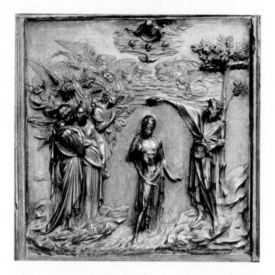

90. LORENZO GHIBERTI. The Baptism of Christ
*(relief on baptismal font). c. 1425. Gilt bronze, 23½″*
*square. Baptistery, Siena*

large shell-like bowl, which in turn holds
an aedicula tabernacle with reliefs of the
Prophets on its sides; this is crowned by tiny
rejoicing bronze *putti* and by a superstruc-
ture, at the very top of which stands a small
marble statue of the Baptist. This magnifi-
cent work was executed (1416–29) as a joint
effort of the leading Sienese sculptor Jacopo
della Quercia and outstanding Florentine
masters such as Donatello and Ghiberti.
Here, the baptismal font becomes a vehicle
for the presentation of a rich variety of
statues and reliefs, all of which relate to the
theme of salvation—in the same way as did
the pulpits of the two Pisanos earlier—but
with special reference to the sacrament of
Baptism.

*Wall Niches for Statues.* Since about 1270,
the niche had been the most frequent device
for displaying freestanding sculpture, and
its popularity continued in the Renaissance.

91. *Northwest corner, Orsanmichele, Florence. 14th*
*and 15th centuries*

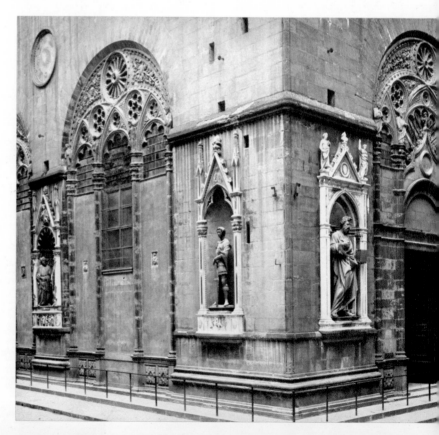

The only important change was in the style of the niche and of the sculptured figure it contained. The history of this change can be read on the outer walls of the Church of Orsanmichele in Florence, with its series of statues executed over a period of about a hundred years (pl. 91).[26] The oldest figures, dating from the mid-fourteenth century, are still in Gothic style and are set within ogival Gothic niches. In 1411 Donatello placed in such a Gothic niche a statue of St. Mark which revealed that the sculptural ideal of antiquity was already in the process of revival (pl. 137). When, about 1423, he designed a marble niche for his statue of St. Louis, it was in the shape of a Classical aedicula. The Donatello niche now contains Verrocchio's group of Christ and St. Thomas (pl. 92). Thereafter, the aedicula niche became the standard Renaissance setting for sculpture. It has been demonstrated again and again that the aedicula motif is one of the leading forms of Renaissance art. Borrowed from antiquity, it revolutionized the design of a wide range of architectural elements and furnishings: among these were windows, portals, altarpieces, wall tombs, sacramental tabernacles, and wall niches for the display of sculpture.

*Sculptured Portals.* The sculptured portal, the outstanding element of Gothic architectural decoration, was increasingly neglected with the coming of the Renaissance. Examples of this feature occur here and there during the quattrocento, but without the monumental proportions and elaborate ornament of the traditional portal. Jamb statues were abandoned once and for all. The only place where figures carved in the round continued in use was in the tympanum above the portal. Elsewhere sculpture was restricted to reliefs, and these were lined up one above another on the pilasters framing the door, in an entirely different position and with a different function from those they still had north of the Alps. Beginning

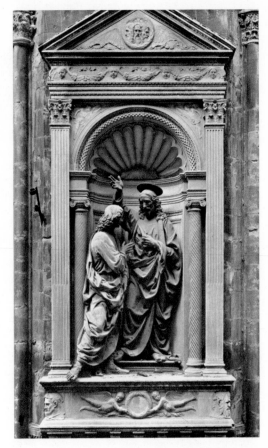

92. ANDREA DEL VERROCCHIO. Christ and St. Thomas. *c. 1465–83. Bronze, lifesize (marble niche by* DONATELLO, *c. 1423). Orsanmichele, Florence*

in 1425, the Sienese sculptor Jacopo della Quercia designed a most impressive example of this Italian type for the main portal of San Petronio in Bologna (pl. 93). In the cinquecento the figured portal became extinct and was replaced by the purely architectonic type. With the dominance of the aedicula portal, the tympanum relief also disappeared. Before this happened, however, in the Early Renaissance the glazed terra cottas of the Della Robbia workshop had made something quite charming of tympanum decoration, an ornamental type in which all of Italy delighted (Colorplate 20).[27]

*Bronze Doors.* Since Early Christian times, it had been customary in Italy to decorate wooden or bronze church doors with reliefs.[28] The builders of the Romanesque

93.   JACOPO DELLA QUERCIA. *Main portal, S. Petronio, Bologna. Begun 1425*

period continued to ornament doors with bronze reliefs or niello (metal decorated with incised designs filled with a deep-black alloy). In the trecento, for bronze doors that were still of Romanesque type, Andrea Pisano designed reliefs in the Gothic quatre-foil form. This formal type was taken over in the quattrocento by Ghiberti for the first of his bronze doors, the north doors, for the Baptistery in Florence (1403–24; pl. 94). For his second set of doors, however, the gilded east doors or "Gates of Paradise" (1425–52), he devised a new decorative framework more to the Classical taste of the Renaissance (Colorplate 21). He utilized the scheme of the baptismal font in the Baptistery of Siena, which has been discussed above.[29] Donatello, too, used the new motif for the bronze doors of the Old Sacristy of San Lorenzo in Florence (1429–40; pl. 95), and the Florentine Antonio Filarete created a monumental door of this sort for the main portal of St. Peter's in Rome (1435–45). In the High Renaissance, the Florentine architect and sculptor Jacopo Sansovino carried the Ghiberti version even further, with an impressive heightening of its decorative quality, in the sacristy door of San Marco in Venice (begun 1545; pl. 96).

When one considers the development of the figured portal—with its basic rejection of the florid style inherited from the Gothic period—it seems doubly significant that the Renaissance, by contrast, should have lavished such attention on the panels of the door itself. As the decoration of the portal was reduced to a simple architectural frame, its formerly elaborate figural decoration was

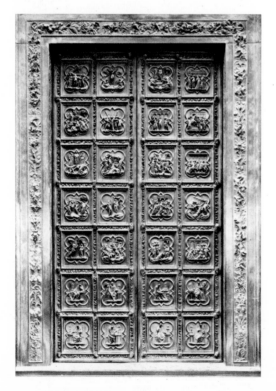

94.   LORENZO GHIBERTI. *North doors. 1403–24. Gilt bronze, height 18′ 6″. Baptistery, Florence*

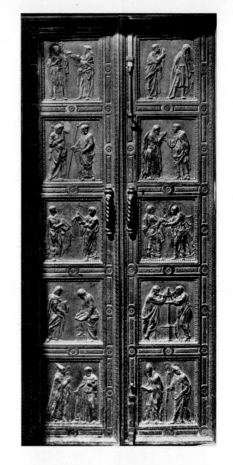

95. DONATELLO. *Sacristy doors. c. 1429–40. Bronze, height of doors 92½". Old Sacristy, S. Lorenzo, Florence*

transferred to the door itself, with ambitious relief ornament, and the notable sculptural development of the portal typical of the medieval period was abandoned in favor of a revived emphasis on the door only, as had been the rule in classical antiquity.

## Secular types

Just as the various components of religious edifices were transformed during the Renaissance, so also new forms were devised for the decoration of secular buildings, and these nonreligious innovations present further evidence of the creative achievement of the period.

*Fountains.* Already in the thirteenth and fourteenth centuries, fountains had been conceived as independent monuments, especially when they served as the principal outlet for the communal water supply on the main squares of larger towns. Utility and decoration were joined in the creation of as fine a work as the fountain that Nicola and Giovanni Pisano erected for Perugia in 1278. It was still within this tradition that the first important fountain of the Renaissance was designed, the major work of Jacopo della Quercia, the Fonte Gaia on the Piazza del Campo, the main square of Siena (1409–28; pl. 4). Even the kind of imagery used—the allegorical political "propaganda" discussed in Chapter Two—belonged to an older tradition, and the architectural and decorative forms were still largely those of the late trecento in style and character.

In Florence, Donatello hazarded a break with tradition. Unfortunately, only the

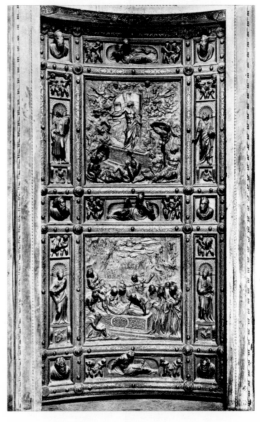

96. JACOPO SANSOVINO. *Sacristy door. Begun 1545. Bronze. S. Marco, Venice*

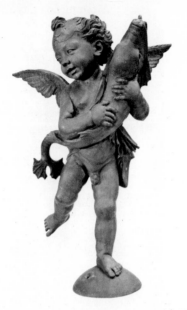

97. ANDREA DEL VERROCCHIO. Putto with Dolphin.
c. 1465. Bronze, height 27″ (without base). Palazzo
Vecchio, Florence

bronze figures have survived from his
fountains: *David* in the Museo Nazionale
and *Judith and Holofernes* from the fountain
in the Palazzo Medici, presently set up in
Piazza della Signoria (Colorplates 31, 22).
David and Judith are Old Testament figures
who seem to have been chosen as subjects
because their stories provide a symbolic sig-
nificance for the waters of the fountain. (It
must be admitted, however, that positive
evidence that these figures were once used
on fountains is available only for the Judith
and Holofernes group.) When these statues
were incorporated in fountains, the water
flowed out of a corner tassel on the cushion
at Judith's feet and, perhaps, also out of the
base on which David stands.

The flow of water from these spouts also
suggested the blood pouring from the
wounds of Holofernes and Goliath. Here,
the aesthetic barrier between reality and the
world of artistic imagination seems, quite
deliberately, to have been broken down,
although it is likely that Donatello was
simply carrying on a medieval tradition. In

the same way, medieval baptismal fonts of-
ten include symbolic allusions to water, such
as that at Hildesheim, Germany, in which
the healing virtues of water are made the
main theme of scenic reliefs and supporting
figures, with the latter representing the
streams of Paradise. It was, in fact, typical of
the Late Gothic style north of the Alps that
life and art were brought together with no
thought of any aesthetic barrier between
them; natural materials, even real hair and
cloth garments, were used in votive pictures
and wooden statues. It should be noted,
however, that in Donatello's fountain fig-
ures such traditional symbolism was infused
with the new Classical monumentality typi-
cal of Renaissance statuary.

It remained for Verrocchio to bring this
new character to a fuller realization. His
bronze *Putto with Dolphin* (pl. 97), done
about 1465, could only have been created
in the Renaissance.[30] From the outset it was
intended for a fountain, so that its position
until recently, on a delightful sixteenth-
century fountain in the entrance court of the
Palazzo Vecchio in Florence, was perfectly
appropriate. In this bronze figure of a child,
the traditional Biblical theme so often used
for fountains before the Renaissance was
replaced by a Hellenistic motif—one that
was probably borrowed from such Hel-
lenistic statues as the famous *Boy with a
Goose* (Munich, Glyptothek). The sculptor
aimed at nothing more than a stimulating
play of forms; that the statue should delight
the eyes and give immediate pleasure seemed
enough for both the patron and the artist.
There is even a touch of humor: the charm-
ing cherub appears to squeeze the gigantic
fish so tightly that water spurts from its
mouth.

In the sixteenth century, with the High
Renaissance, the fountain became a play-
ground for water gods. Nymphs and river
deities, along with their amphibious com-
panions, were appropriated from classical

mythology and art and installed in their native element, water. Ever true to the spirit of this classical world of fancy, the Humanists invented new nature gods, embodiments of local streams and watercourses, and these newly naturalized Italian water divinities were enthusiastically adopted for fountain decoration. Henceforth, the divinity of nature was to be the standard theme for fountains; it has reappeared continually, in all its wonderful diversity and charm, throughout the periods of Mannerism, the Baroque, the nineteenth century, and even in our own time.

*Commemorative Monuments.* The commemorative monument was a revival, and to an even greater degree the creation, of the Renaissance era.[31] Such monuments, as conceived both in antiquity and in modern times, were virtually unknown to the Middle Ages. The very rare exception confirms the rule, and what might seem to qualify as such often turns out to have originated in a quite different idea. In many cases the medieval work was, in fact, an object of veneration, such as the crosses in marketplaces and at roadsides or the figures of saints or their attributes (e.g., the lion of St. Mark) that were set up on columns. In other instances, it was a legal symbol used to affirm some political institution—such as the lion of Brunswick, the imperial marker at Magdeburg, or the Low German figures of Roland—in which what counted was not the glorification of the institution but the assertion of a legal claim.

The patrons and artists of the Renaissance reverted to the commemorative function that had been assigned to this medieval kind of votive object or signpost in antiquity. In the years 1428–31, Donatello created for the Old Market in Florence a memorial column, called the *Dovizia*,[32] which though lost is known to us through old pictures. This was certainly the earliest monument in the modern sense. Atop a gigantic Corinthian column was a female figure, larger than lifesize, bearing a basket of fruit and flowers on her head. On the very same spot had once stood an ancient memorial column, which supported a statue of a youth representing the tutelary deity of the city of Florence. Replacing this ancient predecessor, Donatello's *Dovizia* was conceived in complete conformity with the spirit of antiquity. It was an allegory of the superabundance, and hence of the material wealth, which it was hoped Mother Nature would lavish on the Florentine market—as indeed she did. Few works of art express so unmistakably the bond between nature and the antique spirit, that fundamental, distinguishing premise of the Renaissance. Both in content and form, it must have had the effect of a manifesto.

In yet another way the Renaissance was the creator of our modern monuments. In northern Italy, during the trecento, the tomb had evolved into something of a commemorative monument by being taken from its customary place inside the church and installed in an outdoor space.[33] This tendency is exemplified in the equestrian statues surmounting the pyramidal roofs of the freestanding tabernacles built near the Church of Santa Maria Antica in Verona. Dating from 1339 and 1375, these are funerary monuments to the knights of the Scaliger family. On the basis of these Late Gothic works, Donatello devised something new. His monument to the *condottiere* Erasmo da Narni (1444–53; pl. 98)—familiarly known as the "Gattamelata"—in front of the Basilica of Sant'Antonio in Padua already gives the impression of a true commemorative monument, reviving as it does the ancient Roman style of equestrian statues, such as that of Marcus Aurelius on the Capitoline. It uses an ancient material, bronze, and its form owes something also to the antique bronze horses over the façade of San Marco in nearby Venice. Nonetheless,

it remains very much a tomb, differing little in essence from those of the Scaliger family. The high pedestal is unmistakably a cenotaph—no longer, to be sure, an actual repository for the bones of the deceased, but designed as if it were.[34]

More than a century earlier, however, in 1328, there was already erected a memorial to a famous man that was to inspire a new kind of commemorative monument: the fresco by Simone Martini in the Palazzo Pubblico of Siena in which the *condottiere* Guidoriccio da Fogliano is depicted astride his horse in the camp before the besieged city. In Florence and Siena, from the end of the trecento on, it became customary to erect wooden or stone equestrian statues of military leaders, although still only inside churches and on tombs.[35] But upon such trecento Tuscan prototypes was modeled the first true equestrian monument—the bronze effigy of Duke Niccolò III d'Este in Ferrara (1441–51), which originally stood in the ducal palace but is now lost.[36] Responsible for this work were two Florentine masters, Antonio di Cristoforo and Niccolò Baroncelli, but Leon Battista Alberti also was involved and perhaps supplied the initial creative impetus. A generation later, the new equestrian motif was to reach a Classical perfection in the great statue of Bartolommeo Colleoni in Venice (1479–96; Colorplate 23) by the Florentine Verrocchio.[37]

Commemorative monuments to famous persons were not limited to equestrian statues but also included simple standing figures, such as that which the city of Mantua once planned to erect to its most illustrious native, the Latin poet Virgil, for which a sketch from the workshop of Mantegna survives (pl. 99).[38] Since the nineteenth century the nonreligious memorial statue, as created during the Renaissance, has become the standard form of commemorative monument.

At this point, some comment is necessary

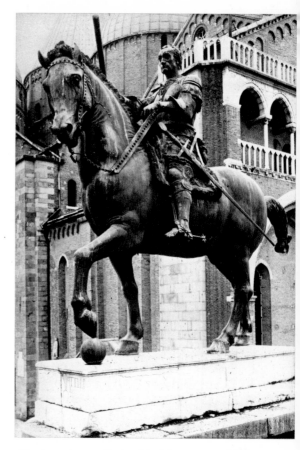

98. DONATELLO. Equestrian Monument of "Gattamelata" (Erasmo da Narni). *1444–53. Bronze, height without base c. 11'. Piazza del Santo, Padua*

on the subject of architecture and statuary. In antiquity, the full-round figure was often conceived as a wholly independent work, standing free in space. In the Middle Ages, however, the statue virtually always was simply one element in an architectural ensemble. The quattrocento masters undertook to regain for sculpture its long-lost independence and gradually liberated the full-round figure from its medieval restrictions. Therefore, the opportunity to place a statue autonomously in an open space such as a town square must have seemed an ideal solution. This also explains in part why fountains and commemorative monuments

became objects of such strong interest. In this type of sculpture, it was possible to discard completely the long-standing subordination of the statue to architecture; the architectural setting could be relegated to an auxiliary role and the statue itself allowed to emerge as the focus of attention. The finest product of this significant change in attitude was the monumental equestrian statue.

*Decoration for Public Celebrations.* Fifteenth- and sixteenth-century Italians delighted in the great variety of elaborate decorations called for by their public celebrations.[39] As far back as the trecento, there had been craftsmen in Florence specializing in this art form, and they were welcomed everywhere in Italy.[40] In the quattrocento and cinquecento, this ephemeral world of beauty acquired great significance. Even more than in monumental art, the characteristic Renaissance delight in ancient forms, in classical myth and history, had an ideal outlet here.

The triumphal entries into great cities of important personages provided agreeable occasions to bedeck streets and palaces. Among countless examples, we shall cite only one. When the Medici Pope Leo X visited his native city of Florence in 1515, triumphal arches were erected and false façades set up to hide unfinished church fronts.[41] Such counterfeit architecture, made of wooden scaffolding, stretched canvas, and stucco, was an ideal setting for the Renaissance world of Classical form and concepts. Here the imagination of patrons and artists could disport itself without restraint, to the joy of a public avid for every kind of spectacle. Vasari gives rapturous accounts of such occasions in his biographies of the Rusticis and other artists. Holiday celebrations, ceremonial events, and dramatic performances provided further opportunities for the free exercise of artistic imagination and invention—carnival processions with their decorated carts, funeral corteges, religious drama in the churches, and secular plays and ballets in the theaters.

Artists in the cinquecento, especially in Florence, organized their own celebrations to give free rein to their fancy, to allow their artistic imagination to shoot off into the most bizarre fantasies. Vasari recounts the following noteworthy story about one of the great painters of the High Renaissance[42]:

*Andrea del Sarto presented an octagonal church like San Giovanni, but resting on columns. The pavement was formed of jelly, resembling a variously coloured mosaic; the columns, which looked like porphyry, were large sausages; the*

99. WORKSHOP OF MANTEGNA. Sketch for a Statue of Virgil. *c. 1499. Pen and ink. The Louvre, Paris*

*bases and capitals, parmesan cheese; the cornices were made of pastry and sugar, and the tribune of quarters of marchpane. In the middle was a choir desk made of cold veal, with a book made of pastry, the letters and notes being formed of peppercorns. The singers were roast thrushes with open beaks, wearing surplices of slender pig's caul, and behind these were two large pigeons for the basses, with six larks for the sopranos.*

An artist's joke—nothing more. But just as a deeper meaning is often hidden in child's play, so in this riot of fancy there is revealed something of what made the Renaissance artist what he was. It is no mere accident that Andrea del Sarto's "octagonal church" was a central-plan structure, the form which was at that time the favorite of the artist's imagination. Above all, however, there is revealed here the fundamental power of the now fully independent joy in form and color for their own sake and, no less important, the subjective nature of artistic feeling for the object. In this respect also, the Renaissance pointed the way to Mannerism, to the Baroque, to the nineteenth century, and to modern art. (German literature, for instance, provides an amusing parallel to Vasari's account—the famous description in Gottfried Keller's *Grüne Heinrich* of an artists' celebration in Munich.)

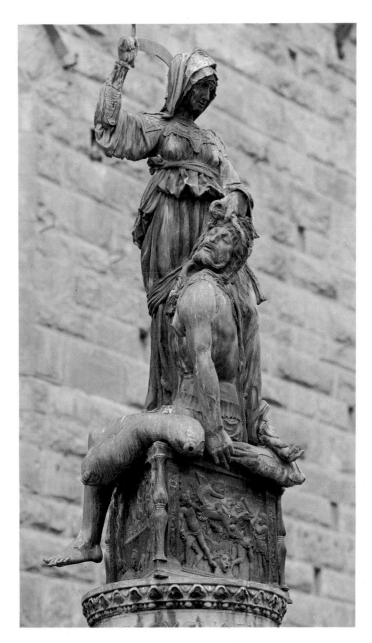

Colorplate 22.   DONATELLO. Judith and Holofernes.
*c. 1460. Bronze, height including base 93″. Piazza della
Signoria, Florence*

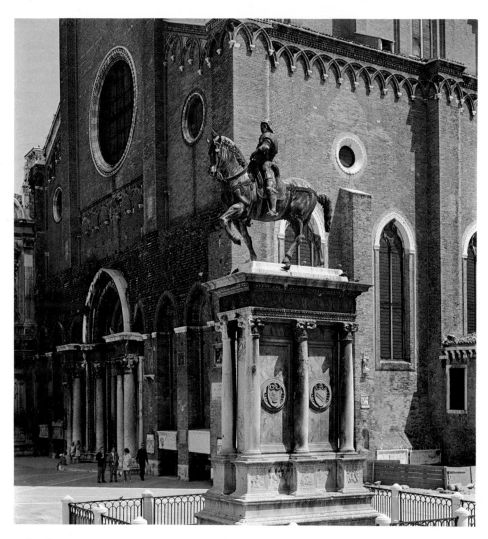

Colorplate 23. ANDREA DEL VERROCCHIO. Equestrian Monument of Colleoni. *1479–96. Bronze, height without base c. 13′. Campo SS. Giovanni e Paolo, Venice*

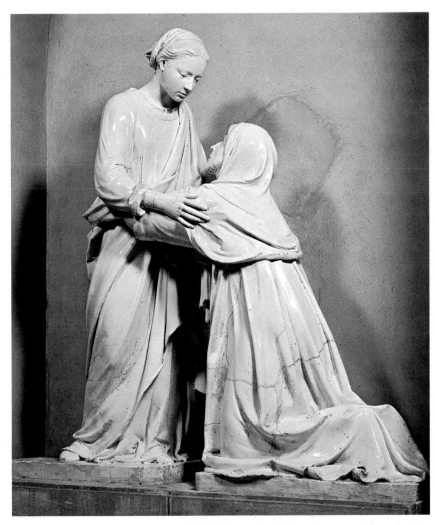

Colorplate 24.  LUCA DELLA ROBBIA. The Visitation.
*c. 1445. Glazed terra cotta, height 61″. S. Giovanni
Fuorcivitas, Pistoia*

Colorplate 25. MICHELANGELO. Battle of Lapiths and Centaurs. *c. 1491–92. Marble, 33¼ × 35½″. Casa Buonarroti, Florence*

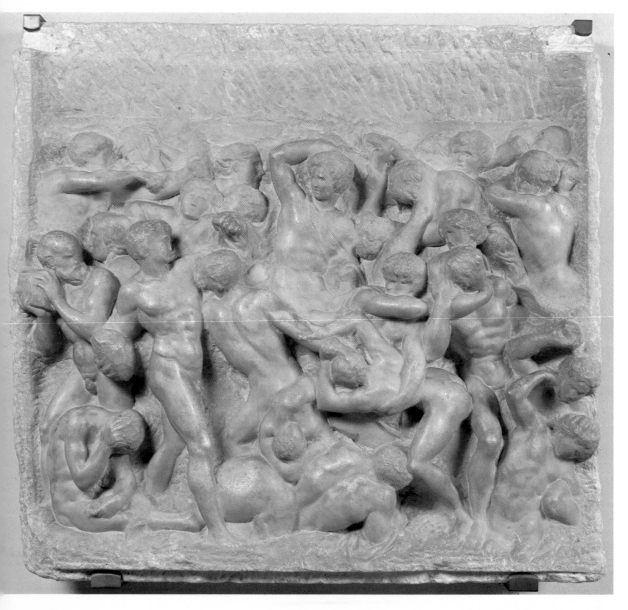

# CHAPTER
# FIVE
# SCULPTURE *Functions and types*

We have seen what tasks were assigned to Renaissance sculpture in connection with architectural decoration, as well as the solutions that were found for it in specific types of structures. Now the question arises: just how were statues themselves conceived? Essentially, this is a question of precisely what were the formal possibilities available to sculpture.

*Statues.* The independent statue continued to be relatively rare. In the Renaissance, it was most often used for devotional images and, therefore, remained tied to its long-standing religious function. Nevertheless, such religious images gained a greater formal autonomy, and the architectural setting, which was seldom lacking in the Middle Ages, was now sometimes abandoned entirely. Moreover, the expressive quality of such sculpture was greatly enhanced, for it was a fundamental drive of the Renaissance to seek to reveal the hidden significance in every subject—an aim that affected the treatment of both traditional and new subject matter. Thus, the prophet in the wilderness, John the Baptist, and the repentant Magdalene who took shelter with the first Christian hermits were rendered by Donatello with an unprecedented force (pls. 100, 101).[1] The late medieval "vesper image," the Pietà, was brought to a Classical perfection by Michelangelo.[2] An ancient subject such as Saint Sebastian was given an entirely

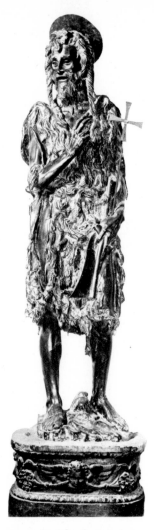

preoccupation with the emotional meaning of traditional Biblical subjects led also to highly dramatic sculpture groups such as those showing Judith and her maid with the head of Holofernes. Certain themes were given truly Classical form in lifesize proportions: the Visitation in the glazed terra-cotta

*101. DONATELLO. Mary Magdalene. 1454-55. Wood, height 74". Baptistery, Florence*

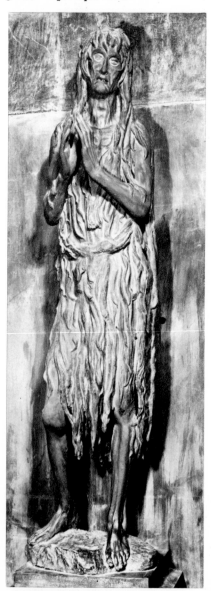

*100. DONATELLO. St. John the Baptist. 1457. Bronze, height 73". Cathedral, Siena*

new character; the young saint, chained to a tree and pierced by arrows, was now conceived as a handsome nude in the Classical style.[3] From the quattrocento on, old themes, which until then had been depicted only within their traditional setting, were taken out of context and used for independent statues—John the Baptist as a child or youth (Donatello, Antonio Rossellino; pls. 102, 103),[4] David the shepherd with his catapult and the head of Goliath (Donatello, Michelangelo, Verrocchio; Colorplate 31, pls. 136, 140),[5] or Judith with the head of Holofernes (Donatello; Colorplate 22).[6] The

group by Luca della Robbia in San Giovanni Fuorcivitas in Pistoia (Colorplate 24); the Baptism of Christ in the marble group by Andrea Sansovino in the Baptistery of Florence (1502/1505; pl. 104); the Holy Family (pls. 105, 106) in marble groups by Andrea Sansovino and Francesco da Sangallo in Rome and Florence.

Whatever one might expect, sculpture based on Christian themes was much more frequent in the Renaissance than that using explicit themes from pagan antiquity. This simple fact is too often forgotten, since enthusiasm for Classical antiquity has long been considered the very essence of the Renaissance. It was certainly a revolutionary factor of great significance, but the fact is that

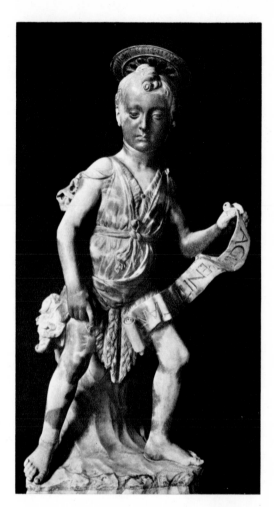

*103.* ANTONIO ROSSELLINO. St. John the Baptist as a Child. *1477. Marble, height 38⅝". Museo Nazionale, Florence*

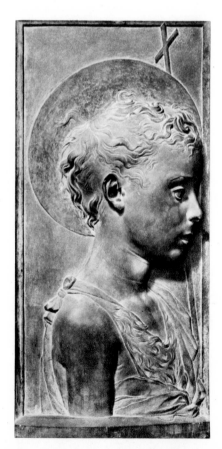

*102.* DONATELLO. St. John the Baptist as a Youth. *c. 1455. Marble, height 68". Museo Nazionale, Florence*

common opinion errs in ascribing more importance to it than to the traditional Christian cultural bases. Strong evidence for this lies in the fact that it was not until the High Renaissance that large statues on definite Classical themes were introduced. The subject of drunken Bacchus led this procession, in marble figures by Michelangelo and Jacopo Sansovino (pls. 107, 108).[7] Such statues had great appeal for the more learned connoisseurs, who sought them eagerly for their private collections.

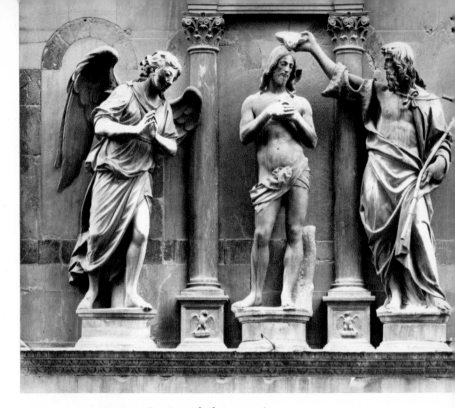

104. ANDREA SANSOVINO. Baptism of Christ. 1502/
1505. Marble, height of Baptist 8'6". Portal group above
east doors, Baptistery, Florence

105. ANDREA SANSOVINO. Holy Family. c. 1520.
Marble, height 49¼". S. Agostino, Rome

106. FRANCESCO DA SANGALLO. Holy Family. 1526.
Marble. Orsanmichele, Florence

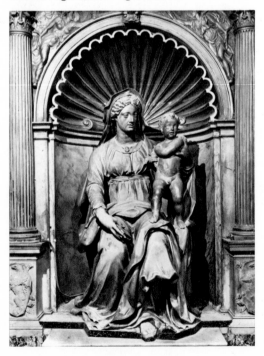

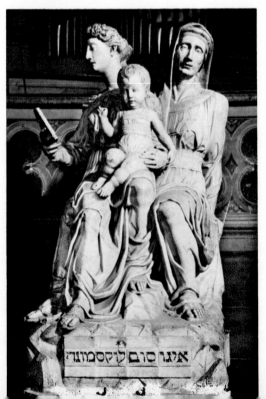

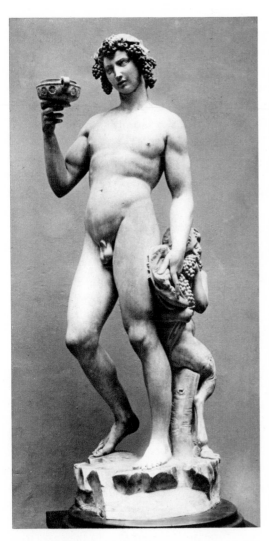

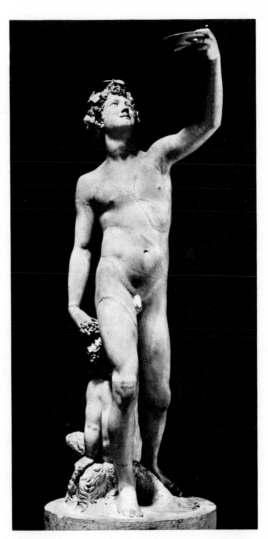

*107.* MICHELANGELO. Bacchus. *1496–97. Marble, height 80". Museo Nazionale, Florence*

*108.* JACOPO SANSOVINO. Bacchus. *1511–12. Marble, height 57½". Museo Nazionale, Florence*

*Independent Relief Panels.* In the quattrocento and cinquecento, as in earlier periods, relief panels usually were produced in series and were associated with architectural elements such as funeral monuments, altarpieces, bronze doors, choir tribunes, pulpits, sacramental shrines, baptismal fonts, and the like. The independent relief panel remained rare, although it did occur, and was used mostly for religious purposes, such as the plaques depicting the Madonna that served as devotional images inside houses and in the wall shrines along public streets.

In the early years of the High Renaissance, when its Classical style was being developed, the single relief, like the independent statue, began to adopt ancient themes as a means of

*109.* FRANCESCO DI GIORGIO. Battle at the Wedding of Peirithoüs. *c. 1477–82. Stucco relief, 19½ × 24". Victoria and Albert Museum, London*

presenting beautiful forms for their own sake. About 1477–82, probably at the request of that outstanding connoisseur Duke Federigo da Montefeltro of Urbino, the Sienese master Francesco di Giorgio created a number of separate reliefs, including the *Judgment of Paris* (Dreyfus Collection, Paris), the

*Wedding of Peirithoüs and Deidameia* (Staatliche Museen, Berlin), and the *Battle at the Wedding of Peirithoüs* (pl. 109; erroneously titled in the museum *An Allegory of Discord*).

About the same time, Verrocchio did a pair of reliefs for Matthias Corvinus, King of Hungary, with portraits of Alexander the Great (pl. 110) and the Persian king Darius.[8] The direct inspiration for these undoubtedly came from a relief portrait of Caesar by Desiderio da Settignano. In all likelihood, the indirect source can be found in the depictions of famous men common in Italy ever since Giotto created his fresco cycle in Naples (now lost). The theme was further developed in the quattrocento, for example, in the frescoes of Andrea del Castagno in the Cenacolo di Sant'Apollonia in Florence (pl. 111), with such historical figures as Pippo Spano, Dante, and Petrarch. The Florentine Bertoldo di Giovanni lent important support to this tendency in a bronze relief, in the Classical manner, of a cavalry battle that he did sometime before 1491 (pl. 112),[9] and this may have inspired the young Michelangelo's marble relief *Battle of Lapiths and Centaurs* (Colorplate 25).[10] Henceforth, the independent relief plaque on themes from classical antiquity was to be a special favorite of Renaissance artists and patrons.

*Tondos.* The tondo,[11] a relief in circular medallion form constituting a self-contained effigy or scene, also became very popular in this period. Small medallions had been frequent decorative motifs in the borders of mosaics and frescoes since Early Christian time in late antiquity. In the early trecento, in his Navicella mosaics in Rome and especially in his great fresco cycle in the Arena Chapel of Padua, Giotto had so enriched the contents of this design and so impressively enlarged its dimensions that it was only a matter of time before the round picture became a widely adopted independent form. This was achieved in the quattrocento, most

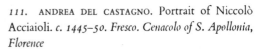
111.   ANDREA DEL CASTAGNO. Portrait of Niccolò
Acciaioli. *c. 1445–50. Fresco. Cenacolo of S. Apollonia,
Florence*

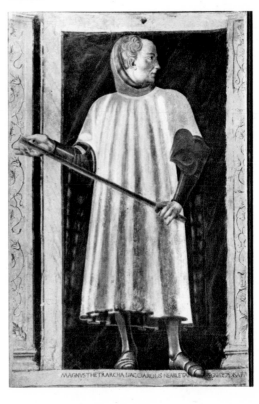

110.   ANDREA DEL VERROCCHIO. Alexander the Great.
*c. 1480. Marble relief, 21 × 14½″. The National Gallery
of Art, Washington, D.C. Gift of Therese K. Straus,
1956*

112.   BERTOLDO DI GIOVANNI. Battle Scene. *c. 1490.
Bronze, 16⅞ × 39″. Museo Nazionale, Florence*

of all by the Florentine painters, such as Masaccio in his *Visitation of the Childbed* (pl. 113), Domenico Veneziano in his *Adoration of the Magi* (Staatliche Museen, Berlin), and Fra Angelico and Fra Filippo Lippi in the *Adoration of the Magi* (pl. 114).

The relief sculptors promptly appropriated the new form. Donatello was the first to do so when, about 1435–43, he designed stucco reliefs for the medallions Brunelleschi had proposed for the Old Sacristy of San Lorenzo in Florence (pls. 115, 116). Soon after, his Florentine followers devised an effective and pleasing variant, the Madonna tondo, a marble medallion with a half figure of the Mother of God, such as that introduced by Bernardo Rossellino in the lunette of his funeral monument for Leonardo Bruni in Santa Croce in Florence (Colorplate 16). This was to become a common feature of Renaissance tombs and, generally, was flanked by worshiping angels also in relief. Still another variant was provided by Ros-

sellino's contemporary Luca della Robbia,[12] and later by his nephew Andrea, who used glazed terra cotta in making an astonishing number of relief tondos of the most diversified and charming character: half figures of the Madonna, sometimes surrounded by angels, (Colorplate 20); the Evangelists (Pazzi Chapel, Florence); allegories of the Virtues (pl. 117); portrait busts (pl. 118). One should again mention here the notable tondo series of infants in swaddling clothes executed by Andrea della Robbia for the Ospedale degli Innocenti in Florence (pl. 56).

The round shape of the tondo suggests a circular composition for the figures within —an ideal fundamental organization that came to be appreciated for its formal possibilities. Raphael exploited it with the utmost of Classical consistency in one of his most famous paintings, the *Madonna of the Chair* (pl. 199).

*Portrait Busts.* The artists and public of Roman antiquity had been especially fond

113.   MASACCIO. Visitation of the Childbed (desco da parto). *c. 1426. Panel, diameter 22″. Staatliche Museen, Berlin*

114.   FRA ANGELICO *and* FRA FILIPPO LIPPI. Adoration of the Magi. *c. 1445. Panel, diameter 54″. The National Gallery of Art, Washington, D.C. Samuel H. Kress Collection*

115. DONATELLO. St. John the Evangelist. *c. 1435–
43. Stucco roundel, diameter 84½″. Old Sacristy, S.
Lorenzo, Florence*

116. DONATELLO. Ascension of St. John the Evan-
gelist. *c. 1435–43. Stucco roundel in vault, diameter
84½″. Old Sacristy, S. Lorenzo, Florence*

117. LUCA DELLA ROBBIA. Temperance, *from the series of Four Cardinal Virtues. 1460–66. Glazed terra cotta, 78¾". Ceiling, Chapel of the Cardinal of Portugal, S. Miniato al Monte, Florence*

118. ANDREA DELLA ROBBIA. *Bust of a Lady. c. 1470. Glazed terra cotta, diameter 17¾". Museo Nazionale, Florence*

of the sculptured portrait bust. This formal type survived in the Romanesque and Gothic periods in religious art only, in the special form of reliquary designed as the bust of a saint whose relics were contained therein. Only in the fourteenth century was it taken up again for portraiture, by the sculptor Peter Parler on the triforium of the Cathedral of Prague. It is possible that this revival was inspired by Italian portraiture of the trecento, perhaps by the work of Andrea Orcagna. But Parler's busts were still conceived as part of an architectural ensemble and, thus, must be considered architectonic sculpture of the sort typical of the Gothic: each bust is set within an arched niche, and together these niches compose a kind of tympanum over a portal. Further, each bust was carved directly from the same block of stone as its niche, with bust and niche therefore executed as an integral unit. Finally, the portrait series in the triforium (1374–85) is but a part of a larger ensemble, that is, the over-all program of figural decoration for the Cathedral choir, based on the medieval conception of the *civitas dei*. Such a sculptural program was virtually standard in Gothic times for the decoration of cathedrals.[13]

It remained for the quattrocento to bring about a notable reversal, restoring to the portrait bust the spirit and form it had had in antiquity. Donatello's silver bust of St. Rossore (Museo di San Matteo, Pisa), done before 1427, is still obviously a reliquary.[14] But the painted stucco bust of Niccolò da Uzzano (pl. 119), the work of a sculptor of the next generation, probably Desiderio, is quite different in character.[15] It represents what the portrait bust had been in ancient Rome and also what the portrait bust of the Renaissance was to become—a strongly individualized portrait and nothing more, a figure entirely devoid of religious connotation and of association with any kind of architectural setting. Probably the inspiration came from the death mask, since like

the ancient Romans, the Italians of the Renaissance had the custom of commissioning such masks to be hung in their dwellings as memorials to the deceased. The visual aspect of the Renaissance bust corresponds to the ancient model, as does the drapery, that idealized Classical garment which, as in the Middle Ages, was molded of real cloth soaked in plaster of Paris and laid over the stucco body of the statue.

From such beginnings, busts in marble and bronze were soon developed into portraits taken from life, which were among the most magnificent creations of the Renaissance. With unwonted freshness, the inexhaustible treasures of inspiration offered by nature and life were re-created in aesthetic form: the radiant joy of a young boy in busts by Desiderio da Settignano (pl. 120); the bittersweet grace of aristocratic girls and women in busts by Desiderio and Verrocchio (pl. 121, Colorplate 26); the proud

120. DESIDERIO DA SETTIGNANO. Laughing Boy. *c. 1453–55. Marble, height 13″. Kunsthistorisches Museum, Vienna*

119. DESIDERIO DA SETTIGNANO(?). Niccolò da Uzzano. *c. 1460. Painted terra cotta, height 18¼″. Museo Nazionale, Florence*

121. DESIDERIO DA SETTIGNANO. Bust of a Lady (Isotta da Rimini). *c. 1455–60. Marble, height 21″. The National Gallery of Art, Washington, D.C. Samuel H. Kress Collection*

strength of the noble virile youths who were of the circle of Lorenzo the Magnificent in busts by Verrocchio and Antonio Pollaiuolo (Colorplate 27); the wisdom and dignity, and even a hint of slyness, of mature and greying men as in the portrait of Matteo Palmieri by Antonio Rossellino or that of Pietro Mellini by Benedetto da Maiano (pls. 122, 123);[16] and, finally even the forceful temperament and elevated spirit of the great geniuses of art, as seen in the bust of Mantegna in Sant'Andrea in Mantua (pl. 124).

and very numerous, were portraits of contemporary local saints; in Florence, Archbishop Antonino, who lived about the middle of the fifteenth century, was depicted in countless busts following his canonization, which came soon after his death. Also produced in quantity were busts of Christ, turned out cheaply in terra cotta by the Verrocchio workshop for what one might call mass distribution.

The ultimate in Renaissance portrait busts was achieved by Michelangelo, whose overlifesize marble Brutus (Colorplate 28) is an idealized portrait of the man of action, a Classical embodiment of manly virtue.[18]

*122.* ANTONIO ROSSELLINO. Matteo Palmieri. *1468. Marble, height 23⅝". Museo Nazionale, Florence*

*123.* BENEDETTO DA MAIANO. Pietro Mellini. *c. 1474–76. Marble, height 21". Museo Nazionale, Florence*

Sometimes a religious motivation was still sought for the portrait bust; hence, beneath the mask of many a religious image of the Renaissance era there was a contemporary portrait. Often found in Florentine art of the second half of the quattrocento were paired busts of young boys, which were apparently nothing more than portraits of the scions of prominent families but which were undoubtedly intended to represent the sacred playmates Jesus and John the Baptist (pl. 125).[17] Much in demand also,

This portrait of the murderer of a tyrant—the man who assassinated Caesar, the murderer of the Roman Republic—is a passionate testimonial from its creator to the civic ideal of the Florentine Republic, a political manifesto intended to tilt the scale of current politics at the very moment when the Spanish and German armed might of

Emperor Charles V was preparing to deal a deathblow to the ancient and honorable institution. Perhaps better than any other, this one work of art reveals a basic truth: the veneration of the Renaissance for classical antiquity had roots that reached far beyond

124. G. M. CAVALLI. Bust of Mantegna. *1480.* Bronze. *S. Andrea, Mantua*

the level of mere aesthetic form, roots that corresponded in every way to the prevalent attitudes and aspirations of the men of the period.

## Minor forms

Without a doubt, the ideals of the Renaissance achieved perfect expression in one art form in particular, namely, minor sculpture, or the small sculptured piece. For this reason, these creations deserve separate and special treatment.[19] Minor in dimensions but not in excellence, such works of art were, by their very nature, absolutely without function, without any purpose ulterior to their own decorativeness. They were, one might

say, pure play and nothing more, and in this respect they are quite distinct from any type of art discussed thus far.

As early as the Romanesque and Gothic periods, the presumed religious function of this kind of object had been scarcely more than a convenient excuse for its creation. One need only think of the medieval water vessels, the aquamaniles shaped like lions, roosters, horsemen, and the like. Evidently, the designers of such liturgical utensils viewed the obligatory, traditional ewer shape as an outlet for their plastic imagina-

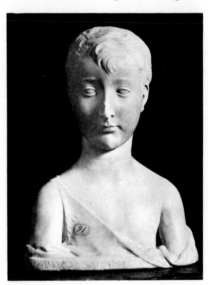

125. ANTONIO ROSSELLINO. Bust of John the Baptist as a Child. *c. 1461. Marble, height 15″. Museo Nazionale, Florence*

tion, a welcome opportunity to give free rein to their delight in the bizarre and the beautiful. This imaginative freedom was true also of secular minor plastic arts in the Middle Ages. In these, eroticism played a most important part, whereas in "official" art—that is, in the large forms—it was virtually nonexistent. This tendency is seen in the so-called "love coffers" and in even more extreme examples such as carved knife handles on which are depicted a tightly embracing pair of naked lovers.

The Renaissance went much further in the free exercise of artistic imagination. Like the decorations for festive occasions, the minor plastic arts were a veritable paradise for satisfying the artist's delight in the curious and extraordinary, his joy in beauty for its own sake, and his passion for Classical motifs. Indeed, these arts constituted a kind of catchall, an omnium-gatherum of motifs of all sorts; yet, at the same time, they provided the clearest of mirrors for the diverse ideas and themes that stirred the awakened spirit of men of the quattrocento and cinquecento. It was the new aristocracy, now gathered together in the refined existence of the courts, which especially favored the minor plastic arts. In their courtly world, all the driving forces of the new society moved in consort—men of action and prophets of the new learning, dynastic princes and warrior mercenaries, Humanist philosophers and artists. It was at one such court that the first steps were taken in the development of the new minor art forms of the Renaissance.

*Medals.* Out of ordinary coins, there gradually developed what might be termed a display coin, the medal.[20] Saints, spiritual or temporal rulers enthroned, or coats of arms had been depicted on medieval coins. Whether conveyed in human form or in symbols, these graven images were nothing more than emblems of the authority responsible for minting the coin. A change in coinage practices occurred about 1390. In one of the centers of Humanist studies, the university town of Padua, the reigning prince, Francesco II Novello da Carrara, after winning back his illegitimate authority, had two display coins of a markedly different character struck off. These bore accurate likenesses in profile of the Paduan despot and of his father, Francesco I.[21] The portraits were modeled after old Roman coins, specifically, the sesterces bearing profiles of the Roman emperors.

This new type of bronze medal was thereafter taken up by one of the greatest masters of the Early Renaissance, Pisanello.[22] In his activity of the 1430s and 1440s he established their definitive appearance. Instead of being stamped, his medals were cast from molds. Apparently inspired by Burgundian display coins, he devoted one face to a profile portrait and the other to an allegorical emblem that was the device, or *impresa*, of the person portrayed. Thus, on a medal made for King Alfonso V of Aragon and Naples there appears the motto *liberalitas augusta* ("princely generosity"), together with the symbol of an eagle abandoning its quarry to smaller birds of prey (Colorplate 29).

Assuredly, the medal is one of the most interesting creations of Renaissance art. Its portrait likenesses testify to the self-awareness and realism of the men of its time, and the *impresa* it bears affords a profound insight into the ideas that the leading men and women of the period chose as guiding principles for their lives. The medals of Pisanello constitute an artistic treasure of the highest quality in their portraiture and in their beauty of design. Throughout the Renaissance, the medal was to remain one of the most fruitful and attractive art forms.

*Plaquettes.* Analogous to the medal is the plaquette, a somewhat larger round or rectangular plate of bronze or some noble metal, bearing bas-relief that might depict any theme from the entire range of secular and religious imagery.

*Bronze Statuettes.* The bronze statuette, which arose as an offshoot of the large cast-metal statue or relief, comprised both single figures and groups. Large bronzes had usually been further decorated, with a variety of small figures distributed over the base or frame or elsewhere, as exemplified by the frieze on Donatello's pulpit in San Lorenzo in Florence (pl. 87) with its playful *putti*, horsemen, centaurs, and vases. Such small

*126.* DONATELLO. *"Atys-Amorino." c. 1440. Bronze, height 41". Museo Nazionale, Florence*

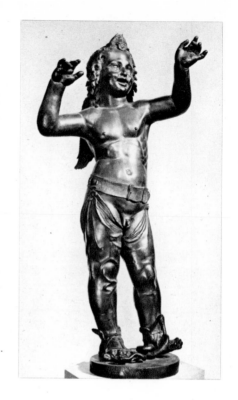

marginal figures soon became freestanding statuettes and groups, especially in the work of certain pupils of Donatello in Padua and Florence from about 1460 on. Donatello himself had made some independent contributions to this sculptural genre in a classical vein (pl. 126). These small-scale sculptures were apparently made specifically for individual collectors and art lovers.

The small bronzes offered their many enthusiastic collectors a kind of microcosm of Renaissance imagery, particularly in their re-creation of the world of classical antiquity. They portrayed the beauty of nude pagan gods, but also the sinister, demonic, half-divine and half-animal anomalies such as centaurs and sphinxes, as well as the pathos of the heroes of classical myth and history. A few examples should suffice to demonstrate this wealth of imagery. Among the small bronzes of the Paduan Andrea Riccio, the most prolific artist in this field, can be found these ancient themes (pls. 127–130)[23]: the gods Venus, Vulcan, Bacchus, and Hecate; the demigods and fabulous creatures such as Pan, Marsyas, nymphs, satyrs and satyresses, and the sphinx; heroes and favorites of the gods, including Adonis, Europa on the bull, and the singer Arion; allegories of Pomona and Abundantia; and other figures whose Arcadian character connects them with classical pastoral poetry such as a naked stripling with a goat, a nude amphora bearer, and the like.

*127.* ANDREA RICCIO. Pan Listening to Echo. *Bronze inkstand. Ashmolean Museum, Oxford*

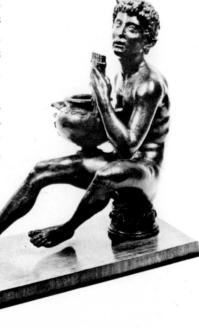

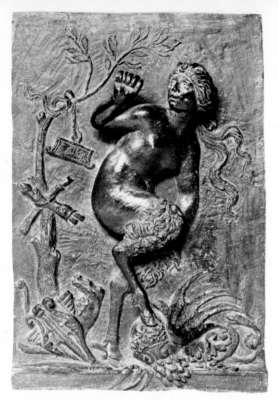

128. ANDREA RICCIO. *Satyress. Bronze, height 6½″. Cleveland Museum of Art*

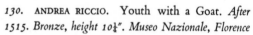
130. ANDREA RICCIO. Youth with a Goat. *After 1515. Bronze, height 10¼″. Museo Nazionale, Florence*

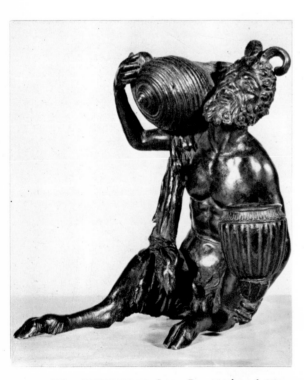

129. ANDREA RICCIO. Satyr. *Bronze inkstand. Museo Nazionale, Florence*

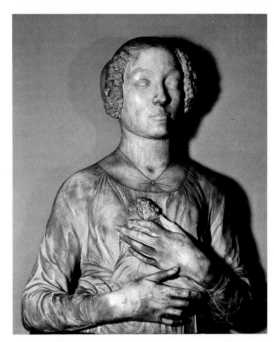

Colorplate 26.  ANDREA DEL VERROCCHIO. Bust of
a Lady. *c. 1475–80. Marble, height 24″. Museo Na-
zionale, Florence*

Colorplate 27.  ANTONIO POLLAIUOLO. Bust of a
Young Warrior. *c. 1460. Terra cotta, height 19½″.
Museo Nazionale, Florence*

Colorplate 28.  MICHELANGELO.  Brutus *(portion).*
*After 1537. Marble, height without base 29″. Museo*
*Nazionale, Florence*

Colorplate 29. PISANELLO. Medal of Alfonso V of Aragon, *recto and verso.* 1449. Bronze, diameter 4¼". *Museo Nazionale, Florence*

Colorplate 30. BERTOLDO DI GIOVANNI. Arion. *1473(?). Bronze, height 17½". Museo Nazionale, Florence*

134

Colorplate 31. DONATELLO. David.
Bronze, height 62¼″. Museo N.
Florence

The small bronzes of another leading master, Bertoldo di Giovanni (d. 1491), a Florentine follower of Donatello, include these motifs: Bellerophon taming Pegasus (pl. 131); Hercules afoot, on horseback (pl. 132), or wrestling with the Nemean lion; and Arion (or perhaps Orpheus) wandering lost in the enchantment of his own music, vibrating at one with the music of his viol— one of the most profound and fascinating representations of the magic of music in all the history of art (Colorplate 30).[24]

Another aspect of Renaissance art is more clearly revealed in the small bronzes than elsewhere: it was, oddly enough, imitation of classical antiquity that led the Renaissance artist to an appreciation of nature. To the famous ancient statue of the youth removing a thorn from his foot there correspond a number of Renaissance statuettes showing personages engaged in everyday activity, such as a stone breaker and a falconer.

Ancient depictions of Europa and the bull and of Hercules and the lion gradually encouraged charmingly naturalistic statues of other animal subjects such as cows, goats, and rams.

Small bronzes were very likely the most accurate barometer of cultural currents during the Renaissance, and so they too depicted Christian subjects, though much less often. By their very nature, they tended to neglect what was officially approved and, instead, to try to satisfy the whims and enthusiasms of the learned public who collected them. For just this reason, they give us a glimpse of an important undercurrent of Renaissance thought—popular superstition. Again the art of Riccio offers conclusive evidence, for among his small bronzes are a witch astride a ram (pl. 133), a witches' Sabbath, and many similar themes taken from common beliefs in sorcery.

Representations of the realms of faith, of

*132.* BERTOLDO DI GIOVANNI. Hercules on Horseback. *c. 1483. Bronze, height 10¾". Galleria Estense, Modena*

*131.* BERTOLDO DI GIOVANNI. Bellerophon Taming Pegasus. *c. 1483. Bronze, height 13". Kunsthistorisches Museum, Vienna*

superstition, of daily existence, of nature, and of the pagan world of antiquity—these are the most important themes of the minor plastic arts. That the themes per se interested the men of the quattrocento and cinquecento is indicated by the great popularity of

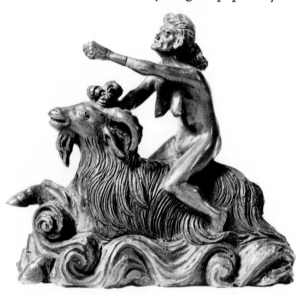

133.   ANDREA RICCIO. Witch Astride a Ram. *Bronze. Kunsthistorisches Museum, Vienna*

this form of art. Other equally important reasons for this popularity can be found, however. This art form satisfied a delight in the curious and the bizarre, a fundamental human drive; it satisfied in like measure the pure aesthetic pleasure in beautiful form, one of the major concerns of the men of that time; and finally, but not least in importance, it satisfied the sensuous joy in nudity, another basic drive in all times for all men.

## Putti

Besides the smaller plastic forms, one more Renaissance type of figure sculpture deserves special mention—the *putto*.[25] An important element in both monumental and minor

sculpture, this is one of the most conspicuous motifs of Renaissance art. The *putto* is a naked little boy, usually with a small pair of wings. The form made sporadic appearances in Italy as early as the end of the duecento and in the trecento, but it did not become truly popular with artists and public alike until the quattrocento. This development is perfectly understandable when it is made clear what the *putto* is and what he represents. The *putto* is nothing more than a descendant of Amor and the amoretti, of Cupid, and therefore of the representations of the young god of love and his followers that had been omnipresent in ancient art ever since the Hellenistic period. The Renaissance masters —who were, of course, Christian— transformed these ancient cupids into angels and thereby adapted them to a Christian context. But this conversion brought into Christian art other allusions that were inseparable from the amoretti motif—an untroubled sensuality, the irresistible enchantment of childlike qualities, and a touch of humor. With the introduction of these pagan and playful traits, the dignified, sacrosanct image of the Christian angel was irrevocably lost. The aesthetic gain for art, however, is scarcely estimable. The stern majesty of much Renaissance art is lightened and made more sympathetic by the fact that the sublime rubs shoulders with its opposite, in the humorous play of the *putti*. One need only recall the *putti* who appear along with the prophets and sibyls in Michelangelo's Sistine Chapel frescoes or those in Raphael's *Sistine Madonna* (pl. 185). Besides this, the duality of the *putto* made possible a blurring of the barriers between religious and profane art. He is not always an angel but can be found everywhere, in both religious and secular art and in imitations of ancient pagan motifs. His casual and disarming presence binds together the most contradictory elements into an ideal organic unity.

## Techniques and materials

Along with the form of a work of art, its material must be considered. Every material presupposes its own special handling, and this fact is linked to another, equally well-known phenomenon: the particular stylistic ideal of any period is best expressed in one specific material and, consequently, in the special technique appropriate to that material. To realize that ideal, the means are chosen which best express it. For Romanesque sculpture, the juxtaposition of different materials is characteristic; the end in view was often quite different, depending on the particular place and time, and thus a diversity of materials was used, including stone, marble, stucco, bronze, wood, and ivory. With the triumph of monumental architectural sculpture in the Gothic period, at first stonework became the leading technique; later, north of the Alps, woodcarving was dominant. The Renaissance introduced a new constellation. As had been typical in the Romanesque period, the Renaissance called for various techniques, with no single means becoming clearly dominant—though there was a special preference for one material, namely, marble.[26]

*Stonecarving*. The Renaissance sculptor placed special value on marble, especially the white marble from Carrara in western Tuscany. This majestic crystalline material would have delighted him if for no other reason than that it had often been used by his venerated Classical predecessors. Moreover, it permits a delicate treatment of nude flesh in close approximation of natural appearances, especially when the surface is rubbed with brownish wax.[27] None of the other, less "noble" varieties of stone could compete with marble for the artist's favor.

The essential nature of sculpture received a graphic formulation, perhaps extreme but valid for all time, from one of the greatest Renaissance theorists of art. Vasari compared the creation of a stone statue to the act of bathing: just as a man in a tub is revealed completely free of the surrounding element when the water runs out, so the figure emerges from the block when the surrounding stone is chipped away. The points of departure in stonecarving are therefore the prismatic block of material and especially the surfaces that encase it, together with the artist's own idea of the figure conceived to be hidden in the block.

*Woodcarving*. In the fifteenth century, woodcarving gained the upper hand north of the Alps, chiefly in Late Gothic Germany. With the artists and public of the Italian Renaissance the technique never found favor, and therefore in the south it was reserved almost exclusively to folk art and to the more insignificant workshops. Otherwise, the outstanding Italian workshops and masters employed the material and woodcarving tools rarely. Only Donatello furnished a significant exception with, for example, his *Mary Magdalene* in the Baptistery of Florence (pl. 101).

*Bronze Casting*. Bronze gradually gained such favor, however, that one wonders if perhaps bronze, and not marble, should be considered the preferred material of Renaissance sculpture.[28] Again, emulation of classical antiquity accounts for this to a large extent, since Greco-Roman art had made much use of bronze. In Florentine sculpture of the era, it was considered the more important material. In the cycle of figures at Orsanmichele, it was reserved for the statues donated by the rich and powerful guilds (the *arti maggiori*); the smaller guilds (*arti minori*) had to settle for the cheaper material, marble.[29] Everywhere, nonetheless, both large and small bronzes were among the outstanding artistic creations of the Renaissance. And yet, bronze sculpture and all the plastic arts in which the mass of the figure

is created by adding material to an initial armature (*per via di porre*) were considered by Michelangelo as belonging to the realm of painting rather than to sculpture, which he insisted was the art of removing material from around a figure (*per forza di levare*). For this reason, we make a distinction between "plastic arts" and "sculpture."

*Terra Cotta.* There is the closest association between bronze and terra cotta, hard baked clay. Clay models were used in preparation for bronze statues, and the manufacture of independent terra-cotta figures and reliefs found an enthusiastic reception because the material was so inexpensive. An especially fine and characteristic specialty was the polychrome glazed terra-cotta work of the Della Robbia studios in Florence. Luca della Robbia learned the technique of glazing molded figures from the processes used in ceramics that had been developed in the Islamic regions of Spain. The secret of this technique was closely guarded by its inventor and passed on only to his sons and grandsons. The Della Robbia glazes with their pure, brilliant coloring—mostly white, light blue, and green—provided a felicitous medium for the joyous sensuality of Renaissance figures.[30]

*Stucco.* Stucco was used mostly for architectural decoration, as had also been the practice in Romanesque art. We have already seen an Early Renaissance example in Donatello's stucco medallions for the Old Sacristy of San Lorenzo in Florence (pls. 115, 116). Relief images in stucco of the Madonna became especially popular, though these were generally no more than pedestrian imitations of marble reliefs. Nevertheless, they made available to the ordinary man works of art that would be beyond his means if such images were executed in marble. They found their place in innumerable shrines inside and outside the houses of a public that was not so well-to-do, just as the marble and bronze prototypes were installed in the palaces of the noble and wealthy.

## The formal vocabulary

In the arts of all periods prior to our own, the formal possibilities of sculpture and the other plastic arts were determined by the universally acknowledged aim of imitating the human figure or some other object existing in nature. Hence, it is more difficult to define what is specific to the sculpture of a particular period than to characterize its architecture. True, it is possible to demonstrate certain typical elements in Renaissance sculpture and plastic arts; but these were, for the most part, elements inherited from preceding styles—Romanesque, Byzantine, Gothic, and especially that of classical antiquity. Furthermore, these were elements which have only an auxiliary function and which do not sum up the style. The decisive factor lies elsewhere: namely, in the conscious aim of Renaissance culture to model its artistic conceptions upon natural prototypes. Those Renaissance artists who also expressed themselves in writing made this intent very clear—indeed, insisted on it. For this reason there is no purpose in trying to define in general terms a formal vocabulary that is peculiar to Renaissance sculpture; what needs to be said about it is best accounted for in the actual treatment of form as seen in the works themselves.

## Formal treatment

For the Renaissance sculptor, formal treatment—or what can be termed "style" in the conception of a figure—was derived from a conscious will to model after nature. Carving and modeling, besides offering the capability of copying many of the basic features of a man or an animal, can go further and can be used to reveal the hidden essence of the creature, the universal Idea,

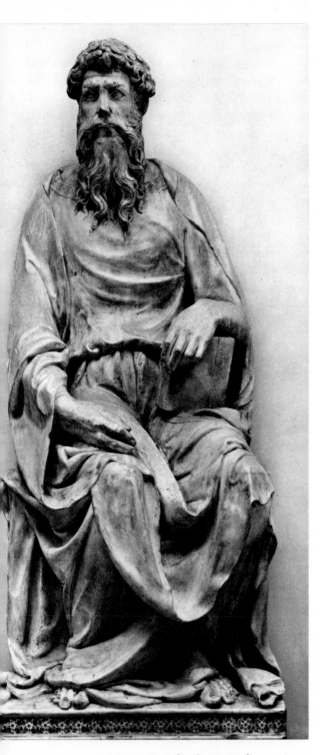

134. DONATELLO. St. John the Evangelist. *1408–15. Marble, height 82⅝″. Museo dell'Opera del Duomo, Florence*

which in nature is concealed under the myriad fortuitous variations that natural forms assume. For this reason, sculpture and modeling occupied a central place in Renaissance art. It was indeed a work of sculpture —the monumental marble seated figure of John the Evangelist in the museum of the Cathedral of Florence (pl. 134), a masterpiece by the young Donatello—that Vasari used to demonstrate his principle of *disegno*. This principle, above all others, was fundamental to Renaissance aesthetic theory and art.

We must distinguish clearly how Renaissance practice differs from that of earlier periods in which sculptors also claimed to be following the age-old precept of working from nature. The medieval sculptor probably thought that this was exactly what he was doing. To impute any other intent to him is to transfer the tendencies toward abstraction found in modern art to the art of a period for which they are totally irrelevant, thus propounding a grievous historical error. Gothic, Romanesque, and Byzantine art reveal, without any ambiguity, that their creators had lost the skill of depicting man and other natural creatures as they are in nature, as organisms whose form and proportions are set down for all time by nature and therefore are, in their main features, not subject to willful alteration. The medieval image could be, and often was, patterned after nature; it was in no way obliged to be made so. Just as often—indeed, much more often—it conformed to other directives to such an extent that its form and proportions were, to say the least, quite remote from those of the natural object being depicted.

What imposed these different ways of seeing and doing with respect to artistic activity was usually religion. In Christian thought the world of nature, the terrestrial sphere, was inextricably linked with supernatural forces, and medieval art expressed this relationship clearly. Statues, for instance,

were adapted to church architecture with indifference to natural forms and proportions, especially in the Gothic period. The medieval church was not designed to make manifest the laws of nature but, rather, to embody an image of the ideal Christian world scheme, a reflection of the supraterrestrial *civitas celestis,* the Heavenly Jerusalem.

The sculptors and other plastic artists of the Renaissance were distressed by the "unnaturalness" of medieval art and recoiled from it. To them the entire medieval way of thinking about art seemed an attitude contrary to nature, and they turned away from it to seek a more "natural" conception in the rediscovered world of antiquity. It was on this basis that they worked out the principle of *disegno*: the artist must not merely imitate mechanically what he sees in nature, with all its accidental contingencies, but rather should aim to reveal through his art the underlying essence, the Idea, the eternal laws of nature.

This revolutionary thesis determined the course of all subsequent sculpture and plastic art in the Western world until the twentieth century, when modern principles of distortion and abstraction supplanted it. The continued indifference of a great part of today's public to abstract art is evidence of the continuing influence of the Renaissance ideal. What this change in orientation actually meant to the Renaissance must now be explored, though of necessity in summary fashion, for within the present limits we can single out only the most significant conceptions and try to characterize their most typical manifestations.

*The Nude.* As might be expected, the nude figure achieved immense popularity in Renaissance art. Medieval art had from time to time employed this most natural of all forms of human representation, but only when a suitable occasion presented itself, that is, only as an exception which was required by a particular subject such as Adam and Eve. The draped figure was much more frequently used.

The Renaissance, however, opened the way for representation of the fully undraped figure. Curiously enough, it continued to be relatively rare, despite the fact that it was the focal point of artistic interest, somewhat as the central-plan church was for architecture. The work that made the definitive break with the past was probably the bronze *David* by Donatello (c. 1430; Colorplate 31).[31] What differentiates this nude from all medieval nudes is the sensuality in the modeling of the naked body, a quality that had disappeared with the passing of antiquity. One is struck not only by the lifelike vitality of its members and the sensual feeling for flesh but, above all, by its embodiment of eternal law, that truth which lies beneath mere external appearance. It is not just that the body contours, limbs, and the flesh that seems almost to breathe are patterned after nature; most significantly, the entire figure, the total conception, is "natural." The relationships among the parts are "right," and the whole sense of movement is "right."

Greek art had discovered a Classic formulation of the laws of proportion and motion in the "canon" of Polyclitus, as exemplified in the *Doryphorus,* the gracefully striding spear-bearer. This formula revealed, in terms of representational art, the natural laws of structure and movement inherent in the human body, or what might be called the natural principles of statics and dynamics in the human machine. One leg bears the weight, the other is bent backward at the knee and relaxed. Every part of the body is pervaded with this same rhythm. The shoulder corresponding to the tensed, weight-bearing leg droops with a sense of strain, while the other shoulder, in relation to the free leg, is accordingly raised in an attitude of relaxed ease, and so on through a myriad of details. One need only try the same pose

before a mirror to verify the natural inevitability of this principle of weight distribution, which might be termed "ponderation."

Through his application of the principle of *disegno,* Donatello discovered this fundamental rule and embodied it in a bronze figure, no doubt making use of the Classical prototypes of Polyclitus and perhaps also of Praxiteles. He transposed the Old Testament theme of David into something Classical, and he did this with an apparent effortlessness, a sensitive adaptation of the Polycletan canon to the special requirements of a Christian subject.

What is revealed by this is that in Renaissance art the figure is based on essentially the same laws as architecture—certainly not in the medieval sense, however, in which the statue is subordinated to its architectural

*135.* LEONARDO DA VINCI (*copy after*). Leda and the Swan. *Panel,* 47¼ × 34″. *Collection Countess Gallotti Spiridon, Rome*

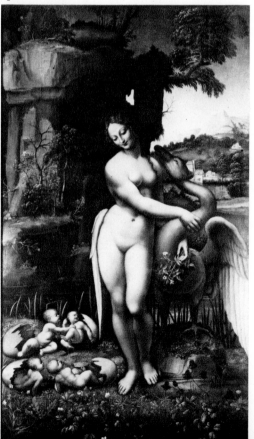

setting, but rather because architecture and figure alike respect the same naturally determined laws. What Donatello achieved in his nude figure of David, with the help of the ancient canons, can best be described by the notion of *contrapposto*; and we have already seen to what extent this principle was exploited in Renaissance architecture. In Donatello's *David,* this principle of body mechanics is evident in the carefully calculated, minutely balanced counterplay of contradictory forces and elements such as tension and relaxation, upward-downward and forward-backward movement, and nude flesh and accessories. In one respect, for a time at least, the use of *contrapposto* remained limited: unwritten law still maintained that a statue must be conceived, must present itself, from one point of view only, from the front—a holdover from medieval stone sculpture, which could do nothing else. This trait applies to nearly all nude figures of the Early Renaissance.

A further step was taken in Verrocchio's *Putto with Dolphin,* now on the fountain in the Palazzo Vecchio in Florence, dating from about 1465 (pl. 97). The movement of the childish body is much more freely evolved in space, and such a release from the medieval conception was evidently inspired by Hellenistic models.

It was not until the High Renaissance that the human figure was finally liberated from the medieval limitation to a frontal position. The decisive step was taken by Leonardo da Vinci about 1500, in his *Leda and the Swan.* Although a painting and not a statue, and despite the fact that it has survived only in copies (pl. 135), Leonardo's *Leda* deserves mention in the history of sculpture and the plastic arts—indeed, merits a place of honor, for the figure is conceived entirely as a statue. This image drawn from ancient mythology can, in fact, serve as a classic example of the full nude figure as conceived in the Renaissance[32]:

*The lovely feminine body, standing in the classical* contrapposto, *is built up by a multitude of different directions of movement, and presents an interesting variety of aspects. . . . Furthermore, its gentle turn of the torso, its subtle turning of the head in one direction, while the arm reaches across the body in the other, provided the archetype of the ideal Manneristic figure—that famous* figura serpentinata *which seeks to make the subject visible from all sides by imparting to it an upward spiral motion.*

This classical nude figure had an extraordinary impact on its time. Its influence can be detected in works of even the greatest artists of the epoch—certainly in Raphael, but also in Michelangelo. Because of such achievements we can well understand the proud conviction of Vasari that the Renaissance had not only matched antiquity but had even surpassed it.

Such figural tendencies, as well as others that had great significance in the High Renaissance, are revealed in Michelangelo's celebrated *David* (pl. 136). With a huge, already worked marble block that was assigned to him in 1501, the sculptor undertook a commission to carve an Old Testament figure which was to be the crowning element of an exterior buttress of the Cathedral of Florence. Completed in 1504, the *David* caused an immediate sensation; the public was awestruck in its admiration for the work. An artists' committee composed of Leonardo da Vinci, Giuliano and Antonio da Sangallo, and Botticelli, among others, suggested that this colossus be placed not on the Cathedral but in the Piazza della Signoria, the Loggia dei Lanzi, or the interior court of the Palazzo Vecchio. The Florentine government decided to place it near the entrance of the Palazzo Vecchio,

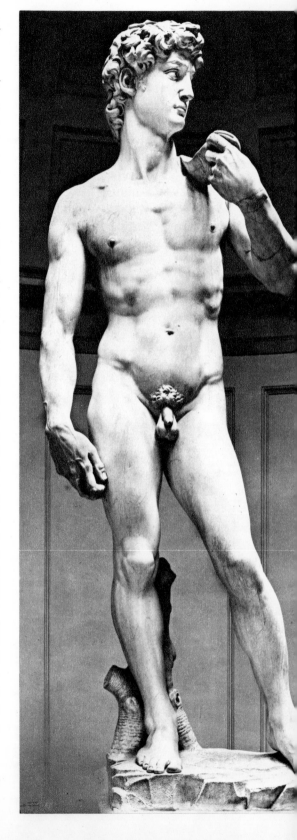

136.   MICHELANGELO. David. *1501–4. Marble, height 18'. Accademia, Florence*

seat of the government, and thus emphasize the political implications of its subject. Since the quattrocento David, as the slayer of tyrants, had represented the spirit of Florentine freedom and was also regarded as patron of the city and guardian of justice. The interpretation given the figure by the city government must surely have corresponded to its significance for the passionate patriot Michelangelo and to his strong sense of freedom. His monumental *David* fulfilled the desire of his contemporaries for the gigantic, in response to which a few years later, in Rome, Bramante also would elevate architecture to a superhuman plane. Michelangelo fashioned his statue after the impressions that contemporary thinkers had of the embodiment "of Fortitudo and of Ira" (De Tolnay), represented as youths in a manner similar to the medieval prototype of the ancient Hercules. The right side of the figure was caught in a tight or tense attitude, while the left side was loose and relaxed, in the characteristic *contrapposto* disposition.

Naturally there remained some contradiction between the logically realized subject of the athletic youth and the giant size of this figure. The execution of detail is truly miraculous, however, as can be seen in the right hand and especially in the head, where "for the first time such a tragic conception of beauty is absorbed; a conception that would continue or lead from the Sistine Chapel ceiling to the Medici Chapel" (Kriegbaum). The fact that we do not possess a fully developed piece of High Renaissance sculpture executed by Michelangelo can best be explained by the complicated nature of the master and by his restless and constant efforts to attain new heights. For the group of artists that was to emerge soon thereafter (c. 1506), the word "success" would allude to the desirable elements of confusion and torsion in their art; in other words, it referred to Mannerism.

*The Draped Figure.* We have said that the nude had somewhat the same function for Renaissance sculpture as the central-plan church had for architecture; the draped figure might be said, then, to correspond to the basilica, for both had been the most prominent forms in the Middle Ages and were to remain the most prevalent in the Renaissance. This analogy can be carried even further, since in both cases the Renaissance masters strove to develop an inherited medieval scheme and to recast it according to the inherent laws of nature. Four examples will show how this development took place.

Again, it is by Donatello that the new conception is best revealed. His enthroned, over-lifesize *St. John the Evangelist* (1408–15; pl. 134), designed to be placed in a niche of the Gothic façade of the Cathedral of Florence, retains a somewhat Gothic character in the arrangement of the drapery folds.[33] But Donatello made something quite different out of the Gothic convention, with an astonishing wealth of formal and rhythmic energies dynamically opposed. The masterful play of *contrapposto* carries the eye from the restlessly draped lower limbs to the fixed, upright torso, and from there to the overpowering and imperturbable head. With the willful movement of its elements, this conception seems to lead out of and beyond the corporeal embodiment to a spiritual significance, from the idea of the imposing seated figure to the Idea of the Apostle of the Apocalypse. As noted before, it was this figure which Vasari chose to illustrate the Renaissance principle of *disegno*. This noble work shows quite uniquely what can be achieved through this principle and, in truth, what can be achieved only through the profound penetration of an artistic genius into both the physical and the spiritual essence of the figure to be depicted.

Another major aspect of Renaissance style is represented by Donatello's monumental marble statue of the Apostle Mark, commissioned for Orsanmichele in 1411 (pl.

137).[34] Here the draped standing figure, conceived according to the ancient Polycletan canon, is completely imbued with the Renaissance principle of *contrapposto*. The inspiration for this work came, apparently, from the female figures draped in chitons executed by the school of Phidias at the time of the building of the Parthenon or from the figure of Eurydice on the well-known relief depicting the legend of Orpheus.

A comparison of this Classical solution with the still-Gothic seated figure of St. John described above—both executed at about the same time—demonstrates that the application of Classical means of expression permitted a richer deployment of *contrapposto* energies. Qualities that seem merely intimated in the *St. John* (as in its presumed prototype, an apostle figure in niche on the inner façade of the Cathedral of Reims[35]) are fully brought out in the *St. Mark*. In the latter, for the first time there is a true and natural relationship of the legs to the torso. The shoulder on the side of the weight-bearing leg droops correctly, the relaxed shoulder is properly raised, and the head twists in the opposite direction to the drooping shoulder in order to balance the raised shoulder. Here then, for the first time since antiquity, the natural mechanics of the human body have been incorporated into a work of art with complete consistency. For the first time, too, this system of stresses and balances, in which energies are distributed over an area roughly in the shape of a cross, includes the arms: the relaxed, non-weight-bearing left leg is answered by the relaxed, hanging right arm, and the tense weight-bearing right leg by the equally tense left hand.

Moreover, there is another new and very substantial achievement: the flow of the drapery appears to be determined logically by the movement of the body wearing it. Gothic style had given independent and arbitrary lines to drapery, but this largely decorative effect was now completely rejected. Both body and drapery follow the same natural laws of gravity, and this gives rise to a *contrapposto* of great richness in the body contours and garment folds, a most effective play of opposing directional lines. Among the elements of countermovement, the creased folds of drapery are especially striking. These constitute perhaps the earliest evidence in Italy of such drapery treatment which was to become customary in the Late Gothic style north of the Alps beginning with the Ghent Altar of Van Eyck.

Once again, in this figure as in the *St. John*, the conceptual genius of Donatello transcends the realm of the formal and attains the higher plane of the spiritual, of the religious. The powerful head of St. Mark appears to be modeled after ancient portraits of philosophers such as Epicurus; yet Donatello makes it seem the very essence of everything that a Christian associates with the Apostles, as witnesses of the earthly sojourn of Christ. Michelangelo is quoted as having said of this *St. Mark*: "If the man in his lifetime was really the way the statue makes him out to have been, then one can believe everything he wrote in his Gospel, for in my whole life I have never met anyone who appears to be such a thoroughly honest man." The identification of St. Mark with the Classical type of pagan philosopher thus led to a deepening of the Christian expressive significance, a tendency that was in every way characteristic of the Renaissance.

Donatello's *St. Mark* remained the finest realization, since those of antiquity, of the draped figure until well into the cinquecento. Jacopo Sansovino's monumental marble figure of the Apostle James in the Florence Cathedral (1511–18; pl. 138) is a masterpiece of Classical style,[36] standing in

*137.* DONATELLO. St. Mark. *1411–13. Marble, height ▶ 93". Orsanmichele, Florence*

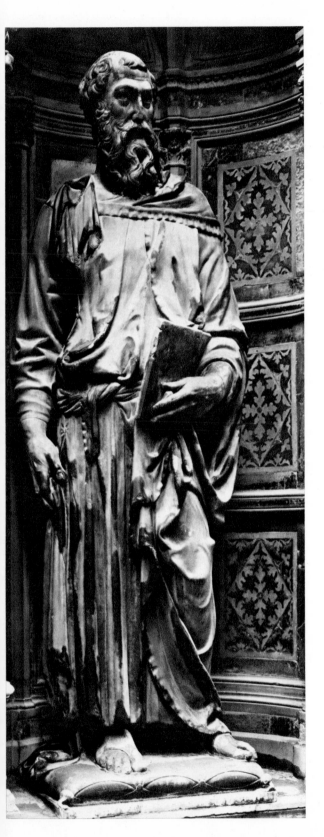

somewhat the same relationship to Donatello's *St. Mark* as Leonardo's *Leda* does to Donatello's *David*. The contrapuntal energies introduced by Donatello are here brought to full realization. What is new in this work, yet at the same time Classical, is its free, harmonious relationship to space.

But the greatest draped figure of the entire Renaissance is unquestionably *Moses* by Michelangelo (Colorplate 32).[37] It is a seated figure like Donatello's *St. John,* but a comparison of the two statues shows clearly what the Renaissance movement had achieved in the intervening hundred years. The corporeal aspect, that of a man in the fullest powers of his maturity, was now realized with unsurpassable effect. In the undraped parts of the body the muscles are strongly delineated. The Laocoön group, which had been found only a short while before (1506), had opened the eyes of Italian sculptors to this kind of anatomical underscoring. In its bodily movement and in the lines of its drapery, the possibilities of *contrapposto* are exploited to the utmost; still, one becomes unconscious of the perfection of its form because of its revelation of a higher, spiritual value. Even more than in Donatello's *St. Mark,* the *Moses* seems primarily a manifestation of spirit incarnate, the visual embodiment of a fundamental concept of Christian belief. The titanic genius of the greatest portrayer of the human being in the Renaissance period presents in this statue the overwhelming personality of the great lawgiver and leader of the Israelites, the unforgettable image of the mighty, wrathful champion of an omnipotent God. Confronted with such images—those of Michelangelo above all—people spoke of the attribute of *terribilità*; before such sublimity, their reverence became fear and trembling.

*The Armored Figure.* A third main type of sculpture figure in the Renaissance was the knightly warrior in armor,[38] a type with an

138. JACOPO SANSOVINO. *St. James the Greater. 1511–18. Marble, over lifesize. Cathedral, Florence*

statue of Timo von Kistritz in the choir of the Naumburg Cathedral (c. 1260)—we see clearly what the Renaissance could do and what it wished to do. In sharp contrast to the Gothic work, the Renaissance image is finite, a human depiction complete in itself. Planted firmly on both legs, the figure is alert and taut, fully modeled and clearly articulated, and filled with a personal authority that projects even into the surrounding space. The mail tunic, armor, and cloak are all clearly described in their formal and material properties, yet in such a way that they remain intimately related to the body within and to its movements. The *disegno* principle brought into being here the perfect archetype of the Christian knight, the very essence of the physical and spiritual qualities of the battle-ready warrior-saint. Vasari formulated it thus[39]:

> He made a most spirited figure of St. George in armour, in the head of which there may be seen the beauty of youth, courage and valour in arms, and a proud and terrible ardour; and there is a marvellous suggestion of life bursting out of the stone. It is certain that no modern figure in marble has yet shown such vivacity and such spirit as nature and art produced in this one by means of the hand of Donatello.

Vasari does not speak explicitly of the Christian character of this *St. George,* but in every respect his words reflect the profoundly spiritual nature of Donatello's creative power. We should once again attune ourselves to such voices of direct testimony from the Renaissance, which have long been drowned out by the weighty expositions of art historians of the late nineteenth and early twentieth centuries. These erudite scholars believed themselves in possession of "objective" scientific methods far superior to the chatter of a mere artist and writer of the sixteenth century such as Vasari, who was ignorant of formal analysis and historical

age-old history, which was taken over from the Late Gothic masters of the fourteenth century in Italy and north of the Alps. Like the draped figure, it was developed into something new in the course of the Renaissance. The oldest, and quite likely the greatest, example of the form is again by Donatello: his marble statue of St. George (pl. 139), which once stood in an exterior niche of Orsanmichele and which dates from about 1415–17. If we compare this with a Gothic work of equivalent artistic merit and with a related subject—for instance, the

method as practiced in the nineteenth century. Do not certain important, perhaps even decisive, traits of Donatello's *St. George* remain obscure if we refuse to listen to the more contemporaneous account of Vasari?

What the courtly, aristocratic art of the second generation of Renaissance masters was able to make out of the armored figure is seen in the bronze *David* by Verrocchio (pl. 140), dating from about 1473–75. The armor has become an elegant leather jerkin, stylized in the ancient manner; the forthright militancy is now nothing more than a graceful pretense, and behind it one senses no more

*139. DONATELLO. St. George Tabernacle. c. 1415–17. Marble (the statue has been transferred to the Museo Nazionale and replaced with a bronze copy); height of statue 82". Orsanmichele, Florence*

*140. ANDREA DEL VERROCCHIO. David. c. 1473–75. Bronze, height 49½". Museo Nazionale, Florence*

than the festive jousts and tourneys that were the delight of Lorenzo de' Medici.

Corresponding to these two standing figures are two great Renaissance equestrian monuments (pl. 98, Colorplate 23): Donatello's "Gattamelata" in Padua (1444–53) and Verrocchio's Colleoni in Venice (1479–96). The earlier work is noble and calm, the very image of a dependable military leader; the later work reveals a self-centered, vainglorious mercenary, the typical *condottiere*.[40]

Once again, as with the wall tomb, the portrait bust, the nude, and the draped figure, it was Michelangelo whose genius brought the armored figure to its ultimate

development. The seated dukes of the Medici tombs in San Lorenzo in Florence (Colorplate 18, pl. 84) elevate the theme from a temporal level to the higher values of the eternal. Both of the idealized nobles appear in armor, and both are abstractions of their temperaments, incarnations of human character types. As images that express wonderfully in posture and attitudes their respective qualities, they represent eternal human types that astrologers, then as now, maintain are destined to appear continually under the prevailing influence of certain planets.

*Reliefs.* The Renaissance relief derived from Italian reliefs of the duecento and trecento.[41] About 1259, Nicola Pisano had devised a fundamentally new narrative relief style.[42] In Byzantine art, the natural delight in narration could never develop fully, since the conventional schemes of representation were considered to be something sacred, rather like articles of belief that had assumed concrete form and, therefore, could never undergo any significant modification. The Gothic relief, on the other hand, was not bound by conventional hieratic precepts but, instead, was dependent on its architectural setting. Every figure, whatever its narrative role, was subordinated stylistically to its essential function in an architectural whole, and its expository value was thus limited.

Italian reliefs, ever since Nicola Pisano, were quite different from these predecessors, for their aim was graphic narration. For this reason, Nicola isolated each relief pictorially by a frame or with a framework of figures. Within this frame, he worked in a rich relief style that resembles painting in its suggestion of space; for this, his inspiration came from Hellenistic and Roman sarcophagi. His son Giovanni carried this type of narrative relief still further. Andrea da Pontedera (called Andrea Pisano, though apparently not a relative of the other two

sculptors) clung to the Gothic scheme on his bronze doors for the Baptistery in Florence (1330–38). There are relatively few figures in each relief, and these are sparsely distributed across a single plane in order to stand out more clearly on the neutral relief background.

For his reliefs on the tabernacle of Orsanmichele (1352–59), Andrea Orcagna adopted the manner of presentation with which Giotto had revolutionized painting.[43] His figures are encased in a setting, as they had been in the High Gothic rood screen at Naumburg (a unique exception), and as had become frequent in the Late Gothic period north of the Alps since the work of the Parlers in the last third of the fourteenth century.

The Italian trecento type of relief, modeled after painting, was to be transformed in the Renaissance.[44] It was to lose the realistic feeling for space evident in the work of Nicola and Giovanni Pisano and of Orcagna, the spatial ordering of figures in various superimposed planes or on a kind of constructed, architectonic stage. In the Renaissance relief, the effect of space was conveyed, but space was not actually present; it was projected onto a flat surface by means of perspective foreshortening. In the use of this technique, it does not matter how far the figures are detached from the background and, consequently, whether they are almost fully modeled in the round or remain virtually flat, or range through the whole scale of relief between these two poles.

*Rilievo schiacciato,* the minimal degree of low relief, is an especially characteristic creation of the Renaissance. Donatello's *Madonna dei Pazzi* (pl. 141) presents this new type already fully realized, though it dates only from about 1422.[45] Its connection with the trecento is unmistakable, for it recalls Giovanni Pisano's statuette of the Madonna in the Prato Cathedral in the way that

Mother and Child are intimately bound together—the Christ Child radiant with the joy of living, but Mary seemingly troubled by a presentiment of tragedy. The half-figure format was taken over by Donatello from easel paintings, such as the waist-length paintings of the Madonna by the trecento Sienese artist Ambrogio Lorenzetti, and this scheme was to become a favorite in Renaissance reliefs. The spirit of the quattrocento is perceived in this work of Donatello chiefly in the sensitive feeling for naturalism with which Mother and Child are depicted and in the perspective composition. They appear as if set within a close-range square window whose frame is extremely foreshortened, as it would appear to someone standing directly in front of it—in fact, as it should be rendered exactly at the point from which the viewer himself is to look at the relief. In this way, the composition of the relief in itself establishes a relationship between the work and the spectator. Similar carefully calculated relationships in Renaissance architecture have already been mentioned, in particular the different relationships of the viewer to the spatial organization of solids and voids. By this means, then, Donatello broke down the aesthetic barrier between the representational world of the work of art and the real world of the beholder. In other works, such as the *David* and the *Judith and Holofernes,* discussed earlier, he accomplished this in other ways, which will be examined more fully in our subsequent discussion of perspective in painting.

The *Madonna dei Pazzi* can be taken as typical for the quattrocento relief. The Early Renaissance relief is entirely conceived in terms of a picture composed with perspective means. Donatello himself developed this new art in a variety of ways. In his *Annunciation,* a tabernacle in Santa Croce (Colorplate 33), he demonstrated the monumental possibilities of the form, with large

141. DONATELLO. Madonna dei Pazzi. *c. 1422. Marble, 29½ × 27⅞″. Staatliche Museen, Berlin*

relief figures presented within a Classical aedicula, as if deployed on a stage.[46] Elsewhere, as in the reliefs of the high altar of Sant'Antonio in Padua (pl. 142), he enriched it with imposing Classical architectural backgrounds and dramatic groups of figures in movement.[47] In still other examples, using low relief, he presented visionary scenes that seem to take place in infinite space, such as the *Assumption of the Virgin* (pl. 143) for the Brancacci Tomb in Sant' Angelo a Nilo in Naples.[48]

Other masters drew from the new relief style something that fitted their own personalities. In his great bronze east doors (the "Gates of Paradise") for the Baptistery in Florence, Ghiberti openly competed with painting in the effects he sought, presenting interiors and landscapes as settings for figure groups (Colorplate 34). He achieved the impression of spatial depth not merely through linear perspective, as employed in a drawing, but especially through a kind of aerial perspective in which the depth (thickness) of the relief is subtly graduated

*142.* DONATELLO. Miracles of St. Anthony: The
Ass of Rimini. *1446–50. Bronze, 22½ × 48½″. Relief
on the high altar, S. Antonio, Padua*

*143.* DONATELLO. Assumption of the Virgin. *1427–
28. Marble, 21 × 28¾″. Tomb of Cardinal Brancacci,
S. Angelo a Nilo, Naples*

*144.* DESIDERIO DA SETTIGNANO. Madonna and
Child. *1455–56. Marble, diameter 46″. Relief on monu-
ment of Carlo Marsuppini, S. Croce, Florence*

Colorplate 32.   MICHELANGELO.   Moses.   *c.  1515.*
*Marble,  height  8′4″.  S.  Pietro in Vincoli,  Rome*

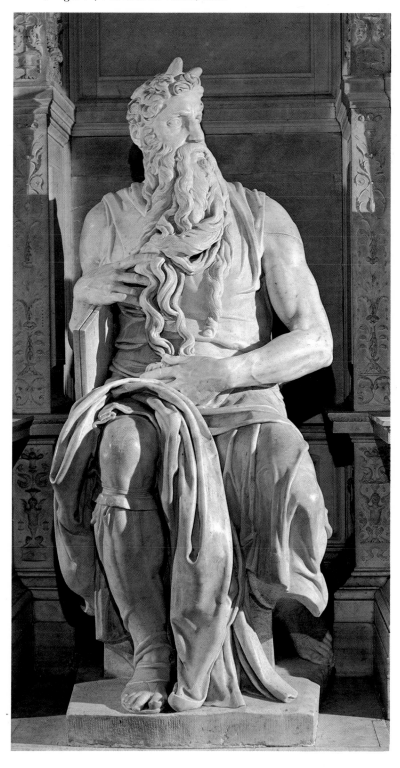

Colorplate 33. DONATELLO. Annunciation Tabernacle. *c. 1428–33. Sandstone, with residual gilt and polychromy (the* putti *are terra cotta), entire height 13′ 9½″. S. Croce, Florence*

Colorplate 34 LORENZO GHIBERTI. Jacob and Esau *(relief on east doors). c. 1435. Gilt bronze, 31¼″ square. Baptistery, Florence*

Colorplate 35. PAOLO UCCELLO. Battle of San Romano. *1456. Panel, 5′11″ × 10′5½″. The Louvre, Paris*

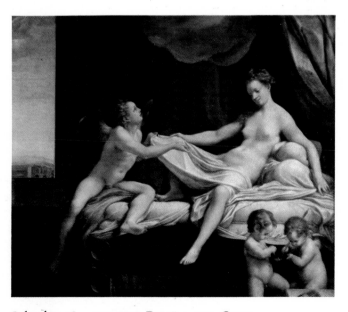

Colorplate 36. CORREGGIO. Danaë. *c. 1532. Canvas, 63½ × 68″. Borghese Gallery, Rome*

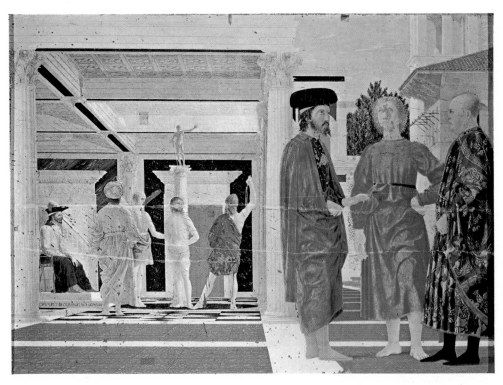

Colorplate 37. PIERO DELLA FRANCESCA. The Flagellation of Christ. *1456–57. Panel, 23¼ × 32″. Ducal Palace, Urbino*

Colorplate 38. GIORGIONE. Self-portrait as David. *c. 1505. Canvas, 20½ × 17″. Herzog Anton Ulrich Museum, Brunswick*

from the almost completely detached, virtually fully modeled figures of the foreground to a very slight elevation from the picture plane in the background, with a compositional space enlivened by a multitude of small figures.[49]

Desiderio da Settignano followed Donatello's techniques closely. Inspired by reliefs such as the *Madonna dei Pazzi,* he worked out a bas-relief style of unprecedented delicacy. His half-figures of the Madonna and Child (pl. 144) rendered in *rilievo schiacciato* are almost as finely drawn as an etching.[50]

Especially toward the end of the fifteenth century, when the Classical style of the Early Renaissance had developed into the mature Renaissance style, other artists turned to ancient themes and exploited all the formal possibilities and thematic variations inherent in them, as in the young Michelangelo's *Battle of Lapiths and Centaurs* (Colorplate 25). Still, almost without exception, the relief remained throughout the Renaissance what Donatello had made of it: conceived as a picture, using spatial effects and perspective means, it was, in short, less a sculptural than a painterly mode of expression.

# CHAPTER SIX

## PAINTING *Functions and types*

To grasp the basic traits of Renaissance painting,[1] we must first look into the special tasks assigned to it in the quattrocento and cinquecento and must, at the same time, keep in mind always just how these works of art were intended to fit into an architectural setting. Since we have already dealt with the latter aspect, we can now concentrate on the question of the function of painting, although we shall still have occasion to point out additional ways of displaying paintings that were developed in this period.

*Official Painting.* Most Renaissance paintings had for their special purpose the representation of something or someone of importance and of general interest. In churches, the altars and frescoes were designed to glorify God and the saints, but these forms had an additional purpose: namely, to testify to the donor's devotion to the saints and to win for him God's blessings.

Nonreligious paintings, whether panels or frescoes, also had definite tasks to fulfill. There exists, for example, a series of panels depicting the Virtues in allegorical guise, mainly by Antonio and Piero Pollaiuolo (pl. 145), which was commissioned in 1469 or 1470 by the College of Judges of the Florentine Cloth Merchants' Guild to be placed around the walls of their tribunal as graphic reminders of the duties and guiding principles of judges. Many Renaissance frescoes were intended to commemorate outstanding personalities in public life and to

perpetuate the memory of their great achievements. Fine examples of this type are the equestrian portraits of the mercenaries John Hawkwood (pl. 146) and Niccolò da Tolentino (pl. 147) by Paolo Uccello (1436) and Andrea del Castagno (1456), respectively, monumental frescoes that stand out so strikingly on the walls of the Cathedral in Florence.

Counterparts of these are found in frescoes that were meant to heap shame and ignominy on the enemies of the state,[2] a typically Renaissance use of painting, such as the frescoes that once decorated the outer walls of the Bargello, the Florentine palace of justice, where traitors were depicted hanging head

145. ANTONIO *and* PIERO POLLAIUOLO. Hope, *from the series of Virtues. c. 1470. Panel, 65¾ × 34½". Uffizi Gallery, Florence*

downward as in their ignoble executions. The shame of the leaders of the Albizzi party, after their defeat at the Battle of Anghiari in 1440, was perpetuated in this way. We owe to no less an artistic genius than Leonardo da Vinci one of the most graphic of such depictions. He sketched the Cardinal Francesco Salviati, the archbishop of Pisa, in this shameful position, hanging by his feet from a window of the Palazzo Vecchio in Florence. The Cardinal had taken part in the Pazzi conspiracy of April 26, 1478, in which Giuliano de' Medici was assassinated while attending High Mass in the cathedral and his brother, Lorenzo the Magnificent, barely escaped with his life. Afterward, Botticelli was commissioned to do wall paintings of the malefactors hanging upside down from the palace windows with a rope around their necks.

Of course, it was not only traitors but also the heroes of the time who were commemorated for all eternity in such painted monuments. The victory of the government troops in the Battle of Anghiari, one of the notable events of Florentine history, was celebrated in a monumental fresco created for the Palazzo Vecchio by Leonardo da Vinci in 1503.[3] Unfortunately, this work, one of the major achievements of the High Renaissance, has survived only through copies of some of its details. We shall see later that this fresco properly belonged to the special type known as the "historical" picture.

*Painting for Connoisseurs.* A separate category of painting consisted of those works done especially for private collectors whose tastes and interests did not tend to religious or political subjects, but rather to subjects meant to appeal to cultured persons who appreciated intellectual themes and artistic excellence in form and technique. It was a type already known in the Middle Ages and cultivated in the Late Gothic period by Northern painters such as Jan van Eyck, but its

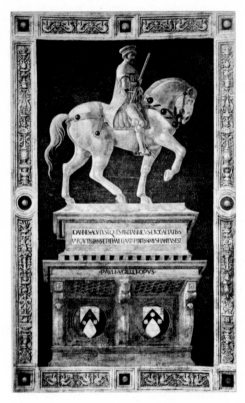

146. PAOLO UCCELLO. Equestrian Portrait of Sir John Hawkwood. *1436. Detached fresco. Cathedral, Florence*

major development was reserved for the quattrocento and the cinquecento.

By their very character destined for connoisseurs, these paintings had the same decorative function as small bronze statuettes. There is great diversity in their subject matter and form. Although frescoes are not entirely excluded from this category, generally it is composed of easel paintings of modest dimensions executed on wood or canvas.[4] Moreover, though usually consisting of single paintings, there were sometimes groups or cycles of such works, especially when commissioned as decoration for a palace room and set into the walls as permanent decor. An example of this type is provided by three battle scenes by Paolo Uccello, which are now distributed among

three museums (Louvre, Colorplate 35; Uffizi; and National Gallery, London) but which originally hung together in a room of the Palazzo Medici in Florence.[5]

Such paintings, either singly or grouped in cycles, were customarily placed in a *studiolo*, the intimate study or private library of a highly placed person. It is difficult to determine whether such a picture or series of pictures was actually set into the walls of these rooms (and if so, exactly how) or whether the works were simply hung in the usual way. This intent was true even for such celebrated paintings as Botticelli's *Birth of Venus* and *Primavera* and the great mythlogical compositions of Titian, which were once located in the *studioli* of the Este, Gonzaga, and Della Rovere dukes and duchesses of Ferrara, Mantua, and Urbino.

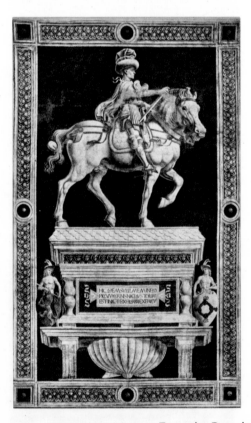

147. ANDREA DEL CASTAGNO. Equestrian Portrait of Niccolò da Tolentino. *1456. Detached fresco. Cathedral, Florence*

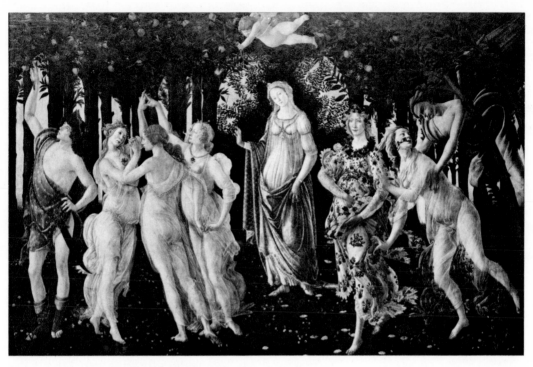

148. SANDRO BOTTICELLI. Primavera. 1477–80.
Panel, 6'8" × 10'3½". Uffizi Gallery, Florence

What is of particular interest in these paintings for connoisseurs is their subject matter. Understandably, the themes most appreciated were those central to the Humanist education received by the cultured audience which commissioned these works: namely, representations of the ancient gods, heroes, and historical personages. That such themes invited generous use of the nude endeared them the more to these patrons. Besides the Botticelli and Titian paintings mentioned above, other outstanding works of this sort are Leonardo da Vinci's *Leda* (pl. 135), Giorgione's *Venus* (Dresden), and Correggio's *Danäe* (Colorplate 36). Also popular were themes taken from contemporary classicizing literature. Botticelli's *Primavera* (pl. 148) appears to have been inspired by the poetry of Angelo Poliziano, and possibly a similar literary source would explain the mysterious, still undeciphered *Allegory of*

*Sacred and Profane Love* by Titian (pl. 149) and certain paintings by Giorgione. The allegorical picture had a special attraction because it stimulated the play of symbolic thought that was dear to the Renaissance elite, as in the tiny allegorical pictures of Giovanni Bellini with their complex symbolism (pl. 150).[6]

Other goals, enthusiasms, and hobbies of the wealthy collectors are reflected in painting—the desire for fame conveyed in depictions of contemporary events, including battle scenes such as those of Uccello; the delights of the hunt, as in Uccello's hunting scenes (pl. 151); joy in music, as in the *Concert* by Titian (or Giorgione) in the Palazzo Pitti, Florence; or the pleasures of society, as in the *Concert champêtre* of Giorgione (pl. 152).

As must be clear, these paintings for private dwellings were, above all, secular in

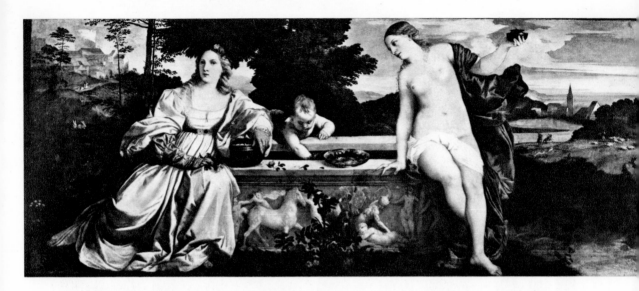

149.   TITIAN. Allegory of Sacred and Profane Love. *c. 1515–16. Canvas, 3′10¾″ × 9′3″. Borghese Gallery, Rome*

150.   GIOVANNI BELLINI. Fortuna. *c. 1490–1500. Panel, 10½ × 7¼″. Accademia, Venice*

theme. However, religious subjects are not completely absent among them, for there are some devotional pictures of particularly personal and intimate feeling that were executed for private chapels. It is significant to note that in certain of these, however, the Christian content seems hidden beneath a display of quite different qualities. In the small *Flagellation* by Piero della Francesca (Colorplate 37),[7] the sacred scene is relegated to the background and, through exaggerated perspective, becomes very small; whereas the foreground is occupied by a group of portrait figures from the social ambient of the patron. The whole picture is dominated by its setting of Classical architecture, a veritable display piece of perspective foreshortening that is a clear demonstration of how important a role this science played in the life and art of Piero. While the religious theme undoubtedly had some importance for the painter and the patron, the portraits, the Classical architecture, and the perspective solution were just as important to them. It was not, then, primarily the religious subject which determined the character of this picture but, rather, the personal tastes and interests of the connoisseur who commissioned it and the artist who executed it.

151. PAOLO UCCELLO. Hunt Scene. *1460. Panel,*
*25½ × 65". Ashmolean Museum, Oxford*

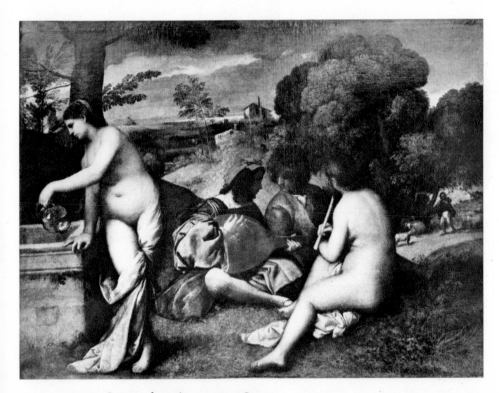

152. GIORGIONE. Concert champêtre. *c. 1510. Can-*
*vas, 43¼ × 54⅜". The Louvre, Paris*

*Portraits.* Thus far in this study we have distinguished between different kinds of art on the basis of their functions. To this basis we must now add a distinction between the subject of a painting and its form, since new themes and new forms both hold great importance in Renaissance painting. One of the most significant of these new themes is the portrait.

tive of some function in religious, political, or social life (public official, emperor, bishop, knight), without personal attributes other than the garments and insignia appropriate to his position and his coat of arms. The transition to the new, individualized portrait came about in the late thirteenth century, and especially in the course of the fourteenth.[8] However, it was not until the fifteenth century that it attained the status of an independent painting type, valuable in and for itself; this was an achievement of the Ren-

153. PIERO DELLA FRANCESCA. Federigo da Monte-feltro, Duke of Urbino. *1465. Panel,* $18\frac{1}{2} \times 13''$. *Uffizi Gallery, Florence*

154. PIERO POLLAIUOLO. Portrait of a Young Lady. c. 1470. *Panel,* $18\frac{1}{2} \times 13''$. *The Metropolitan Museum of Art, New York*

In the Renaissance portrait, the sitter is portrayed as he appeared to the eyes of the painter, that is, as a unique personality whose character is expressed in his total physical appearance, above all in his face. Early and high medieval portraits used quite different means of characterization: what counted was not an individual personality but the representa-

aissance. To the remarkable emergence of the sculptured portrait bust there corresponds the even more remarkable development of the painted portrait, an exemplary product of the Renaissance in that it expresses many of the fundamental attitudes of

the time—a delight in everything individual and personal, as well as a tendency to seek out and honor men who were representative and notable for their social rank or their achievements.

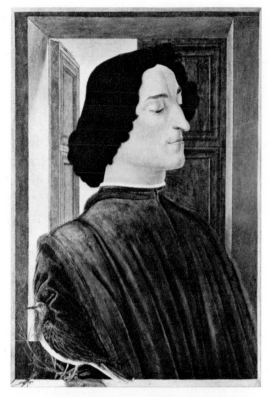

155. SANDRO BOTTICELLI. Giuliano de' Medici. c. 1478. Panel, 29¾ × 20⅜″. The National Gallery of Art, Washington, D.C. Samuel H. Kress Collection

The profile pose was favored in the earliest of the new type of portrait; this was apparently an innovation of Giotto[9] which was eagerly taken up in the second half of the trecento not only in Italy but also north of the Alps in the French courts.[10] It retained its popularity in the first half of the quattrocento with the outstanding work of Pisanello. In the mid-fifteenth century, Piero della Francesca adopted the profile for his fine portraits of Duke Federigo da Montefel-

tro (pl. 153) and his Duchess. Although diminishing in general favor in the second half of the century, the pose still served for superb portraits by Mantegna, Pollaiuolo, Botticelli (pls. 154, 155), and Ghirlandaio, as well as for the moving likeness of the reformer Girolamo Savonarola by Fra Bartolommeo. It was still used on occasion in the early sixteenth century, for example, by Piero di Cosimo and Pontormo (pls. 156, 157).

The three-quarter profile, invented by the Franco-Netherlandish schools, competed with the full profile in Italy during the second

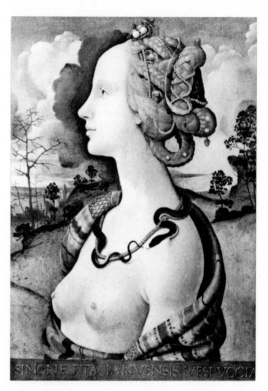

156.   PIERO DI COSIMO. Simonetta Vespucci. c. 1501. Panel, 22¼ × 16½″. Musée Condé, Chantilly

half of the quattrocento and thereafter remained the norm. It deserves attention not only for the inexhaustible richness of its possibilities but also because of the continuing expressive power of this creation of the

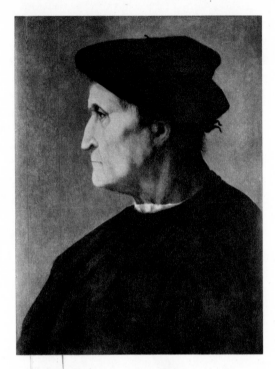

157.   PONTORMO. Portrait of a Man. *c. 1520. Panel, 19½ × 15½". Uffizi Gallery, Florence*

great Renaissance masters, right up to our own day. In the form that it assumed in the late quattrocento and in the cinquecento, it ranks among the most profound and extraordinary achievements of art in any epoch. Seldom were the nobility and personal worth of such colorful personalities so fully and so perfectly expressed. The human image was, so to speak, coined anew and rendered with incomparable creative force. All the qualities that men have ever esteemed were captured in these portraits: the inexhaustible diversity of the physical being and the human visage, including even the slightest of deformities (Ghirlandaio, *Old Man and His Grandson,* pl. 158); the mysterious grace of womanly beauty; the proud bearing of

158.   DOMENICO GHIRLANDAIO. An Old Man and His Grandson. *c. 1480. Panel, 24½ × 18". The Louvre, Paris*

princes and the great of the earth; the refined, cultivated traits of the courtier (Raphael, *Baldassare Castiglione,* pl. 159); the inner dignity of exceptional men and women; the genius of great artists (Giorgione, *Self-portrait as David,* Colorplate 38); the cynicism of a freebooter of Humanism such as the infamous Pietro Aretino (Titian, *Pietro Aretino,* pl. 160); and so on, through all the forms and conditions of man.

The portraits of popes by Raphael remain unsurpassed of their type. Deeply contradictory natures such as those of the warrior-priest Julius II (pl. 161) and the pleasure-loving art patron Leo X (Colorplate 39) were caught for all time in their very essence by one of the greatest painters of any age. Moreover, in the portrait of Leo X with the cardinals Luigi de' Rossi and Giulio de' Medici (Leo's cousin, later to become Pope Clement VII, under whom Rome was to know the ultimate ignominy), one senses all the dark, intrigue-laden atmosphere that, under this most Renaissance of popes, led

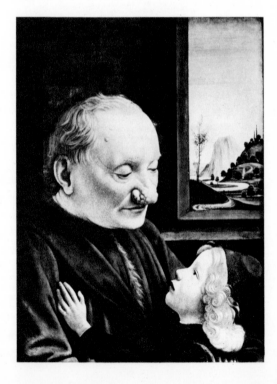

159. RAPHAEL. Baldassare Castiglione. *c. 1516.*
*Canvas, 32 × 26". The Louvre, Paris*

160. TITIAN. Pietro Aretino. *1545. Canvas, 42⅝ ×*
*29¾". Palazzo Pitti, Florence*

161. RAPHAEL. Pope Julius II. *1511–12. Panel, 42½ ×*
*32". Uffizi Gallery, Florence*

162. TITIAN. Pope Paul III and His Grandsons. 1546. Canvas, 78½ × 49″. Museo di Capodimonte, Naples

painting reappeared in Italy in the trecento, first merely as a background for figures, as in the frescoes of Ambrogio Lorenzetti in the Palazzo Pubblico, Siena, but soon perhaps as an independent subject in some small paintings of the same artist (Siena, Pinacoteca).[11] Beginning in the mid-fourteenth century, background landscape acquired considerable importance in the miniatures executed at the Burgundian and French courts, and in the first third of the fifteenth century, landscape was to have a rich development in the works of the Flemish painter Jan van Eyck.

This new thematic possibility was seized fatally to the Reformation and the Protestant schism. Even more uncanny is the historical portent seen in the depiction of a princely pope amid the frightening duplicity of his intimate circle in Titian's portrait of Paul III with his two Farnese grandsons (pl. 162). Just as clearly revealed elsewhere are national characteristics such as the Spanish aloofness of the Emperor Charles V and the ebullient French capriciousness of his opponent King Francis I, and also the guileless good nature of the obese Elector of Saxony, Johann Friedrich—all of these rulers portrayed by Titian (pls. 163–165). The greatest achievement was Leonardo's, for his *Mona Lisa* (Colorplate 40) is rightfully the most famous portrait in the world. Only a Renaissance master of the first rank could have created this magically seductive archetype of mysterious womanliness, her beauty and mood never to be fully divined.

*Landscape.* Like the portrait, landscape

163. TITIAN. Charles V with a Dog. 1533. Canvas, 75½ × 43¾″. The Prado, Madrid

upon eagerly by the Italians in the quattrocento, and understandably so, since it gave wide scope to Renaissance interest in depicting reality and, moreover, because it corresponded to the other prevalent interest of the time, namely, the enthusiasm for the wonders of antiquity. Roman painting had already developed the landscape into an independent genre, although we are not certain that such works were actually known to

the second half of the fifteenth century, the painters of all the Italian schools set their figures in delightful landscape backgrounds. The finest of these were by Giovanni Bellini, who infused the landscape with religious feeling (Colorplate 41). Divinity touched not only the figures but also, and especially,

164. TITIAN. King Francis I of France. *1538. Canvas, 43¼ × 35″. The Louvre, Paris*

165. TITIAN. The Elector Johann Friedrich of Saxony. *1550. Canvas, 40¾ × 32½″. Kunsthistorisches Museum, Vienna*

the Humanists and artists of the fifteenth and early sixteenth centuries. Be that as it may, landscape painting endeared itself to the Renaissance artists and patrons, who brought it to a high point of excellence.

Among the masters of the first generation who concerned themselves with landscape, two stand out—Pisanello and Domenico Veneziano. Their landscape painting was apparently inspired by that of the Netherlandish and Franco-Burgundian schools.[12] In

the earthly realm in which they moved, all of Creation.

Beginning in the 1470s Leonardo introduced a new and different feeling for nature.[13] As had no one before him, he captured what might be called the "painterly" feeling of the atmosphere. Through a curiously vitalized atmosphere, the landscape was made to convey a mood and at the same time to reflect human sentiments. In his work for the first time is announced that peculiar identification of the world of nature

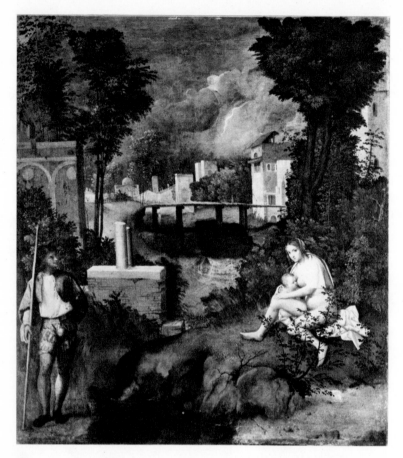

166. GIORGIONE. The Tempest. c. 1505–10. Canvas, 32¼ × 28¾". Accademia, Venice

with the world of man, that mingling of the spiritually transfigured landscape with the emotions and sensations proper to man which has characterized the feeling for and response to nature from the dawn of modern times until the end of the nineteenth century (pl. 216).

Leonardo's new conception of landscape was carried further, chiefly by the Venetians Titian and Giorgione (pl. 166). Yet, despite this extraordinary development, landscape painting in Italy remained subordinate to the figure composition. Nor is this surprising, since for the Italian Renaissance the principal study of mankind was man. It was left to Northern painters such as Albrecht Altdorfer (for example, in his tiny scenes done in 1507 and 1510) to make of the landscape an autonomous category of painting. In

Italy, and elsewhere in Europe, however, this development did not occur on any general scale until the Mannerist and Baroque periods.

*Genre Painting.* A term that can be applied to all kinds of scenes from daily life, genre did not become an independent category until the Mannerist and Baroque periods, since during the Renaissance, like landscape painting, it was usually limited to subordinate details in religious and narrative pictures. Within such limits, nonetheless, it prepared the way for its eventual independence. The first manifestations came in the duecento and trecento, in the naturalistic details of the pulpits of Nicola and Giovanni Pisano and in the paintings of artists such as Pietro Lorenzetti.[14] We can credit the Renaissance feeling for reality, and that of the quattro-

cento especially, with gradually realizing the possibilities inherent in this kind of scene from everyday life. Such realistic notes, it was soon discovered, could be introduced into religious and narrative paintings, and this was done increasingly in the Early Renaissance. There were cases in which the religious theme was little more than a pretext for a genre painting. Such was the net effect in the major work of Domenico Ghirlandaio, the cycle of frescoes depicting the life of the Virgin located in the main choir chapel of Santa Maria Novella in Florence (1485–90; pl. 167), in which scenes from the daily household life of Florence illustrate the Bible story.[15]

Renaissance painters seldom carried things so far, however, even though the introduction of such human elements—elements of genre in the broadest sense of the word—was one of the dominant traits of religious painting of the time, and it is this quality which

makes many paintings of the era continue to capture the popular fancy today. One need only recall the many famous pictures of the visit of St. Anne to the Virgin Mary. The mother with her child, an eternal motif touching people of all times, was thereby given imperishable form, and the finest masters of the Renaissance, Leonardo and Raphael especially, reached their greatest heights in treating this subject. The feeling for what is human, the love of the unchanging ritual of earthly life, would seem to be one of the most deeply rooted and beautiful national traits of the Italians, and this characteristic found ample expression in the painting of the High Renaissance, that painting which fully merits the designation "Classical."

Still, the independent genre picture remained an exceptional type, except in Venice, that port of all nations, where Carpaccio painted two typical female citizens,

*167.* DOMENICO GHIRLANDAIO. The Birth of the Virgin. *1485–90. Fresco. S. Maria Novella, Florence*

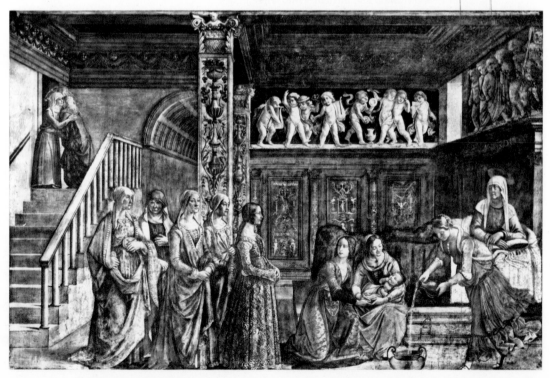

168. VITTORE CARPACCIO. Courtesans. *c. 1510.*
*Canvas, 37 × 24¾". Museo Correr, Venice*

plainly courtesans (pl. 168), and thereby in-
augurated a new subject, which nineteenth-
century Paris was to find particularly to its
taste. It is readily apparent that the Renais-
sance delight in every aspect of contempo-
rary life led to occasional excesses. Along
with their celebrated Madonnas, the school
of Raphael turned out whole cycles of
frankly pornographic pictures, the graphic
counterpart of Aretino's notorious literary
*Ragionamenti.* Such products of the Renais-
sance reveal the other face—one might say
the seamy side—of the sensual delight funda-
mental to Renaissance art.

*Classical Themes.*[16] Personages and scenes
from mythology and ancient history play as
great a part in Renaissance painting as in the
minor arts, and hardly a single great master
of the quattrocento and cinquecento ne-
glected their rich possibilities. It should
suffice to mention Mantegna's *Triumph of
Caesar* (Hampton Court), Botticelli's *Birth of
Venus* and *Primavera* (pls. 169, 148), Signorel-
li's *School of Pan* (pl. 170), Leonardo's *Leda*
(known in copies only; pl. 135), Raphael's

169. SANDRO BOTTICELLI. The Birth of Venus. *After
1482. Canvas, 5'9" × 9'1½". Uffizi Gallery, Florence*

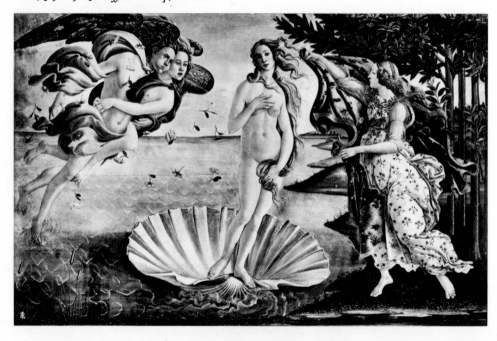

Colorplate 39. RAPHAEL. Pope Leo X with Cardi-
nals Giulio de' Medici and Luigi de' Rossi. c. 1517.
Panel, 60½ × 47″. Uffizi Gallery, Florence

Colorplate 40. LEONARDO DA VINCI. Mona Lisa.
1503. Panel, 30¼ × 21″. The Louvre, Paris

Colorplate 41. GIOVANNI BELLINI. Sacred Allegory.
*c. 1490. Panel, 28¾ × 47″. Uffizi Gallery, Florence*

Colorplate 42. RAPHAEL. Triumph of Galatea.
*c. 1512. Fresco. Villa Farnesina, Rome*

Colorplate 43.   TITIAN. Flora. *c. 1520. Canvas, 31 × 24¾". Uffizi Gallery, Florence*

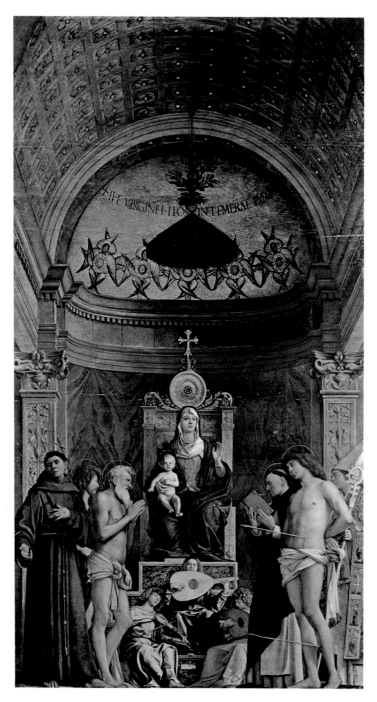

Colorplate 44. GIOVANNI BELLINI. Madonna and Saints (San Giobbe Altarpiece). *Late 1480s. Panel, 15′4″ × 8′4″. Accademia, Venice*

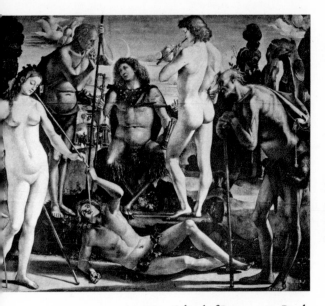

170. LUCA SIGNORELLI. School of Pan. *c. 1490. Panel,
6'4½" × 8'4½". Formerly Kaiser Friedrich Museum,
Berlin (destroyed in World War II)*

171. RAPHAEL. Three Graces. *c. 1500. Panel, 6¾"
square. Musée Condé, Chantilly*

*Three Graces* (pl. 171), Giorgione's Dresden
*Venus,* Titian's *Venus of Urbino* (pl. 172),
*Bacchanale* (Prado), and *Danaë* (pl. 173), and
Correggio's *Danaë* (Colorplate 36).

As is well known, the figures and events
of the Greek myths, as they were transmitted
through ancient poetry and painting to all
Humanist adherents, are in essence Classical
embodiments of what might be called eter-
nal qualities of the human being. These must
have had an inevitable appeal for the Ren-
aissance masters, and it is as such eternal
verities that they were interpreted in their
paintings. An even stronger appeal must
have been exercised by the fact that ancient
art had thereby prepared the way for the re-
finement of the natural into the ideal, and
this was a passionate concern of these paint-
ers. Their own achievement could therefore
be considered to belong to a higher plane,
and they could arrive at solutions of perfect
harmony in painting more easily than in
other art mediums.

No one, not even Correggio or Titian,
succeeded in realizing all the potential of
these themes as completely as Raphael. His

fresco cycle in the Villa Farnesina in Rome[17]
is not only the most extensive tribute to an-
tiquity in the entire Renaissance period but
is also, in a certain sense, incomparably per-
fect. The full range of possibilities of this
type of painting are realized here as nowhere
else. In the *Triumph of Galatea* (Colorplate
42), with its lovely sea nymph skimming
over the ocean in her seashell chariot, dis-
daining her unhappy lover Polyphemus,
Raphael joins the company of Titian and
Correggio in homage to womanly beauty.
The delightful romance of Cupid and Psyche
incites him to depict the Olympian gods and
their doings with an authentically Classic
and enchanting spirit of humor (pl. 174). In
these frescoes, which everywhere show the
master's genius, sheer delight is elevated to
the noblest joy in existence and is illumi-
nated by a Classical beauty.

*Astrological Themes.* The age-old belief
that the stars ordain man's fate again came to
the fore in the quattrocento. Painting, the
most "alert" to change of the major arts, did
not lag behind. The greatest monument to
such magical thought is the fresco cycle by

172.   TITIAN. Venus of Urbino. *1538. Canvas, 47×*
*65". Uffizi Gallery, Florence*

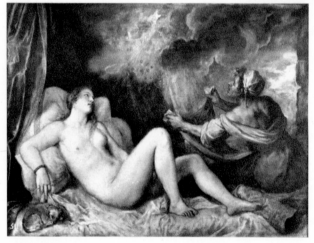

174.   RAPHAEL. Cupid and Psyche. *c. 1518. Fresco.*
*Villa Farnesina, Rome*

173.   TITIAN. Danaë. *1554. Canvas, 50½×70". The*
*Prado, Madrid*

175. FRANCESCO DEL COSSA. The Month of March. *c. 1470. Fresco. Palazzo Schifanoia, Ferrara*

Francesco del Cossa in the Palazzo Schifanoia in Ferrara (pl. 175).[18]

*Allegory.* An especially characteristic form of expression of medieval thought and art was allegory. Of all that the Middle Ages handed down, perhaps nothing was more interesting and attractive in essence to the Renaissance mind than this kind of recondite symbolism. What must have imposed it so deeply on Renaissance taste was precisely the fact that it had its roots in antiquity. The Greeks had revealed the possibility of transforming a phenomenon from the world of nature, or of the spirit, or of moral life, first into an intellectual concept and then into a visible or apprehensible image.

It was in this spirit that the noblest allegories of the Renaissance were conceived, such as the *Primavera* (pl. 148) and the *Calumny of Apelles* (pl. 176) of Botticelli; the *Fortuna* of Giovanni Bellini (pl. 150); the *Nemesis*, the *Knight, Death, and the Devil*, and the *Melencolia I* of Dürer (pls. 177–179); and the *Flora* of Titian (Colorplate 43). In this connection, mention must also be made of the monumental marble *Victory* by Michel-

176. SANDRO BOTTICELLI. Calumny of Apelles. *Late 1490s. Panel, 24⅝ × 36″. Uffizi Gallery, Florence*

angelo in the Palazzo Vecchio in Florence (pl. 180).

*Historical Painting.* We may consider as a separate category of painting the representation of historical events, another inheritance from the Middle Ages.[19] This type stands in somewhat the same relation to narrative religious painting, one might say, as the secular portrait does to the portrait of a saint. For Renaissance man, with his inherent feeling for reality and his appetite for glory, this kind of painting spoke to something deep within him. Understandably, it became a

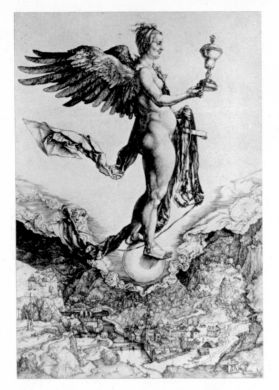

177. ALBRECHT DÜRER. Nemesis (Die Grosse Fortuna). 1501–2. *Engraving*

special favorite with the painters of the quattrocento and cinquecento, who exploited all its monumental possibilities. Among Renaissance works of this type in a Classical vein were the unfinished *Battle of Anghiari*, begun by Leonardo in 1505 (now lost, but known from various sixteenth- and seventeenth-century copies, including the notable drawing by Rubens in the Louvre; pl. 181), and the lost cartoon (1504) for a planned mural depicting the Battle of Cascina by Michelangelo, a study of nude soldiers that is also known through several later copies (pl. 182). To be noted in this context, too, are the lost battle scenes painted by Titian for the Doges' Palace in Venice.

*Christian Themes.* An over-all view of Renaissance painting makes it clear that the great majority of themes employed were Christian and that the highest achievements were in this domain. Christian imagery, that

179. ALBRECHT DÜRER. Melencolia I. 1514. *Engraving*

178. ALBRECHT DÜRER. Knight, Death, and the Devil. 1513. *Engraving*

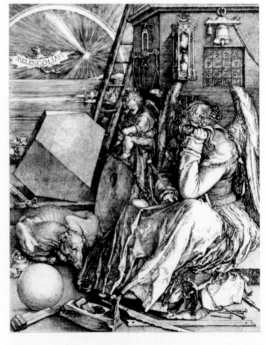

mighty, fertile, and deeply significant organism which had arisen during late antiquity and had been developing for more than a thousand years thereafter, was to live on in the painting of the Renaissance. Indeed, through the systematic spirit and the creative imagination of Renaissance painters, it gained in force and, especially, in individualization. The astonishing diversity that resulted can only be summarily indicated here, for it is not feasible to do more than single out what was new and characteristic and what achieved truly Classical expression in this great era of art.

Among the innovations of Renaissance painting, the most popular was, without doubt, the so-called *sacra conversazione*.[20] Its ancestor was the *Maestà*, a type of imagery created by the Sienese painters of the trecento, principally Duccio and Simone Martini, in which the Madonna is enthroned as

180.  MICHELANGELO. Victory. *c. 1527–28. Marble, height 8′6¾″. Palazzo Vecchio, Florence*

181.  PETER PAUL RUBENS. *Copy of* LEONARDO's Battle for the Standard, *central section of* Battle of Anghiari. *c. 1615. Black chalk, pen and ink, 17¾ × 25⅛″. Cabinet des Estampes, The Louvre, Paris*

*182.* FRANCESCO (*or* ARISTOTILE) DA SANGALLO. *Copy of* MICHELANGELO's Battle of Cascina. *Early 16th century. Grisaille, 30 × 52". Collection the Earl of Leicester, Holkham Hall (Courtesy Courtauld Institute of Art, London)*

Queen of Heaven amid a veritable court of angels and saints. In the *sacra conversazione* of the quattrocento and cinquecento, the courtly, ceremonial aspect of the scene is abandoned. What unifies the personages included is, precisely, their attitude of *conversazione*, which gives the effect of a discourse or meditation on sacred doctrine or events, creating a mood of solemn intimacy that is devoutly religious. A fundamental force of the Renaissance movement is exemplified in this: the sacred truths of Christianity are experienced by man in a new way, with inner personal feeling but, at the same time, with illuminating thought and dialogue.

This new variety of altarpiece was the creation of a pious painter-monk, the Dominican Fra Angelico, in his high altar for San Marco in Florence (1437–41). All important painters of the late fifteenth and sixteenth centuries developed this formal type with increasing beauty and renewed variation, including Andrea Mantegna in his San Zeno altarpiece in Verona (pl. 73), done in 1457–59, and Piero della Francesca in a retable commissioned for the Church of San Bernardino in Urbino and executed some-

time between 1470 and 1477 (pl. 183). The Sicilian Antonello da Messina, in 1475 or 1476, created an epoch-making painting of this sort for Venice, the altarpiece of San Cassiano, which unfortunately has survived in fragments only, as reconstructed by Johannes Wilde.[21] Inspired by this masterpiece, Venetian artists turned to the *sacra conversazione*: first, Giovanni Bellini, in his mature phase in the altarpiece for a chapel in the Hospital of San Giobbe in Venice (Colorplate 44); then Giorgione, in his altarpiece for San Liberale in Castelfranco (pl. 184).[22]

The High Renaissance brought to the *sacra conversazione* a sense of drama and a new monumentality of conception. Instead of the somewhat rigid, conventional symmetry that had been typical of the form, in Venice Titian devised an asymmetrical, diagonal composition for his *Pesaro Madonna* (pl. 208). In Florence, Andrea del Sarto applied his customary charm to the *Madonna of the Harpies* (Colorplate 50). Fra Bartolommeo, Andrea's contemporary and countryman, infused the theme with incomparable representational qualities; in Parma, Correggio lavished on it an entirely new kind of atmospheric value and formal design. Raphael's *Sistine Madonna* (pl. 185) is universally, and justly, celebrated as the greatest achievement in this form.[23] In this work he brought the most profound religious sentiment to the highest point of expressive power, refining out of the conventional conception of the subject everything that was earthly in favor of a pure supraterrestrial aura: the Mother of God soars above the company of saints to a celestial sphere where her glory is proclaimed by a myriad of angels' heads bathed in celestial light—a truly visionary apparition. The age-old Christian theme of the supernatural vision found in Raphael's masterpiece, with all the means of the High Renaissance, its ultimate expression.

183. PIERO DELLA FRANCESCA. Madonna and Child with Saints and Angels, Adored by Federigo da Montefeltro. *c. 1470–77. Panel, 67 × 97". Brera Gallery, Milan*

In yet other kinds of religious figure compositions, Renaissance painters realized their special task of creating a visible union of the realm of the divine with the world of man. The celestial was made comprehensible by showing its effect on mortals, and the greatest examples are found in the works of those very painters to whom is attributed the most perfect mastery of pure form.

This series of masterworks begins with the fresco of *St. Peter Healing the Sick* by Masaccio in the Brancacci Chapel of Santa Maria del Carmine in Florence (pl. 186), and continues in the great cycles by Piero della Francesca in San Francesco in Arezzo and by Mantegna in the Eremitani Church in Padua (Colorplate 45, pls. 187–189). In the *Meeting of the Queen of Sheba with Solomon* and in the *Battle at the Milvian Bridge*, Piero revealed with incomparable art the penetration of the divine into the earthly acts of men. The entire composition of the battle scene is impregnated with the feeling of *In hoc signo vinces*. Mantegna's *St. James Led to His Execution* also had this feeling of the wondrous made visible. His new conception of Christian art spread even into regions that were still under the sway of the Late Gothic style, as can be seen in Pacher's *Coronation of the Virgin* on the altar at St. Wolfgang (1471 and after; pl. 190) and Bernt Notke's *St. George* group in Stockholm (1489; pl. 191).

This series of examples would be incomplete without mention of two highly individual and significant fresco cycles, those of Michelangelo in the Sistine Chapel (pl. 192) and of Raphael in the Vatican Stanze.[24] In his cycle, dating from 1508 to 1512, Michelangelo traced Christian origins from his overpowering image of God the Father

184. GIORGIONE. Castelfranco Madonna. *c. 1505. Panel, 78¾ × 60". S. Liberale, Castelfranco*

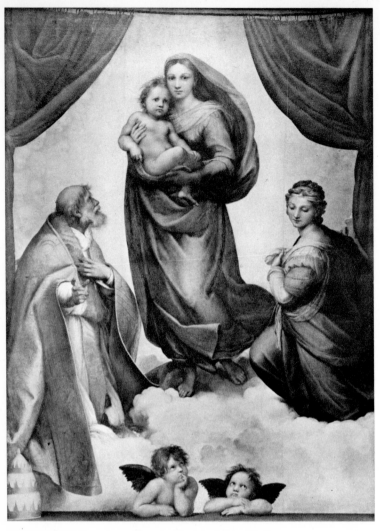

185. RAPHAEL. Sistine Madonna. 1513. Canvas,
8'8" × 6'5". Gemäldegalerie, Dresden

186. MASACCIO. St. Peter Healing the Sick. 1427.
Fresco. Brancacci Chapel, S. Maria del Carmine, Flor-
ence

187. PIERO DELLA FRANCESCA.
Meeting of the Queen of Sheba
with Solomon. *1450s. Fresco.
S. Francesco, Arezzo*

188. PIERO DELLA FRANCESCA.
Battle at the Milvian Bridge
(*detail; see* Colorplate 45).
*1450s. Fresco. S. Francesco,
Arezzo*

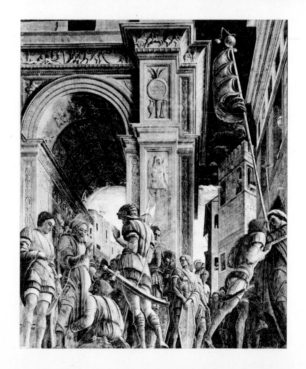

189. ANDREA MANTEGNA. St.
James Led to His Execution.
*1449–57. Fresco (restored, after
damage in World War II). Ove-
tari Chapel, Church of the
Eremitani, Padua*

on through the Creation, the early history of man, figures of the prophets and sibyls, and the personages and events of the Old Testament. For a single artist, for one man working alone, this was a titanic creative achievement, a product of the artistic imagination matched in the entire history of art perhaps only by the new sculptural conceptions of the Greek gods that we owe to Phidias and by the revolution in the depiction of Christ brought about through the work of Dürer.

Raphael's extensive Stanze frescoes represent no less an achievement, even though less overwhelming in immediate impact.[25] In his decoration of three halls in the Vatican, the so-called "Stanze," all the religious, philosophical, and artistic convictions representative of Renaissance art are ordered into one vast cosmos. It is not too much to say that in these monumental paintings the entire world-view of the Renaissance was materialized.

*192.   MICHELANGELO. Interior of Sistine Chapel, ▶ showing ceiling frescoes and Last Judgment. 1508–12. Vatican, Rome*

In the Stanza della Segnatura (1509–11) the four faces of the groin vault bear medallions with allegorical embodiments of what were then considered the four most significant forces in spiritual life—theology, philosophy, jurisprudence, and poetry. (If we compare these with the faculties of present-day universities, it is apparent that the natural sciences and medicine are missing—and that their place is taken by poetry!) On the walls the same four forces are presented, this time not as allegories, however, but in the form of large-scale narrative compositions with numerous figures.

The *Disputà* (pl. 193), a scene depicting the debate over the Sacrament, a kind of *sacra conversazione* of a special character, represents the spirit of theology. The Trinity

*190.   MICHAEL PACHER. Coronation of the Virgin. 1471–81. Center portion of wooden shrine, figures about lifesize. Parish church, St. Wolfgang, Austria*

*191.   BERNT NOTKE. St. George. 1489. Painted wood, about lifesize. State Historical Museum, Stockholm*

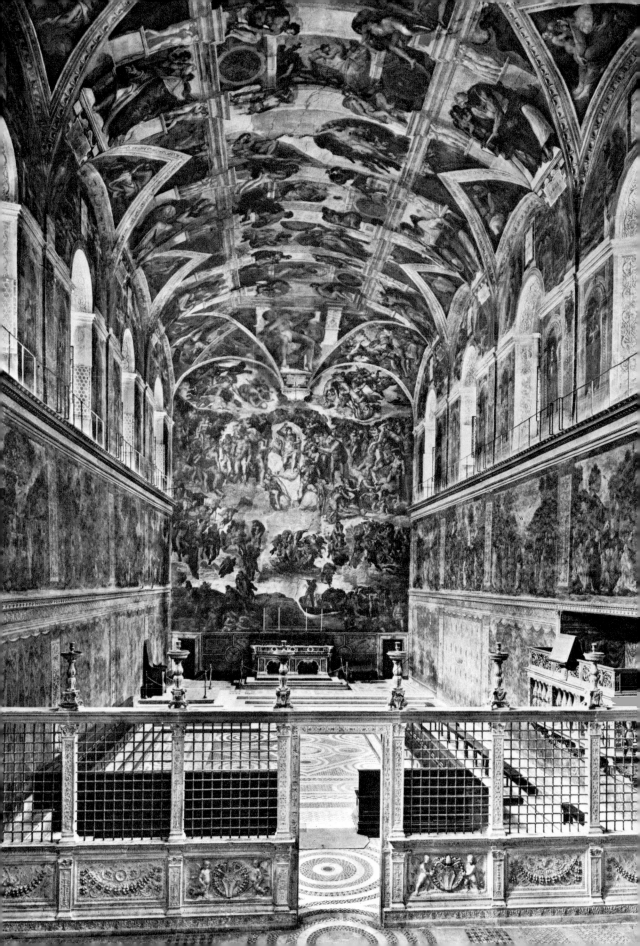

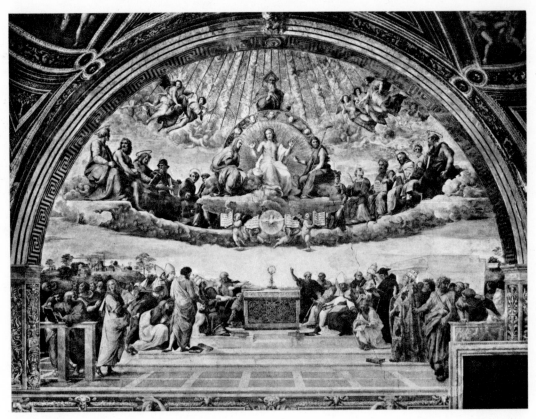

*193.*   RAPHAEL. Disputà. *1509. Fresco. Stanza della Segnatura, Vatican, Rome*

is enthroned in Heaven, with Mary and St. John paying homage, surmounting a semicircle of Apostles and saints. This ceremonial scene in Heaven continues the medieval tradition of the Last Judgment, though recast and created in a new spirit. Below, the great teachers of the Church in all centuries are engaged in debate over the Trinity, that is, over the fundamental mystery of Christian belief portrayed above them in the heavens. The focus for this group of teachers is an altar on which stands a monstrance, the receptacle of the Sacrament, the bond of salvation that links the triple aspect of God with the Christian community on earth.

The *School of Athens* (pl. 194) represents the discipline of philosophy. Once again, an abstract concept is transformed by the painter's creative imagination into some-

thing real and historical. Echoing the theological dispute on the other wall, the same theme of debate is used, but here it is the great philosophers of antiquity who seek the truth. Here we have another—this time pagan—variant of the *sacra conversazione,* one in which Greek philosophy is conceived as a prelude to as yet unborn Christian thought. The figure groups are highly animated and rich in variety, and at their exact center stand the two great wise men of ancient times, Plato and Aristotle. The stage on which this takes place is a great vaulted, pillared hall, a monumental and majestic setting that is a free development of the architectural conception which Bramante, at that very moment, was applying to St. Peter's.

Poetry is symbolized by *Parnassus* (Colorplate 46). On a hilltop sits enthroned

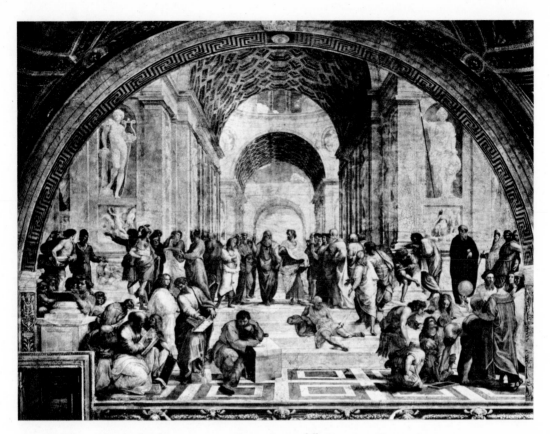

194. RAPHAEL. School of Athens. *1510–11. Fresco. Stanza della Segnatura, Vatican, Rome*

195. RAPHAEL. The Liberation of St. Peter from Prison. *1513. Fresco.
Stanza d'Eliodoro, Vatican, Rome*

*196.*    RAPHAEL. The Meeting of Leo I and Attila. *1513–14. Fresco. Stanza d'Eliodoro, Vatican, Rome*

*197.*    RAPHAEL. The Mass of Bolsena. *1512. Fresco.*
*Stanza d'Eliodoro, Vatican, Rome*

Apollo, the Greek god of poetry, and around him are gathered the Muses and the great poets of pagan antiquity and the Christian Era, from Homer and Virgil to Dante and Petrarch.

In the second room, the Stanza d'Eliodoro (1511–14), are depicted wondrous or miraculous events that, in Raphael's time, were taken as landmarks on the path which God had set for the Catholic Church: the liberation of St. Peter from prison (pl. 195); the deliverance of Rome by Pope Leo I from siege by Attila the Hun (pl. 196); the miraculous Mass of Bolsena (pl. 197), during which an erring Bohemian priest was converted through a miracle accomplished by the Host (which since the fifteenth century had erroneously been considered as the origin of the feast of Corpus Christi); the expulsion of the Syrian conqueror Heliodorus from the Temple in Jerusalem (pl. 198), a

198. RAPHAEL. Explusion of Heliodorus from the Temple. *1512. Fresco. Stanza d'Eliodoro, Vatican, Rome*

symbol of the assault against the Papal State by the French king Louis XII that Pope Julius II withstood in the siege of Ravenna in 1512 (the Pope himself appears in this fresco, enthroned on a palanquin supported by Raphael, Dürer, and other artists of his time).

In his Sistine Chapel frescoes, Michelangelo wished to present, above all, religious feeling and those spiritual and human powers which have their roots in the Bible. Raphael's concern in the Stanze frescoes was quite different: he undertook to show that the principal forces of spiritual, ecclesiastical, and historical tradition form part of a single all-embracing and ordered system. He brought together Biblical as well as secular historical and mythological scenes, events both long past and current, within a single pictorial conception. Single frescoes, as a matter of fact, encompass a span of as much as fifteen hundred years, as witnessed in their events and participants. What Raphael achieved here was an act of the highest intellectual and spiritual value. This attempt to reveal the religious motivation of such a poetic and, in the deepest sense, philosophical world outlook, this incredible undertaking in which the forces of intellect and of history are all shown to be products of God's will—to achieve this with nothing more than the means of paint must be appreciated as one of the mightiest deeds ever carried through by the human spirit. It can only be compared with Dante's *Divine Comedy* or with Goethe's entire *œuvre*; it is understandable that the poet of the *Westöstlichen Diwan* paid tribute to Raphael as a phenomenon of human creative power. The nineteenth-century heirs of Goethe understood the significance of Raphael in this way. Their research exhumed the forgotten symbols of Raphael's Stanze, but understanding of this aspect of his work—and with it the admira-

199. RAPHAEL. Madonna of the Chair. *1516. Panel, diameter 28". Palazzo Pitti, Florence*

tion of him as another such universal genius —has since been lost. We shall have deprived ourselves of an incomparable treasure if we do not revive that full understanding and admiration.

*Tondos.* The tondo has already been discussed in connection with relief sculpture, and it was noted then that sculptors and painters shared equally in the development of this form. From about 1470 on, Botticelli brought a new grace to the painted tondo in his pictures of the Madonna surrounded by angels (Colorplate 47). Signorelli and then Michelangelo strove to master the peculiar requirements of this form and to bring it to perfection, but Raphael was the first to realize fully the compositional possibilities of circular design. His *Madonna of the Chair* (pl. 199) may be considered the classic tondo-painting, that in which everything conforms to the essential idea of the tondo. This painting is one of the great wonders of all Renaissance art in its seeming ease and naturalness, in the enchanting loveliness of

the Mother of God, here dressed in peasant clothing and radiant in the mysterious light of the infant Jesus, and in the way in which the presentiment of divinity is enhanced through its perfect form and fresh animation.

## Techniques and materials

A distinction must be made on technical grounds between portable paintings and wall paintings. Most portable paintings in the quattrocento and cinquecento were done on wood, though somewhat later canvas also began to be used. For these, either tempera or oil was used, whereas wall paintings were executed in the fresco technique.[26]

*Tempera.* Tempera was a technique taken over from the Middle Ages by artists of the quattrocento and was used, almost to the end of that century, for most Italian paintings on wood panels or canvas. As a binding medium for the pigment, egg yolk was used. Characteristically, in this technique, tonality and color hues are light and delicate. Applied thinly, the paint does not completely conceal the preparatory undercoat of chalk or gypsum. The over-all effect, therefore, is somewhat flat and opaque. The quattrocento painters fully understood how to get the most out of the technical properties of the tempera technique and how to use it with charm and delicacy. (Unfortunately, the original effect is often grievously altered by the varnishes used by modern restorers.)

*Oil.* In the early fifteenth century the technique of oil painting was introduced in the Netherlands, and from there it was transmitted to Italy about the middle of the century. In Italy it was taken up with ever-increasing enthusiasm and by the beginning of the cinquecento, became the dominant technique. The use of oil as a binder permits a thicker coating of pigment and stronger, more brilliant color effects, which are enhanced rather than diminished by varnish-

Colorplate 45. PIERO DELLA FRANCESCA. Battle at the Milvian Bridge. *1450s. Fresco. S. Francesco, Arezzo*

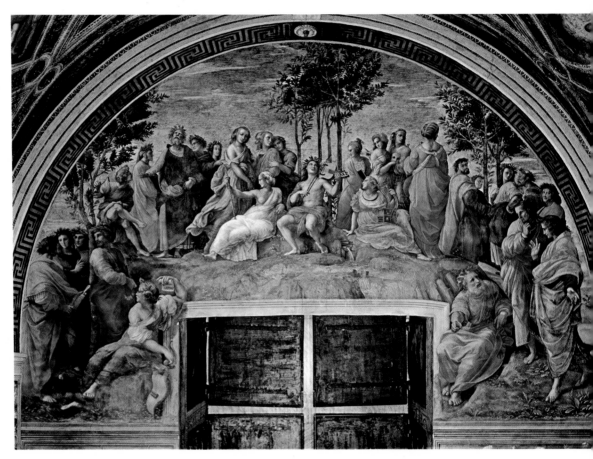

Colorplate 46.   RAPHAEL. Parnassus. *1509–11. Fresco. Stanza della Segnatura, Vatican, Rome*

Colorplate 47. SANDRO BOTTICELLI. Madonna of the Magnificat. *1481–82. Panel, diameter 45¼″. Uffizi Gallery, Florence*

Colorplate 48. CORREGGIO. Assumption of the Virgin (*portion*). *1526–30. Fresco. Dome, Cathedral, Parma*

Colorplate 49. LEONARDO DA VINCI. Virgin of the
Rocks. *Begun 1483. Panel, 75 × 43½". The Louvre,
Paris*

ing. The technique of applying paint was itself affected; the draftsmanly technique proper to tempera gave way to a freer, more painterly use of the brush, and this change was appreciated most of all by the Venetians, especially by Titian.

*Fresco.* Fresco[27] gains its name from the fact that it is painting done on a "fresh," still moist base of plaster. It was well known in antiquity, but in the Middle Ages had been almost entirely replaced by secco painting, which used a dry plaster ground. The advantage of the fresco technique is that the liquid paint sinks into the moist plaster surface and becomes bound to it chemically, so that when dried it is, to all intents and purposes, stone-hard and therefore less likely to deteriorate.

The fresco process was apparently rediscovered in Rome toward the end of the thirteenth century by artists working with mosaic. In mosaic, a sketch of the composition to be executed is drawn on a sublayer of cement; then a second layer of cement is spread over a small area of the sketch and, while still moist, it is encrusted with small cubes (tesserae) of colored marble, stone, or glass irregularly imbedded so as to create a great number of tiny reflecting and refracting surfaces for greater brilliance. Thus, as work progresses from day to day, the total composition grows.

The fresco painter works in much the same way, but in the final stage of his work he paints directly on the moist plaster. For the painter, this technique necessarily involves a certain amount of day-by-day improvisation. When the surface layer of plaster (*intonaco*) is placed over the sublayer (*arriccio*), on which the projected design is traced, the guidelines are progressively covered over, and the painter must improvise with the help of the neighboring, as yet uncovered parts of the drawing. The original sketch itself, traced on the sublayer, is of the exact dimensions of the intended composition and includes all details; the use of a "cartoon"—a full-size drawing on paper to guide the artist in his daily work—probably dates only from the quattrocento. Obviously, in view of the need to work on a moist surface, any area not yet painted but given the second coat of plaster must be chipped away at the end of a day's work, to be plastered afresh on the following day.

This technique required both improvisation and monumentality—a double obligation that was especially suited to the spontaneous and generous Italian temperament. (It is well known, for instance, that improvisation in poetry remained the specialty and pride of Italy until well into the nineteenth century.) For this reason, ever since Giotto's time, the fresco was the special domain of Italian painting, its most versatile and cherished means of expression. The Renaissance crowned the development of the fresco, and its greatest painters conceived their most monumental works for this medium. The very word "Renaissance" brings to mind immediately the great fresco cycles of chapels, churches, and palaces: those of Masaccio in Florence, of Piero della Francesca in Arezzo, of Mantegna in Padua and Mantua, of Michelangelo and Raphael in the Vatican, and of Correggio for the dome of the Cathedral of Parma. The Venetians adopted the fresco technique only in rare cases, perhaps because of their wet climate. It might be speculated that the fresco brought to fulfillment the inherent conceptual possibilities characterizing the Italian Renaissance as completely as the discovery of copperplate engraving did for Late Gothic Germany of the same epoch, where the quite different national inclination was to work slowly, to fuss and worry over details, to reduce the great to the small.

*Other Techniques.* Only a minor role was played in the Renaissance by other techniques of painting. The mosaic, the leading technique of Roman and Byzantine pictorial

art, from which Italian painting drew its first inspiration, survived long enough to have a modest—one might say posthumous—flowering in Florence and Venice.[28] Miniature painting was actively pursued in Italy, too, but the results were in no way comparable with those in France, the Netherlands, and Germany.

In the art of stained-glass windows Italy also lagged behind the brilliant achievements of the Late Gothic period north of the Alps. Great Italian masters occasionally became interested in the medium and adapted to it their Renaissance style: for example, Ghiberti, Donatello, and Uccello in Florence (cycles in the Cathedral) and Mantegna in northern Italy.[29]

## Formal treatment

By its very essence, painting has always been an art of representation, bound to models taken from nature. This was more true in the Renaissance than in any other period. For this reason, like sculpture, Renaissance figural painting was never required to develop an autonomous repertory of forms such as those evolved for architecture. Its particular achievement lay in its treatment of representational forms derived from nature.

*Relationship to Nature.* "The more your work resembles nature, the better it will appear." So wrote Albrecht Dürer, and in this principle he recognized what it was that made the Italian Renaissance superior to the manneristic art of the Gothic period. And he wrote further[30]:

*Now I know that in our German nation, at the present time, are many painters who stand in need of instruction, for they lack all real art, yet nevertheless have many great works to make. Forasmuch then as they are so numerous, it is very needful for them to learn to better their work. He that worketh in ignorance worketh more painfully than he that worketh with under-*

*standing; therefore let all learn to understand aright. . . . The attainment of true, artistic, and lovely execution in painting is hard to come unto; it needeth long time and a hand practised to almost perfect freedom. Whosoever, therefore, falleth short of this cannot attain a right understanding (in matters of painting), for it cometh alone by inspiration from above. The art of painting cannot be truly judged save by such as are themselves good painters.*

Falsity in painting—this was for the prophets of the Renaissance in Late Gothic Nürnberg the basic fault of Late Gothic painting: "For if it is against nature, it is evil," said Dürer of a painting.[31] Attributing a religious sense to the Renaissance concern with nature, he said also[32]: "Do not ever get the notion that you can do anything better than what God has already given power to Nature to accomplish." How painting can be brought into line with nature's laws, he explains thus[33]: "For it is evident that, though the German painters are not a little skillful with the hand and in use of colours, they have as yet been wanting in the arts of measurement, perspective, and other like matters." The arts of measurement (the science of proportion) and perspective, these are for Dürer the basic acquisitions of Renaissance painting, and he explains that he came to know them through the Venetian Jacopo de' Barbari[34]: "Without proportion, no figure can ever be perfect, even though it be made with all possible diligence."

In the writings and drawings of the leading Italians also, the sciences of proportion and perspective are considered the key to the new orientation of formal treatment, the principles according to which the depiction of the human body and of space is carried out in keeping with the laws of nature. This had become evident as early as Ghiberti; as we have already seen, he praised Giotto for having brought art back to nature and thereby to grace, to "gentilezza," and pre-

cisely because he respected the true (innate) relations and measures. The most impressive evidence for this attitude is furnished by the treatise on perpspective by Piero della Francesca and by the notebooks and proportion studies of Leonardo.

*The Science of Proportion.* In their inquiries into the "true" and "beautiful" proportions of human and other bodies (that of the horse, for example), Renaissance masters gave credit to the antiquity they revered, both to its theoretical writings (Dürer, among others, often refers to Vitruvius) and to the surviving masterpieces of ancient sculpture: Ancient painting, which would doubtless have communicated much to them, was still scarcely known: the Pompeian frescoes were not unearthed until the eighteenth century, and painted Greek vases from Etruscan tombs not before the nineteenth. Their models, therefore, were marble and bronze statues, and these sufficed to teach the painters natural treatment of the forms, relationships, and movements of the human body. But this imitation of the past was supplemented by intensive study of anatomy from life, and in this too the painters emulated antiquity, as Alberti had recommended.[35]

The studies in proportion by Leonardo and Dürer reveal with what zeal they pursued their researches; it is no accident that Leonardo enjoys a place of distinction in the history of surgical anatomy also. However, the laws that Renaissance painters sought in the relationships and forms of the naked human body were revealed most interestingly in their planimetric drawings, the same figures that underlie the solid and spatial designs of Renaissance architecture. Based on the nude studies, the draped figure was also brought into accord with natural laws, by the painters in particular. For his *Adoration of the Magi* and *Last Supper,* Leonardo first drew nude figure studies (pls. 200, 201) and only later, in the second phase of his work,

200. LEONARDO DA VINCI. Study for Adoration of the Magi. *c. 1481. Pen and silverpoint, $11\frac{1}{4} \times 8\frac{1}{2}''$. The Louvre, Paris*

201. LEONARDO DA VINCI. Study for Last Supper. *c. 1481. Pen and ink with traces of silverpoint, $11 \times 8''$. The Louvre, Paris*

added draperies and garments, so that the movements of the naked limbs determine the fall of the cloth. Raphael proceeded in the same manner, and such a procedure was recommended as early as Alberti's treatise on painting. With this method in mind, it should become clear how closely linked Renaissance painting, sculpture, and architecture were and, moreover, that the figures in Renaissance painting owe their great appeal to their naturalness, their obedience to universal laws, and their plastic values. Leonardo's *Leda* is definitive proof of this (pl. 135).

Furthermore, the significance of "truth" and "beauty" with reference to proportion extends beyond the realm of the purely aesthetic. In his treatises, Alberti expressed a conviction that art, moral life, and civic virtue are all part of one and the same great unity. The old Roman state, for example, and with it Classic art with all its truth and beauty, perished because Roman *virtù* had broken down. Therefore, Alberti proclaimed, the task of architecture in all times was to create a worthy setting for the worthy actions of worthy men.[36] The mathematician Luca Pacioli, friend to Piero della Francesca, went even further, in naming one of his treatises *De divina proportione* ("On Divine Proportion"), a title expressing the sentiment that the divine harmony of the world order is revealed in the beauty of proportions. It is plain, then, that Renaissance aesthetics had a religious basis and that form was valued as an expression of the divine. This religious appreciation of the art and science of proportion was upheld by all the leading intellects of the Renaissance.

*Perspective.* For those who were schoolboys about 1900, the mere word "perspective" arouses painful recollections of mortally dull drawing classes. For the men of the Renaissance, however, it was a word fraught with magic. *Prospectiva* was a wondrous enigma, a mystery whose unraveling aroused the passions of seekers after truth. It

was a problem that touched the arts and the sciences alike—indeed, even philosophy and theology—for it was of both physical and metaphysical import, a matter of "symbolic form" as Erwin Panofsky so aptly termed it.[37]

The discovery that, of two objects of the same size, one appears smaller as it retreats from the viewer's eye, and that parallel lines seem to meet as they recede into the distance until a common vanishing point is reached—these were revelations which exposed the contradiction between appearance and reality, between spatial organization as it is perceived by the subject and as it exists in objective fact. The resolution of this contradiction, the disclosure of the hidden law that governs it, was an exploit of the inquiring and reflective intellect. It opened a brilliant era of scientific discovery, in the course of which Copernicus and Galileo, with their research into the relationships between earth and sun and into the rotation of the globe, were much later to reveal and solve other puzzling contradictions also inherently subordinate to cosmic law.

What such revolutionary discoveries must have meant to their contemporaries is perhaps more easily sensed in our own time than it could have been by the generation that preceded us. The quantum theory of Max Planck, Einstein's theory of relativity, atomic physics—all these revolutionary, pioneering steps in science have completely altered, and are still in the process of transforming, our notions of what the world is like and have affected every aspect of our existence. In this process, moreover, even the close cooperation between the visual arts and the sciences that was so characteristic of the Renaissance is being repeated in our time. Just as perspective was explored by Renaissance architects, sculptors, painters, and mathematicians together, so many artists today work with an intimate awareness of the findings of physicists, who in turn have

202. ALBRECHT DÜRER. Draftsman Drawing a Vase. *c. 1527. Woodcut*

exposed the hidden concordance between their theories and abstract painting. Scientific illustrations in the style of abstract painting, worked out in continuous intellectual contact between physicists and painters oriented to abstract art, appear to be a most effective means of illustrating concepts that go beyond our experience of the visible.

The decisive intuition leading to the discovery of perspective seems to have been that of an artist, the creator of Renaissance architecture, Filippo Brunelleschi, of whom Vasari recounts[38]:

*He gave much attention to perspective, which was then in a very evil plight by reason of many errors that were made therein, and in this he spent much time, until he found by himself a method whereby it might become true and perfect —namely, that of tracing it with the ground-plan and profile and by means of intersecting lines,* *which was something truly most ingenious and useful to the art of design. In this he took so great delight that he drew with his own hand the Piazza of S. Giovanni, with all the compartments of black and white marble wherewith that church was incrusted, which he foreshortened with singular grace.*

Brunelleschi's understanding of perspective grew from the pragmatic gropings of trecento painters such as Giotto and Ambrogio Lorenzetti. Alberti, on the other hand, while in Rome, set up experiments with a camera obscura, a darkened box into which light enters through a peephole and is then reflected onto a surface where the reflected and enlarged image can be traced. On this experimental basis Alberti established the theoretical and mathematical principles expounded in his treatises. Together with the mathematician Luca Pacioli, Piero della

203. ALBRECHT DÜRER. Draftsman Drawing a Reclining Nude. *c. 1527. Woodcut*

Francesca explored these same phenomena at the court of Urbino and codified the results in a theoretical treatise.[39] Their efforts were followed by those of many others interested in perspective problems (pls. 202, 203).

What all this yielded in the end was a mathematically precise linear construction of the image in space, based on the laws of optics; along with this, there evolved a systematic technique of foreshortening of figures within the optical field. With such means, the fundamental requirement of the Renaissance for naturalistic representation was extended to the depiction of space, which more than anything else seemed to justify the contemporary boast of artistic superiority over the Gothic.

Another point must be mentioned, however. Of the two ancestors of the Renaissance, classical antiquity and the Gothic, antiquity had known and used central-projection perspective, whereas what survived of that science in the Middle Ages and the Gothic period was an incoherent miscellany of practices that had once comprised an integral body of knowledge. The Renaissance was obliged to find and forge anew for itself a meaningful science of perspective, both empirical and theoretical, and this in itself constituted a mighty achievement.

The significance of Renaissance perspective, as Bernhard Schweitzer recognizes, is diametrically opposed to that of antiquity. The ancient world, some five hundred years before Christ, had brought about a "subjectivization of the world of objects," which permitted a more precise representation of the essential, real existence of things in space than was possible for the Middle Ages ("objectification of a world of appearances become unreal"; "gathering together of scattered elements under the laws of nature"). From this there resulted, perhaps quite unconsciously, an agreement between Classical and Renaissance perspective that rose above distinctions[40]: "The subject came to occupy the key position in the world of appearances, in the phenomenal world."

A fundamental property of central perspective is the fact that the spatial disposition of the objects depicted is always and necessarily in relation to the viewer, that is, to a subjective factor. Everything is arranged in a picture as if, from the viewpoint of the beholder, the objects really are foreshortened. As we have seen, Renaissance architecture proceeded in the same fashion. In other words, in Renaissance art the object becomes a function of the subject, and this is a phenomenon of exceptional significance, with an importance that extends even into the fields of religion and philosophy. That man can never grasp reality, that the objective is only apprehensible subjectively, this profound truth was explored theoretically and in practice by the discoverers of central perspective—though unconsciously and while pursuing other ends. It affected philosophical thought in ever-greater measure, beginning with the Renaissance and continuing through Kant in the eighteenth century to Einstein in the twentieth. These names testify to what extent our own times are still linked with such earlier epistemological, theoretical discoveries.

Such perceptual problems have a religious bearing. In medieval pictures, sacred figures were depicted in essentially the same manner as were images in most ancient works of art —as objectively existing entities, completely indifferent to how the beholder may apprehend them subjectively. In Renaissance painting, however, figures were subordinated to systematic laws of perspective and were therefore dependent on a relationship with the spectator. Their existence is, so to speak, not absolute but relative; what counts now is their relationship to the believer who views them, to a devout soul—in a word, to what they signify as appearances. It is for this reason that divine and holy figures in

204. ANDREA MANTEGNA. *Illusionistic ceiling decoration. Completed 1474. Fresco. Camera degli Sposi, Ducal Palace, Mantua*

Renaissance pictures communicate to us so directly, so forcefully, in certain ways with greater intensity than comparable figures in medieval painting. But thereby also arises the possibility that what is divine may be reduced to a mere fiction in a materialistic world.

The Renaissance recognized this threat of a pervasive materialism, or at least sensed it, but sought to exorcise it from its own thinking. This act of self-awareness, of voluntary acceptance of certain limits not to be transgressed, dignifies the age with a triumphant greatness. The High Renaissance hastened to set limits upon the unrestrained enthusiasm for perspective of the Early Renaissance. True enough, excited by the illusionistic achievements of Mantegna (pl. 204), artists of the High Renaissance occasionally could not resist the temptation to render, usually in cupola frescoes, figures soaring heavenward as they would be seen by a beholder standing below, as if the upward flight were in fact

taking place directly over his head. In such virtuoso exercises, the application of illusionistic foreshortening came perilously close to the merely frivolous, as in Correggio's cupola frescoes in Parma Cathedral (pl. 205, Colorplate 48). In general, however, painters of the High Renaissance tended to mitigate the rigorous mathematical laws of perspective foreshortening. It sufficed for them that the foreshortening appear naturalistic; nonetheless, it was not obligatory that it always be so, and quite often it was not. The painters of the Classical period avoided the rigidity of the too-mathematical with subtle tact. More important to them than subjective appearance was, evidently, the objective essence of spatial relationships, which could only be grasped intellectually.

In this respect, art makes a decided break with mere mechanics, for although the lens of the camera eye is modeled after the human eye, it lacks the elasticity and sensitive capacity for accommodation possessed by the human organ of sight. Moreover, deprived of the possibility of a self-induced mental correction, the photographic lens remains simply a mechanism, and one which would have been foreign to the intellectual aims and achievements of Renaissance artists. By refusing to follow mathematical principles to their ultimate consequences, Renaissance artists succeeded in retaining spiritual significance and devout conviction in their religious paintings.

Raphael was the greatest master of this art of self-restraint.[41] The vast halls in his *School of Athens,* for example, seem to be in correct mathematical perspective but are in fact foreshortened with a certain license (pl. 194). The space they enclose, the stage setting for the figure composition, is so conceived that the force of mathematical restrictions is not apparent, and both the figures and their theater of action give the impression of a free and independent disposition. Raphael's artistic intention appears even more clearly

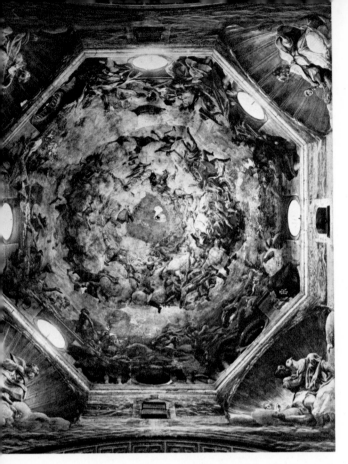

205. CORREGGIO. Assumption of the Virgin. 1526–30. Fresco. Dome, Cathedral, Parma

in the *Sistine Madonna* and *Transfiguration* (pls. 185, 209).

In the *Transfiguration*, the Vision on the Mount is not subjected to the same laws of perspective construction as the scene of healing that fills the lower half of the picture. This inconsistency is almost immediately, and uncomfortably, sensed by the viewer; the two scenes, heavenly and earthly, are deliberately intended to clash with each other.[42] In the *Sistine Madonna,* perspective foreshortening is also made to violate the natural law, but here one is scarcely conscious of it. Only careful scrutiny reveals that the Virgin, both in her scale size and in the way in which her feet are disposed, is not presented with the same perspective foreshortening as the rest of the picture. The liberty that the painter took here is most important for the general effect of the painting and accounts for the deep sense of mystery which suffuses this greatest altarpiece in all of Catholic art—its soul-healing wonder of an entirely true, entirely natural-seeming revelation of divinity, which is nevertheless full of a visionary illumination, the mystery of transcendence incarnate, the apparition of the supernatural on earth.

Italy's special lesson for Europe resides, as Karl Vossler once pointed out, in its prudent refusal of extremism, in its gift for reconciling the seemingly irreconcilable. In Raphael's work this fundamental strength of the genius of the Italian nation is made wonderfully clear. After the Italians of the Early Renaissance had discovered "subjective" perspective, one of the great masters of the High Renaissance thereafter proceeded to circumvent the compulsory aspect of this modern acquisition in order to bring it into harmony with the Christian content of

206. CORREGGIO. The Adoration of the Shepherds ("The Holy Night"). 1522–30. Panel, 8'4¾" × 6'2". Gemäldegalerie, Dresden

medieval art and medieval human attitudes.

Following upon the Early Renaissance invention of linear, central-vanishing-point perspective, the artists of the High Renaissance worked out the painterly, atmospheric possibilities of so-called "aerial perspective." Leonardo da Vinci discovered that objects appear to change not only by diminishing in size as they recede from the viewer's eye but also in apparent color and tone according to the volume of the air mass filling the distance. This effect is due to the refraction of light rays passing through the atmospheric medium. He examined this natural phenomenon on theoretical and scientific grounds in the sections devoted to optics in his treatises[43] and applied his findings to painting in the *sfumato* technique that he developed. This technique lends a misty or smoky aura to the picture, even though it uses only those means proper to painting—light and color. In this way, Leonardo revealed how all objects in space are bound into a single unity through the medium of light, and he proved that this property of things follows specific rules.

Leonardo's *Virgin of the Rocks* (Louvre, Colorplate 49; also National Gallery, London) is both a scientific demonstration and a masterpiece of art. There is both truth and beauty in the figures suspended in the atmosphere, in the interweaving of light with shadow and half-shadow in the rocky grotto, and in the gradation of color, glowing in the foreground and gradually decomposing in the middle ground, until finally it seemingly dissolves into pure air and light in the background. We have already noted the liberating effect this achievement of Leonardo had on landscape art in the High Renaissance and what sensitivity to mood was attained thereby. In this development, Correggio played a role comparable to that of Raphael in the development of graphic linear perspective. He gave even greater significance to Leonardo's chiaroscuro (the play of light against dark), infusing this aesthetic and scientific phenomenon with religious implications. In his *Nativity* altarpiece (pl. 206), he did not place the light source outside the picture, as Leonardo did, nor did he make it a natural source; instead, it streams forth from the tiny ethereal body of the Christ Child, thus realizing with new means the age-old mystery of the miraculous which had been the lifeblood of medieval art. The new art of light and color of the High Renaissance—above all, that of Correggio—had an immeasurable influence on the subsequent history of painting, for it furnished the essential basis for Mannerism, the Baroque, and the nineteenth-century development: from Titian and Tintoretto through Caravaggio, Rubens, and Rembrandt to Delacroix and Manet and beyond.

*Laws of Composition.* We have seen how Renaissance painting treated objects, figures, and space, but there remains the question of how these elements were combined into a picture, of how they were composed. The quattrocento and cinquecento artists considered it self-evident that every picture must be something finite, unified, complete in itself. This idea of the autonomy of the picture was a product of the early trecento, when Giotto achieved in painting what Nicola Pisano before him had achieved in the art of relief.[44] The painter gained this autonomy by avoiding the sweeping lines which might carry the eye out beyond the borders of the picture and toward infinity, as had been the tendency in Gothic painting. Further, he masterfully developed every formal composition from its own specific subject matter, establishing a firm system of coordinates within the lines of the frame. He intensified the unity of the locked, finite picture by a dramatic concentration in the representational treatment and thereby initiated a technique of "balances" similar to the *contrapposto* of ancient statues.

The Renaissance of the quattrocento and cinquecento brought Giotto's conception of a picture and his method of composition to . maturity, an apex attained the in High Renaissance with Leonardo's *Last Supper* (1495–98; pl. 210). To evaluate the art of composition in Renaissance painting, one must take as basic that "Classic" art whose principles were expounded in Heinrich Wölfflin's famous study (1899).[45] In doing so, the great achievements of "pre-Classic" quattrocento painting are tacitly included in the definition, for the frescoes of Masaccio, Piero della Francesca, and Mantegna, in the final analysis, follow the same principles as Wölfflin's Classic style and constitute indispensable links between its first premonitions in Giotto and its fulfillment in Leonardo, Raphael, and Titian.

A fundamental element of Classical composition is clarity. To achieve this end, the pictorial organism that is a painting must be complete in itself and unaffected by anything outside its frame. It must be immediately apprehensible within a single field of vision, since it was felt that art is nothing other than an attempt by the human spirit to master the dizzying, multifarious world of phenomena and appearances and to impose on it a comprehensible order. In their sense of composition, Renaissance painters offer just enough to establish the meaningful organization they value so highly. As early as Alberti's treatise on painting, such moderation was urged; he based his recommendation on the ancient concept of "decorum."

The essential substance of a Classical painting consists in an elementary planimetric-stereometric figure. One is tempted to say that it is *crystallized*. Almost always it is symmetry (that is, equilibrium) which dominates. The favored form was the stable equilateral triangle or the pyramid, as can be seen in such Classic instances as the *Madonna del Prato* of Raphael (Vienna), the *Virgin of the Rocks* of Leonardo, the *Castelfranco*

*Madonna* of Giorgione, and the *Madonna with Cherries* of Titian (Colorplate 49, pls. 184, 207). The circle, also, was used as a basic figure, notably by Raphael in the *Madonna of the Chair* and the *Disputà* (pls. 199, 193), where the entire composition circles about the tiny disk of the monstrance.[46] In this application of elementary mathematical figures, Renaissance painting joins with a similar procedure in architecture. On the highest plane, distinctions between the various categories of Renaissance art prove to be purely arbitrary and comparatively unimportant, for all of them share that single, universal structural basis underlying all the philosophical and aesthetic attitudes of the period.

The full significance of the planimetric-stereometric configurations of Renaissance painting should be evaluated within the context of the entire history of European art. For many centuries, European art had been subject to the polarity of two great opposite tendencies. Ever since prehistoric times and since the first manifestations of ancient Greek art, two contradictory possibilities had presented themselves: on the one hand, the abstract and ornamental and, on the other, the naturalistic and representational, especially representation of the human being. In antiquity the representational principle dominated; in the Middle Ages the ornamental prevailed. The High Renaissance maintained these two opposing forces in consummate equilibrium. During a brief "golden age," there was realized a miracle of perfect compromise, in which depictions of human beings—organically conceived bodies that were at the same time complete incarnations of soul and mind—constituted a "figure" in the higher sense of the word, an abstract ornament.

The formal phenomenon constituted by the planimetric-stereometric configurations of Renaissance painting was first analyzed by Wölfflin, and its deeper meaning thereafter

207. TITIAN. Madonna with Cherries. *c. 1515. Panel, 31¾ × 39⅞". Kunsthistorisches Museum, Vienna*

interpreted by Theodor Hetzer.[47] As presented by the latter scholar, Giotto's return to compositional principles based on mathematical forms was in essence the expression of a religious feeling for the world: the mathematical figure conveys the divine law of the world order.

What is true of Giotto remained true, this author believes, for the Renaissance on the whole. When one of the leading theorists of the early Classical art of the Renaissance, the mathematician Luca Pacioli (as noted before, a friend and colleague of Piero della Francesca), gave his treatise the title *De divina proportione,* he was expressing a conviction that religion and science were linked together by the deepest of bonds. The rise of the natural sciences that began with the Renaissance bears out this growing belief. Kepler, one of the great scientists of the seventeenth century, discovered a new planet while attempting to account for the presumed deviation from its orbit of another, known planet; Kepler's religious conception of the divine

harmony of the universe was such that he could not conceive such an orbit other than as a symmetrical, mathematically perfect form. That form had to be the circle, the perfect form which the fifteenth-century philosopher Nicholas of Cusa had proclaimed as the symbol of divinity. This same symbol was esteemed by Raphael, in the sixteenth century, as the most worthy for his sublime figure compositions. So understood, the planimetric-stereometric configuration of Classical painting in the Renaissance is seen to be a "symbolic form" exactly like perspective.

Moreover, it differs in essence and in practice from the similarly planimetric compositions of medieval, and especially Gothic, painting. We have already seen how this difference affected Renaissance architecture. In Gothic art, the planimetric scheme was taken as a point of departure. This meant that organic forms (whether human, animal, or vegetable) were drawn by the artist on the basis of such mathematical forms (see, for example, the *Wheel of Fortune* in the architectural sketchbook of Villard de Honnecourt, dating from about 1250). In Renaissance art the procedure was reversed: planimetric-stereometric configurations were sought in natural forms and drawn from them, as in Dürer's proportion studies (pl. 1). What is demonstrable for the single figure is also applicable to the total composition. In some borderline cases, nevertheless, it must remain uncertain whether the mathematical design was not the primary source and, therefore, whether the abstract form was not rather arbitrarily imposed on the figures. Such exceptions, however, help to prove the rule.

The Renaissance principle of clarity was complemented by another—the striving for variety. *Variatio delectat*: laws are only beneficent insofar as they allow for the exercise of freedom. The painters of the Renaissance respected the old dictum. Unity necessarily

implies the inexhaustible richness of diversity; symmetry is so much more satisfying when tight restrictions are loosened; harmony is richer when opposing forces (the *contrapposto* that also animates the rigid patterns of Renaissance architecture and sculpture) are brought into concordance. All great compositions of Classical painting are nourished by this fundamental need for freedom within the laws of necessity. If this were not so, they would not excite our interest and would be no more than inert and lifeless embodiments of rules.

Giorgione was past master of this art of variation. In the *Castelfranco Madonna* (pl. 184), he permits the most diverse elements to function both in opposition and in concordance: the equilateral triangle of the group of figures; the verticals and horizontals of the throne and wall; the circle of the heraldic shield (compare this with what has been said of Brunelleschi's Old Sacristy); the enclosed architectural space of the foreground against the open landscape background; the diversity of age and sex in the infant Jesus, the youthful Madonna, the young knight St. Liberale, and the mature St. Francis; the contrast of nude, draped, and armored figures, as well as between architecture, decorative detail, the human figure, and landscape and between symmetry and asymmetry (consider the diagonal lance, for instance).

In *Madonna of the Harpies* (Colorplate 50) Andrea del Sarto fuses similar contradictions into yet a tighter composition.[48] In an over-all aspect of quietude and harmony, contrasts are raised to a dramatic, emotional pitch: the architectonic forms of the pilasters of the background played off against the ornamental forms of the sculptured harpies of the pedestal on which the Madonna stands like a living statue (copied, as a matter of fact, from a statue by Jacopo Sansovino); the great draped figures and the naked Child and *putti*. As so often in Classical compositions, the vector energies of the various

personages are here employed to relax the symmetry of the group arrangement: the Virgin is full-face, St. Francis in a turned three-quarter profile, the young St. John in a forward three-quarter view. All the figures, including the Christ Child and the *putti*, have such diverse directional em-

208.   TITIAN. Madonna with Members of the Pesaro Family. *1519–26. Canvas, 16' × 8'10". S. Maria dei Frari, Venice*

209. RAPHAEL. *Transfiguration. 1517–20. Panel, 13′3½″ × 9′1½″. Pinacoteca, Vatican, Rome*

phases that each appears an individual sculptured form.

The greatest achievements in the compositional art of variation and tension were those of Titian and Raphael. In the *Pesaro Madonna* (pl. 208), Titian broke the bonds of symmetry with the most subtle skill, disposing the protagonists so that they rise in a diagonal from lower left to upper right. The artist found the means to obtain compositional equilibrium by opposing the main diagonal with a secondary diagonal, like the other arm of a St. Andrew's cross, composed of the prominent banner and the stable donor group of the lower right corner. But, above all he reinforced the basic verticality of his format by introducing the two huge pillars that occupy the middle ground. On this firmly oriented substructure, the figures,

for all their movement, are securely anchored. Nevertheless, in this picture (1519–26) Titian was already moving toward the anti-Classical formal concept marking the end of the Renaissance.

In his *Transfiguration* (pl. 209) Raphael, the guiding spirit of the Roman school, raised the art of Classical composition to a level of such sublimity that most present-day viewers fail to understand this painting, the last work he left us. Goethe, however, expressed his great appreciation of it in a thoroughgoing description.[49] All the compositional elements employed by the artists of the High Renaissance appear in this wonderful work. In addition, there is something new—the arresting motif of the boy in convulsions, which echoes the pathos of the then recently unearthed Hellenistic statues of the Laocoön group. The disciples and family gathered in an agitated but helpless crowd around the possessed boy constitute one pole. The opposite pole is formed by the visionary scene above, in which Christ, suspended between the Old Testament figures of Moses and Elijah and transfigured in radiant glory, appears to his three companions on the mountaintop. These two poles are set against each other as symbols of the earthly and the divine, signifying human confusion and divine redemption. This juxtaposition is the ultimate revelation of that spiritual tension lying at the base of the most mysterious rule of life, as well as the expressive culmination of the entire drama of composition in Italian painting since Giotto. Here, the supernatural pervades and stirs the earthly. The last word of one of the most illustrious spirits of the Renaissance, this painting discloses its deepest meaning only to those who can comprehend that the impulses which created these forms flowed from the primal source of Christian belief.

The dramatic type of composition grew, as we have seen, from a double root—from the quest for variety, for freedom within

limits, but also from the Christian concept of tension between the human and the divine. This type of composition took on such great significance in the Renaissance that its special rules must be examined separately.

One of its most effective means was a play of expressive gestures, evoking a pathos which, in its Classical Renaissance manifestation, outstripped anything the Middle Ages had accomplished. This distinction must not be taken as a value judgment, however, but rather as a distinction in kind. Two circumstances account for it. First, the Italian has an innate capacity for externalizing his inmost feelings in gesture, whereas the Northerner usually cannot even comprehend this mode of expression, or at least not without some effort—to say nothing of his lack of sympathy with it. Second, the formulas of expression found in ancient sculpture were taken over by the Renaissance to embody spiritual and psychological qualities within the physical, and this constituted an expressive language which Greek and Roman artists had developed over the course of cen-

turies to the fullest power.[50] In addition, the Italian masters, especially in the High Renaissance, recommended a close observation of daily life, which they found to be an inexhaustible source for the vocabulary of gesture. In their dramatic compositions they anticipated intuitively the findings of modern scientific psychology, thereby exhibiting that capacity for sensing truths which belongs to genius. Leonardo began the search for a scientific basis for what had been until then an imaginative, artistic achievement.

To define the essence of dramatic composition, we must keep in mind the religious basis already discussed. The various spiritual energies of the personages depicted are brought within a single pictorial unity, in harmony with the mysterious divine elements that influence them. This pictorial unity is such that it can be taken in at one glance. The representational content is clearly set forth by artistic means alone, and it is invariably captured at the most telling moment, the crucial point—that illuminating instant when past, present, and even fu-

210.　LEONARDO DA VINCI. The Last Supper. 1495-98. Mural, 14′5″ × 28′3″. S. Maria delle Grazie, Milan

*211.* MASACCIO. Tribute Money. *c. 1425. Fresco.*
Brancacci Chapel, S. Maria del Carmine, Florence

ture can all be read at once. In this sensitive insight again, the High Renaissance antici-pated something which only later was to be realized in other fields. The concept of the "crucial moment" was not defined for lit-erary drama before the theoretical writings of the seventeenth and eighteenth centuries, and in practice it was realized only by the poetry of the two centuries between Shake-speare and Goethe.

The most perfect manifestation of this idea is the *Last Supper* of Leonardo da Vinci (pl. 210), and its most profound interpreta-tion was given us by Goethe—a fact that in itself has a deep significance. The greatest master of the German spiritual drama was, as is well known, an admirer of Shakespeare, and Shakespeare himself was an heir of the Italian Renaissance. The Elizabethan play-wright took the plot for one of his finest plays from Matteo Bandello, the very same Italian novelist who, as a boy, watched Leonardo paint his *Last Supper* and who in his *Novelle,* printed in Lucca in 1554, left us an impressive account of how the artist wrestled with the conception of this picture.

Leonardo's accomplishment was possible only because the art of psychological, dra-matic pictorial composition had been devel-oped since the time of Giotto with the most disciplined intellectual consistency. Giotto's frescoes in the Scrovegni Chapel in Padua

initiated this art (c. 1306), followed in the middle phase by Masaccio's *Tribute Money* in Santa Maria del Carmine in Florence (c. 1425; pl. 211), and as the immediate pre-decessors of Leonardo's Classical achieve-ment, by the frescoes of Piero della Fran-cesca in Arezzo (c. 1450–60; pl. 187, Color-plate 45) and of Mantegna in Padua (1449–57; pl. 189).

Leonardo's *Last Supper* was succeeded by the great dramatic compositions of the other Classical Renaissance masters: Raphael's *Transfiguration* (1517–20; pl. 209), Titian's *Assumption* (1516–18; Colorplate 51), and the monumental altarpieces painted by Cor-reggio in the 1520s (pl. 206).

*The Art of Color.* Certainly we cannot understand painting without discussing color, which in all periods has been one of the primary means of that art. Here we shall indicate only what it meant to Renaissance painting. The lack of a universally accepted, precise terminology makes it difficult to propound the question of color in words. If, however, we accept Hans Jantzen's distinc-tion between the "specific value" of color and its "representational value," we have at least one essential guide for our discussion.[51] The specific value is the hue, which is the basic, inherent physical quality of the color and also the capacity of colors to comple-ment each other, to intensify or to repel each

other—in short, all those distinct properties which are inseparable from the color itself.

In the Middle Ages, it was "specific color" which was most emphasized, that is, color of value in and for itself. Thus, in medieval miniatures, we may find blue or red horses, even though then as now these were recognized as being contrary to nature. The Renaissance imposed an essentially different function on color: colors must above all else correspond to the natural, and what is most important is their representational value, their ability to render naturalistically the physical and other essential qualities of the object depicted (texture, solidity, its position in space and light, etc.). Obviously, this is a general principle only, and one limitation must be noted—colors in Renaissance painting also have a certain specific value, just as in the Middle Ages they also had some representational value. In the quattrocento and cinquecento, the relations between specific and representational values allowed for innumerable gradations between them, according to the different aims of individual phases, schools, and artists of the period. Despite this, the preeminence of representational value was fundamentally unchallenged—a fact that is rich in consequences for our study. Ever since the Renaissance and until the twentieth century, painters took as their point of departure the conviction that colors must correspond to nature. The Expressionists, the Fauves, and abstract painters were the first to challenge this premise.

We must take at least a cursory glance at the diverse uses of color in the Renaissance. The revolutionary innovation of the Early Renaissance urged a thoroughgoing, uncompromising limitation to representational (i.e., naturalistic) color. The leading school, that of Florence, sought to make full use of color as an adjunct to modeling, since the artists' principal concern was with the depiction of actual reality. This method was still recommended in the writings of Leonardo da Vinci, and an extreme illustration of what this entailed is provided by his *Adoration of the Magi* (Uffizi). This work is unfinished, with only the underpainting; yet all its essential elements are already present, painted in brown on a brownish ground. The final differentiated colors were obviously intended to be laid down at the very last stage as a mere adjunct, as it were, to the all-important draftsmanship. In contrast to this, other schools and even a few self-willed painters of the Florentine school granted a greater role to the specific value of color. Thus, Piero della Francesca, although a Tuscan by birth and a Florentine by training, became one of the greatest colorists of all time; and Uccello, also a Florentine, despite the fact that he was obsessed by drawing and perspective, created some coloristic masterpieces in panel painting. However, the main proponents of painting based on color were the Venetians.

A compromise between the diverse tendencies was effected in the High Renaissance. About 1500, it was no longer necessary to advocate the principle that color must be naturalistic and representational. Painters once again became more independent, and increasingly they stressed the specific value of color. It remained predominantly naturalistic in the Classical phase, but at the same time was used decoratively and symbolically. Once more, Raphael must be hailed as incomparable in this respect. In his paintings, color becomes truly a kind of sacred mystery; in some secret way, the opposing properties of color are bound together. His colors are never in contradiction to nature but always retain their representational value. Beyond this, too, they are beautiful in and for themselves. Individual colors seem somehow unique, mysteriously permeated with light; yet they work together in perfect harmony. The *Sistine Madonna* (pl. 185) reveals these qualities most beautifully. In it, color has something we can only

Colorplate 50. ANDREA DEL SARTO. *Madonna of*
*the Harpies. 1517. Panel, 81½ × 70″. Uffizi Gallery,*
*Florence*

Colorplate 51. TITIAN. Assumption of the Virgin.
1516–18. Panel, 22'8" × 11'10". S. Maria dei Frari,
Venice

Colorplate 52.   PISANELLO. A Boar. *Pen and ink and watercolor, 5½ × 7⅞". The Louvre, Paris*

Colorplate 53.   Cassone, *with* Offering of Banners on the Piazza del Duomo. *Florentine, early 15th century. Tempera on wood. Museo Nazionale, Florence*

Colorplate 54. BACCIO PONTELLI. *Intarsia in the studiolo of the Ducal Palace, Urbino. 1477–82*

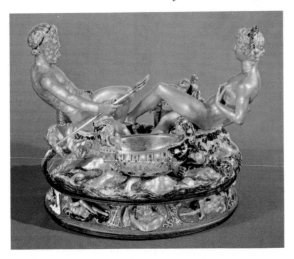

Colorplate 55. BENVENUTO CELLINI. Saltcellar of Francis I. *1539–43. Gold, enamel, and precious stones, 10¼ × 13⅛". Kunsthistorisches Museum, Vienna*

Colorplate 56. *Murano glass. Reliquary vase. 16th century. Museo Vetraio, Venice*

Colorplate 57. *Murano net glass. Filigree covered goblet vases. Late 16th century. The Corning Museum of Glass, Corning, New York*

term "elemental," for it appears like a fundamental, original element of all Creation, thereby acquiring symbolic value as well. And it is symbolic in another sense: it reveals the transcendental in what is depicted, uniting everything earthly into a higher unity. In the *Disputà* (pl. 193), a golden semicircular nimbus wreathes the dominant enthroned Christ, shining out radiantly around the entire figure. In this case as in others, Raphael did not hesitate to employ colors as symbolically as medieval religious painters had done. In the Stanze frescoes, and even more in the *Sistine Madonna,* the colors are filled with a light as translucent as in medieval stained-glass windows. Occasionally Raphael effects this kind of infusion of the spiritual into visible reality with other, more modern means. With light and color he illuminates the physical entity in such a way that it seems a visionary apparition. The throngs of angels behind the Sistine Madonna dissolve into a cloud of glory, which in the soft light glows a golden yellow.

Titian worked with similar means, as seen in his *Assumption* (Colorplate 51). This Venetian painter is considered the greatest master of color of the Renaissance,[52] and his particular genius may be defined thus: the decorative, specific properties of sensually satisfying colors are transmuted into an intoxicating, organ-like sound of music.

# CHAPTER SEVEN

# THE GRAPHIC ARTS

## Drawing

Within the hierarchy of Renaissance art mediums, drawing occupies a key position. It is no accident that the theorists chose the Italian word for drawing, *disegno,* to characterize the fundamental conceptual principle of the time. In the initial drawing, the essential Idea of the object to be depicted was given its primary and purest form, without its later concomitants of color and ornament. This method was true of all the arts, not only of painting but equally of sculpture and architecture. As a consequence, drawing attained an entirely new position among the arts. In the Middle Ages, it had been merely a useful adjunct in preparing the work to be carried out in detail by craftsmen, a project sketch or plan, something like the blueprint used by today's architects. Once the work was completed, the preliminary drawing itself had no further significance and was no longer of any interest to anyone—which explains why so few medieval drawings have been preserved.

Beginning with the quattrocento, however, the drawing came to reveal more and more of the creative spirit behind the work of art. No other form of art discloses more directly the struggle of the artist to pin down his ultimate conception. Its subtle technique records the fleeting fancy, all the hesitations and groping of the mind wrestling with matter, and for this reason artists themselves placed the highest value on these incom-

parably revelatory documents of the creative process. In contrast to previous practice, drawings were now preserved and often gathered together in notebooks; moreover, they came to be sought after eagerly by connoisseurs. A single incident suffices to underline this new appreciation of the drawing: when Raphael and Dürer wished to express their mutual admiration, they sent each other a drawing to "show their hand."

The legacy of Renaissance drawings is extraordinarily rich. Too numerous and too diversified to be treated comprehensively and in detail, only the more significant types can be discussed within the limits of our text.

*Documentation.* For Renaissance artists, the drawing served as a means of studying existing art monuments which might have some value in clarifying their own ideas as to what art should be. Such documentation, initiated by Brunelleschi, played an important part in forging the new formal vocabulary taken from antiquity and applied to Renaissance architecture. The sketchbooks of Giuliano da Sangallo (1465 and after) in the Vatican Library and in Siena are the most important surviving collection of this sort (pl. 212). This Florentine architect of the early Classical phase formed a virtual chain of correspondents in various countries to send him sketches of the outstanding edifices of the entire Western world. On the basis of their sketches, he did drawings of his own, which he assembled into notebooks that comprised a repertory of world architecture, a veritable encyclopedia of all the architectural types and forms in the known world. This notion of a "world architecture" was the basis of the compendium of universal art history which, about 1470 or 1480, another Florentine (perhaps Antonio Manetti) placed at the beginning of his biography of Brunelleschi. Three hundred years before Herder and Goethe elaborated the concept of a "world literature," there dawned on certain Florentines the idea that there was a world art, a world

architecture. The sketchbooks of Giuliano da Sangallo contain architectural monuments of the most diverse periods: above all, the ancient edifices of Italy, France, Greece, and Spain, but also major works of Byzantine architecture such as the Hagia Sophia in Constantinople and the Tomb of Theodoric in Ravenna, as well as those buildings of the Tuscan proto-Renaissance of the eleventh to thirteenth centuries which were still believed to be creations of classical antiquity (among them, the Baptistery of Giuliano's own city, Florence).

Assuredly, other Renaissance masters assembled similar artistic documentation of older monuments (there remains, for example, a sketch of the Church of Sant' Antonio in Padua from the pen of Pisanello),[1] but unfortunately the bulk of such drawings has been lost.

*Preparatory Sketches.* Drawing served not only to record that which was already done but also as the most effective means of working out the problems involved in larger artistic tasks. This usefulness has been discussed above, so that only a few outstanding cases need be recalled here. In the illustrations to their treatises and in architectural drawings, Francesco di Giorgio and Leonardo da Vinci summed up in truly unique fashion the striving toward new concepts that was so typical of the Renaissance movement. Especially informative are their studies of proportion (pls. 14, 15), and Leonardo's sketches for the *Last Supper* provide an invaluable insight into the creative process (pl. 201).

The same can be said of other Renaissance masters. If all we knew of Michelangelo's tombs for Julius II and for the Medici was what we can see of them today, we would have no notion of the grandiose conceptions he projected but was never permitted to realize. But, happily for us, those great flights of imagination are preserved in countless drawings (pl. 213). The sketches of an-

212. GIULIANO DA SANGALLO. Drawing of the Arch of Constantine, *from a* Sketchbook *(Cod. Vat. Barb. Lat. 4424, fol. 19). Pen and wash. Vatican Library, Rome*

213. JACOMO ROCCHETTI. *Copy of* MICHELANGELO'S Sketch for Tomb of Julius II. *c. 1502. Ink, 20½ × 13½". Staatliche Museen, Berlin*

*214.* RAPHAEL. Study for Pythagoras and Standing Philosophers (School of Athens). *c. 1509. Silverpoint heightened with white. Albertina, Vienna*

other artist, Raphael,[2] provide an exemplary demonstration of the all-important role drawing had come to assume during the Renaissance in the realization of a work of art (pl. 214). Swiftly executed, they seize upon the sudden first idea of a composition and show how that idea gradually evolves into its final form. Studies of the most diverse kinds reveal how the master worked out every detail: figures are first sketched in the nude in order to clarify their movement, and only then is the drapery drawn over them; studies of the model in all sorts of formats show how the artist strove to saturate even the smallest detail with an intense feeling of truth to nature. At the end of these preparatory studies, all the findings of this remarkably systematic procedure were consigned to a cartoon in the definitive form and exact size of the painting to be done.

*Studies from Nature.* Nowhere is the Renaissance concern with nature seen more clearly than in drawings; studies after nature were one of the period's greatest accomplishments. Dürer, the great German follower of the Italian Renaissance movement, remains unsurpassed in this domain. Human beings, animals, plants, and landscape—all these natural phenomena appear in innumerable drawings and watercolor studies (pl. 215) in which he strove, with matchless thoroughness and precision, to pin down their very essence. In Italy, it was Pisanello more than any other artist who preceded Dürer in this pursuit.[3] His animal drawings are among the finest of all times (Colorplate 52). Like Dürer, he explored with pencil not only the traits of man and beast but also the characteristics of vegetation and landscape. With Dürer—an association that is not accidental—the Italian master belongs among the greatest artists of the Renaissance period. The third great master of studies from nature was Leonardo (pl. 216), and everything said of Dürer and Pisanello applies equally to him. As for Raphael, he placed nature studies wholly at the service of monumental composition.

## Engraving

As is well known, in fifteenth-century Germany there were developed two important processes for mechanical reproduction of

215. ALBRECHT DÜRER. Young Hare. 1502. Water-
color and gouache, 10 × 8". Albertina, Vienna

216. LEONARDO DA VINCI. Storm in an Enclosed
Bay. c. 1512–14. Pen and ink over black chalk, 6¼ × 8".
Royal Library, Windsor

drawings: copper engraving and the wood-
cut. Both of these techniques were taken
over by Italian artists during the quattro-
cento.

*Copper Engravings.* In Italy it was, above
all, Antonio Pollaiuolo of Florence and
Andrea Mantegna of Padua who perfected
the art of incising a drawing on a copper-
plate, from which it could then be printed in
series (pls. 217, 218).[4] These two Italian art-
ists are justifiably placed alongside the great-
est contemporary Germans, notably the
Master E. S. and Martin Schongauer. Al-
brecht Dürer (pls. 177–179), the most superb
copper engraver of all time, learned his art
not only from Schongauer but also from the
Italians, as is proved by copies he made of
their prints.

In the High Renaissance there was less enthusiasm for copper engraving. Without being rejected completely, the technique was usually treated not as an autonomous art but only as an auxiliary, as a means of reproducing paintings and disseminating pictorial ideas. Marcantonio Raimondi and other members of the Raphael workshop made prints that spread the knowledge of their teacher's principles and compositions (pl. 219). These copperplate prints used Dürer's techniques, which were greatly admired in Italy, but they abandoned Dürer's emphasis on an abstract beauty of line in order to delineate objects and space more

*217.* ANTONIO POLLAIUOLO. Battle of Naked Men. *1465. Engraving*

clearly. (We have already made note of the cycles of pornographic copperplate prints in connection with the activities of the Raphael school.)

*Woodcuts.* Another major type of graphic art, the woodcut,[5] was used chiefly for book illustration, and it followed the same rules as copper engraving. There is a special decorative charm about the Italian woodcuts, with their lucid play of line. It was graphic artists in Venice, the center of the printing trade, who brought to perfection the specifically Italian woodcut style, so closely linked with the ideals of the Renaissance (pl. 220). Hans Holbein the Younger, one of the very greatest masters of the German woodcut, was so deeply influenced by the beauty of Venetian woodcut illustrations that his *Dance of Death* could scarcely have been conceived without this pioneer work.

The Italian woodcut seldom rose to the rank of an independent art, unlike the widely practiced and admired German woodcut of Dürer's time. Only a few Italian works can lay claim to such distinction: Titian's woodcuts and the color woodcuts of the Raphael school and of the Sienese and northern Italians; but these developments did not occur until the onset of the period of Mannerism.

## Writing and printing

Script and typography are as significant as architecture for study of the Renaissance, for they also brought into being a new vocabulary of forms.

*Script.* The development of script began in the study rooms of the Humanists during the first half of the quattrocento.[6] Just as contemporary architects were replacing Gothic forms with a formal vocabulary adapted from antiquity, so the scribes more and more abandoned the spiky Gothic characters in favor of the Antiqua, that is, characters modeled after old Roman examples. These two developments ran parallel courses. Like architects, the scribes took as their point of departure Italian works of the Middle Ages, especially of the eleventh and twelfth centuries, that were influenced by antique models. Thus, just as architects took buildings of the Italian proto-Renaissance as models for their Classical conceptions, so the scribes chose the small-letter script they found in manuscripts of those same centuries, as well as in others dating from the Carolingian period.

218. ANDREA MANTEGNA. Battle of Sea Gods.
*c. 1493. Engraving*

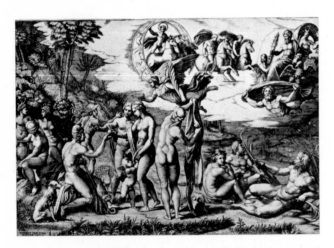

219. MARCANTONIO RAIMONDI. The Judgment of
Paris. *Engraving*

In a second phase of the movement, scribes and architects both turned to a revival of authentic antique forms drawn from their study of ancient monuments. For the scribes, this development was largely limited to copying inscriptions, and imitation of these inscriptions on buildings, statues, and paintings led to a revival of the old Roman capital letters.

In still another way, Renaissance script was intimately linked with Renaissance art. Like columns and whole buildings, like the human body as depicted by draftsmen, sculptors, and painters, so each letter of the new Classicizing alphabet was subject to the same rigorous rule of proportion. Letters were designed by analogy to parts of the human body and also were interpreted planimetrically within an organic conception as one more revelation of universal natural laws, as being no less than an embodiment of the divine harmony of the universe.

Under the refining influence of the small-letter script, there developed in Italy during the quattrocento a new cursive script on the basis of the trecento cursive, and this led eventually to our modern Latin cursive script, the style of handwriting in use today.

220. VENETIAN SCHOOL. Poliphilo in Polia's Lap.
*Woodcut illustration*, Hypnerotomachia Poliphili.
*Venice, 1499*

*The Printed Book.* The art of printing books[7] was, as is well known, invented in Germany in the middle of the fifteenth century. It was almost immediately introduced into Italy, where it was rapidly taken up and disseminated. In Italian incunabula of the second half of the quattrocento and in works of the early cinquecento, the new Renaissance script was adapted to the printed book, as were woodcut illustrations (pl. 221). The rich store of Renaissance ornamentation was also introduced into bookmaking as a decorative device.

The special beauty of the Renaissance book lies in the balance and clarity of the page layout. The Early and High Renaissance makers of books achieved products of perfect design and symmetry, very likely attributable to their highly developed sense of the decorative value of rhythmically articulated surfaces. Their creations arose from the same fundamental drives as those of the architects and painters.

Characteristic of the thoroughgoing systematic character of Renaissance culture is the practice, developed in the sixteenth century, of completing a book with an index of names and subject matter. Without this innovation of the Renaissance, modern culture, which is so completely based on books, would undoubtedly have been greatly impeded in its achievements.

221. *Page from* De harmonia mundi totius, *by Francesco Giorgi. Venice, 1525*

# CHAPTER EIGHT

# DECORATIVE ARTS

"Free" or "fine" art on one side and "applied art" or "arts and crafts" on the other: this distinction is a product of a nineteenth-century way of thinking. Ever since the French Revolution, since 1789, then, the split between fine arts and crafts has been commonly accepted. And yet, the way to this distinction was paved as early as the Renaissance. It is true that during the Renaissance proper, however, the rift was never complete and that, in general, art and artisanry were still part of the same unity. For this reason the notion of "arts and crafts" or "applied art" is basically inappropriate to the quattrocento and cinquecento—the more so because it represents the kind of division of labor that modern industrialism introduced.

Much more appropriate to the actual situation in the Renaissance is the term "minor arts," since the distinction between fine art and craft was at that time not a matter of principle but only of degree. All it amounted to was that in the minor arts the craftsmanly and utilitarian aspects were more conspicuous than in architecture, sculpture, painting, or the graphic arts. Indeed, the so-called fine or free arts are far from devoid of craftsmanly and utilitarian aspects, and they were "fine" or "free" only in rare exceptions right up to the French Revolution. Their vitality and superiority over the art of the nineteenth century reside, in no small degree, precisely in this salutary

interrelationship. It is evident that the close bonds between architecture, sculpture, painting, and the minor arts were based on something else: the same stylistic ideal of the Renaissance is expressed in the "major" arts as is also, and equally, embodied in furniture, ceramics, glassware, gold- and silverwork, jewelry, textiles, and embroidery.

## Furniture

"Furniture"—*mobili* in Italian—originally designated those furnishings that could be moved around, which were indeed "mobile," as distinguished from those which were built into a room or fixed in position. The term will be taken here in its widest application. Along with literally mobile pieces, permanently built-in cabinetwork was a conspicuous feature of the Renaissance. Fixed or movable, all these furnishings were designed and executed by the same masters in the same spirit: wall cupboards, wardrobes, sacristy cabinets, choir stalls, wainscoting, ceilings, chests, benches, chairs of all kinds, taborets, stools, tables, credences and sideboards, coffers, reading desks, music stands, and the like. All these types, whether fixed or movable, were taken over by the quattrocento from the Middle Ages to be given new forms, new shapes, and new character; mostly, they were executed in walnut, the favorite wood of the period.

*Cabinetwork.* Renaissance cabinetwork[1] presents itself as a tightly closed, compact physical entity and is thereby distinguished, even at a quick glance, from Gothic furniture, or at least from the more richly ornamented variety. Forms that seem to radiate out into space, such as pinnacles, pyramids, spires, gables, and the like, were progressively abandoned in the quattrocento; instead, the simple essential structure, the basic stereometric design, was intentionally em-

phasized in these wooden objects, as markedly as in major constructions executed in stone. Surfaces are largely unadorned, without complication, and the full emphasis is on their planimetric beauty, their restraint, and their functional quality. One senses always the sure instinct for correct proportions that went into their design. The finest products of Renaissance cabinetmaking have the same noble feeling for formal beauty that stamps the greatest masterworks of architecture and painting (pl. 222). Just as in monumental architecture, a Classicizing organization was fully exploited to enrich the planimetric harmony of the smooth surfaces with an organic, full-bodied character. To achieve this result, special new techniques were developed.

*Woodcarving.* The decorative parts of wood furniture were brought into relief by ornamental carving. Architectonic structure, abstract ornament, figural decoration —all these were due to the woodcarver's art. And the Renaissance created enchanting specimens of that art.

*Stucco.* Occasionally, *cassoni* (wooden chests, usually intended to hold a dowry) were richly adorned.[2] A layer of stucco was applied and then was modeled, gilded, worked in relief, and painted. Sometimes figural painting was added, usually mythological scenes. *Cassone* painting constitutes a separate and delightful category of Renaissance painting (Colorplate 53).

*Intarsia.* Especially popular was the intarsia technique,[3] wood inlay on a background of wood. Basically, this was no different in conception from marble or mosaic incrustation techniques used in stone buildings. The surface of a piece of wooden furniture or wood paneling was decorated by inlaying other woods of different grain or color which were worked into abstract ornamental or figural designs. Renaissance intarsia patterns generally consist of planimetric shapes, but they may also depict vegetable

222. *Wall cabinet. 16th century. Walnut. Palazzo Venezia, Rome*

or human forms. Indeed, they may even go so far as to risk the most difficult of tasks—perspective representations of all kinds, including architecture or still lifes with books and musical instruments.[4] It has even been suggested that it was the intarsia medium that inspired painters to create autonomous still life. The highly skilled masters of this technique even dared to enter into competition with the painters in depicting landscape and figures. What could be achieved with this apparently unpromising technique is nowhere better seen than in the superb inlaid wall panels of the *studiolo* of Federigo da Montefeltro in the Ducal Palace of Urbino (Colorplate 54), dating from 1477–82, which are among the most precious and ingenious creations of all Renaissance art.[5]

## Metalwork

*Wrought Iron.* Wrought iron[6] was widely used in the quattrocento and cinquecento and with the greatest skill. It produced minor masterpieces, in such types as chapel grilles, torch holders in dragon or vegetable shapes, palace lamps resembling small ecclesiastical vessels, and andirons.

*Weapons.* The armorer's craft was not confined to merely practical purposes, but typically for the Renaissance, highly artistic decoration was lavished on all sorts of weaponry[7]: shields, armor, helmets, swords, daggers, and everything used in the accoutrement of the perfect knight. Thus, practical skill was necessarily combined with artistic techniques of working in precious metals: etching on metal, damascene work in gold or silver (the incrustation of precious metals into the engraved surface of steel armor), chasing (embossing or engraving metal surfaces), and so forth. Artistically beautiful armament of this sort, for both the knight and his horse, was among the most cherished possessions of the great lords of the quattrocento and cinquecento. Masters of the highest rank did not disdain to design them, and the skilled artisans in precious metals who turned the artists' sketches into objects of real beauty were famed far beyond the borders of the Italian territories. No true distinction can be made between art and craft in this field: Michelangelo, for instance, adorned magnificently the armor of the two princes in his marble statues of the Medici tombs (Colorplate 18), and Benvenuto Cellini describes in his autobiography how inseparably related weapons making and monumental sculpture were in his own work.

*Small Bronzes.* In bronze founding,[8] monumental statues and figurines were conceived according to the same principles, and the same sculptors did both types. Donatello, Verrocchio, and Cellini—to name only the most important—were as proud of their small utilitarian objects as of their great statues, as one reads from the autobiographies of Ghiberti and Cellini. We have already discussed the small bronze statuette and here need only refer to the

purely decorative utensils conceived and fashioned in the same way. Candelabra, candlesticks, mortars, bells, table chimes, lamps, and the like were all executed with artistic charm and beauty. Even bronze cannons often became masterpieces of art in their form and decoration.

*Goldsmith Work.* The greatest refinement in metalwork was undoubtedly attained by the goldsmiths.[9] Today we can only imagine, on the basis of what we read in innumerable contemporary accounts, what extraordinary heights were reached in this art, since most of the objects were later melted down because of the intrinsic value of the metal used. Only a few examples remain, and very few of these are among the most celebrated pieces. For instance, the goldsmith work of someone of the stature of Lorenzo Ghiberti, who, as is known from his *Commentarii,* delighted in such work and was proud of it, is entirely lost.

Most of the objects in precious metals that have survived are ecclesiastical ornaments and utensils, largely preserved in church treasuries. Among these are such major works as the silver frontal for the high altar in the Florence Baptistery, with fine reliefs by Verrocchio and Pollaiuolo (pl. 223), and a reliquary from the private collection of Lorenzo de' Medici, kept in San Lorenzo in Florence (pl. 224).[10] The famous saltcellar made for King Francis I by Cellini (Colorplate 55) will give some idea of the lavishness of cinquecento work, but its exuberance and fantasy mark it as essentially Mannerist rather than Renaissance in style. Somewhat more abundant is the gold and silver jewelry worn by both men and women.[11] Often embellished with enamel inlay and precious stones, many pieces constitute artistic achievements of noble beauty.

*223.* VERROCCHIO, POLLAIUOLO, *and others. Altar frontal with scenes from the life of St. John the Baptist. Begun 1366, completed 1483. Silver. Museo dell'Opera del Duomo, Florence*

224.   *Reliquary of SS. Cosmas and Damian. Floren-
tine. 15th century. Gold and silver. S. Lorenzo, Florence*

## Ceramics and glassware

Among Renaissance creative achievements
must be numbered vessels of baked clay, for
these too are works of art. Such creations
were exceptional in the Middle Ages, but
with the quattrocento this type of art re-
gained the high rank it had enjoyed in
antiquity and in medieval Islam. It was the
Islamic work which, in fact, provided the
impetus for a revival of this long-forgotten
art.

*Majolica and Faïence.* Majolica and faï-
ence are names used to designate one and
the same technique, a kind of earthenware
richly ornamented with colored glazes.[12] On
a lightly baked clay vessel is spread a thick
glaze of tin, which is then treated with color.
These strong, lustrous colors are bound to
the glaze in a second baking. The decorative
value of such objects is extraordinary, and
they can compete with the best of Greek
vases, Oriental ceramics, and Islamic vessels.
The technique was first experimented with
in Italy in the trecento and then perfected in
the quattrocento under the influence of
Islamic objects. Most of these Islamic wares
were imported from Spain, especially from
Majorca, for which reason the Florentines,
the earliest masters of the craft, named them
"Majolica." The town of Faenza, on the
northern slopes of the Emilian Apennines,
soon came to specialize in such work and
gave its name to it—the word "faïence,"
which entered the English language by way
of France. The most important workshops
for this ware were to be found in Faenza,
Cafaggiolo (near Florence), Deruta and
Gubbio in Umbria, Urbino, and Venice;
the high point of this art occurred between
1500 and 1530. Collectors came to place such
value on these minor art objects, and the
ceramicists developed such pride in their
work, that the best pieces were almost all
signed, as were the Greek vases of the fifth
century B.C.

Decoration on these vessels may be either
abstractly ornamental or figural, or often
both. In the combination type, the two
elements are played off against each other
with the same subtle feeling for a rhythmic
*contrapposto* articulation of surfaces that
gives such vitality to the work of Renais-
sance architects and painters. Thus, on round
dishes, a wonderful concord is produced
between the flat, richly ornamented border
and the enclosed central medallion, with
its figural representation. Here the inherent
character of the tondo motif brought an
important influence to bear on the design,
just as it did in relief sculpture and painting

225. *Renaissance ceramics:* (left) *plate with stigmatization of St. Francis. Faenza, c. 1500;* (center) *dish with a noblewoman on horseback. Florence, c. 1460;* (right) *plate with St. John the Baptist. Faenza, c. 1495*

(pls. 225–227). The colors used were generally white and blue, more rarely also green, yellow, and black. In Deruta a special luster glaze was perfected that had the shimmer of mother-of-pearl, and in Gubbio Giorgio Andreoli discovered a luster glaze that produced a wonderful harmony of red and gold.

The masters of ceramics knew how to enhance the beauty of their production not only through form and color but also with often elaborate figural scenes. The entire world of Renaissance concepts and fancies appeared on plates and vessels in much the same formulations as were employed for paintings and small bronzes. Religious themes were not absent, but secular themes were more frequent, especially those drawn from classical mythology and history, allegory, genre scenes, and portraits. Certain types of subject matter acquired an importance in ceramics that, even in paintings done for connoisseurs, had merited no such independent emphasis, such as genre scenes, depictions of animals and plants, and landscapes. Inspiration for this very likely came from the graphic arts, from engravings, in which a similar development took place. As a matter of fact, the ceramicists often copied engravings directly in their own medium.

226. *Majolica plate with grotesque border ornament. Siena, c. 1510*

227. *Majolica plate with bust of noblewoman and inscription. Faenza, c. 1580*

Painting on ceramics must be done swiftly and with a secure sense of improvisation, since no correction or retouching is possible after their firing. This gives these objects the special charm of the spontaneous, something like the charm of drawing and fresco. Its special distinction, however, lies in the brilliance of the enamel-bright colored glazes and in the decorative stylization encouraged by this special technique.

*Glass*. The Renaissance also brought about striking changes in glasswork.[13] What was new in hollow glassware in the quattrocento and cinquecento was its delicate thinness and transparency. Fragile and water-clear, its qualities bring out what is most beautiful in the special nature of this material. Such properties made the Italian glass strikingly different from the thick, murky, greenish peasant glass of Northern Europe in the Middle Ages; in fact, even after the immigration of Italian glassmakers into the northern countries, well into the Baroque period, this art remained a secret of the Italians and was regarded elsewhere with wonder.

In Italy itself, these qualities seem to have been inherited from antiquity by way of Byzantium; even in the late Middle Ages, Venice belonged to the Byzantine cultural sphere. On the nearby island of Murano, glassmaking had long been—as it still is—the major occupation. Ever since the thirteenth century, Murano glass has been considered the finest not only in Italy but throughout the Occident (Colorplate 56).

Almost all the specialties of what had been a highly developed art of glass manufacture in antiquity were revived in Murano beginning in the quattrocento. There was hollow glass, thin and colorless, as well as glass tinted while still in a molten lump with various shades of blue, green, and amber with manganese red or blood red, and with gold gilt applied. These colored glasses were cut into tesserae and chips to be used in mosaics or set into marble surfaces to decorate buildings; they were formed into buttons, imitation pearls, and rosary beads; and they were combined with colorless hollow glass to make decorative vessels of all sorts. Still other specialities were agate-like marbled glasses, such as milk glass and opaline glass modeled after those of antiquity, and the so-called "millefiori" (thousand flowers) glass made by cutting through artfully combined, many-hued glass rods to produce a flower-like pattern beneath a layer of colorless glass. Once again an ancient discovery that was revived.

An authentic Venetian innovation in the High Renaissance was thread or net glass (Colorplate 57); in this technique, milk-glass threads are inserted in colorless hollow glass when still incandescent, to make a network of opaque threads within the transparent glass, which creates a subtle and enchanting tonality. Further enrichment was found in the combination of enamel painting with hollow glass; on either colorless or milk glass, polychrome coats of arms or other symbols were painted and made permanent by firing, to create yet another attractive combination of contrasting materials.

Not only technical excellence but also the beauty of its forms distinguish Murano glass—forms in which the creative imagination of the artisans was stimulated by antiquity, for the workmen of Murano had methodically assembled a veritable treasure of ancient vessels that served them as models. In almost no other material does the nobility of ancient vessel forms appear with such beauty, ingenuity, and clarity as in glass, above all in the paper-thin, transparent hollow glass. Although Murano glass is treasured everywhere in the world, the richest collection remains that preserved in the factory at Murano.

*Crystal*. There is also an ancient basis for the art of cutting highly polished mountain crystal with the wheel and decorating its

Colorplate 58. *Embroidered velvet chasuble of Pope Nicholas V. Museo Nazionale, Florence*

Colorplate 59. RAPHAEL. St. Paul Preaching at Athens. *1515–16. Cartoon for tapestry, watercolor on paper, 11'3" × 14'6". Victoria and Albert Museum, London*

Colorplate 60. COSIMO TURA. The Virgin and Child Enthroned. *c. 1480. Panel, 94½ × 40″. National Gallery, London*

Colorplate 61. RAPHAEL *and assistants. Grotesque and arabesque ornament. c. 1516–18. Stucco and fresco. Logge, Vatican, Rome*

surface with figures.[14] In this incomparably beautiful and precious material also, the ancient vessel forms were used to greatest advantage, and the figural scenes acquired, through a masterful technique of incision, a wonderful, ethereal delicacy. Such splendid vessels, often further adorned with gold and precious stones, were sought after avidly by connoisseurs and were among the greatest treasures of the princely collections of the cinquecento.

## Textiles

The textile arts, among the greatest achievements of the Renaissance, set a standard for the entire Western world, and they stand in the same relationship to the major arts as do glass and ceramics. Once again it was the artisans of the duecento and trecento who made the basic technical discoveries.[15] In that period, so decisive for all the arts, there arose in Italy, on the basis of Byzantine practice, a highly developed silk manufacture that was, both technically and artistically, rich in promise of future achievements. In the trecento, the Tuscan town of Lucca assumed leadership in textile making, and it was then that the techniques and design of silks in Italy attained their distinctive character through the continuing influence of the Islamic Near East and the Orient. This development was pursued in the quattrocento by combining the techniques and patterns introduced from foreign sources with the Renaissance ideals of beauty.

*Silk.* Plain unpatterned silks continued to be produced in the Renaissance period, but these are of minor importance to our study, since the significant artistic textiles in the quattrocento were the patterned velvets.

*Velvet.* Plain velvets were produced in Italy as early as the duecento, but it was not until the quattrocento that an effort was made, notably in Venice and Florence, to work out a technique of patterning.[16] The new type of cloth rapidly found great favor, and creative ingenuity and imagination were lavished upon it. Its special distinctions were its technical perfection and the motifs and decorative stylization of its patterns. New motifs were added to the traditional Byzantine, Islamic, and Oriental repertory; these were derived, as might be expected, from the antique—pomegranates, vases with handles, wreaths and garlands, all of them full of possibilities for the naturalistic-minded designers of the Renaissance. For courtly circles, emblematic bands with mottoes, heraldic devices, animals, hunting scenes, and the like were interspersed among the revived antique motifs. We have already seen to what extent such intellectualistic tastes of the aristocracy found expression in small bronzes, paintings, and ceramics.

Characteristically, in textiles too, the aim was for a greater clarity and precision in decorative design. In its silks, the trecento had sought the charm of the unexpected, the apparently accidental, which was typical of the asymmetrical loose patterning of Oriental fabrics; the quattrocento, instead, insisted on symmetry and order, so that the individual motifs were more clearly contrasted with each other and with the background. It was as if the Occidental sense of beauty, the taste for Classical organization, had reasserted itself in textile design as elsewhere.

The technique of weaving velvet was especially adaptable to the kind of distinctive and emphatic forms and clear, orderly patterning sought after in the Renaissance. The soft, lustrous colored velvet surfaces were often contrasted with gold or silver backgrounds, and in this again we see a fundamental principle of the Renaissance—the love of well-balanced contrasts, the opposition between pattern and background playing a role somewhat analogous to the formal principle that operated also in architecture, sculpture, and painting. This tension, this working with contrast in subtly varied

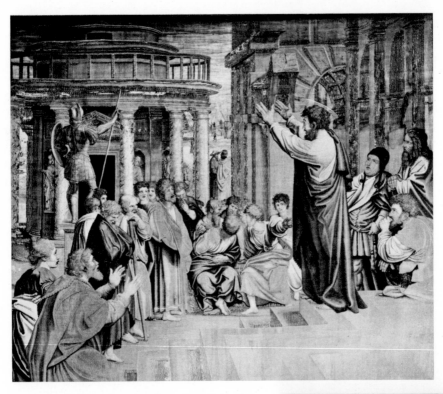

228. St. Paul Preaching at Athens. *Brussels, c. 1515–19. Tapestry (after cartoon by* RAPHAEL). *Vatican Museums, Rome*

229. St. John Being Conducted to Prison. *1466–80. Embroidery (after cartoon by* ANTONIO POLLAIUOLO). *Museo dell'Opera del Duomo, Florence*

gradations, was made possible by a special technique of weaving. The pile of the colored velvet surfaces was in part sheared down, in part left uncut, to produce a patterned play of differentiated surfaces. The cut surfaces were still further divided and patterned by shearing down to different heights, producing an effect like relief.

Such velvets became one of the chief articles of export, sought after everywhere in the Western world for liturgical vestments (Colorplate 58), secular garb, and wall coverings. Again, it is principally in church treasuries that examples have been preserved.

*Tapestry.* The walls of dwellings, churches, and public buildings in Renaissance Italy were covered with woven hangings, though Italy itself did not produce such stuffs but imported them from the Low Countries and northern France. This source is attested by the Italian word for tapestries, *arazzi,* from the Flemish town of Arras, which was one of the most important centers of tapestry making.[17] Nevertheless, the designs often came from Italian artists, even from some of the greatest of the age, such as Andrea del Sarto, who designed a series on the theme of St. John the Baptist that are still hung in the Loggia de'Lanzi in Florence on the saint's day and other solemn occasions. The full-size cartoons by Raphael for the set of tapestries in the Vatican provide further evidence of the importance of this art form in the Renaissance (Colorplate 59, pl. 228).

*Embroidery.* Linen and silk were embroidered with threads of the same material, and sometimes with strands of catgut wrapped in gold or silver wire.[18] Silk embroidery was used principally for liturgical vestments. Designs tended to be purely ornamental, and figural depictions were much less frequent than in Late Gothic Germany, although examples did occur. Occasionally artists of the highest rank were called on for embroidery designs. Antonio Pollaiuolo,

for instance, provided sketches for embroidered material that is preserved in the Museo del Duomo in Florence, with a cycle of scenes from the life of John the Baptist (pl. 229).[19]

Embroidery on linen was much more common than on silk which remained a costly commodity, and in the wealthier homes embroidered linen was employed for articles of daily use such as tablecloths, wall hangings, and shirts. Through the influence of the Renaissance development, traditional folk motifs were transformed and gained fresh charm, and the popular art of Umbria and Tuscany continues even today to produce a similar kind of embroidery in combinations of blue on white, red on white, and white on white.

# CHAPTER NINE

# ORNAMENTAL MOTIFS

Renaissance architecture, monuments, sculpture, painting, the graphic arts, and the minor arts all have in common the same types of ornamental detail. In all periods, ornamentation is the element least subject to functional demands; therefore, in the case of Renaissance art, it provides the clearest vehicle for the underlying conceptual forces of that movement. All the basic concepts of the Renaissance artist found concise expression in the realm of ornamentation through the use of definite and effective formulas.

## Formal vocabulary

We have seen that in Renaissance art the following major factors are fundamental: the relationship to Gothic style, over which it triumphed, as well as the relationship to nature and to antiquity. The latter had a positive influence, which was exerted also on those forms based on elemental geometric configurations. Other associations played a more peripheral role, such as the relationship to Oriental art. All these relationships can be found clearly manifested in the formal vocabulary of ornament, for ornamentation, like architecture (but unlike sculpture and painting), possesses a specific and distinctive formal vocabulary.

*Naturalistic Motifs.* A basic principle of Renaissance art is the belief that art must imitate nature. Theorists from Boccaccio to Vasari made this a central point in their

doctrines. From this premise, architects gave a new form to their structures and developed a special system of proportions. Sculptors owed to it the truth and orderliness of their work. Painters derived from it new subject matter such as the portrait and landscape, and also the art of representing bodies and space as well as their particular use of color. In ornamentation, this concern with nature was expressed with utmost clarity, inspired probably by Gothic traditions from north of the Alps which were made known in Italy through illuminated manuscripts and goldsmith work.

In this development Ghiberti was the decisive figure; in 1424, he decorated the bronze frame of his first door for the Baptistery of Florence with a garland in relief (pl. 230), thereby immortalizing, so to speak, by artistic means those wreaths of flowers which were, and still are, placed around doors on festive occasions.[1] This motif, taken from life, he executed with a naturalism previously unknown. The leaves, blossoms, and fruit of various plants and trees are so faithfully depicted in these bronze garlands and with such extraordinary diversity that they seem to anticipate Albrecht Dürer's famed drawings of plants. Besides, Ghiberti introduced a great number of small animals—owls, birds of prey, songbirds, weasels, squirrels, and the like—with a truly astonishing feeling for reality, equaled only by the greatest Renaissance painters of animals, such as Pisanello and Dürer.

The impact of this new art of ornamentation was powerful and full of consequences, leading in the quattrocento and cinquecento to an ever-increasing and extremely diversified production of naturalistic decoration. Patrons and artists alike delighted in the manifold richness of nature as depicted in every art medium.

The garland motif was given a particular charm by Luca della Robbia, who used it for

230. LORENZO GHIBERTI. *Frieze surrounding north doors (detail). 1403–24. Bronze. Baptistery, Florence*

his brightly glazed terra cottas.[2] For his tomb of Piero and Giovanni de' Medici in San Lorenzo in Florence (1469–72; pl. 231),[3] Verrocchio employed the same motif with great dignity, taking for inspiration the old Roman acanthus form of the Corinthian capital. In Mantegna's paintings, Madonnas and saints are set off by highly naturalistic garlands of fruit and flowers (pl. 232). His followers in Ferrara and Venice, in particular Giovanni Bellini and Cosimo Tura (pl. 150, Colorplate 60), developed this decorative device still further and passed it on to artists north of the Alps. The high point of naturalistic ornamentation occurred in the quattrocento.

*Classicizing Motifs.* The masters of the Renaissance were convinced that they could best approach nature through the study and imitation of ancient works of art. In architecture and in many types of minor arts, this conviction gave rise to a new formal vocabulary and compositional technique. In sculpture and painting, the study of the antique had great influence on the treatment of form and composition. It was in ornamentation, however, that this profound debt of the Renaissance to antiquity was most clearly expressed. Beginning with the quattrocento, naturalistic and Classicizing formal vocabularies became associated with each other, and in the Early and High Renaissance both elements were synthesized into a single unity, a union encouraged by the fact that in imperial Rome ornamental art had gone through a naturalistic phase, witnessed notably in the Ara Pacis Augustae in Rome. The Renaissance masters of ornamental art derived many motifs from the rich sources offered by countless surviving Roman buildings, decorations, statues, and bronzes. Architecture took from the Romans the so-called "cymatium"—the egg and dart molding—and various other types of leaf patterns, as well as the denticulate design, plaitwork, palmettes, the diverse forms of

cornices, bases, and the like; above all, it took the orders of capitals, particularly the Corinthian acanthus shoots and the highly decorative acanthus leaf (pl. 6).

In the other arts, there were no limits to the use of ornamental motifs, and a veritable world of representational possibilities grew out of the ornamental and figural elements inherited from imperial Rome. It was a world that appealed to man's feeling for nature but also, and equally, to his delight in the fantastic, introducing as it did mythological persons and scenes that had a remote religious significance which, once the old Oriental and pagan religions had faded away, had lived on in the group subconsciousness with all its magical mystery. Waterspouts and door knockers were made in the shapes of lions' heads and animal or human masks, perhaps in some dim recollec-

*231.* ANDREA DEL VERROCCHIO. Tomb of Piero and Giovanni de' Medici. *1469–72. Marble and bronze. Old Sacristy, S. Lorenzo, Florence*

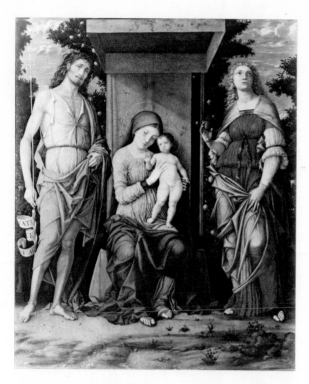

232.  ANDREA MANTEGNA. Madonna and Child with Saints. *Late 15th century. Canvas, 54½ × 45½″. National Gallery, London*

tion of their primitive mystique. The feet on furniture were transformed into lion or griffon claws, the round-arched recesses of niches into seashells. Fabulous creatures appeared everywhere: griffons, sphinxes, centaurs, fauns, harpies, gorgons' heads, and many, many more. Purely ornamental forms were also borrowed from Rome: herms, trophies, candelabra, and the like. Everything that had been known to antiquity in the way of ornament lived again in Renaissance decoration.

This movement reached its high point about 1516–18 when Raphael, in his official capacity as overseer of historical monuments, studied the works of ancient Rome systematically and made use of his discoveries in decorating the Logge in the Vatican.[4] There he applied a type of ornamentation which became known as *grotteschi*, from the ancient grottoes where it was found but which, legitimately enough because of its

aspect, can be rendered in English as "grotesque" (Colorplate 61). Some engravings of Agostino Veneziano furnish excellent examples of this style of decoration (pl. 233).

Even before the great body of Roman models was rediscovered, however, certain artists had attempted to revive the grotesque style: Giuliano da Sangallo in his tomb for Francesco Sassetto in Santa Trinita in Florence (c. 1483–85) and, to a lesser degree, in the vaults of the sacristy of Santo Spirito in the same city (1489; pl. 234); Filippino Lippi in his frescoes for Santa Maria sopra Minerva in Rome (1488–93; pls. 235, 236) and for Santa Maria Novella in Florence (1489 and after; pl. 237), as well as at Poggio a Caiano (pl. 238) and in his drawings; Bramante in some of his buildings in Milan (c. 1479–99); and other artists besides. Like the Pompeian frescoes that inspired it, grotesque decoration has a very special character and appeal. Acanthus branches spring from vases to bear not flowers but masks or fabulous creatures. Other fantastic and amusing creatures swarm all over the tendrils: monsters, cupids, and beasts of all kinds. Within the network of foliage scattered loosely and at random are tiny scenes, mostly mythological and illusionistic, like minuscule framed pictures hung on the acanthus tendrils. In the grotesque decoration of Raphael, Renaissance Classicizing ornament attained perfection, and it was to have an inestimable effect on all subsequent decoration, Mannerist, Baroque, Neoclassic, and even on that of the nineteenth and twentieth centuries.

*Geometric Motifs.* Along with naturalistic and Classicizing motifs, geometric forms were an important part of Renaissance ornamentation. Squares, rectangles, triangles, circles, rhomboids, and the like, were frequent in ancient Roman marble inlays and mosaics, both as single forms and in artfully contrived combinations. They were inevitably adopted by Renaissance artists

233. AGOSTINO VENEZIANO. *Grotesque ornament.*
*c. 1520. Copper engraving*

234. GIULIANO DA SANGALLO. *Vault decoration. 1489.*
*Vestibule of Sacristy, S. Spirito, Florence*

235. FILIPPINO LIPPI. St. Thomas Receiving Approval for His Work from
Christ on the Cross. *1488–93. Fresco. S. Maria sopra Minerva, Rome*

236. FILIPPINO LIPPI. The Dispute Between St. Thomas Aquinas and the Heretics.
*1488–93. Fresco. S. Maria sopra Minerva, Rome*

237. **FILIPPINO LIPPI.** St. Philip Exorcising the Demon from the Idol of Mars. *1489 and after. Fresco. S. Maria Novella, Florence*

238. **FILIPPINO LIPPI.** *Remains of fresco decoration in the Loggia. c. 1502. Villa Medici, Poggio a Caiano*

for marble inlay, mosaic pavements, ceiling designs, and intarsia. Their geometric interplay of forms aroused and satisfied the contemporary fascination with mathematical rules and problems. Characteristically, the greatest architects and painters— Bramante, Leonardo, Dürer—were enthralled by the possibilities of complicated, yet harmonious geometric ornament, and among the most impressive examples of this are the so-called *gruppi* of Bramante and the knotted-cord ornaments of Leonardo, which bear, interestingly enough, the title "Academia Leonardi Vinci" (pl. 239). Albrecht Dürer reproduced these designs in his woodcuts—a fact that is equally significant.

*Oriental Motifs.* During the Renaissance, Italy played a mediating role between Occident and Orient because of its geographical situation and its political and cultural activity, and this was the principal source of its economic well-being. The arts, too, were thereby affected, as is obvious

*239. Ornament after Leonardo's "nodi." Rijksmuseum, Amsterdam*

for instance, in Byzantine influence on Renaissance architecture and painting, and especially in the Islamic and Oriental influences on ceramics and textiles. As their names indicate, the "arabesques" and "moresques" of Renaissance ornamentation came from the Near East (pl. 240).[5]

Perhaps the general favor that such designs elicited was due to their exotic character. In Islamic art they had an ancient history, having first appeared as stems and leaves, to be stylized later into abstract forms that scarcely reveal their vegetable origin. The tendrils became curves of almost mathematical precision—parabolas, hyperbolas, and spirals. The leaves and flowers became no less abstract, so that only the swelling rise and fall of the curves still recall the organic prototype. The abstract character of these designs is further emphasized by a symmetrical disposition and the lack of any suggestion of modeling in the round. They appear only as dark silhouettes on a light ground, or the reverse, especially when employed in intarsia.

It was apparently the mathematical abstraction of these patterns which appealed to Renaissance artists. In geometric ornament,

*240. Moresque and arabesque ornament*

from the trecento to the cinquecento, one often has the impression that Islamic influences must have been at work. The arabesque, with its charming elegance, must have seemed an ideal means of introducing movement and rhythm into more rigid geometric ornamental schemes.

## Formal treatment

In conclusion, the question must be posed as to how the diverse elements of the formal vocabulary of Renaissance ornamentation were synthesized into an organic aesthetic unity; how the naturalistic, Classicizing, geometric, and Oriental motifs were all combined into a satisfactory whole. Up to now, we have been concerned only with what one might call the vocabulary of the ornamental forms, with their definition and etymology. Now we must also consider "word inflection" and "syntax," the principles according to which single words are built into meaningful sentences. In clarifying this problem, the character of the Renaissance is again revealed in its essential qualities and, indeed, with overwhelming impressiveness.

*Completeness.* A Renaissance work of art is basically a finite object, contained in itself. Gothic works, on the other hand, seem to soar beyond their physical limits, although as early as the duecento and trecento this expansive movement tended to become calmer, as seen in the development of the relief from the time of Nicola Pisano and likewise in the development of painting and architecture. Ornamental composition also obeys this principle, at least as a rule, remaining close and self-contained, neither striving to go beyond its borders nor admitting any disturbance from outside. This was a fundamental compositional principle of all the Renaissance arts.

*Clarity.* The essential character of the Renaissance work of art can be taken in at a glance, as an organism that has neither too much nor too little of any element, as an imaginative concept which, like an organic body, conforms rigorously to the immutable laws of nature. This is true of buildings of all kinds as well as of sculpture and painting in the quattrocento and cinquecento. In all these major types of art, compositional schemes are constructed on the basis of geometric or stereometric figures in response to the conscious striving toward completeness, immediate comprehensibility, clarity, and order. This too reveals a basic principle of Renaissance art which is applicable to all forms, including ornamentation. Almost always, Renaissance composition is developed symmetrically, with its elements combined into geometric figures such as the square, rectangle, triangle, circle, or spiral, whether the basic motifs be abstract or organic.

In the realm of ornament also—indeed, in this realm above all—an eternal philosophical-religious feeling was given form: the feeling that the universe obeys divine principles of order and that the essence of this supranatural order is revealed most purely in the ideal form of mathematical figures. It was this same feeling which impelled Luca Pacioli to entitle his mathematical treatise *De divina proportione.*

*Variation.* Within the fixed and ordered scheme, some room is left for a salutary freedom. The diversity introduced by such variation compensates for the singleness and rigor of the over-all structure. Buildings, sculpture, and above all painting, are all impressive evidence of this effect. So also is ornamental composition which, more than any other type of art, respects the same principles of composition as painting. In both forms, everything conceivable is done to temper the over-all rigor with an easy grace. In both, symmetry is loosened so that one is scarcely conscious of its directive function. While enjoying the enchanting

details, one almost forgets the mathematical exactitude of the whole, seduced by the illusion that everything here is caprice and free play. But rigor and freedom stand in a beneficent relationship to each other. The beholder comes to appreciate this when he goes beyond mere sensual pleasure to the pleasure of the intellect. Just as in the great arts of architecture, sculpture, and painting, so also in ornamental composition there is concealed more than what pleases the senses. Ornament, too, reveals what was the ultimate aim of the Renaissance movement: revelation of the spiritual in the world of matter, the exalted mystery of the authority of the divine in all of created nature.

# NOTES

## Chapter one

[1] Literature on the concept of "Renaissance": Arthur Haseloff, "Begriff und Wesen der Renaissancekunst," *Mitteilungen des Kunsthistorischen Instituts in Florenz*, III (1931), pp. 373 ff.; Hans Kauffmann, "Über 'rinascere,' 'Rinascità,' und einige Stilmerkmale der Quattrocentobaukunst," *Concordia Decennalis; Festschrift der Universität Köln aus Anlass des zehnjährigen Bestehens des deutsch italienischen Kulturinstituts Petrarca-Haus in Köln* (Cologne, 1941), pp. 123 ff.; Walter Paatz, "Renaissance oder Renovatio? Ein Problem der Begriffsbildung in der Kunstgeschichte des Mittelalters," *Beiträge zur Kunst des Mittelalters—Vorträge der ersten deutschen Kunsthistorikertagung auf Schloss Brühl, 1948* (Berlin, 1950), pp. 16 ff.; Walter Paatz, "Die Gestalt Giottos in der Literatur des Trecento—eine Studie über die Ursprünge der Kunsttheorie der Renaissance" (lecture, excerpt published as "Die Bedeutung des Humanismus für die Toskanische Kunst des Trecento—ein Versuch," *Kunstchronik*, VII, 1954, pp. 114 ff.); Herman Baeyens, *Begrip en Probleem van de Renaissance* (Louvain, 1952); Hans Kauffmann, "Italienische Frührenaissance," *Arbeitsgemeinschaft für Forschung des Landes Nordrhein-Westfalen, Jahresfeier 1956* (Cologne and Opladen, 1957); Martin Gosebruch, "'Varietà' bei Leon Battista Alberti und der wissenschaftliche Renaissancebegriff," *Zeitschrift für Kunstgeschichte*, XX (1957), pp. 229 ff.; Erwin Panofsky, *Renaissance and Renascences in Western Art* (2 vols.; Stockholm, 1960).

[2] The most important original sources: cf. Julius von Schlosser, *Die Kunstliteratur* (Vienna, 1924; with bibliography). Giovanni Villani, *Cronica* (c. 1340); Giovanni Boccaccio, *Decameron* (c. 1350–60); Cennino Cennini, *Libro dell'Arte* (c. 1400); Filippo Villani, *De origine civitatis Florentiae et ejusdem famosis civibus* (c. 1400). (Concerning these and other writ-

ings of the fourteenth century, cf. Paatz, *Kunst-chronik*, VII, pp. 114 ff.) Leon Battista Alberti, *Treatises* (c. 1435–50); Lorenzo Ghiberti, *I Commentarii* (c. 1450); Anonymous (Antonio di Tuccio Manetti?), *Vita di Filippo di Ser Brunellesco* (c. 1470–80); Albrecht Dürer (d. 1528), *Writings;* Giorgio Vasari, *Le Vite . . .* (1550–68).

[3] Vasari, *Le Vite*, ed. G. Milanesi (Florence, 1878), I, pp. 215 ff.

[4] *Ibid.*, p. 228 (trans. G. du C. De Vere, London, 1912, I, p. xlvii).

[5] *Ibid.*, pp. 137–38 (trans. L. S. Maclehose, *Vasari on Technique*, London, 1907, pp. 83–84).

[6] *Ibid.* (ed. 1568), pp. 93, 96.

[7] *Decameron*, Sixth Day, Fifth Novel (trans. R. Aldington, Garden City, N.Y., 1949). In addition to to this and the two following citations, cf. Paatz, *Kunstchronik*, VII, pp. 114 ff.

[8] *Cronica*, Bk. XI, Chap. 12.

[9] Julius von Schlosser, *Lorenzo Ghibertis Denkwürdigkeiten* (Berlin, 1912), pp. 35–36.

[10] Ernst Heidrich and Heinrich Wölfflin, *Albrecht Dürers schriftlicher Nachlass* (Berlin, 1920), p. 277 (trans. W. M. Conway, *The Writings of Albrecht Dürer*, London, 1958, p. 247).

[11] *Ibid.*

[12] *Ibid.*, p. 272 (trans. Conway, p. 245).

[13] Arnold von Salis, *Antike und Renaissance* (Erlenbach-Zurich, 1947); Ingvar Bergström, *Revival of Antique Illusionistic Wallpainting in Renaissance Art* (Stockholm, 1957).

[14] Cf. Julius von Schlosser, "Über einige Antiken Ghibertis," *Jahrbuch der Kunsthistorischen Sammlungen des Allerhöchsten Kaiserhauses, Wien*, XXIV (1903), p. 152, n. 2; Paatz, *Kunstchronik*, VII, pp. 114 ff.

[15] Giorgio Vasari, *Gentile da Fabriano e Pisanello*, ed. Adolfo Venturi (Florence, 1896), I, p. 49.

[16] Herbert von Einem, *Goethe und Dürer* (Hamburg, 1947), p. 12.

[17] *Ibid.*, p. 15; Heidrich and Wölfflin, *Albrecht Dürers . . .*, p. 270 (trans. Conway, p. 245).

[18] Von Einem, p. 16; Heidrich and Wölfflin, pp. 290–91 (trans. Conway, p. 250).

[19] Von Einem, p. 16; Heidrich and Wölfflin, pp. 311–12 (trans. Conway, p. 179).

[20] *Le Vite* (ed. Milanesi), II, p. 395, n. 1.

[21] *Ibid.*, I, pp. 168–69 (trans. Maclehose, p. 205).

[22] *Ibid.*, p. 169 (trans. Maclehose, p. 206).

[23] Heidrich and Wölfflin, pp. 321–22 (trans. Conway, p. 178, n. 1).

[24] Paatz, *Beiträge zur Kunst des Mittelalters*, pp. 16 ff.

# Chapter two

[1] Bernhard Schmeidler, *Das spätere Mittelalter von der Mitte des 13. Jahrhunderts bis zur Reformation*, Vol. IV of *Handbuch für den Geschichtslehrer*, ed. O. Kende (Leipzig and Vienna, 1937); Karl Brandi, "Die Renaissance," *Propyläen-Weltgeschichte*, IV (1932), pp. 157 ff.; Leonhard von Muralt, "Das Zeitalter der Renaissance," *Neue Propyläen-Weltgeschichte*, III (1941), pp. 1 ff.

[2] Walter Paatz, *Werden und Wesen der Trecento-Architektur in Toskana* (Burg, 1937), pp. 101 ff.

[3] Walter and Elisabeth Paatz, *Die Kirchen von Florenz* (Frankfort), IV (1952), pp. 482, 491 ff.

[4] Jenö Lanyi, "Der Entwurf zur Fonte Gaia in Siena," *Zeitschrift für bildende Kunst*, LXI (1927–28), pp. 257 ff.; idem., " Quercia-Studien," *Jahrbuch für Kunstwissenschaft* (1930), pp. 59 ff.

[5] Of the very rich literature on this subject, only the most important works can be cited here. Jakob Burckhardt, *The Civilization of the Renaissance in Italy*, trans. S. G. C. Middlemore (London, 1960); Hubert Janitschek, *Die Gesellschaft der Renaissance in Italien und die Kunst* (Stuttgart, 1879); Eugène Müntz, *Histoire de l'art pendant la Renaissance* (3 vols.; Paris, 1889–95); Johan Huizinga, "Das Problem der Renaissance," and "Renaissance und Realismus," *Wege der Kulturgeschichte* (Munich, 1930), pp. 89 ff. and 140 ff.; Ernst Walser, *Gesammelte Studien zur Geistesgeschichte der Renaissance* (Basel, 1932); Brandi, *Propyläen-Weltgeschichte*, IV, pp. 157 ff.; Werner Näf, "Staat, Gesellschaft, Wirtschaft im Zeitalter der Renaissance," *Staat und Staatsgedanke* (Bern, 1935), pp. 47 ff.; Martin Wackernagel, *Der Lebensraum des Künstlers in der Florentinischen Renaissance* (Leipzig, 1938); Von Muralt, *Neue Propyläen-Weltgeschichte*, III, pp. 1 ff.; Paul Oskar Kristeller, "Humanism and Scholasticism in the Italian Renaissance," *Byzantion*, XVII (1944–45), pp. 346 ff.; Wallace K. Ferguson, *The Renaissance in Historical Thought* (Boston, 1948), and the review by Hans Baron, *Journal of the History of Ideas*, XI (1950), pp. 493 ff.; Wallace K. Ferguson, "The Interpretation of the Renaissance: Suggestions for a Synthesis," *Journal of the History of Ideas*, XII (1951), pp. 483 ff.;

Paul Oskar Kristeller, "The Modern System of the Arts: a Study in the History of Aesthetics," *Journal of the History of Ideas*, XII (1951), pp. 496 ff., and XIII (1952), pp. 17 ff.; Baeyens, *Begrip en Probleem*.

[6] Cf. pertinent articles in Thieme-Becker, *Künstlerlexikon*.

[7] For literature on this subject, see n. 5 and also Aby Warburg, *Gesammelte Schriften*, Vols. I and II: *Die Erneuerung der heidnischen Antike* (Leipzig and Berlin, 1932).

[8] Cf. Rudolf Wittkower, *Architectural Principles in the Age of Humanism* (3d ed. rev.; New York, 1965) as well as Paatz, *Kunstchronik*, VII, pp. 114 ff.

[9] Von Salis, *Antike und Renaissance*.

[10] Aby Warburg, "Sandro Botticellis 'Geburt der Venus' und 'Frühling,'" *Gesammelte Schriften*, I, pp. 1 ff., 307 ff.

[11] Reinhard Herbig, "Alcuni dei ignudi," *Rinascimento*, III (1952), pp. 3 ff.

[12] Aby Warburg, "Italienische Kunst und internationale Astrologie im Palazzo Schifanoja zu Ferrara," *Gesammelte Schriften*, II, pp. 459 ff., 627 ff.

## Chapter three

[1] Of the vast literature on architecture, only a very few of the most important basic works can be cited here. Jakob Burckhardt, *Geschichte der Renaissance in Italien* (1st ed., Leipzig, 1867; 3d ed. with the collaboration of Heinrich Holtzinger, Stuttgart, 1891); Carl M. Stegmann and Heinrich von Geymüller, *The Architecture of the Renaissance in Tuscany* (2 vols.; New York, 1924); Hans Willich and Paul Zucker, *Die Baukunst der Renaissance in Italien* (2 vols.; Berlin and Potsdam, 1914–29); Adolfo Venturi, *Storia dell'arte Italiana* (Milan, 1901–39), VI–XI; Paul Frankl, *Die Entwicklungsphasen der neueren Baukunst* (Leipzig and Berlin, 1914); Kauffmann, *Concordia Decennalis*, pp. 123 ff.; Wittkower, *Architectural Principles*.

[2] Cornel von Fabriczy, *Filippo Brunelleschi* (Stuttgart, 1892); Hans Folnesics, *Brunelleschi* (Vienna, 1915); Ludwig H. Heydenreich, "Spätwerke Brunelleschis," *Jahrbuch der Preussischen Kunstsammlungen*, LII (1931), pp. 1 ff.

[3] *Le Vite* (ed. Milanesi), II, pp. 337–38.

[4] Cf. Heydenreich, *Jahrbuch der Preussischen Kunstsammlungen*, LII, pp. 1 ff. Cf., for a contrary view, Frank D. Prager, "Brunelleschi's Inventions and the

'Renewal of Roman Masonry Work,'" *Osiris*, IX (1950), pp. 466–68.

[5] *Il libro di Giuliano da Sangallo (Cod. Vat. Barbarino lat. 4424)*, ed. Christian Huelsen (2 vols.; Leipzig, 1910); *Il taccuino Senese di Giuliano da Sangallo*, ed. Rodolfo Falb (Siena, 1902).

[6] Burckhardt, *Geschichte der Renaissance*, 1891, pp. 33 ff.

[7] *Ibid.*, pp. 48 ff., 87 ff.

[8] For the significance of the column in Renaissance architecture, see especially Alberti (Wittkower, *Architectural Principles*, pp. 33 ff.).

[9] *Ibid.*, pp. 8, 35 ff.

[10] Hans Jantzen, *Über den gotischen Kirchenraum* (Freiburg, 1928).

[11] Cf. Paatz, *Werden und Wesen*.

[12] Burckhardt, *Geschichte der Renaissance*, 1891, pp. 67 ff.

[13] *Ibid.*, pp. 325 ff.

[14] *Ibid.*, pp. 81 ff., 93 ff.

[15] *Ibid.*, pp. 322 ff. Nevertheless, Alberti spoke of the superiority of the vault (Wittkower, *Architectural Principles*, p. 9).

[16] Walter Paatz, "Italien und die künstlerischen Bewegungen der Gotik und Renaissance," *Römisches Jahrbuch für Kunstgeschichte*, V (1941), p. 209 (Chapter House of Sta. Felicita, Florence, 1387).

[17] Paatz, *Werden und Wesen*, p. 124.

[18] Walter and Elisabeth Paatz, II (1941), p. 552, n. 133; Philipp Schweinfurth, *Die byzantinische Form* (Berlin, 1943), pp. 53–56.

[19] Wittkower, *Architectural Principles*, pp. 3, 27–29; André Chastel, *Marsile Ficine et l'art* (Geneva and Lille, 1954).

[20] Burckhardt, *Geschichte der Renaissance*, 1891, pp. 175 ff. About the concept of the organic in the aesthetic of Alberti and its derivation from Vitruvius, see Wittkower, *Architectural Principles*, pp. 8, 33.

[21] Wittkower, *Architectural Principles*, pp. 7, 29.

[22] Cf. articles by Walter Überwasser in *Jahrbuch der Preussischen Kunstsammlungen*, 1936, and *Oberrheinische Kunst*, VIII (1939), pp. 25 ff.; *idem.*, "Massgerechte Bauplanung der Gotik und Beispielen Villards de Honnecourt," *Kunstchronik*, II (1949), pp. 200 ff.

[23] Wittkower, *Architectural Principles*, p. 11 and Pl. 1, pp. 14 ff., and Pls. 2–4, pp. 29 ff.

[24] Burckhardt, *Geschichte der Renaissance*, 1891, pp. 98 ff., 175 ff.

[25] *Ibid.*, pp. 148 ff., 157 ff.

[26] For its evaluation in Alberti's theory of art, see Wittkower, *Architectural Principles*, pp. 6 ff.

[27] Walter and Elisabeth Paatz, II (1941), pp. 473 ff., and V (1953), pp. 128 ff.

[28] Burckhardt, *Geschichte der Renaissance*, 1891, pp. 322 ff.

[29] Interior view in Theodor Hetzer, *Die Sixtinische Madonna* (Frankfort, 1947), p. 9.

[30] Touring Club Italiano, *Attraverso l'Italia*, Vol. 16: *Emilia e Romagna* (Milan, 1950), p. 239, Pl. 503.

[31] Franz Xaver Zimmermann, *Die Kirchen Roms* (Munich, 1935), pp. 294 ff., Pls. 122–23.

[32] Touring Club Italiano, Vol. 16, p. 163, Pl. 331 (incorrectly identified as "Madonna di Campagna").

[33] Burckhardt, *Geschichte der Renaissance*, 1891, p. 160.

[34] *Ibid.*, pp. 115–34.

[35] Wittkower, *Architectural Principles*, pp. 1–11 (Alberti) and pp. 12–13 (Francesco di Giorgio).

[36] Walter and Elisabeth Paatz, II (1941), p. 479, and I (1940), pp. 536 ff.

[37] Wittkower, *Architectural Principles*, pp. 9–10 (with bibliographical references); Aby Warburg, "Eine Astronomische Himmelsdarstellung in der Alten Sakristei von S. Lorenzo in Florenz," *Gesammelte Schriften*, I, pp. 169, 366.

[38] Heydenreich, *Jahrbuch der Preussischen Kunstsammlungen*, LII, pp. 4 ff.; Walter and Elisabeth Paatz, III (1952), pp. 114 ff.

[39] Ludwig H. Heydenreich, "Die Tribuna der SS. Annunziata in Florenz," *Mitteilungen des Kunsthistorischen Institutes in Florenz*, III (1919–32), pp. 268 ff.

[40] Wittkower, *Architectural Principles*, pp. 47 ff.

[41] *Ibid.*

[42] Burckhardt, *Geschichte der Renaissance*, 1891, p. 167, Pls. 170–71; Walter and Elisabeth Paatz, V (1953), pp. 121 f., 133 f.

[43] Burckhardt, *Geschichte der Renaissance*, p. 122.

[44] *Ibid.*, pp. 123–25. A chronological list of the important central-plan churches in Italy is given in Wittkower, *Architectural Principles*, p. 20, nn. 1, 2.

[45] Costantino Baroni, *Bramante* (Bergamo, 1944).

[46] Wittkower, *Architectural Principles*, pp. 19 ff.

[47] Burckhardt, *Geschichte der Renaissance*, 1891, p. 121.

[48] *Ibid.*, p. 130

[49] *Ibid.*, p. 125; Baroni, *Bramante*.

[50] Burckhardt, *Geschichte der Renaissance*, pp. 125 ff.; Heinrich von Geymüller, *Die ursprünglichen Entwürfe für Sanct Peter in Rom* (Vienna, 1875); Dagobert Frey, *Bramantes St. Peter-Entwurf und seine Apokryphen* (Vienna, 1915); Theobald Hofmann, *Entstehungsgeschichte des St. Peter zu Rom* (Zittau, 1928); Ludwig H. Heydenreich, "Zur Genesis des St. Peter-Plans von Bramante," *Forschungen und Fortschritte*, X (1934), pp. 365 ff.; Baroni, *Bramante;* Otto H. Förster, *Bramante* (Vienna, 1956), pp. 209 ff.

[51] For the bases in theology and artistic theory of this change, see Wittkower, *Architectural Principles*, pp. 29–30.

[52] Burckhardt, *Geschichte der Renaissance*, 1891, pp. 152–57.

[53] Heydenreich, *Mitteilungen des Kunsthistorischen Institutes in Florenz*, III, pp. 268 ff.; Wolfgang Lotz, "Michelozzos Umbau der SS. Annunziata in Florenz," *Mitteilungen des Kunsthistorischen Institutes in Florenz*, V (1937–40), pp. 402 ff.; Ludwig H. Heydenreich, "Die Klosterkirche S. Francesco al Bosco im Mugello," *Mitteilungen des Kunsthistorischen Institutes in Florenz*, V (1937–40), p. 399, n. 1.

[54] Lotz, *Mitteilungen des Kunsthistorischen Institutes in Florenz*, V, pp. 416–17; Walter and Elisabeth Paatz, IV (1953), pp. 91, 93 ff.

[55] Burckhardt, *Geschichte der Renaissance*, 1891, p. 153, Pl. 151; Walter and Elisabeth Paatz, V (1953), pp. 51, 53 f. (Known also as S. Francesco al Monte.)

[56] Wittkower, *Architectural Principles*, pp. 47 ff.

[57] Burckhardt, *Geschichte der Renaissance*, 1891, p. 70, Pls. 69, 167; Giulio Lorenzetti, *Venezia e il suo estuario* (Venice, Milan, Rome, and Florence, 1926), pp. 316 ff., Pl. LXIX.

[58] Burckhardt, *Geschichte der Renaissance*, pp. 136 ff.

[59] Wittkower, *Architectural Principles*, pp. 41 ff.; Walter and Elisabeth Paatz, III (1952), pp. 677 ff. I must disagree with Wittkower's limitations of the Renaissance and trecento elements.

[60] Wittkower, *Architectural Principles*, pp. 37 ff.

[61] Walter and Elisabeth Paatz, II (1941), pp. 467, 527 ff., n. 33; Giuseppe Marchini, *Giuliano da Sangallo* (Florence, 1942).

[62] Burckhardt, *Geschichte der Renaissance*, 1891, pp. 167 ff.

[63] Walter and Elisabeth Paatz, III (1952), pp. 19 ff.

[64] Heydenreich, *Mitteilungen des Kunsthistorischen Institutes in Florenz*, III, pp. 268 ff.; Walter and Elisabeth Paatz, I (1940), p. 79.

[65] Baroni, *Bramante*.

[66] Burckhardt, *Geschichte der Renaissance*, 1891, pp. 222 ff.

[67] Paatz, *Römisches Jahrbuch für Kunstgeschichte*, V, p. 216.

[68] Walter and Elisabeth Paatz, II (1941), pp. 445 ff.

[69] Burckhardt, *Geschichte der Renaissance*, 1891, pp. 185 ff.

[70] *Ibid.*, pp. 59 ff. (on rustication).

[71] Herbert Siebenhüner, "Der Palazzo Farnese in Rom," *Wallraf-Richartz-Jahrbuch*, XIV (1952), pp. 144 ff. (on Michelangelo's contribution).

[72] Burckhardt, *Geschichte der Renaissance*, 1891, pp. 235 ff.

[73] Marchini, *Giuliano da Sangallo*, pp. 16–20, 85–86, Pls. II–IV; André Chastel, "Problèmes de l'architecture à la Renaissance," *Bibliothèque de Humanisme et Renaissance*, XIII (1951), p. 367.

[74] Marie Louise Gotheim, *Geschichte der Gartenkunst* (Jena, 1914), I, pp. 219 ff.; *Mostra del Giardino Italiano* (catalogue; Florence, 1931).

[75] *Memoirs of a Renaissance Pope: The Commentaries of Pius II*, trans. Florence A. Gragg, ed. Leona C. Gabel (New York, 1959). See also Boccaccio, *Decameron*, Introduction to the Third Day.

[76] Burckhardt, *Geschichte der Renaissance*, 1891, pp. 229 ff.

[77] Maina Richter, "Die 'Tessa murata' im florentinischen Gebiet," *Mitteilungen des Kunsthistorischen Institutes in Florenz*, V (1937–40), pp. 352 ff.

[78] Ludwig H. Heydenreich, *Leonardo da Vinci* (New York, 1954), p. 79.

[79] Ludwig H. Heydenreich, "Pius II. als Bauherr von Pienza," *Zeitschrift für Kunstgeschichte*, VI (1937), pp. 105 ff.

[80] Burckhardt, *Geschichte der Renaissance*, 1891, pp. 232 ff.

[81] *Ibid.*, pp. 224 ff.

## Chapter four

[1] Cf. Walter Paatz, "Von den Gattungen und vom Sinn der gotischen Rundfigur," *Sitzungsberichte der Heidelberger Akademie der Wissenschaft, Philosophisch-historische Klasse* (Heidelberg, 1951).

[2] Burckhardt, *Geschichte der Renaissance*, 1891, pp. 292 ff.

[3] Hans Kauffmann, *Donatello* (Berlin, 1935), p. 99.

[4] *Ibid.*, pp. 109 ff. (reconstruction as a shallow, reliefalike aedicula); Rolf Band, "Donatellos altar im Santo zu Padua," *Mitteilungen des Kunsthistorischen Institutes in Florenz*, V (1937–40), pp. 315 ff. (reconstruction as a spacious, architectonic aedicula).

[5] Giuseppe Fiocco, *Mantegna* (Milan, 1937), p. 24, Pl. 19.

[6] *Ibid.*, pp. 41 ff., 155 ff., Pls. 47–54.

[7] Ludwig H. Heydenreich, "Berichte über die Sitzungen des Instituts," *Mitteilungen des Kunsthistorischen Institutes in Florenz*, V (1937–40), pp. 436 ff.; Walter and Elisabeth Paatz, I (1940), p. 127; Christian Adolf Isermeyer, "Die Capella Vasari und der Hochaltar in der Pieve von Arezzo," *Eine Gabe der Freunde für Carl Georg Heise zum 28 VI 1950* (Berlin, 1950), pp. 137 ff.

[8] Walter and Elisabeth Paatz, I (1940), pp. 602, 693, n. 605; Isermeyer, *Eine Gabe ... für Carl George Heise*, pp. 137 ff.

[9] Leo Planiscig, *Desiderio da Settignano* (Vienna, 1942), pp. 33–37, 48, Pls. 63–67; Walter and Elisabeth Paatz, II (1941), p. 496.

[10] Ulrich Middeldorf, "Eine Zeichnung von Andrea Sansovino in München," *Münchner Jahrbuch für bildende Kunst*, N.F., X (1933), pp. 138 ff.

[11] Planiscig, *Desiderio da Settignano*, pp. 48–49, Pls. 76–79.

[12] *Ibid.*, p. 44, Pls. 19–21 (parts of the tabernacle are now in The National Gallery of Art, Washington, D.C.); Walter and Elisabeth Paatz, IV (1952), p. 639.

[13] Walter and Elisabeth Paatz, V (1953), pp. 315 ff.

[14] Karl August Laux, *Michelangelos Juliusmonument*, Berlin, 1943; Herbert von Einem, "Michelangelos Juliusgrab im Entwurf von 1505 und die Frage seiner ursprünglichen Bestimmung," *Festschrift für Hans Jantzen* (Berlin, 1951), pp. 152 ff.

[15] Burckhardt, *Geschichte der Renaissance*, 1891, pp. 274 ff.; Fritz Burger, *Das florentinische Grabmal bis Michelangelo* (Strassburg, 1904).

[16] The first stage may be seen in Donatello's tomb of Pope John XXIII (Coscia) in the Baptistery of Florence (1421–27). Cf. Kauffmann, *Donatello*, pp. 96 ff.; Walter and Elisabeth Paatz, II (1941), p. 205.

[17] Leo Planiscig, *Bernardo und Antonio Rossellino* (Vienna, 1942), pp. 15 ff., 49–50, Pls. 11–14; *idem.*, *Desiderio da Settignano*, pp. 22–28, 45, Pls. 22–36; Walter and Elisabeth Paatz, I (1940), pp. 552, 579–80.

[18] Friedrich Kriegbaum, *Michelangelo Buonarroti*,

*die Bildwerke* (Berlin, 1940), pp. 13 ff., 37 ff.; Laux, *Michelangelos Juliusmonument*, pp. 303 ff., 317 ff., 328 ff.; Werner Gramberg, "Zur Aufstellung des Skulpturen-Schmuckes in der Neuen Sakristei von S. Lorenzo," *Mitteilungen des Kunsthistorischen Institutes in Florenz*, VII (1955), pp. 151 ff.

[19] Wolfgang Braunfels, "Zur Gestalt-Ikonographie der Kanzeln des Nicola und Giovanni Pisano," *Münster*, II (1949), pp. 321 ff.

[20] Kauffmann, *Donatello*, pp. 71 ff.

[21] Luitpold Dussler, *Benedetto da Maiano* (Munich, 1924?), pp. 22–30, 79–81, Tab. 4–10.

[22] Kauffmann, *Donatello*, pp. 177 ff. Kauffman believes these pulpits may have been conceived as singing galleries.

[23] Kauffmann, *Donatello* pp. 71 ff.; Leo Planiscig, .*Donatello*, (Vienna, 1939), Pls. 57 ff.

[24] Leo Planiscig, *Luca della Robbia* (Vienna, 1940), Pls. 5–21.

[25] Wolfgang Lotz, *Der Taufbrunnen des Baptisteriums zu Siena* (Berlin, 1948).

[26] Paatz, *Sitzungsberichte der Heidelberger Akademie der Wissenschaft, Philosophisch-historische Klasse*, 1951, pp. 9 ff., 14 ff.

[27] Planiscig, *Luca della Robbia*, plates.

[28] Burckhardt, *Geschichte der Renaissance*, 1891, pp. 300 ff.

[29] Leo Planiscig, *Lorenzo Ghiberti* (Vienna, 1940), plates.

[30] Leo Planiscig, *Andrea del Verrocchio* (Vienna, 1941), p. 55, Pls. 48–54.

[31] For the antecedents and history of commemorative monuments, see Werner Haftmann, *Das italienische Säulenmonument* (Leipzig and Berlin, 1939), pp. 111 ff.

[32] *Ibid.*, pp. 139–42; Kauffmann, *Donatello*, pp. 41 ff.

[33] Haftmann, *Das italienische Säulenmonument*, pp. 143 ff.

[34] *Ibid.*, pp. 147–48; Kauffmann, *Donatello*, pp. 139 ff.

[35] Wackernagel, *Der Lebensraum des Künstlers*, pp. 196 ff.; Haftmann, *Das italienische Säulenmonument*, p. 144.

[36] Haftmann, *Das italienische Säulenmonument*, pp. 145–50.

[37] *Ibid.*, pp. 109, 148; Planiscig, *Andrea del Verrocchio*, p. 56, Pls. 68–76.

[38] Giuseppe Fiocco, *Mantegna*, p. 84, Pl. 172.

[39] Burckhardt, *The Civilization of the Renaissance*, pp. 401 ff. Burckhardt, *Geschichte der Renaissance*, 1891, pp. 370 ff.

[40] Villani, *Cronica*, Bk. VIII, chap. 70.

[41] Vasari, *Le Vite* (ed. Milanesi), V, p. 24.

[42] *Ibid.*, VI, pp. 610 ff. (trans. De Vere, VIII, p. 120).

## Chapter five

[1] Kauffmann, *Donatello*, pp. 31, 148 ff., 150 ff.

[2] Kriegbaum, *Michelangelo Buonarroti*, p. 42.

[3] Planiscig, *Bernardo und Antonio Rossellino*, p. 56, Pls. 66 ff. (*St. Sebastian*, Empoli); Dussler, *Benedetto da Maiano*, pp. 57, 59–60, Tab. 32, Pl. 41 (*St. Sebastian*, Oratory of the Misericordia, Florence).

[4] Kauffmann, *Donatello*, pp. 43 ff.; Planiscig, *Bernardo und Antonio Rossellino*, Pls. 90 ff.

[5] Kauffmann, *Donatello*, pp. 12, 43, 159 ff., 167 ff.; Planiscig, *Andrea del Verrocchio*, pp. 21–23, 51, Pls. 25–32.

[6] Kauffmann, *Donatello*, pp. 165 ff.

[7] Kriegbaum, *Michelangelo Buonarroti*, pp. 43 ff.; Hans Kauffmann, "Bewegungsformen an Michelangelostatuen," *Festschrift für Hans Jantzen*, pp. 141 ff.; Hans R. Weihrauch, *Studien zum bildnerischen Werke des Jacopo Sansovino* (Strasbourg, 1935), pp. 12 ff.

[8] Planiscig, *Andrea del Verrocchio*, p. 52, Pls. 37–38.

[9] Wilhelm von Bode, *Bertoldo und Lorenzo dei Medici* (Freiburg, 1925).

[10] Kriegbaum, *Michelangelo Buonarroti*, p. 44.

[11] Moritz Hauptmann, *Der Tondo* (Frankfort, 1936); Paatz, *Römisches Jahrbuch für Kunstgeschichte*, V, p. 219.

[12] Planiscig, *Luca della Robbia*.

[13] For the Prague portrait program, see Karl M. Swoboda, *Peter Parler* (Vienna, 1940).

[14] Kauffmann, *Donatello*, pp. 31 ff.

[15] *Ibid.*, pp. 37 ff., 47 ff.; Paatz, *Römisches Jahrbuch für Kunstgeschichte*, V, p. 190.

[16] Planiscig, *Desiderio da Settignano; idem., Bernardo und Antonio Rossellino; idem., Andrea del Verrocchio;* Dussler, *Benedetto da Maiano*.

[17] Planiscig, *Desiderio da Settignano*, Pls. 1, 8–13, 37, 53, 80 ff.; *idem., Bernardo und Antonio Rossellino*, Pls. 37, 72–75.

[18] Kriegbaum, *Michelangelo Buonarroti*, pp. 22, 44, Pl. 90.

[19] Leo Planiscig, *Piccoli bronzi italiani del Rinasci-*

*mento* (Milan, 1930); *idem.*, *Venezianische Bildhauer der Renaissance* (Vienna, 1921).

[20] Aloïss Heiss, *Les médailleurs de la Renaissance* (9 vols.; Paris, 1881–92); George F. Hill, *A Corpus of Italian Medals of the Renaissance Before Cellini* (2 vols.; London, 1930).

[21] Hill, *A Corpus of Italian Medals . . .* ; Bernhard Degenhart, *Antonio Pisanello* (Vienna, 1940), pp. 40 ff.

[22] *Ibid.*

[23] Planiscig, *Piccoli bronzi; idem.*, *Venezianische Bildhauer.*

[24] *Ibid.;* Von Bode, *Bertoldo.*

[25] Siegfried Weber, *Die Entwicklung des Putto in der Plastik der Frührenaissance* (1898); Wilhelm von Bode, *Florentine Sculptors of the Renaissance* (trans. J. Haynes; 2d ed. rev., New York, 1928). pp. 162 ff.; Margret Lisner, "Die Sängerkanzel des Luca della Robbia" (dissertation, Freiburg, 1955), pp. 143 ff.; U. Hatje, "Der Putto in der italienischen Kunst der Renaissance" (dissertation, Tübingen, c. 1955).

[26] Burckhardt, *Geschichte der Renaissance*, 1891, pp. 262–63.

[27] *Ibid.*

[28] *Ibid.*, pp. 298 ff.

[29] Walter and Elisabeth Paatz, IV (1952), p. 519, n. 83.

[30] Planiscig, *Luca della Robbia.*

[31] Kauffmann, *Donatello*, pp. 159 ff.

[32] Heydenreich, *Leonardo da Vinci*, I, p. 53.

[33] Kauffmann, *Donatello*, pp. 16 ff.

[34] *Ibid.*, pp. 14 ff.

[35] Wilhelm Vöge, "Donatello greift ein reimsisches Motiv auf," *Festschrift für Hans Jantzen*, pp. 117 ff.

[36] Weihrauch, *Studien zum bildnerischen Werke*, pp. 7 ff.

[37] Kriegbaum, *Michelangelo Buonarroti*, p. 35.

[38] Kauffmann, *Donatello*, pp. 5 ff. According to Herbert Siebenhüner ("Der Hl. Georg des Donatello," *Kunstchronik*, VII, 1954, pp. 266–68), the figure was first made in 1409–13 as a portrayal of the victorious David for the Cathedral of Florence. Then, in 1415, it was acquired for Orsanmichele by the armorers' guild and, in 1415–17, reworked by Donatello as a representation of St. George.

[39] *Le Vite* (ed. Milanesi), II, p. 403 (trans. De Vere, II, p. 243).

[40] Kauffmann, *Donatello*, pp. 133 ff.; Planiscig,

*Andrea del Verrocchio*, pp. 39 ff., 56, Pls 68–76.

[41] Paatz, *Römisches Jahrbuch für Kunstgeschichte*, V, pp. 174–76, 197, 204.

[42] Karl M. Swoboda, "Zur romanischen Kunst in der Toskana," *Kritische Berichte*, I (1927–28), pp. 69–70.

[43] Hans D. Gronau, *Andrea Orcagna und Nardo di Cione* (Berlin, 1937), pp. 12 ff.

[44] Kauffmann, *Donatello*, pp. 55 ff.

[45] *Ibid.*, pp. 67 ff.

[46] *Ibid.*, pp. 79 ff.

[47] *Ibid.*, pp. 133 ff.

[48] *Ibid.*, p. 68.

[49] Planiscig, *Lorenzo Ghiberti;* Julius von Schlosser, *Leben und Meinungen des Florentiner Bildners Lorenzo Ghiberti* (Munich, 1941); Ludwig Goldscheider, *Lorenzo Ghiberti* (London, 1949); Richard Krautheimer, *Lorenzo Ghiberti* (Princeton, 1956).

[50] Planiscig, *Desiderio da Settignano*, Pls. 3, 14, 15, 17.

## Chapter six

[1] The most important comprehensive works on Italian Renaissance painting: Joseph A. Crowe and Giovanni Battista Cavalcaselle, *A History of Painting in Italy* (3 vols.; London, 1903–14); Bernard Berenson, *The Italian Painters of the Renaissance* (Oxford, 1930; 2d ed., New York, 1952); Raimond van Marle, *The Development of the Italian Schools of Painting* (19 vols.; The Hague, 1923–38); Bernard Berenson, *Italian Pictures of the Renaissance* (Oxford, 1932); Max Goering, *Italian Painting of the Sixteenth Century* (London, 1936).

[2] Wackernagel, *Der Lebensraum des Künstlers*, pp. 196 ff.

[3] *Ibid.*, pp. 72 ff.

[4] *Ibid.*, pp. 152 ff. (frescoes) and pp. 160 ff. (other paintings).

[5] *Ibid.*, pp. 171 ff.; John Pope-Hennessy, *The Complete Work of Paolo Uccello* (London, 1950), pp. 19–23, 150–52, Pls. 45–68.

[6] Luitpold Dussler, *Giovanni Bellini* (Vienna, 1949), pp. 40–42, 93, Pls. 77–81.

[7] Kenneth Clark, *Piero della Francesca* (London, 1951), pp. 19–21, 204, Pls. 27–30; Herbert Siebenhüner, "Die Bedeutung des Rimini-Freskos und der Geisselung Christi des Piero della Francesca," *Kunstchronik*, VII (1954), pp. 125–26; Rudolf Wittkower

and B. A. R. Carter, "The Perspective of Piero della Francesca's 'Flagellation,'" *The Journal of the Warburg and Courtauld Institutes*, XVI (1953), pp. 292 ff.

[8] Harald Keller, "Die Entstehung des Bildnisses am Ende des Hochmittelalters," *Römisches Jahrbuch für Kunstgeschichte*, III (1939), pp. 227 ff.

[9] Paatz, *Kunstchronik*, VII, pp. 114 ff.

[10] Degenhart, *Antonio Pisanello*, p. 38; Grete Ring, *A Century of French Painting* (London, 1949), pp. 191, 195, 199.

[11] Paatz, *Römisches Jahrbuch für Kunstgeschichte*, V, p. 201.

[12] Degenhart, *Antonio Pisanello;* Georg Pudelko, "Studien über Domenico Veneziano," *Mitteilungen des Kunsthistorischen Institutes in Florenz*, IV (1932–34), pp. 166 ff.

[13] Heydenreich, *Leonardo da Vinci*, pp. 168–71.

[14] Cf. Pietro Lorenzetti's retable of 1342 in the Pinacoteca in Siena (*The Birth of Mary*).

[15] Jan Lauts, *Domenico Ghirlandaio* (Vienna, 1943), pp. 6, 28–40, 52–54, Pls. 55–91.

[16] Von Salis, *Antike und Renaissance*.

[17] *Ibid.*, pp. 190 ff.

[18] See n. 12, Chapter two and further studies by Gustav Hartlaub.

[19] Werner Hager, *Das geschichtliche Ereignisbild. Beitrag zu einer Typologie des weltlichen Geschichtsbildes bis zur Aufklärung* (Munich, 1939).

[20] Johannes Wilde, "Die 'Pala di San Cassiano' von Antonello da Messina. Ein Rekonstruktionsversuch," *Jahrbuch der Kunsthistorischen Sammlungen in Wien*, N.F. III (1929), pp. 70 ff.; Pudelko, *Mitteilungen des Kunsthistorischen Institutes in Florenz*, IV, pp. 195 ff.; Paatz, *Römisches Jahrbuch für Kunstgeschichte*, V, pp. 220 f.; Wolfgang Braunfels, "Giovanni Bellinis Paradiesgärtlein," *Münster*, IX (1956), pp. 2 ff.; Karl Kasper, "Die ikonographische Entwicklung der Sacra Conversazione" (dissertation, Tübingen, 1954).

[21] Wilde, *Jahrbuch der Kunsthistorischen Sammlungen in Wien*, N.F. III, pp. 70 ff.; Jan Lauts, *Antonello da Messina* (Vienna, 1940), pp. 23 ff., 36–38, Pls. 43–48.

[22] Dussler, *Giovanni Bellini:* altarpiece for the church of SS. Giovanni e Paolo (burnt), pp. 20–22, 90, Pl. 48; altarpiece from S. Giobbe, now in the Accademia, pp. 25–26, 91, Pls. 49–50; altarpiece (1488) in S. Maria de' Frari, pp. 26–28, 91, Pls. 52–57; altarpiece (1488) in S. Pietro Martire, Murano,

pp. 28–31, 91, Pls. 58–61; altarpiece (1505) in S. Zaccaria, pp. 49–51, 95, Pls. 96–100.

[23] Hetzer, *Die Sixtinische Madonna.*

[24] Robert Oertel, *Michelangelo, die Sixtinische Decke* (Burg, 1940); Friedrich Kriegbaum, "Zur florentiner Plastik des Cinquecento: Michelangelo und die Antike," *Münchner Jahrbuch für bildende Kunst*, 3. Reihe, III–IV (1952–53), pp. 10 ff.

[25] Julius von Schlosser, "Giusto's Fresken in Padua und die Vorläufer der Stanza della Segnatura (*Jahrbuch der Kunsthistorischen Sammlungen des Allerhöchsten Kaiserhauses*, Wien, VII (1896), pp. 13 ff.; Adolf Rosenberg, *Raffael* (3d ed.; Stuttgart and Leipzig, 1906), pp. XX ff., Pls. 39 ff.

[26] Kurt Wehlte, *Temperamalerei* (3d ed.; Ravensburg, 1954); *Ölmalerei* (5th ed.; Ravensburg, 1954).

[27] Kurt Wehlte, *Wandmalerei* (3d ed.; Ravensburg, 1948); Robert Oertel, "Masaccio und die Geschichte der Freskotechnik," *Jahrbuch der Preussischen Kunstsammlungen*, LV (1934), pp. 229 ff.; idem., "Wandmallerei und Zeichnung in Italien," *Mitteilungen des Kunsthistorischen Institutes in Florenz*, V (1937–40), pp. 217 ff.

[28] Werner Haftmann, "Ein Mosaik aus dem Beisitz des Lorenzo Magnifico," *Mitteilungen des Kunsthistorischen Institutes in Florenz*, VI (1940), pp. 98 ff.; André Chastel, "La Mosaique à Venise et à Florence au XV siècle," *Arte Veneta*, VIII (1954), pp. 119 ff.

[29] Hildegard (Conrad) van Straelen, *Studien zur florentiner Glasmalerei des Trecento und Quattrocento* (Wattenscheid, 1938).

[30] Heidrich and Wölfflin, *Albrecht Dürers . . . ,* pp. 221–22 (trans. Conway, pp. 176–77).

[31] *Ibid.*, p. 273.

[32] *Ibid.*, p. 277 (trans. Conway, p. 247).

[33] *Ibid.*, p. 244 (trans. Conway, p. 231).

[34] *Ibid.*

[35] Von Salis, *Antike und Renaissance*, pp. 136 ff. (Laocoön group) and pp. 153 ff. (about the later development of the Three Graces group).

[36] Leon Battista Alberti, *De re aedificatoria* (Florence, 1485), VI, 3 *et passim.*

[37] Erwin Panofsky, "Perspektive als symbolische Form," *Vorträge der Bibliothek Warburg* (1924–25), pp. 258 ff.; Guido Joseph Kern, "Die Entwicklung der centralperspektivischen Konstruktion in der Europäischen Malerei von der Spätantike bis zur Mitte des 15. Jahrhunderts," *Forschungen und Fort-*

*schritte*, XIII (1937), pp. 181 ff.; John White, "Developments in Renaissance Perspective," *The Journal of the Warburg and Courtauld Institutes*, XIV (1951), pp. 42 ff.; Bernhard Schweitzer, *Vom Sinn der Perspektive* (Tübingen, 1953); André Chastel, "Marqueterie et perspective au XVe siècle," *La Revue des Arts*, III (1953), pp. 141 ff.; John White, *Perspective in Ancient Drawing and Painting* (London, 1956).

[38] *Le Vite* (ed. Milanesi), II, p. 332 (trans. De Vere, II, p. 198).

[39] Piero della Francesca, *De prospectiva pingendi*, ed. G. Nicco Fasola (Florence, 1942).

[40] Schweitzer, *Vom Sinn der Perspektive*.

[41] Wolfgang Lotz, "Das Raumbild in der Italienischen Architekturzeichnung der Renaissance," *Mitteilungen des Kunsthistorischen Institutes in Florenz*, VII (1956), pp. 193, 213 ff.

[42] Ordenberg Bock von Wülfingen, *Raffael Santi, die Verklärung Christi* (Berlin, 1946).

[43] For Leonardo's theoretical writings on art, see Von Schlosser, *Die Kunstliteratur*, pp. 140 ff.; Leonardo da Vinci, *Treatise on Painting*, trans. A. Philip McMahon (Princeton, 1956). See also Ludwig H. Heydenreich, "Quellenkritische Untersuchungen zu Leonardos Malareitraktat," *Kunstchronik*, IV (1951), pp. 255 ff.

[44] Theodor Hetzer, *Giotto* (Frankfort, 1941), pp. 18 ff.

[45] Heinrich Wölfflin, *Classic Art* (New York, 1952).

[46] Theodor Hetzer, *Gedanken um Raffaels Form* (Frankfort, 1932), pp. 18 ff.

[47] Hetzer, *Giotto*, pp. 48 ff., 95 ff.; "Giotto und die Elemente der abendländischen Malerei," *Beiträge zur geistigen Überlieferung* (Godesberg, 1947), pp. 280 ff.

[48] Inge Fraenkel, *Andrea del Sarto* (Strasbourg, 1935).

[49] Quoted in Bock von Wülfingen, *Raffael Santi*.

[50] The concept of "formulas of expression" (*Pathosformel*) was originated by Aby Warburg (see n. 5, Chapter two).

[51] Hans Jantzen, "Über Prinzipien der Farbengebung in der Malerei" (1913–14), reprinted in *Über den gotischen Kirchenraum und andere Aufsätze* (Berlin, 1951), pp. 61 ff.; Theodor Hetzer, *Tizian, Geschichte seiner Farbe* (Frankfort, 1935); idem., *Giotto*, pp. 146 ff.

[52] Hetzer, *Tizian*.

## Chapter seven

[1] Degenhart, *Antonio Pisanello*, Pl. 143.

[2] Ulrich Middeldorf, *Raphael's Drawings* (New York, 1945), pp. 11–12.

[3] Degenhart, *Antonio Pisanello*.

[4] Paul Kristeller, *Kupferstich und Holzschnitt in vier Jahrhunderten* (Berlin, 1905).

[5] *Ibid.*; Arthur M. Hind, *An Introduction to a History of Woodcut* (London, 1935).

[6] Burckhardt, *Geschichte der Renaissance*, 1891, pp. 327 ff.; Bertold Bretholz, "Lateinische Palaeographie," *Grundriss der Geschichtswissenschaft*, I, part 1 (1912), pp. 102 ff.

[7] Sven Dahl, *Geschichte des Buches* (Leipzig, 1928), pp. 88 ff.

## Chapter eight

[1] Adolf Feulner, *Kunstgeschichte des Möbels seit dem Altertum* (2d ed.; Berlin, 1927); Edmund Wilhelm Braun-Troppau, "Das Kunstgewerbe der Renaissance," *Geschichte des Kunstgewerbes*, ed. H. Bossert (Berlin, 1928–35), VI, pp. 3 ff.

[2] Paul Schubring, *Cassoni* (Leipzig, 1923); Wackernagel, *Der Lebensraum des Künstlers*, pp. 167 ff.

[3] Burckhardt, *Geschichte der Renaissance*, 1891, pp. 306 ff.; Chastel, *La Revue des Arts*, III, pp. 141 ff.

[4] Charles Sterling, *La nature morte de l'antiquité à nos jours* (Paris, 1952), Chap. IV.

[5] Pasquale Rotondi, *Il Palazzo Ducale di Urbino* (Urbino, 1950–51).

[6] Adolf Brüning, *Die Schmiedekunst seit dem Ende der Renaissance* (Leipzig, 1902); Otto Höver, *Wrought Iron; Encyclopedia of Ironwork*, trans. A. Weaver (2d ed.; New York, 1962); Braun-Troppau, *Geschichte des Kunstgewerbes*, VI, pp. 30 ff.

[7] Burckhardt, *Geschichte der Renaissance*, 1891, pp. 366 ff.

[8] *Ibid.*, pp. 302 ff., 384 ff.

[9] *Ibid.*, pp. 360 ff.; Braun-Troppau, *Geschichte des Kunstgewerbes*, VI, pp. 28 ff.

[10] Walter Holzhausen, "Studien zum Schatz des Lorenzo il Magnifico im Palazzo Pitti," *Mitteilungen des Kunsthistorischen Instituts in Florenz*, III (1919–32), pp. 104 ff.

[11] Burckhardt, *Geschichte der Renaissance*, 1891, pp. 366 ff.

[12] *Ibid.*, pp. 368 ff.; Braun-Troppau, *Geschichte des Kunstgewerbes*, VI, pp. 15 ff.

[13] Robert Schmidt, *Das Glas* (Berlin, 1922); Philipp Schwarz, *Gläserformen* (Stuttgart, 1916); Heinrich Strehlow, *Der Schmuck des Glases* (Leipzig, 1920); Karl Jaeger, *Kunstgläser* (Munich, 1922); Braun-Troppau, *Geschichte des Kunstgewerbes*, VI, pp. 23 ff.

[14] Burckhardt, *Geschichte der Renaissance*, 1891, pp. 365 ff.; Braun-Troppau, *Geschichte des Kunstgewerbes*, VI, pp. 27 ff.

[15] Otto von Falke, *Kunstgeschichte der Seidenweberei* (2 vols.; Berlin, 1913).

[16] Braun-Troppau, *Geschichte des Kunstgewerbes*, VI, pp. 31 ff.

[17] *Ibid.*, pp. 32 ff.

[18] *Ibid.*, pp. 33 ff.

[19] Walter and Elisabeth Paatz, II (1941), p. 210.

## Chapter nine

[1] Burckhardt, *Geschichte der Renaissance*, 1891, p. 300; Planiscig, *Lorenzo Ghiberti*, Pls. 3, 36–39.

[2] Planiscig, *Luca della Robbia*, plates.

[3] Planiscig, *Andrea del Verrocchio*, Pls. 15–24.

[4] Burckhardt, *Geschichte der Renaissance*, 1891, pp. 349 ff.; Von Salis, *Antike und Renaissance*, pp. 35–37 ff.; Friedrich Piel, *Die Ornamentgrotteske in der italienischen Renaissance* (Berlin, 1961?).

[5] Burckhardt, *Geschichte der Renaissance*, 1891, p. 263.

# BIBLIOGRAPHY

Titles marked with an asterisk (*) are available in paperback editions.

## General

ANTAL, FREDERICK. *Florentine Painting and Its Social Background*. London: K. Paul, 1948.

*BARON, HANS. *The Crisis of the Early Italian Renaissance*. 2 vols. Princeton, N.J.: Princeton University Press, 1955.

*BLUNT, ANTHONY. *Artistic Theory in Italy, 1450–1600*. Oxford: Clarendon Press, 1966.

*BURCKHARDT, JAKOB. *The Civilization of the Renaissance in Italy*. Translated by S. G. C. Middlemore. London: Phaidon, 1960.

CHASTEL, ANDRÉ. *Art et humanisme à Florence au temps de Laurent le Magnifique*. Paris: Presses Universitaires de France, 1959.

———. *Italian Art*. Translated by Peter and Linda Murray. New York: Thomas Yoseloff, 1963.

FERGUSON, WALLACE K. *The Renaissance in Historical Thought*. Boston: Houghton Mifflin, 1948.

HARTT, FREDERICK. *History of Italian Renaissance Art*. New York: Abrams, 1969.

*HAUSER, ARNOLD. *The Social History of Art*. Translated in collaboration with the author by Stanley Goodman. 2 vols. New York: Knopf, 1951.

LUCAS-DUBRETON, JEAN. *Daily Life in Florence in the Time of the Medici*. Translated by A. Lytton Sells. New York: Macmillan, 1961.

*PANOFSKY, ERWIN. *Renaissance and Renascences in Western Art*. 2nd ed. Stockholm: Almqvist & Wiksell, 1965.

*———. *Studies in Iconology: Humanistic Themes in the Art of the Renaissance*. New York: Oxford University Press, 1939.

*PATER, WALTER H. *The Renaissance*. New York: Modern Library, 1924.

SALIS, ARNOLD VON. *Antike und Renaissance*. Erlenbach-Zurich: E. Rentsch, 1947.

*SEZNEC, JEAN. *The Survival of the Pagan Gods*. Translated by Barbara F. Sessions. New York: Pantheon, 1953.

*SYMONDS, JOHN ADDINGTON. *Renaissance in Italy*.

Vol. III: *The Fine Arts*. 3rd ed. London: J. Murray, 1934.

*SYPHER, WYLIE. *Four Stages of Renaissance Style*. Garden City, N.Y.: Anchor Books, Doubleday, 1955.

WACKERNAGEL, MARTIN. *Der Lebensraum des Künstlers in der Florentinischen Renaissance*. Leipzig: E. A. Seeman, 1938.

WHITE, JOHN. *Art and Architecture in Italy, 1250–1400*. Pelican History of Art. Baltimore: Penguin Books, 1966.

*WIND, EDGAR. *Pagan Mysteries in the Renaissance*. 2nd ed., revised and enlarged. Baltimore: Penguin Books, 1967.

*WÖLFFLIN, HEINRICH. *The Art of the Italian Renaissance*. New York: G. Putnam's Sons, 1903.

———. *Classic Art*. Translated by Peter and Linda Murray. New York: Phaidon, 1952.

## Sources

*HOLT, ELIZABETH, ed. *A Documentary History of Art*. Vols. I, II. Garden City, N.Y.: Anchor Books, Doubleday, 1957–58.

*KLEIN, ROBERT, and ZERNER, HENRI, eds. *Italian Art, 1500–1600: Sources and Documents*. Englewood Cliffs, N.J.: Prentice-Hall, 1966.

*ALBERTI, LEON BATTISTA. *On Painting*. Translated by John R. Spencer. Revised edition. New Haven, Conn.: Yale University Press, 1966.

———. *Ten Books on Architecture*. Translated by James Leoni. Edited by Joseph Rykwert. London: Tiranti, 1955.

*The Life of Brunelleschi*. Introduction and Notes by Howard Saalman. Translated by Catherine Enggass. University Park, Pa.: Pennsylvania State University Press, 1970.

*CASTIGLIONE, BALDASSARE. *The Book of the Courtier*. Translated by Charles S. Singleton. Garden City, N.Y.: Doubleday, 1959.

*CELLINI, BENVENUTO. *Autobiography*. Translated by John Addington Symonds. Garden City, N.Y.: Doubleday, 1960.

*———. *Treatises on Goldsmithing and Sculpture*. Translated by C. R. Ashbee. London: E. Arnold, 1898.

*CENNINI, CENNINO. *Il libro dell'arte* (*The Craftsman's Handbook*). Translated by Daniel V. Thompson,

Jr. 2 vols. New Haven, Conn.: Yale University Press, 1932–33.

DURER, ALBRECHT. *The Writings of Albrecht Dürer*. Translated by William M. Conway. London: Peter Owen, 1958.

FILARETE (Antonio Averlino). *Treatise on Architecture*. Translated with an Introduction and Notes by J. R. Spencer. 2 vols. New Haven, Conn.: Yale University Press, 1965.

LEONARDO DA VINCI. *Treatise on Painting*. Translated and annotated by A. Philip McMahon. 2 vols. Princeton, N.J.: Princeton University Press, 1956.

*The Literary Works of Leonardo da Vinci*. Edited by Jean Paul Richter. 2nd ed., revised and enlarged. 2 vols. New York: Oxford University Press, 1939.

*VASARI, GIORGIO. *Lives of the Most Eminent Painters, Sculptors, and Architects*. Translated by G. du C. de Vere. 10 vols. London: Medici Society, 1912–15.

*Vasari on Technique*. Translated by Louisa S. Maclehose. Edited by G. Baldwin Brown. London: J. M. Dent, 1907.

## Architecture

ANDERSON, WILLIAM J. *The Architecture of the Renaissance in Italy*. 4th ed., revised and enlarged. New York: Scribner's, 1909.

HAUPT, ALBRECHT, ed. *Renaissance Palaces of Northern Italy and Tuscany*. 3 vols. London: B. T. Batsford, 1931.

*LOWRY, BATES. *Renaissance Architecture*. New York: Braziller, 1962.

MAGNUSON, TORGIL. *Studies in Roman Quattrocento Architecture*. Stockholm: Almqvist & Wiksell, 1958.

*MASSON, GEORGINA. *Italian Gardens*. New York: Abrams, 1961.

*———. *Italian Villas and Palaces*. New York: Abrams, 1959.

*MURRAY, PETER. *The Architecture of the Italian Renaissance*. New York: Schocken Books, 1963.

PAATZ, WALTER. *Werden und Wesen der Trecento-Architektur in Toskana*. Burg: Druck A. Hopfer, 1937.

———, and PAATZ, ELIZABETH. *Die Kirchen von Florenz*. 6 vols. Frankfort: V. Klostermann, 1940–54.

*PEVSNER, NIKOLAUS. *An Outline of European Architecture*. 6th (Jubilee) ed. Baltimore: Penguin Books, 1960.

*SCOTT, GEOFFREY. *The Architecture of Humanism*. 2nd ed., revised. New York: Scribner's, 1924.

STEGMANN, CARL M., and GEYMÜLLER, HEINRICH VON. *The Architecture of the Renaissance in Tuscany*. 2 vols. New York: Architectural Publishing Co., 1924.

*WITTKOWER, RUDOLF. *Architectural Principles in the Age of Humanism*. 3rd ed., revised. New York: Random House, 1965.

## Sculpture

BODE, WILHELM VON. *Florentine Sculptors of the Renaissance*. Translated by Jessie Haynes. 2nd ed., revised by F. L. Rudston Brown. New York: Scribner's, 1928.

———, and MARKS, MURRAY. *The Italian Bronze Statuettes of the Renaissance*. Translated by W. Grétor. 3 vols. London: H. Grevel, 1907–12.

HARTT, FREDERICK; CORTI, GINO; AND KENNEDY, CLARENCE. *The Chapel of the Cardinal of Portugal, 1434–1459, at San Miniato in Florence*. Philadelphia: University of Pennsylvania Press, 1964.

MACLAGAN, ERIC R. *Italian Sculpture of the Renaissance*. Cambridge, Mass.: Harvard University Press, 1935.

*PANOFSKY, ERWIN. *Tomb Sculpture*. Edited by H. W. Janson. New York: Abrams, 1964.

POPE-HENNESSY, JOHN. *Italian Gothic Sculpture*. London: Phaidon, 1955.

———. *Italian High Renaissance and Baroque Sculpture*. 3 vols. London: Phaidon, 1963.

———. *Italian Renaissance Sculpture*. London: Phaidon, 1958.

———. *Renaissance Bronzes from the Samuel H. Kress Collection: Reliefs, Plaquettes, Statuettes, Utensils and Mortars*. London: Phaidon, 1965.

SEYMOUR, CHARLES. *Sculpture in Italy, 1400 to 1500*. Pelican History of Art. Baltimore: Penguin Books, 1966.

VALENTINER, WILHELM R. *Studies of Italian Renaissance Sculpture*. London: Phaidon, 1950.

## Painting

*BERENSON, BERNARD. *Italian Painters of the Renais-* sance. New York: Phaidon, 1952.

———. *Italian Pictures of the Renaissance: The Venetian School*. 2 vols. London: Phaidon, 1957.

———. *Italian Pictures of the Renaissance: The Florentine School*. 2 vols. London: Phaidon, 1963.

———. *Italian Pictures of the Renaissance: The Central and North Italian Schools*. 3 vols. London: Phaidon, 1968.

BERGSTRÖM, INGVAR. *Revival of Antique Illusionistic Wallpainting in Renaissance Art*. Stockholm: Almqvist & Wiksell, 1957.

BORSOOK, EVE. *The Mural Painters of Tuscany*. London: Phaidon, 1960.

CROWE, JOSEPH A., and CAVALCASELLE, GIOVANNI BATTISTA. *A History of Painting in Italy*. 2nd ed., edited by L. Douglas. 6 vols. London: John Murray, 1903–14.

———. *A History of Painting in North Italy*. 2nd ed., edited by T. Borenius. 3 vols. New York: Scribner's, 1912.

DEWALD, ERNEST T. *Italian Painting: 1200–1600*. New York: Holt, Rinehart and Winston, 1962.

ETTLINGER, L. D. *The Sistine Chapel Before Michelangelo.* New York: Oxford University Press, 1965.

FREEDBERG, SYDNEY J. *Painting of the High Renaissance in Rome and Florence*. 2 vols. Cambridge, Mass.: Harvard University Press, 1961.

———. *Painting in Italy, 1500–1600*. Pelican History of Art. Baltimore: Penguin Books, 1970.

GODFREY, FREDERICK M. *Early Venetian Painters, 1415–1495*. London: Tiranti, 1954.

GOERING, MAX. *Italian Painting of the Sixteenth Century*. London, 1936.

GOULD, CECIL. *An Introduction to Italian Renaissance Painting*. London: Phaidon, 1957.

MARLE, RAIMOND VAN. *The Development of the Italian Schools of Painting*. Vols. X–XVIII. The Hague: Martinus Nijhoff, 1928–38.

*MEISS, MILLARD. *Painting in Florence and Siena After the Black Death*. Princeton: Princeton University Press, 1951.

OFFNER, RICHARD A. *A Critical and Historical Corpus of Florentine Painting*. Section III, 8 vols., Section IV, 4 vols. New York: New York University Press, 1930–67.

POPE-HENNESSY, JOHN. *Sienese Quattrocento Painting*. New York: Phaidon, 1957.

PROCACCI, UGO. *Sinopie e Affreschi*. Milan: Electa Editrice, 1961.

———, ET AL. *The Great Age of Fresco: Giotto to Pontormo*. Exhibition Catalogue. New York: The Metropolitan Museum of Art, 1968.

SHEARMAN, JOHN. *Mannerism*. Baltimore: Penguin Books, 1967.

WHITE, JOHN. *The Birth and Rebirth of Pictorial Space*. London: Faber & Faber, 1957.

## Drawings and prints

BERENSON, BERNARD. *The Drawings of the Florentine Painters*. Amplified ed. 3 vols. Chicago: University of Chicago Press, 1938.

DEGENHART, BERNHARD, and SCHMITT, ANNEGRIT. *Corpus der Italienischen Zeichnungen, 1300–1450*. Berlin: Mann, 1968–.

DE TOLNAY, CHARLES. *History and Technique of Old Master Drawings: A Handbook*. New York: H. Bittner, 1943.

HIND, ARTHUR M. *Early Italian Engraving: A Critical Catalogue*. 2 vols. London: B. Quaritch, 1938–48.

*———. *A History of Engraving & Etching from the 15th Century to the Year 1914*. London: Constable, 1923.

*———. *An Introduction to a History of Woodcut*. 2 vols. London: Constable, 1935.

TIETZE, HANS, and TIETZE-CONRAT, ERICA. *The Drawings of the Venetian Painters in the 15th and 16th Centuries*. New York: J. J. Augustin, 1944.

## Minor arts

ARCANGELI, FRANCESCO. *Tarsie*. 2nd ed. Rome: Tumminelli, 1943.

BODE, WILHELM VON. *Italian Renaissance Furniture*. Translated by Mary E. Herrick. 2nd ed. New York: W. Helburn, 1921.

D'ANCONA, PAOLO. *La miniatura fiorentina*. 2 vols. Florence: L. S. Olschki, 1914.

FABRICZY, CORNELIUS VON. *Italian Medals*. Translated by Mrs. Gustavus W. Hamilton. London: Duckworth, 1904.

HILL, GEORGE F. *A Corpus of Italian Medals of the Renaissance Before Cellini*. 2 vols. London: British Museum, 1930.

HÖVER, OTTO. *Wrought Iron: Encyclopedia of Ironwork*. Translated by A. Weaver. 2nd ed. New York: Universe Books, 1962.

JACKSON, F. HAMILTON. *Intarsia and Marquetry*. London: Sands, 1903.

LANE, ARTHUR. *Italian Porcelain*. London: Faber & Faber, 1954.

MARCHINI, GIUSEPPE. *Italian Stained Glass Windows*. New York: Abrams, 1947.

MORASSI, ANTONIO. *Art Treasures of the Medici: Jewellery, Silverware, Hard-stone*. London: Oldbourne Press, 1961.

PEDRINI, AUGUSTO. *Italian Furniture: Interiors and Decoration of the Fifteenth and Sixteenth Centuries*. Revised ed. London: Tiranti, 1949.

RACKHAM, BERNARD. *Italian Maiolica*. 2nd ed. London: Faber & Faber, 1963.

ROSSI, FILIPPO. *Italian Jeweled Arts*. Translated by Elisabeth Mann Borgese. New York: Abrams, 1957.

SALMI, MARIO. *Italian Miniatures*. Translated by Elisabeth Mann Borgese. New York: Abrams, 1956.

SANTANGELO, ANTONIO. *A Treasury of Great Italian Textiles*. Translated by Peggy Craig. New York: Abrams, 1964.

SCHUBRING, PAUL. *Cassoni*. 2nd ed., enlarged. Leipzig: K. W. Hiersemann, 1923.

## Artists

### FRA ANGELICO

ARGAN, GIULIO C. *Fra Angelico: Biographical and Critical Study*. Translated by James Emmons. Cleveland: Skira, 1955.

POPE-HENNESSY, JOHN. *Fra Angelico*. New York: Phaidon, 1952.

### ANTONELLO DA MESSINA

BOTTARI, STEFANO. *Antonello da Messina*. Translated by G. Scaglia. Greenwich, Conn.: New York Graphic Society, 1955.

### GIOVANNI BELLINI

HEINEMANN, FRITZ. *Giovanni Bellini e i Belliniani*. 2 vols. Venice: Pozza, 1962.

HENDY, PHILIP, and GOLDSCHEIDER, LUDWIG. *Giovanni Bellini*. New York: Oxford University Press, 1945.

### BENEDETTO DA MAIANO

DUSSLER, LUITPOLD. *Benedetto da Maiano*. Munich, 1924?

## BOTTICELLI

ARGAN, GIULIO C.  *Botticelli: Biographical and Critical Study.* Translated by James Emmons. New York: Skira, 1957.

BODE, WILHELM VON.  *Sandro Botticelli.* Translated by F. Renfield and F. L. R. Brown. New York: Scribner's, 1925.

HORNE, HERBERT P.  *Alessandro Filipepi, Commonly Called Sandro Botticelli, Painter of Florence.* London: Bell, 1908.

## BRAMANTE

BARONI, COSTANTINO.  *Bramante.* Bergamo: Istituto Italiano d'Arti Grafiche, 1944.

*CHIERICI, GINO.  *Donato Bramante, 1444–1514.* Translated by Peter Simmons. New York: Universe Books, 1960.

FÖRSTER, OTTO H.  *Bramante.* Vienna: A. Schroll, 1956.

## BRUNELLESCHI

ARGAN, GIULIO C.  *Brunelleschi.* Milan: Mondadori, 1955.

LUPORINI, EUGENIO.  *Brunelleschi.* Milan, 1964.

## CARPACCIO

LAUTS, JAN.  *Carpaccio: Paintings and Drawings.* Translated by Erica Millman and Marguerite Kay. New York: Phaidon, 1962.

## ANDREA DEL CASTAGNO

RICHTER, GEORGE M.  *Andrea del Castagno.* Chicago: University of Chicago Press, 1943.

## CORREGGIO

GHIDIGLIA QUINTAVALLE, AUGUSTA.  *Correggio: Frescoes in San Giovanni Evangelista in Parma.* Translated by Olga Ragusa. New York: Abrams, 1964.

PANOFSKY, ERWIN.  *The Iconography of Correggio's Camera di San Paolo.* London: Warburg Institute, 1961.

POPHAM, ARTHUR E.  *Correggio's Drawings.* New York: Oxford University Press, 1957.

## DELLA ROBBIA

MARQUAND, ALLAN.  *The Brothers of Giovanni della Robbia: Fra Mattia, Luca, Girolamo, Fra Ambrogio.* Princeton, N.J.: Princeton University Press, 1928.

PLANISCIG, LEO.  *Luca della Robbia.* Vienna, 1940.

## DESIDERIO DA SETTIGNANO

PLANISCIG, LEO.  *Desiderio da Settignano.* Vienna, 1942.

## DONATELLO

GOLDSCHEIDER, LUDWIG.  *Donatello.* New York: Oxford University Press, 1941.

HARTT, FREDERICK.  *Donatello: Prophet of Modern Vision.* New York: Abrams, 1973.

JANSON, H. W.  *The Sculpture of Donatello.* 2 vols. Princeton, N.J.: Princeton University Press, 1957.

KAUFFMANN, HANS.  *Donatello.* Berlin, 1935.

## ALBRECHT DÜRER

PANOFSKY, ERWIN.  *Albrecht Dürer.* 2 vols. Princeton, N.J.: Princeton University Press, 1948.

## FRANCESCO DI GIORGIO

BRINTON, SELWYN J. C.  *Francesco di Giorgio Martini of Siena, Painter, Sculptor, Engineer, Civil and Military Architect (1439–1502).* Vol. I. London: Besant & Co., 1934.

PAPINI, ROBERTO.  *Francesco di Giorgio, Architetto.* 3 vols. Florence: Electa Editrice, 1946.

WELLER, ALLEN S.  *Francesco di Giorgio, 1439–1501.* Chicago: University of Chicago Press, 1943.

## GHIBERTI

GOLDSCHEIDER, LUDWIG.  *Ghiberti.* London: Phaidon, 1949.

KRAUTHEIMER, RICHARD, and KRAUTHEIMER-HESS, TRUDE.  *Lorenzo Ghiberti.* Princeton, N.J.: Princeton University Press, 1956.

## GHIRLANDAIO

LAUTS, JAN.  *Ghirlandaio.* Vienna, 1943.

## GIORGIONE

BALDASS, LUDWIG VON.  *Giorgione.* Translated by J. M. Brownjohn. New York: Abrams, 1965.

RICHTER, GEORGE M.  *Giorgio da Castelfranco, Called Giorgione.* Chicago: University of Chicago Press, 1937.

## JACOPO DELLA QUERCIA

HANSON, ANNE C.  *Jacopo della Quercia's Fonte Gaia.* New York: Oxford University Press, 1965.

## LEONARDO DA VINCI

*CLARK, KENNETH.  *Leonardo da Vinci; an Account of His Development as an Arctist.* Revised ed., Baltimore: Penguin Books, 1967.

HEYDENREICH, LUDWIG H.   *Leonardo da Vinci.* 2 vols. New York: Macmillan, 1954.

*POPHAM, ARTHUR E.   *The Drawings of Leonardo da Vinci.* New York: Reynal & Hitchcock, 1945.

## FILIPPINO LIPPI
SCHARF, ALFRED.   *Filippino Lippi.* Vienna: Schroll, 1935 and 1950.

## FRA FILIPPO LIPPI
OERTEL, ROBERT.   *Fra Filippo Lippi.* Vienna: Schroll, 1942.

## LORENZO LOTTO
BERENSON, BERNARD.   *Lorenzo Lotto.* London: Phaidon, 1956.

## MANTEGNA
FIOCCO, GIUSEPPE.   *Paintings by Mantegna.* New York: Abrams, 1963.

KRISTELLER, PAUL.   *Andrea Mantegna.* Translated by S. A. Strong. New York: Longman's, Green, 1901.

MEISS, MILLARD.   *Andrea Mantegna as Illuminator: An Episode in Renaissance Art, Humanism and Diplomacy.* New York: Columbia University Press, 1957.

TIETZE-CONRAT, ERICA.   *Mantegna: Paintings, Drawings, Engravings.* New York: Phaidon, 1955.

## MASACCIO
BERTI, LUCIANO.   *Masaccio.* University Park, Pa.: Pennsylvania State University Press, 1967.

HENDY, PHILIP.   *Masaccio: Frescoes in Florence.* Greenwich, Conn.: New York Graphic Society, 1956.

## MICHELANGELO
ACKERMAN, JAMES S.   *The Architecture of Michelangelo.* 2 vols. New York: Viking, 1961–64.

DE TOLNAY, CHARLES.   *Michelangelo.* 5 vols. Princeton, N. J.: Princeton University Press, 1943–60.

GOLDSCHEIDER, LUDWIG.   *Michelangelo Buonarroti: Paintings, Sculptures, and Architecture.* 5th ed. New York: Phaidon, 1962.

HARTT, FREDERICK.   *Michelangelo.* New York: Abrams, 1965.

———.   *Michelangelo: The Complete Sculpture.* New York: Abrams, 1969.

———.   *Michelangelo Drawings.* New York: Abrams, 1970.

## PIERO DELLA FRANCESCA
CLARK, KENNETH.   *Piero della Francesca.* Revised ed. New York: Phaidon, 1969.

GILBERT, CREIGHTON.   *Change in Piero della Francesca.* Locust Valley, New York: Augustin, 1968.

## PIERO DI COSIMO
DOUGLAS, R. LANGTON.   *Piero di Cosimo.* Chicago: University of Chicago Press, 1946.

## PISANELLO
DEGENHART, BERNARD.   *Pisanello.* Vienna, 1940.

SINDONA, ENIO.   *Pisanello.* Translated by J. Ross. New York: Abrams, 1963.

## POLLAIUOLO
CRUJTTWELL, MAUD.   *Antonio Pollaiuolo.* New York: Scribner's, 1907.

ORTOLANI, SERGIO.   *Il Pollaiuolo.* Milan: U. Hoepli, 1948.

## PONTORMO
CLAPP, FREDERICK M.   *Jacopo Carucci da Pontormo, His Life and Work.* New Haven, Conn.: Yale University Press, 1916.

REARICK, JANET.   *Drawings of Pontormo.* 2 vols. Cambridge, Mass.: Harvard University Press, 1964.

## RAPHAEL
FISCHEL, OSKAR.   *Raphael.* Translated by Bernard Rackham. 2 vols. London: K. Paul, 1948.

MIDDELDORF, ULRICH.   *Raphael's Drawings.* New York: H. Bittner, 1945.

SUIDA, WILHELM E.   *Raphael: Paintings and Drawings.* New York: Oxford University Press, 1942.

## GIULIO ROMANO
HARTT, FREDERICK.   *Giulio Romano.* 2 vols. New Haven, Conn.: Yale University Press, 1958.

## ROSSELLINO
PLANISCIG, LEO.   *Bernardo und Antonio Rossellino.* Vienna, 1942.

## GIULIANO DA SANGALLO
MARCHINI, GIUSEPPE.   *Giuliano da Sangallo.* Florence: Sansoni, 1942.

## ANDREA DEL SARTO
FREEDBERG, SYDNEY J.   *Andrea del Sarto.* 2 vols. Cambridge, Mass.: Harvard University Press, 1963.

ANDREA SANSOVINO

HUNTLEY, G. HAYDN.  *Andrea Sansovino, Sculptor and Architect of the Italian Renaissance.* Cambridge, Mass.: Harvard University Press, 1935.

LUCA SIGNORELLI

CRUTTWELL, MAUD.  *Luca Signorelli.* London: Bell, 1907.

SALMI, MARIO.  *Signorelli.* Novara, 1953.

TINTORETTO

TIETZE, HANS.  *Tintoretto: The Paintings and Drawings.* New York: Oxford University Press, 1948.

TITIAN

MORASSI, ANTONIO.  *Titian.* Greenwich, Conn.: New York Graphic Society, 1964.

PANOFSKY, ERWIN.  *Problems in Titian.* New York: New York University Press, 1970.

TIETZE, HANS.  *Titian: Paintings and Drawings.* 2nd ed., revised. New York: Oxford University Press, 1950.

WALKER, JOHN.  *Bellini and Titian at Ferrara, a Study of Styles and Taste.* London: Phaidon, 1957.

WETHEY, HAROLD.  *Paintings of Titian.* New York: Phaidon, 1970-.

COSIMO TURA

RUHMER, EBERHARD.  *Tura: Paintings and Drawings.* London: Phaidon, 1958.

PAOLO UCCELLO

POPE-HENNESSY, JOHN.  *The Complete Work of Paolo Uccello.* 2nd ed., revised. London: Phaidon, 1969.

ANDREA VERROCCHIO

CRUTTWELL, MAUD.  *Verrocchio.* London: Duckworth, 1904, 1911.

PLANISCIG, LEO.  *Andrea del Verrocchio.* Vienna, 1940.

SEYMOUR, CHARLES.  *The Sculpture of Verrocchio.* London: Studio Vista, 1971.

# INDEX

# LIST OF CREDITS

The author and the publisher wish to thank the libraries, museums, and private collectors for permitting the reproduction in black-and-white of paintings, prints, and drawings in their collections. Photographs have been supplied by the owners or custodians of the works of art except for the following, whose courtesy is gratefully acknowledged:

Alinari (including Anderson and Brogi), Florence: 3, 5, 6, 18, 19, 22, 24, 28, 32–35, 37, 38, 40, 41, 50–52, 54, 58, 60, 61, 64–67, 69–75, 77–79, 81–83, 87, 89–91, 93, 94, 97, 101, 103–105, 107–110, 112, 114, 116, 117, 120, 123, 125, 126, 128, 130, 131, 135, 136, 140–144, 149–152, 155, 161, 166, 168, 169, 171, 172, 175, 176, 178, 179, 185, 186, 194, 195, 198, 199, 201, 206, 208–210, 213, 216–218, 223, 226, 228, 230, 234, 237–239, 241–244, 246, 247, 251, 252, 255, 258, 259, 261, 274, 277, 278, 287, 288, 290, 295–299. Aragozzini, Milan: 36. Archives Photographiques, Paris: 188, 203, 212. ATA, Stockholm: 236. Biblioteca Nazionale, Florence: 15. Bildarchiv d. Österreichisches Nationalbibliothek, Vienna: 266. Osvald Böhm, Venice: 96. Robert Bruck, *Das Skizzenbuch von Albrecht Dürer*, Strassbourg, 1905, pl. 125: 2. Eugenio Cassin, Florence: 43, 85, 100, 111, 124, 132, 159, 190, 289. Fiorentini, Venice: 207. Gabinetto Fotografico Nazionale, Florence: 84, 119, 129, 158, 180, 181, 231, 233. Giraudon, Paris: 16, 122, 193, 196, 248. Christian Huelsen, *Il Libro di Giuliano da Sangallo*, Vatican, 1910, fol. 15v: 30. Löbl, Bad Tölz/Oberbayern, Germany: 235. Fratelli Manzotti, Piacenza: 25. MAS, Barcelona: 202, 214. Rollie McKenna, Stonington, Connecticut: 20. O. Morisani *Michelozzo architetto*, Turin, 1951, fig. 125: 31. Eric Pollitzer, Garden City Park, New York: 44, 45. Ezio Quirisi, Cremona: 23. Service de Documentation Photographique, Paris: 224. Walter Steinkopf, Berlin: 1, 138, 211.